OCCASIONAL PAPERS ON ANTIQUITIES, 8

# Studia Varia

## from the J. Paul Getty Museum  Volume 1

MALIBU, CALIFORNIA 1993

© 1993 The J. Paul Getty Museum
17985 Pacific Coast Highway
Malibu, California 90265-5799
(310) 459-7611

Mailing address:
P.O. Box 2112
Santa Monica, California 90407-2112

Christopher Hudson, Publisher
Cynthia Newman Bohn, Managing Editor

Project staff:
Editors: Marion True, Curator of Antiquities, and Ken Hamma,
    Associate Curator of Antiquities
Manuscript Editors: Benedicte Gilman, Angela Thompson, and
    Ilaria Dagnini Brey
Designer: Kurt Hauser
Production Coordinator: Suzanne Watson Petralli
Production Artist: Eileen Delson

All photographs by the Department of Photographic Services,
    J. Paul Getty Museum, unless otherwise noted.

Typography by Andresen Typographics, Tucson, Arizona
Printed by Gardner Lithograph, Buena Park, California

Cover: Sphinx from terracotta relief. Malibu, J. Paul Getty Museum
    79.AD.195.

Library of Congress Cataloging-in-Publication Data

Studia varia.
    p.    cm.—(Occasional papers on antiquities : 8)
    English, German, and Italian.
    ISBN 0-89236-203-0 :
    1. Art objects, Classical.    2. Art objects—California—Malibu.
3. J. Paul Getty Museum.    I. J. Paul Getty Museum.    II. Series.
NK665.S78    1993
    709'.38'07479493—dc20                                       93-16382
                                                                  CIP

# Contents

# Three Pairs of Etruscan Disc Ear Ornaments

LISA BURKHALTER

The Etruscans' love for jewelry is evident in their art, especially that found in funerary contexts.[1] Excavations of tombs in Etruria reveal the wealth of these people and the high quality of their craftsmanship of gold, each fostered in part by the economic prosperity of the orientalizing period. The Etruscan metalworkers perfected the techniques of granulation—the application to a gold surface of small spheres of gold in rows and patterns—and filigree—decorative designs formed from folded wire.[2] Through these detailed goldsmithing processes, they produced elaborate necklaces, bracelets, rings, diadems, fibulae, and ear ornaments.

Among the finery worn by Etruscan women, their ear ornaments are of particular interest. Various styles were popular at different times. During the sixth century B.C. gold disc ornaments and another type of ear decoration, often referred to with the Italian term *a baule* for its resemblance to a valise, were popular in Etruria. While the *a baule* type was unique to Etruria, the disc was popular in other areas of the Mediterranean as well. During the fifth century, the *a baule* style fell out of fashion, and another type of ear ornament, called *en grappe* for the grapelike cluster at the bottom of the design, then gained popularity in Etruria during the fourth century. The disc apparently continued to be a fashionable article of jewelry into the fourth century as well.[3]

In 1983 the Department of Antiquities in the Getty Museum acquired three pairs of Etruscan gold disc ornaments that date from the sixth century B.C.[4] Thought to be from Caere (modern Cerveteri), these pieces are beautiful examples of the Etruscans' skill in goldworking and their decorative processes of granulation and filigree. The fine condition of the pieces may indicate that they were not worn often in antiquity, but perhaps served as grave offerings, for use in the afterlife. A detailed description of these pieces, along with mention of comparative works, is followed by suggestions for methods of wearing the discs in antiquity, a discussion of prototypes for the discs, and finally a discussion of possible locations for gold workshops in ancient Etruria.

Set A (83.AM.2.1) is the largest of the three pairs, with each disc measuring 4.7 cm in diameter (fig. 1). Each disc is composed of a circular sheet of gold encased by a thin, flat rim that projects slightly above and below the sheet along the edge. The upper surface is decorated with seven rosettes, one in the center and the remaining six encircling it. Each rosette has a central floral element connected by twenty-two radiate strips to an encircling band of granulation, which is surrounded by folded ribbon. The spandrels between the central and the surrounding rosettes are filled with unworked gold sheet. Each of the outer spandrels contains a finely detailed woman's face produced in repoussé with a granule positioned beneath the chin. The decorative elements were probably made separately and then arranged, pressed on the sheet, and heated slightly to adhere.[5] On the back of the discs at the center is a projecting hollow gold tube ending in a small loop. Imprints of the rosettes on the upper surface appear on the back.

The closest stylistic parallel for these ornaments is a pair of discs in the Louvre that also has a design made from seven rosettes, one in the center and the other six encircling it (fig. 2).[6] The inner spandrels here, however, bear some detailed granulation, and the designs in the outer spandrels depict palmettes, also in repoussé, rather than women's faces.

Like set A, the discs in the Getty's set B (83.AM.2.2) are made of a circular sheet of gold encased by a thin, flat rim that projects slightly above and below at the edge of the sheet (fig. 3). Each measures 4.2 cm in diameter. The decoration on the upper surface consists of a central rosette surrounded by two concentric

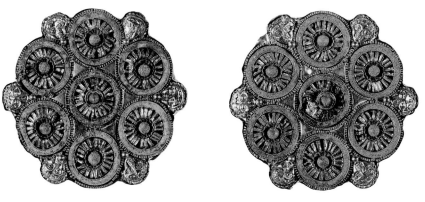

FIGURE I

Pair of gold Etruscan disc ornaments. Malibu, J. Paul Getty Museum 83.AM.2.1.

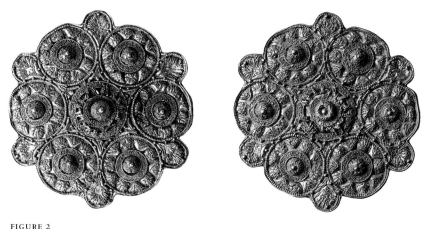

FIGURE 2

Pair of gold Etruscan disc ornaments. Paris, Musée du Louvre Bj 43–44. Photo courtesy Musée du Louvre.

rings of ornamentation. The central rosette is comprised of a granulated boss and three radiate leaves, each with a middle vein of twisted wire. Set between each of the leaves of the central rosette, slightly below the horizontal plane of the disc, is a three-dimensional lion's head worked in repoussé. On either side of each lion's head is a wire ending in a gold sphere.

The ornaments are constructed so that the central rosette is set into the piece, below the plane of the decorated surface. At the center of the underlying sheet, a small circle of gold was cut away and replaced with a concave hemisphere of gold sheet soldered at the back. This area cradles the central rosette. Immediately surrounding this is a circle of gold spheres encased by a wide band of gold sheet covered with tiny gold granules and finally encircled by gold wire. The middle band of ornament consists of twenty fleurettes, each composed of a single granule set in a circular spiral of gold wire; the central granule of

every alternating fleurette is covered in gold dust. The outer band of decoration consists of twenty-eight fleurettes, each made of a concave hemisphere of gold sheet inset with a bead covered in gold dust in the center. Between this final area of ornamentation and the edge of the disc is a band of gold ribbon folded in a serpentine form, followed by a strip of beaded gold wire. On the back of each disc, a small hollow gold tube that ends in a loop projects from the center.

Two works may serve as stylistic parallels for this pair of discs: a pair of similar discs in the collection of the Metropolitan Museum of Art in New York (fig. 4) and a single disc in the British Museum (fig. 5).[7] Like the discs in the Getty Museum, these pieces have a central rosette surrounded by concentric rings of decoration. More importantly, however, each disc bears a central rosette with three lion's heads, produced in repoussé and set between three radiate leaves. These discs appear to have been assembled in a

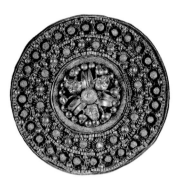
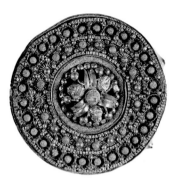

FIGURE 3

Pair of gold Etruscan disc ornaments. Malibu, J. Paul Getty Museum 83.AM.2.2.

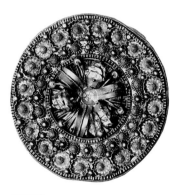
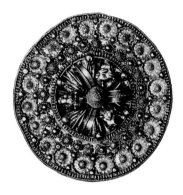

FIGURE 4

Pair of gold Etruscan disc ornaments. New York, The Metropolitan Museum of Art, Rogers Fund, 1913, 13.225.30.A–B. Photo courtesy The Metropolitan Museum of Art.

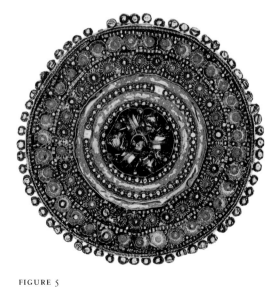

FIGURE 5

Gold Etruscan disc ornament. London, British Museum GR 1980.2-1.42. Photo courtesy Trustees of the British Museum.

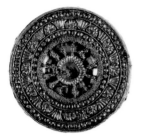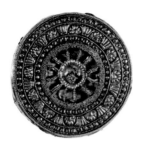

FIGURE 6

Pair of gold Etruscan disc ornaments. Malibu, J. Paul Getty Museum 83.AM.2.3.

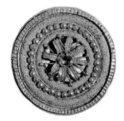

FIGURE 7

Gold Etruscan disc ornament. London, British Museum GR 1872.6-4.743. Photo courtesy Trustees of the British Museum.

similar fashion, each with a small circle of gold sheet cut away from the center and replaced with a concave hemisphere of gold sheet soldered at the back. The disc in the British Museum is larger than those in the Getty collection, measuring 6.1 cm in diameter. It is also more elaborately decorated with additional rings of granulation and a ring of gold spheres around the central rosette. The pair of discs in the Metropolitan Museum shares the basic design and construction of those in Malibu. They differ slightly in the ornament immediately surrounding the central rosette and in the size of the fleurettes in the outer band of ornament. The central rosettes of the discs in New York are surrounded by a band of plain wire encased within a band of wire folded in serpentine form rather than by a ring of gold spheres encased in a band of granulation. The fleurettes in the outer band of decoration are wider than those on the discs in the Getty Museum.

The remaining set of Getty discs, set C (83.AM.2.3), is the smallest of the three pairs, each disc measuring 3.2 cm in diameter (fig. 6). Each disc has a central floral element surrounded by four concentric bands of decoration. The central rosette consists of a circle of twelve widely spaced, radiate strips of gold, each bearing a row of granules along its center. In the center of this rosette is a hole through which projects a wire terminating in a small, flat disc covered with

granules. The first band of decoration surrounding the central rosette is a strip of gold sheet covered with granules. The second band, consisting of forty gold spheres, is encircled in beaded wire. The third band of ornament consists of a pattern of alternating palmettes and lotus leaves worked in repoussé. The final band of decoration consists of sixty-one convex hemispheres produced in repoussé, each with a granule on top. The backs of the discs are heavily encrusted, perhaps from burial conditions.[8]

While there does not appear to be any direct stylistic parallels for this pair, two individual discs in the British Museum share some decorative details. The central rosette of one disc has a design similar to that found on the Getty Museum's pieces (fig. 7).[9] Instead of twelve radiating strips, however, the main rosette has eight thin radiating leaves, each with a row of granules down the center. Another disc in the British Museum has a similar design of alternating repoussé palmettes and lotus leaves in the outer band of decoration (fig. 8).[10]

The flat form of these discs, with their decorated upper surface and the small tube projecting perpendicularly from the back of some, suggests that they served as ear ornaments, although other uses have been proposed.[11] Sixth-century Etruscan tomb paintings and architectural terracotta antefixes frequently depict women with decorated discs at the ear, supporting the argument for their use in this manner.[12] As the backs of the discs are not illustrated in ancient representations, their method of attachment to the ear is not clear. The projecting tube on the back probably would have passed through the earlobe, and a small pin could have been placed through a loop at the end to hold the disc in place, resting flat against the earlobe.[13] These ornaments might also have been worn through a head covering usually referred to as an ear cap, a close-fitting headdress known to have been worn in Cyprus during the sixth century B.C.[14] The caps appear to have been heavily decorated with jewellike attachments, but it is uncertain whether they were made of cloth or metal.

The first disc ear ornaments probably appeared in Ionia.[15] The earliest stylistic prototype for the ear disc, however, appears to be the ear stud that developed in Egypt during the Amarna period of the New Kingdom (1378–1362 B.C.). Made of stone, glass, metal, or faience, these small studs had a thick shaft that, when inserted into a hole in the lobe, left the decorated boss exposed at the base of the ear.[16] This particular style of ear ornament may have spread from

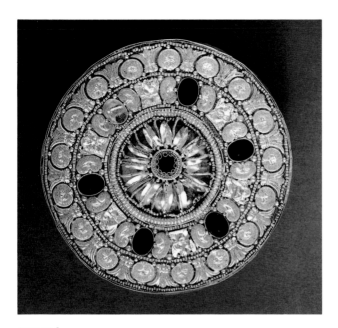

Egypt to the Near East, where it was perhaps modified, and later to Greece through contacts with Ionia.[17] The earliest Greek example of a figure with discs at the ear seems to be a clay head of uncertain gender from Amyklaion, dating to the Late Mycenaean period, now in the National Museum in Athens.[18] Here the discs are not three-dimensional but painted on the figure's earlobes. The popularity of disc ear ornaments in Greece during the Archaic period is evident in the kore figures from the Athenian akropolis, many of whom wear discs at the ear.[19] The custom may then have spread to Etruria during the orientalizing period, either through contacts with the Near East or through trade with the Greeks.

Because most ancient jewelry does not have a precise provenance, specific gold workshops in Etruria have not been established. To date, no evidence of gold workshops themselves has been recovered from excavations. The distribution of find spots for the disc ornaments known today, however, suggests that there was a southern atelier, presumably in one of the major cities.[20] One possible location for a gold workshop during the eighth and seventh centuries B.C. is Caere. Tomb excavations reveal the wealth of this city during the orientalizing period.[21] Located on the west coast of Italy, Caere had convenient access to the rich iron and copper mines of the region. These resources provided the financial means through which merchants of the

city could purchase significant quantities of gold from the nearby Greek colonies of Cumae and Pithekoussai.[22] As the southernmost maritime city of Etruria, Caere was also the closest Etruscan city to the Greek colonies and therefore uniquely exposed to their cultural influence in goldworking as well as other crafts.

While Caere had access to the countries of the Mediterranean through its powerful navy, the city also had significant connections to other Etruscan towns by land. With economic ties to Clusium, Caere apparently influenced the area of Latium, for similar jewelry and pottery have been found in tombs of the same date in these places.[23] Caeretan bronze works have been found at Perugia, while Caeretan *bucchero* pottery has been recovered in Campania.[24] With regard to Caeretan jewelry, Luisa Banti states: "Both the taste for jewelry and the techniques used to produce it arrived from the east or from Rhodes. Soon the Caeretan goldsmiths outdid their models and masters and exported their products to other cities in Etruria, Latium and as far as Cumae, in southern Italy."[25]

M. F. Briguet suggests that a workshop existed in Caere for the *en grappe* style of ear ornament during the fourth century B.C., for almost all of the terracotta antefixes with these ornaments come from this area.[26] Considering Caere's location and trade activity throughout the orientalizing period, an earlier workshop there seems probable. Two discs in the Villa Giulia known to be from Caere are smaller than those in the Getty Museum, yet one of these works, number 46, bears the same motif of a granule set in a circular spiral of gold wire as found on the Getty's set B.[27] Given the lack of information about ancient workshops and their locations, it is difficult further to associate the ear ornaments in the Getty Museum with a certain city; however, they may be considered with similar works as possible products of the same workshop.

The decorative features of the two larger pairs of discs in the Getty Museum, set A (fig. 1) and set B (fig. 3), and of their related works may indicate that each of these groups shares a common origin. As discussed in the earlier descriptions, the closest stylistic parallel to set A in the Getty Museum (fig. 1) is the pair of discs in the Louvre (fig. 2), which entered that museum as part of the Campana collection in 1861.[28] Each of these pieces is similar in size and each bears a design of seven rosettes, one in the center and the other six encircling it, with repoussé work in the outer spandrels.

The pair of discs in New York (fig. 4) and the disc in the British Museum (fig. 5) serve as the closest parallels to set B (fig. 3) in the Getty Museum. Unfortunately, there is no specific provenance information about these works; yet, their similar decorative features and method of construction suggest similar origins. Each of these works is decorated with concentric rings of ornamentation around a distinct central rosette, which consists of a granulated boss with three lion's heads worked in repoussé and set between three radiate leaves. Additionally, each of these pieces is assembled in the same manner, with the central area of the underlying plate cut away and a concave hemisphere of gold sheet soldered around this edge onto the back.

Considering their marked stylistic similarities, the discs in set A in the Getty Museum and the related pieces in the Louvre may represent the work of one goldsmith or ancient workshop, and the discs in set B and their companions in New York and London may represent the products of another. Given the wealth and trade of Caere, that ancient city may be considered a likely location for the production of these works. Until further evidence of jewelry manufacture is recovered from controlled excavations in Etruria, the study of pieces of similar decoration and technique is the first step in beginning to try to identify certain ancient gold workshops and their locations.

Princeton, N.J.

CATALOGUE

The following is a list of published Etruscan gold disc ear ornaments from the sixth–fifth century B.C. located in major collections in the United States and Europe.

*England*

1. Liverpool, Public Museum

   10308, pair of discs. Diam: 2.5 cm. Ex-Mayer collection.

   [M. A. Johnstone, "The Etruscan Collection in the Public Museum of Liverpool," *StEtr* 6 (1932), p. 447]

2. London, British Museum

   1414, single disc. Diam: 3.4 cm. Said to be from Magna Graecia. Burgon collection, 1842.

   1415, single disc. Diam: 3.8 cm. Blacas collection, 1867.

   1416, single disc. Diam: 6.1 cm. Provenance unknown (here fig. 5).

   1417, single disc. Diam: 2.1 cm. Provenance unknown.

   1418, single disc. Diam: 1.9 cm. Castellani collection, 1872.

   1419, single disc. Diam: 6.8 cm. Acquired 1881 (here fig. 8).

   1420, pair of discs. Diam: 2.3 cm. Campanari collection, 1872.

   1421, single disc. Diam: 2.2 cm. Castellani collection, 1872.

   1422–1423, pair of discs. Diam: 2.3 cm. Provenance unknown.

   1424–1425, pair of discs. Diam: 2.8 cm. Castellani collection, 1872 (here fig. 7).

   1426, single disc. Diam: 2.8 cm. Provenance unknown.

   [F. H. Marshall, *Catalogue of the Jewellery, Greek, Etruscan, and Roman, in the Departments of Antiquities, British Museum* (Oxford, 1969), pp. 136–140]

3. London, Private collection

   Two pairs of discs. Diam: 3.6 cm and 4.3 cm.

   Single disc. Diam: 3.6 cm. Said to be from Caere.

   [Unpublished]

*France*

1. Paris, Musée du Louvre

   Bj 43–44, pair of discs. Diam: 5 cm. Campana collection (here fig. 2).

   Bj 47, single disc. Diam: 4.7 cm. Campana collection.

   Bj 50, single disc. Diam: 2 cm. Campana collection.

   [E. Coche de la Ferté, *Les Bijoux antiques* (Paris, 1956), p. 120, pls. XXXIV–XXXV]

*Germany*

1. Berlin, Staatliche Museen Preußischer Kulturbesitz, Antikenabteilung

   GI 413–414 (Misc. 3025–3026), pair of discs. Diam: 4.6 cm. Found in Cettone near Chiusi.

   GI 415 (Misc. 6479), single disc. Diam: 4.6 cm. From Orvieto.

   Inv. 30219, 449, single disc. Diam: 3.4 cm. F. L. von Gans collection.

   Inv. 30219, 450a–b, pair of discs. Diam: 2.9 cm. Ferroni collection, Rome; later F. L. von Gans collection.

   [A. Greifenhagen, *Schmuckarbeiten in Edelmetall* (Berlin, 1970), pp. 91–92]

2. Munich, Staatliche Antikensammlungen und Glyptothek

   Inv. 2477–2478, pair of discs. Diam: 6 cm. From the Candelori collection, Vulci.

   [D. Ohly, *Guide to the Munich Antikensammlungen*, trans. H. Hughes-Brock (Munich, n.d.), pl. 62]

*Italy*

1. Rome, Museo Nazionale Etrusco di Villa Giulia

   46, single disc. Diam: 2.8 cm. From Caere.

   47, single disc. Diam: 2 cm. From Caere.

[M. Pallotino, *Il Museo Nazionale Etrusco di Villa Giulia* (Rome, 1985), pp. 338–339]

2. Vatican, Museo Gregoriano Etrusco

13348, single disc. Diam: 2.1 cm. Falcioni collection.

13547–13550, pair of discs. Diam: 2.5 cm. From Vulci.

13554, single disc. Diam: 2.2 cm. From Vulci.

13557, single disc. Diam: 1.5 cm. Provenance unknown.

13571–13572, pair of discs. Diam: 3.9 cm. Falcioni collection, from Bomarzo.

13573, single disc. Diam: 2.0 cm. Falcioni collection.

[M. Scarpignato, *Oreficerie Etrusche arcaiche* (Rome, 1985), pp. 50–54]

*United States*

1. Chicago, Field Museum of Natural History

Acc. no. 2262, cat. no. 239153.1–2, pair of discs. Diam: 3.5 cm. Provenance unknown.

[T. Hackens and R. Winkes, eds., *Gold Jewelry* (Louvain-la-Neuve, 1983), pp. 101–103]

2. Malibu, J. Paul Getty Museum

83.AM.2.1, pair of discs. Diam: 4.7 cm. Said to be from Caere (here fig. 1).

83.AM.2.2, pair of discs. Diam: 4.2 cm. Said to be from Caere (here fig. 3).

83.AM.2.3, pair of discs. Diam: 3.2 cm. Said to be from Caere (here fig. 6).

[P. Taimsalu, "Etruscan Gold Jewelry," *Aurum* 4 (1980), pp. 37–41]

3. New York, The Metropolitan Museum of Art

40.11.9, pair of discs. Diam: 6.1 cm. From Vulci.

13.225.30.A–B, pair of discs. Diam: 4.3 cm. Provenance unknown (here fig. 4).

[G. M. A. Richter, *Handbook of the Etruscan Collection* (New York, 1940), pp. 32–34]

**NOTES**

Abbreviation:

Marshall    F. H. Marshall, *Catalogue of the Jewellery, Greek, Etruscan, and Roman, in the Departments of Antiquities, British Museum* (Oxford, 1969).

1. This article was completed during my internship in the Department of Antiquities at the J. Paul Getty Museum in 1987–1988. I am grateful to my supervisor, Dr. Marion True, for her guidance and for permission to publish these pieces. I would also like to thank the other members of the department, Ken Hamma, Marit Jentoft-Nilsen, Karen Manchester, Dorothy Osaki, and Karol Wight, for their help and encouragement.

2. Scientists continue to investigate each of these processes, as the Etruscans' precise technique of manufacturing the granules and wire remains an issue of debate. Several theories have been proposed for the production of gold granules and wire in antiquity as well as for the process of attaching them to metal surfaces. Granules of several sizes may be produced by dropping a small amount of molten metal onto a flat surface from a distance of a few feet. To produce granules of a uniform size, small pieces of gold may be set between layers of ash in a crucible and then heated. For detailed explanations of these processes, see H. Hoffmann and P. F. Davidson, *Greek Gold: Jewelry from the Age of Alexander,* exh. cat., Museum of Fine Arts, Boston, and other institutions, November 1965–May 1966 (Mainz, 1966), p. 48, and D. L. Carroll, "A Classification for Granulation in Ancient Metalwork," *AJA* 78 (1974), p. 34.

To attach the granules to a metal surface, one of several methods may have been used. In a process called sintering, the granules would have been set in place with an organic glue or flux. The object would then have been heated only until the glue volatized and the surface "melting point" was attained. At this point, the surface of both the metal and the granule would have melted enough to join the two together (see Carroll, p. 36). Another joining method, called colloidal hard-soldering, was patented in 1933 by H. A. P. Littledale, an English craftsman. Knowing that copper lowers the melting point of gold, he set the gold granules in place with a glue containing copper salts. When the object was heated, the copper salt formed copper oxide, and the glue burned off, attaching the granules to the surface of the sheet with relatively little flux remaining (see Hoffmann and Davidson, pp. 45-46).

The production of wire in antiquity is a more controversial subject. Hoffmann and Davidson state that before the Hellenistic period, wire was made in one of two ways: by twisting a ribbon of gold foil or by hammering and rolling a strip of gold sheet until it was round (see fig. 2 in Hoffmann's article in this volume). They state that drawn wire—wire made by pulling strips of gold through a series of gradually smaller holes in a steel drawplate—does not appear until after the Hellenistic period (Hoffmann and Davidson, pp. 36–41). Carroll, however, claims that drawn wire was used in the Early Dynastic period in Egypt and was a legitimate method for producing wire in Greek and Roman times ("Drawn Wire and the Identification of Forgeries in Ancient Jewelry," *AJA* 74 [1970], p. 401. See also eadem, "Wire Drawing in Antiquity," *AJA* 76 [1972], pp. 321–323). For further information on ancient gold metallurgy, see J. Ogden, *Jewellery of the Ancient World* (New York, 1982), pp. 52–89.

3. The disc apparently continued as a fashionable piece of jewelry into the fourth century, for one appears on the figure of Ramtha Visnai on the lid of an Etruscan sarcophagus of about 370–360 B.C., now in the Museum of Fine Arts, Boston. See C. C. Vermeule, *Greek, Etruscan, and Roman Art: The Classical Collections of the Museum of Fine Arts, Boston* (Boston, 1963), p. 192, ill. p. 203; M. Sprenger and G. Bartoloni, *The Etruscans: Their History, Art, and Architecture,* trans. R. E. Wolf (New York, 1983), fig. 208.

4. Getty Museum 83.AM.2.1–3. For a list of similar works in other collections, please refer to the catalogue at the end of the text.

5. I would like to thank Dr. Herbert Hoffmann for his explanation of this assembly process during a technical examination of the discs at the Getty Museum in March 1988.

6. Louvre Bj 43–44. A. de Ridder, *Catalogue sommaire des bijoux antiques* (Paris, 1924), p. 5, pl. XIII. I would like to thank the Department of Greek, Etruscan, and Roman Antiquities of the Musée du Louvre for allowing me to include these pieces in this article.

7. The Metropolitan Museum of Art 13.225.309.A–B. I am grateful to Dr. Joan Mertens of the Department of Greek and Roman Art for allowing me to examine these pieces in April 1988 and for permission to include them here. For the disc in

the British Museum (GR 1980.2-1.42), see Marshall, pp. 137–138, no. 1416, pl. XX. I would also like to thank Dr. Dyfri Williams of the Department of Greek and Roman Art in the British Museum for his assistance and for permission to include this piece along with several others from the collection of the British Museum in this article.

8. At the time of this writing, the Department of Antiquities Conservation at the Getty Museum is investigating the nature of the incrustation on the backs of these discs.

9. British Museum GR 1872.6-4.743–744, Marshall no. 1424. See also Marshall, p. 137, no. 1424, pl. XX.

10. British Museum GR 1881.5-28.2. See also Marshall, pp. 138–139, no. 1419, pl. XXI.

11. Bernard van den Driessche states the problems involved in identifying the functions of these discs: "Le problème est de savoir s'il s'agit de boutons, de fibules rondes, de boucles d'oreilles, d'ornements de diadèmes, d'ornements de tempe ou d'une autre partie de la parure féminine. Certains de ces objets ont été trouvés par paire, d'autres non. De plus, aucune boucle d'oreille de cette forme ne semble jamais avoir été trouvée veritablement *in situ* près de la tête" ("Une Forme grecque de boucles d'oreilles portées par les korai de l'Acropole," *Revue des archéologues et historiens d'art de Louvain* 4 [1971], p. 82). Marshall (p. 137, fig. 5) mentions the possibility that these ornaments served as fibulae, but he states that the tube projecting from the back would not be sturdy enough to support clothing. Etienne Coche de la Ferté suggests that the discs were perhaps used as diadem ornaments (E. Coche de la Ferté, *Les Bijoux antiques* [Paris, 1984], p. 37). See also M. Cristofani and M. Martelli et al., *L'Or des étrusques,* trans. Ch. Guittard (Paris, 1985), p. 54.

12. For Tarquinian tomb-paintings illustrating a woman wearing a disc at the ear, see M. Moretti, *Pittura Etrusca in Tarquinia* (Milan, 1974), figs. 19, 26–28, 45. See also Marshall, p. 137. For architectural antefixes depicting figures with discs at the ear, see A. Andrén, *Architectural Terracottas from Etrusco-Italic Temples* (Leipzig, 1940), pp. 6–7, 21–22, 32–37, 499–500, and pls. 2, 6, 9, 11, 155.

13. Two discs in the British Museum bear a small loop on the back surface between the tube in the center and the edge; Marshall suggests (pp. 138–139, nos. 416, 419) that this secured a chain that held the pin used to secure the disc in place.

14. Numerous representations of ear caps exist in Cypriot sculpture, and they appear occasionally in East Greek painting, as well as on coins from this area. The caps appear to have been heavily decorated with jewellike attachments; it is uncertain whether they were made of cloth or metal. J. M. Hemelrijk, "Some Ear Ornaments in Archaic Cypriot and East Greek Art," *BABesch* 38 (1963), pp. 34–37, figs. 22–25, and 44. For more on ear caps in Cypriot sculpture, see E. Gjerstad et al., *The Swedish Cyprus Expedition: 1927–1931,* vol. 3 (Stockholm, 1937), esp. pls. XLIX.2, LIII.3, LXXIV.

15. Van den Driessche (above, note 11), p. 73, and Cristofani and Martelli (above, note 11), p. 54.

16. C. Aldred, *Jewels of the Pharaohs* (New York, 1974), p. 143. A beautiful example of an ear stud decorated with filigree and granulation is in the collection of the Royal Scottish Museum, Edinburgh: J. Anderson Black, *The Story of Jewelry* (New York, 1974), p. 26.

17. For a discussion of the connections between Egypt and the Near East, see B. Segall, "Some Sources of Early Greek Jewelry," *BMFA* 41 (1943), p. 43.

18. S. Karouzou, *National Museum: Illustrated Guide to the Museum* (Athens, 1984), p. 123, no. 4382. The circles on the figure's ears appear to represent discs, yet they could illustrate pendant earrings, for it is uncertain whether the line beneath the right ear represents hair or part of an attached pendant. The area beneath the lobe on the left ear is not preserved.

19. Of the kore figures recovered from the Athenian akropolis, ten wear discs at the ear (Athens, Akropolis Museum nos. 616, 648, 660, 661, 670, 672, 674, 675, 680, 682); five have pierced earlobes for metal attachments (Athens, Akropolis Museum nos. 669, 671, 678, 679, 681); ten have no preserved ear features (Athens, Akropolis Museum nos. 136, 465, 475, 510, 594, 598, 613, 615, 643 + 307, 696 + 493 and other fragments associated with this piece); two have no indication of an ornament at the ear (Athens, Akropolis Museum no. 683, and Athens, National Museum inv. 6491); and one wears a spiral ear ornament (Athens, Akropolis Museum no. 673). For more information on these works, see G. M. A. Richter, *Korai: Archaic Greek Maidens* (New York, 1968), pp. 68–84, figs. 328–438.

20. "La répartition, qui touche Cerveteri et Vulci, ainsi que l'Etrurie intérieure, de Bomarzo à Orvieto, jusqu'à Cétona et, peut-être, la Grande-Grèce, indiquerait des ateliers d'Etrurie méridionale" (Cristofani and Martelli [above, note 11] p. 54). "The chief workshops must have been situated in the commercial cities which were generally near the sea; they not only acquired economic and political importance but also became genuine culture centers. As far as jewellery is concerned Vetulonia in northern Etruria and Caere (Cerveteri) in the south were probably the chief centers of manufacture" (F. Coarelli, *Greek and Roman Jewellery,* trans. D. Strong [Milan, 1966], pp. 26–27). See also the catalogue at the end of the text for the discs and some of their provenances.

21. "But the overwhelming majority of the excavated tombs and their contents belong to the seventh and sixth centuries B.C. During this period, Caere must have been an exceptionally rich and populous city, perhaps one of the most splendid in the world then known" (M. Pallotino, *The Etruscans,* trans. J. Cremona, rev. and enl. edn. [Bloomington, 1975], p. 111).

22. "Caere owed its wealth and its commercial and artistic development to its ownership of this ore-rich area, for then as well as now metals were what made people rich and were also the most widespread article of barter" (L. Banti, *Etruscan Cities and Their Culture,* trans. E. Bizzarri [Los Angeles, 1973], p. 39).

23. The most manifest sign of this Caeretan dominance in Latium is the extreme similarity between the jewellery and *bucchero* pottery in the wealthy seventh-century tombs of Caere and objects of the same date in graves at Praeneste (Palestrina) in Latium. Indeed, the two sets of finds are indistinguishable. It is true that this can be partly explained by the exposure of the two cities to the same influences, emanating, in both cases, from Pithecusae and Cumae in Greek Campania (where many of these luxury goods were made for export to Etruria and Latium). But the similarities are too striking for this explanation to be altogether sufficient. Caere and Caeretan immigrants to Praeneste must, presumably, have acted as guides and intermediaries.

(M. Grant, *The Etruscans* [New York, 1980], p. 157)

24. Grant (above, note 23), pp. 147, 155.

25. Banti (above, note 22), p. 41.

26. M. F. Briguet, "Petite tête féminine étrusque," *RLouvre* 24 (1974), p. 250.

27. M. Pallottino et al., *Il Museo Nazionale Etrusco di Villa Giulia* (Rome, 1988), pp. 338–339.

28. Françoise Gaultier, Conservateur in the Department of Greek, Etruscan, and Roman Antiquities of the Musée du Louvre, kindly provided this information about the discs in the Louvre in a letter of August 11, 1988.

# Images of Piety and Hope: Select Terracotta Votives from West-Central Italy

STEPHEN SMITHERS

In antiquity, the cult of a mother goddess and divine nurse (or *kourotrophos*) was prevalent throughout the Mediterranean, from Asia Minor to Sicily and from southern Russia to North Africa. The *kourotrophos* directly intervened in the affairs of men, her domain embracing all aspects of life and death. From early in the Archaic period, images of *kourotrophoi* frequently appeared in the art of central and Southern Italy.[1] These depictions commonly took the form of a seated female holding a swaddled child.[2] Diana, Mater Matuta, Minerva, Persephone, Turan, and Uni are some of the goddesses worshipped as *kourotrophoi* in Italy.

Terracotta votive statues, statuettes, heads, busts, infants, and anatomical parts were common dedications to a *kourotrophos* at her sanctuaries in Etruria, Latium, and Campania. Examples are scattered worldwide in museums and private collections.[3] Recent exhibitions, books, and articles have attempted to bring order to the vast corpus of Italic material. In 1985 Italy celebrated the "Year of the Etruscans" with a series of exhibitions and catalogues dealing with Etruscan art and civilization. A 1988 exhibition mounted by the Staatliche Museen in Berlin included a well-illustrated catalogue of Etruscan material previously unknown to many Western scholars. Annamaria Comella has charted the diffusion of votive statues, heads, statuettes, small bronzes, and body parts, and Maria Fenelli has studied the quantity and distribution of various anatomical votives at different sanctuary sites. Both of these studies have contributed greatly to our understanding of the diffusion of *kourotrophic* votives and the detection of possible medical specialization at certain centers. Helen Nagy has published the extensive collection of Caeretan votive terracottas in the Lowie Museum of Anthropology in Berkeley. A recent study of votive couples by Britt Marie Fridh-Haneson has offered a new interpretation of the function of these dedications within the *kourotrophic* sanctuaries of Etruria and Latium.[4] Her work suggests that the accepted function of other votive types common to these sanctuaries should be examined.

This study will discuss the problems and history associated with Italian votive practice and then concentrate on a group of ten votive heads, a bust, and a *bambino* in the Getty Museum collections. An Etruscan truncated figure with an opened abdominal cavity will be used to illustrate the healing nature of the sanctuaries in which these votive terracottas are found. All these votives were acquired by the Museum between 1971 and 1980, and all lack provenance, but they will be compared to examples in European and American collections from known contexts. This will allow the Getty material to be dated and identified with particular mold series having known provenances. The votive heads will be discussed first and will be divided into two broad categories: Etruscan and Campanian. The arrangement of the votive heads within these two regional classifications will be chronological rather than by prospective coroplastic center. The votive bust and *bambino* will be handled separately. Artistic trends prevalent in the Mediterranean area preceding and contemporary with the appearance of the votives will be considered to aid the understanding of their development in the art of central Italy and to assist the dating of the pieces. Cult practices and religious beliefs in the cultures trading with west-central Italy also will be examined to provide a key to the interpretation of these Italian dedications.

Terracotta votives are mold made and mass produced. Consequently, methods of manufacture must be considered. Normally a patrix was made in clay and baked. Then clay molds were taken, fired, and used to produce terracottas for the central Italian market. Molds derived from the patrix and the resulting offerings created from them are considered "first-

generation" votives. These first-generation molds and votives are usually produced by the original workshop or the same person who created the patrix and are in the clay body used by that workshop. Second and successive generations of the same mold series are the result of molds produced from a patrix other than the original one. Usually the source is an existing mold-made piece in which the paint and slip have been cleaned off to allow the manufacture of another mold. Each successive generation after the patrix has a progressive loss of size due to clay shrinkage. The generations together form a series, and all but the first generation could be derived from any workshop or clay fabric. Trade in terracotta votives along later Roman roads also extend the distance a series might travel from the coroplastic center that produced the original patrix. On occasion, a series that begins at an Etruscan center will even be adopted by a Latian or Campanian workshop and vice versa. This makes it difficult to identify the original site that produced the patrix and stresses the importance of identifying the first generation.[5]

Problems become evident when one begins to examine mold-made material. Certain details often are not indicated on the patrix or appear as blanks. These details include hair treatment, eyebrows, eye outlines, exact outer edges of the lips, and details of the ears. They are often incised into the mold after it is produced from the patrix, and the major surfaces of the mold are probably burnished prior to its firing. Since many molds can be made from the same patrix, these molds may vary in some of their details, resulting in parallel molds. Details in the molds weaken with use, and sometimes additional cutting (to rectify this problem) can create parallel molds in later generations of the series. Sometimes the extensive reworking of a later-generation mold obscures the qualities of the original series and results in a scholar assigning it to its own mold series or another group. Other details and attachments such as jewelry can be added to the pieces after their removal from the mold but prior to firing, thus creating individualized characteristics. On occasion, a mold used for a head series can cross typological boundaries and be used for standing or seated figures or even *bambini.* Consequently, there is no way of knowing the length of time over which a mold series extends or the number of generations the series might contain. Only when the votives are found in a context with other, more securely datable material can they be dated with any confidence.[6]

Molds from the major Italian centers often trav-

eled from one site to the next until circa 500 B.C., after which most centers had their own coroplastic artists.[7] The continued travel of votives from site to site complicates the identification of the original provenance of these pieces and places a heavy reliance on the study of the clay fabric for assigning them to a provenance. The atmosphere of the kiln affects the color of the clay body. Thus, an infinite number of gradations in shade are possible. Despite these variations in the color of the clay fabric, the degree of fineness, amount of mica, and presence of other inclusions (i.e., shells, pebbles, white particles) remain more or less constant at a given center and can be distinguished by the study of a large number of terracottas from a known find spot. Details of manufacture (i.e., the presence or absence of a finer clay surface, the form and position of the vent, the relative weight, or art marks) can also distinguish the products of a particular center.[8] Such details need to be considered in studies and publications of this votive material, but only future clay analyses of terracottas from known sites will provide any positive placement for pieces lacking provenance.[9]

Terracotta male and female votive heads appear toward the end of the sixth century B.C. and comprise the largest category of central Italian offerings now in American collections. Votive busts are less common and generally date after the beginning of the fourth century. Terracotta infants, or *bambini in fasce,* appear during the last quarter of the fourth century. Anatomical votives representing body parts are introduced to the sanctuaries of the *kourotrophos* at the same time as the *bambini.* Occasionally votive deposits will include naturalistically rendered standing male and female nudes, complex representations of the internal organs of the human body, and truncated figures in which the abdominal cavity has been opened to reveal the internal organs (fig. 1). These last examples suggest the practice of medicine within the *kourotrophic* sanctuaries and concerns for the transmission of medical knowledge from one generation of priest-physicians to the next.

Drastic political changes occurred in Italy and the Mediterranean during the Late Classical and Hellenistic periods. Defeats at Himera and Cumae during the fifth century weakened the Etruscans and led to a flourishing of the cities of Magna Graecia. Taras became a prominent power in Southern Italy during the second half of the fifth century, and Magna Graecia effectively formed a barrier between Etruria and mainland Greece. The central Italian political situation became one of continual war with the Greeks. This, combined with the emancipation of Italic peo-

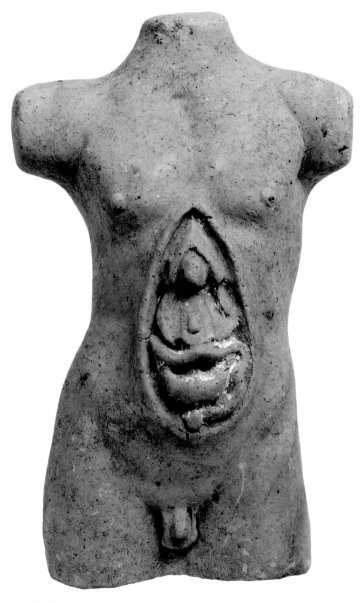

FIGURE I

Etruscan truncated figure with opened abdominal cavity. Height: 20.8 cm. Malibu, J. Paul Getty Museum 73.AD.83.

ples, Roman aggression, and the Gaulic invasion, had a negative impact on overseas trade with Etruscan centers.[10]

Rome began its rise to prominence after the conquest of Veii in 393/392 B.C. and became the master of southern Etruria and Latium by the second half of the fourth century. Rome defeated the Latian towns of central Italy, including Ariccia and her allies, in 338 B.C. and then extended citizenship to the conquered peoples. Latin colonies were established at Fregellae in 328, Lucera in 314, Alba Fucens in 303, and Carsoli in 291 B.C. In 310 B.C. Rome's army successfully moved into central and northern Etruria.[11] The central Etruscan towns succumbed to Rome in the first half of the third century, and Rome became the cultural leader of central Italy.[12] The construction of roads similar to the Via Appia in 312 B.C. accompanied the extension of Roman influence and institutions. This developing network of roads facilitated the spread of new ideas and practices to and from Rome.[13]

The adoption of anatomical votives from Greek religious practice and an increase in the production of

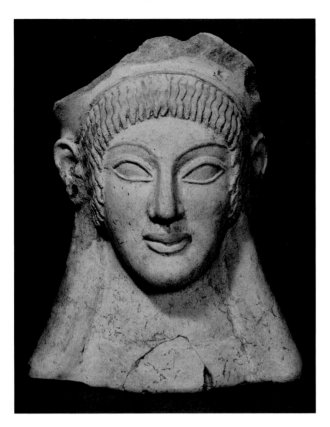

FIGURE 2

Late Archaic Etruscan female head. Height: 26.5 cm. The Art Institute of Chicago C41100. Photo courtesy The Art Institute of Chicago.

terracotta heads at west-central Italic sanctuaries coincided with the rise of Rome during this unstable period. Trade relations between central Italy and Corinth probably influenced the appearance of anatomical votives within the *kourotrophic* sanctuaries of Etruria, Latium, and Campania during the fourth century.[14] Since terracotta heads of this time are found with anatomical votives, it is generally believed that they, too, commemorate successful cures. However, Etruscan votive heads rarely exhibit physical abnormalities. Instead, they portray contemporary Italic ideals of male and female beauty tempered by religious decorum and Greek artistic trends. Age, illness, and deformity are rarely represented, despite the popularity of such subjects in other areas of the Late Classical/Hellenistic *koine*.[15]

It is commonly accepted that Greek prototypes influenced the art of Etruria, Latium, and Campania. For that reason, the terracotta sculpture of these areas is often stylistically dated by comparison to Greek works when associated material with a secure chronology (such as coins, vases, and terracotta lamps) is

lacking. Late Archaic heads depend directly upon models from Attica and are represented by examples in the Art Institute of Chicago (fig. 2) and the Museum of Art and Archaeology at the University of Missouri-Columbia (inv. 78.27). Attic influences on Classical Etruscan style are received indirectly through contacts with Southern Italy and Sicily. These second-hand influences then blend with elements retained from the Late Archaic. By the end of the fifth century B.C. votive heads found at Veii and other sites show a distinct influence from the Greek Severe Style.[16] Late Classical and Hellenistic Italic heads continue styles adopted from Greece during the fifth century and are influenced by Late Classical and Hellenistic Greek models received through continued contacts with Magna Graecia and Sicily. Many of the heads from these later periods belong to large series or related series represented by more than one example in this country.

A blending of Late Archaic stylistic elements with those of the Classical period is evident in a bearded Etruscan votive head in the Getty Museum (fig. 3). The head is veiled. The left side of the neck and the veil below the level of the beard are missing. The Archaic hairstyle is rendered in two rows of locks terminating in tight curls turning inward and outward from the center of the head. The mustache and beard are handled in a similar fashion. The delineation of the brow and nose are somewhat softened. The eyes are framed by lids handled in relief, and the lips are parted; the ears are not indicated. The clay body is pink-orange and contains mica and stone inclusions. A beige-pink slip covers the entire head. Traces of a white preparatory coat are preserved in the flesh areas. Remnants of a rose flesh color appear on the forehead above the bridge of the nose, on the right nostril, and above the outside corner of the left eye below the curling bangs.

An unpublished bearded head from the same mold series and generation is part of the Chigi collection in the Museo Archeologico in Siena (inv. 37846). This head, along with others in the same collection, is attributed to the ancient Etruscan city of Caere.[17] A similar handling of the beard and lips appears on a silenus-head antefix fragment from the temple at Sassi Caduti, near Falerii, dated circa 480 B.C. Other related silenus-head antefixes have been found on the Piano di Città, Tarquinia, and at Orvieto. A later and more human version of this bearded silenus type in which the tight curl of the beard is relaxed is found in the antefixes from Caere's port, Pyrgi. Antonia Rallo has

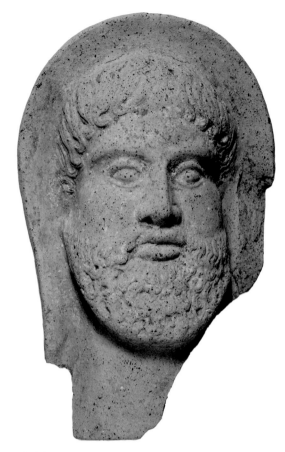

Bearded Etruscan male head. Height: 27.9 cm. Malibu, J. Paul Getty Museum 75.AD.99.

dated these antefixes to the second quarter and the middle of the fourth century. This latter date coincides with Adriano La Regina's placement of a votive head series from Lavinium that utilizes a similar style of beard. All of these examples recall the beard treatment of the Greek bronze "Artemision Zeus" (Athens, National Museum 15161) dated circa 460–450 B.C. A stylistic comparison of the hair and facial details of the Getty head with this bronze supports a date within the second half of the fifth century for both the Getty and the Chigi terracottas.[18]

A slightly later Etruscan female votive head from the Classical period (fig. 4) may come from Veii. The head is broken at the base of the neck and may have been part of a bust or complete statue. The tip of the nose is also broken. Like a Veian votive in Cleveland (Cleveland Museum of Art 21.414), the hair is divided at the center of the head and falls in undulating locks. These locks expand in number from four at the top to eight over the temples. The hair is swept

back over the ears and cropped at mid-ear length behind.[19] Above the waves is a cylindrical *polos* or hat that opens in the center to reveal a pattern of crossing hair locks scratched lightly into the clay.[20] The clay body is red-orange and includes pieces of mica of varying sizes. No pigment or slip is preserved on the surface of the piece.

The Getty terracotta is comparable to Vagnetti's Veian mold series Axxii in both height and handling. This series is known in five variants found in the Campetti area at Veii. One example of this series was uncovered in the excavations of the Portonaccio, and another example from southern Etruria is in the Archaeological Museum at Grosseto. Vagnetti's variant "a" (fig. 5) wears a stephane that encircles the head in a way similar to the *polos* worn by the Getty votive. Variants "b" through "e" replace the stephane with a diadem that terminates just behind the ears. Each of these variants shows a different handling of the hair locks incised into the crown of the head.[21]

The face of the Getty head is oblong, but with broad contours. The eyes are large and the pupil and iris of each is indicated by incision.[22] The lids are rendered in relief, and the upper lid clearly overlaps the lower at the outer corner of the eye. The mouth is small and full. Unlike the examples published by Vagnetti, the ears of the Getty votive are crudely modeled and set far too low on the sides of the head. The disk earrings clearly indicated in Vagnetti's variant "a" are lost in lumps of clay, suggesting the earlobes of the Getty piece. This error in handling implies that the ears were added by a less talented coroplast and may indicate that the Getty head was produced at another Etruscan center from an imported Veian mold.[23]

The shape of the face and the handling of the hair recall a marble kore (Athens, Akropolis Museum 688) and a cinerary statue from Chianciano in the Museo Archeologico in Florence. Richter dates the kore to circa 480 B.C. A mid-fifth-century date for the cinerary statue is supported by an oinochoe in the shape of a female head and a gold pin (both dated to the second quarter of the fifth century) found inside the statue.[24] A comparison of the recessed eye cavities and the well-rendered overlap of the eyelids in the Getty piece with these same details in the kore and the cinerary statue indicate a dating well into the second half of the fifth century for the Getty terracotta. This dating is further confirmed by a comparison of the terracotta head with that of a stone cinerary statue found near a lake in the vicinity of Chiusi. The same high cropping of the hair is seen in this cinerary statue

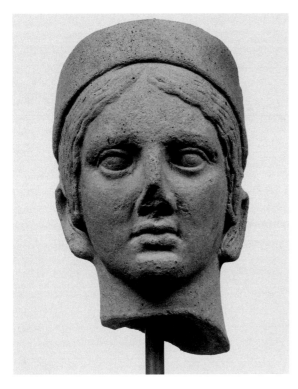

FIGURE 4

Etruscan female head with *polos*. Height: 25.7 cm. Malibu, J. Paul Getty Museum 80.AD.142.

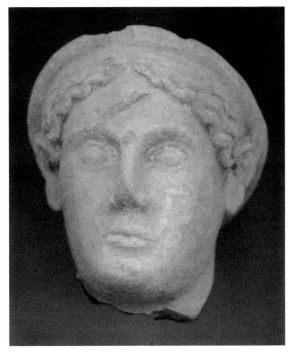

FIGURE 5

Etruscan female head from Veii, Vagnetti's series Axxii variant "a." Height: 21.0 cm. Photo courtesy Soprintendenza alle Antichità dell'Etruria Meridionale.

dated 430–400 B.C. by Mauro Cristofani.[25]

Increased Etruscan contacts with Magna Graecia brought artistic influences from Taras northward. Roman control and southern trade with Naples in the fourth century strengthened these contacts. An Etruscan female votive head (fig. 6) illustrates this contact.[26] The hair is divided at the center of the head and falls in tight, wavy locks that cover the ears. These locks increase from two at the part to five over the temples. A high headdress or hairstyle held in place by a netted band flares outward between the head and the veil. This headdress also has a distinct vertical part at the center and is ornamented by applied spheres of clay arranged in a dense and random pattern. The facial features are softly modeled and recall those of a mid-fourth-century Attic head in the collection of the St. Louis Art Museum (inv. 57.1941). The lips are tightly closed. The thin, bow-shaped upper lip projects slightly forward from the horizontally cut lower lip. The eyes are large and framed by lids rendered in relief. The brow is gently rounded. Clay spheres have been applied to the neck to form a necklace. A clay band projecting outward from the veil and framing the lower edge of the neck forms a supporting base for the votive. The clay body is pink-beige and includes particles of mica and stone of varying sizes. The entire head is covered by a beige slip.

The Getty terracotta closely resembles a votive head found at Anagni published by Annamaria Comella and Matilde Mazzolani. They share the same type of headdress, veil contour, and rendering of the facial planes. Differences occur only in the hairstyle and the applied ornamentation of the diadem and necklace. These minor changes probably represent an attempt by the coroplast to individualize the heads after removal from the mold. Another votive head in the Vatican (Museo Gregoriano Etrusco 13806) shares the same type of headdress, veil contour, and approximate height. This terracotta is attributed to Caere and includes omphalos-style earrings with an arched section below from which three chain pendants are suspended. Similar headdresses appear on four heads from Caere (Lowie Museum of Anthropology 8-2822, 8-2823 [fig. 7], 8-2824, and 8-2839), six head fragments from Lavinium, and female-head antefixes from Chiusi and Colle di Monteluce northeast of Perugia.[27] The greater size of the terracotta from Anagni (34.0 cm high) suggests that the mold series may have originated at this Hernican (later Latian) site and then spread to other localities. The common clay body, size,

and veil contour that the Getty head (fig. 6) shares with the Lowie examples (fig. 7) indicate that the former, too, was probably produced at Etruscan Caere.

The high and swelling headdresses worn by some central Italian female votive heads may reflect the increased contacts with Magna Graecia that begin in the second half of the fifth century. An Attic red-figure kalpis (Florence, Museo Archeologico 81948), attributed to the Meidias Painter (circa 410 B.C.) and found at Populonia, includes a female figure wearing a high hairstyle supported by a netted band similar to that seen in the Getty votive head. The famous relief from Eleusis (circa 440–430 B.C.) depicting Demeter, Triptolemos, and Kore shows Demeter with a tight, wavy hairstyle similar to that seen on the Getty votive. Hafner has dated the votive head in the Vatican to circa 400 B.C. based on comparisons with Southern Italian heads and Marshall's assignment of the earring type to circa 420 B.C. Comella and La Regina have followed Hafner's lead and have assigned the head from Anagni and the fragments from Lavinium to the first decades of the fourth century. Nagy has followed suit and assigned the Caeretan examples in the Lowie collection to the late fifth or early fourth century. The Praxitelean handling of the brow in the Getty example suggests a date more toward the end of the fourth century. A comparison of the handling of the hair, headdress, and facial details seen in the Getty head with those of the female figure in the Banquet of Larth Velcha fresco from the Tomb of the Shields, Tarquinia (circa 280 B.C.), supports this later placement and indicates that the piece could date as late as the first quarter of the third century. Mazzolani's assignment of the Anagni head to the end of the fourth or the third century B.C. supports this placement.[28] The close stylistic correspondence between the Getty votive and the terracotta from Anagni indicates that both should be similarly dated. The similarities already noted between these two heads and the Vatican terracotta imply the same dating for this piece.

Two Etruscan female heads (figs. 8, 9) are related to the previous head by similarities in clay body and the handling of facial details. One is well preserved and intact except for chips in the nose and veil, the other is less clear in its details and broken below the chin. Both heads are from the same mold generation and have relatively the same width and depth. Traces of white are preserved on both cheeks, the right eye, and along the hairline of the right side of the damaged head. The hair of both is divided at the center of the head, and seven locks on either side curl back over a fillet that encircles each head. The facial planes are softly modeled, and the facial type is broader than that seen in the female head, figure 6. The eyes are large and framed by eyelids rendered in relief. The left eye of the intact terracotta is smaller than the right, and both eyes have the iris represented in relief and the pupil indicated by a slight depression. The left eye of the damaged example droops downward at the outside corner and the eyes are left blank. The nose in both is straight and in proportion to the rest of the face. The lips are modeled similarly to those of figure 6, but are parted. The ears are summarily handled and placed a bit low. A clay band at the lower edge of the neck forms a supporting base for the intact votive. The clay body is pink-beige with mica and stone inclusions similar to figure 6. The surfaces of both heads are covered with a beige slip.

An unpublished example of this mold series (Siena, Museo Archeologico 37834) was uncovered in the deposits of the temple of Uni at Caere. The inclusions in the clay body and slip are consistent with those in the two Getty heads. The greater sharpness of the brow and other details of the Siena head suggest that it was produced earlier in the mold generation than the two terracottas in the Getty Museum (figs. 8, 9).[29]

The hairstyle worn by the heads of this mold series experienced a long popularity in Graeco-Roman art and can be seen in the "Apollo Mantua" (Naples, Museo Archeologico Nazionale 831) and the Eirene from a marble group including the child Ploutos (Munich, Staatliche Antikensammlungen und Glyptothek), both Roman copies of Classical Greek originals. Female-head antefixes with the same hairstyle have been found at Pyrgi in the excavations of Temple A and have been dated by Riis to circa 450–400 B.C. Antonia Rollo dates these same antefixes 375–350 B.C. Similar antefixes also have been found at Capua and Teano. Six Capuan female votive heads wearing *poloi* and the same hairstyle (Capua, Museo Campano 2187, 2344, 2346, 2348, 2353, and 2355) have been studied by Bonghi Jovino and dated from 450 B.C. to 200 B.C. A veiled female-head antefix from Taras also has the same hairstyle and has been stylistically dated by Helga Herdejürgen to the second quarter of the fourth century.[30]

The handling of the eyes, brow, and mouth with slightly parted lips coincides with that seen in a veiled male head attributed to the votive deposit of the Temple of Minerva Medica in Rome (Antiquarium Comunale 2581). This male example is the same height as the female head in figure 9 and has been stylistically

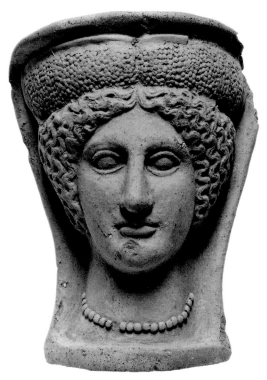

FIGURE 6

Etruscan female head with high headdress and veil.
Height: 26.5 cm. Malibu, J. Paul Getty Museum
75.AD.98.

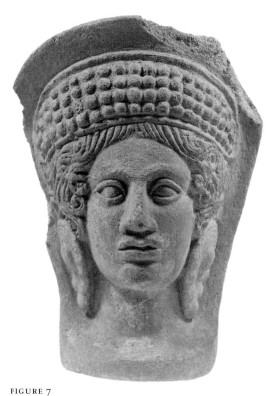

FIGURE 7

Etruscan female head with high headdress and veil
from Caere. Height: 29.3 cm. Berkeley, University of
California, Robert H. Lowie Museum of Anthropology
8-2823. Photo courtesy Robert H. Lowie Museum of
Anthropology.

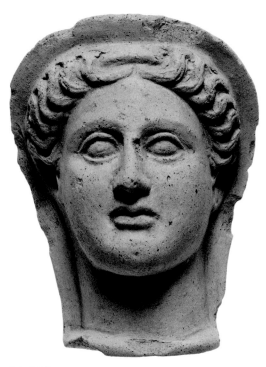

FIGURE 8

Etruscan female head. Height: 24.5 cm. Malibu, J. Paul
Getty Museum 75.AD.100.

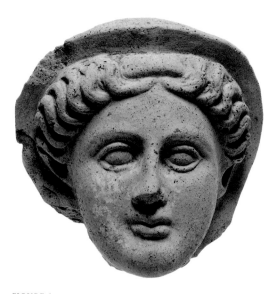

FIGURE 9

Etruscan female head. Height: 19.0 cm. Malibu, J. Paul
Getty Museum 75.AD.101.

dated to the second half of the fourth century by Laura Gatti Lo Guzzo. Keeping in mind Rallo's placement of the antefixes from Pyrgi, Herdejürgen's assignment of the antefix from Taras, and the stylistic handling shared with the male head from Rome, the two votive heads in the Getty Museum and the example in Siena should be dated 350–300 B.C. Comparisons with a female head represented on a Syracusan coin dated 317–310 B.C. and a bronze statuette in the Museo Archeologico in Verona (inv. A4 390) dated 350–325 B.C. show a similar handling of the hair and facial details supporting this placement.[31]

An Etruscan male head in the Getty Museum (fig. 10) is part of a mold series represented by two similar examples in the Kelsey Museum and one in the Los Angeles County Museum (Kelsey Museum of Archaeology 1762 and 1763 [fig. 11] and Los Angeles County Museum of Art M.82.77.24). This series is related to a Veian mold series represented by examples in the Snite Museum of Art at The University of Notre Dame (inv. 62.10), the Kelsey Museum (inv. 1761, 1764, and 1766), and the University Museum at the University of Pennsylvania (inv. MS 5749). The ovoid head is rounded at the chin. The brow and the planes of the nose are softened. The eyes are enlarged and the iris is indicated in relief on the Kelsey head (fig. 11) and on the Getty head (fig. 10). The lips are full with the upper lip bow-shaped. Crescent-shaped bangs project over the forehead and curl left and right from a central part. Horizontally curling locks fill the area between the bangs and the veil. Three locks cover the temples and the ears on either side of the head. The upper lock curls upward and the two lower locks curl downward. The neck merges with the veil, which curves forward to a relief band at the base. The clay body is orange-red and includes particles of mica and stone. The back is rough and pitted. A slip of the same clay covers the entire head and retains brushmarks from its application. Traces of red pigment are evident on the right side of the jaw.

The Kelsey and Getty heads (figs. 10, 11) are from the same mold generation, but the blurring of details found in the Kelsey example is the result of a worn mold. The Kelsey votive has been reinforced with additional clay, and it originally formed part of a bust or statue. The small size (12.0 cm high) and blurred details of Los Angeles County Museum M.82.77.24 mark it as a late example, far removed from the generation producing the other three pieces.[32]

Kelsey 1762 and 1763 (fig. 11) are attributed to Veii. A fragmentary head without a veil found at Veii

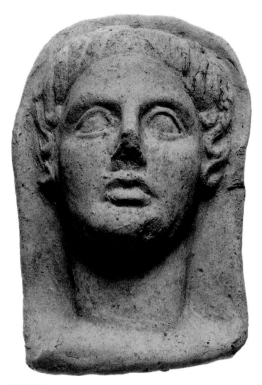

FIGURE 10

Etruscan male head. Height: 24.5 cm. Malibu, J. Paul Getty Museum 75.AD.102.

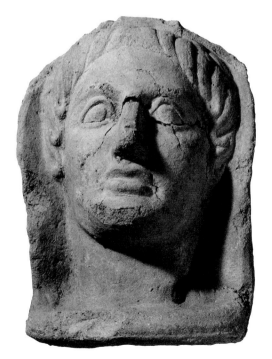

FIGURE 11

Etruscan male head from Veii. Height: 24.7 cm. Ann Arbor, The University of Michigan, Kelsey Museum of Ancient and Mediaeval Archaeology 1763. Photo courtesy Kelsey Museum of Ancient and Mediaeval Archaeology.

and published by Vagnetti supports this attribution. A full-length terracotta statue of unknown provenance in the Museo Civico in Bologna is also part of this same series. An early example of this head type found at Falerii (Rome, Villa Giulia 7322), but not from the same mold series, has been assigned to a Veian workshop by Riis. Related examples with similar curling locks covering the temples and ears have been uncovered at Lavinium and Rome. The male figure from a limestone cinerary urn lid found at Chianciano (Florence, Museo Archeologico 94352) follows the same head type seen in the terracotta votive head series. Bronze statuettes with the same facial characteristics and hairstyle have been found at Falerii (London, British Museum 681) and Falterona (Paris, Louvre 291). A bronze statuette in the Metropolitan Museum in New York shares these same features but lacks a provenance. A bronze oinochoe from Gabii (Paris, Louvre 2955) also takes this head type, as does a bronze head from Bolsena (London, British Museum 1692). A bronze urn lid figure from Perugia (St. Petersburg, Hermitage B 485) is related to this head category.[33]

The head type first appears in Etruria with the influx of Polykleitan models from Southern Italy during the second half of the fifth century. The bronze oinochoe from Gabii dates from this introduction. The terracotta head from Falerii, the urn lid from Chianciano, and the bronze examples previously cited continue the type through the fourth century. Hafner assigns the examples of the mold series in Bologna and Copenhagen to the third century. La Regina also dates the related examples from Lavinium to this same period. Vagnetti proposes a date into the second century for the fragmentary head from Veii. A comparison with the similar handling of the hair and facial details seen on coins depicting King Hieronymus minted at Syracuse 216–215 B.C. suggests that Vagnetti's dating may be a bit late and that the Getty and Kelsey examples should be dated to the second half of the third century. Late examples of greatly reduced size (10.6 cm), such as Los Angeles County Museum of Art M.82.77.24, probably did continue into the next century.[34]

An Etruscan mold series from Caere is represented by an example in the Getty Museum (fig. 12). The head is fragmentary and preserved down to the level of the chin. It is not veiled, and the seam formed by the joining of the front and back molds is visible above the ears. The face is a fleshy ovoid shape. The edges of the brow, deep-set eyes, and nose have been softened. The mouth is small and full. The lips are closed and the contour of the upper is bow-shaped. The upper edge of the large and summarily modeled ears merges with the hair mass. Thick curling relief locks cascade over the forehead and continue down to the ears. These locks proceed left and right from a slightly off-center part, creating a horizontal movement across the forehead. The hair behind the frontal locks framing the face is lightly sketched directly into the clay forming the back of the head. The clay body is brown-beige and contains small mica and stone inclusions consistent with other examples from Caere.[35]

The pigment covering this youthful male head is excellently preserved. Black pigment was used for the hair and red for the facial areas. Short strokes of black pigment extend ahead of a missing fragment on the right side and over the upper portion of the forehead, continuing the relief curl of the hair. A thinly applied layer of black overlaps the red pigment of the brow to indicate eyebrows. A darker red indicates heavy bags beneath the eyes and accents the edge of each nostril. A band of red also cuts across the lower edge of the strands of hair incised into the back of the head. Approximately twenty-five thinly applied black spots are randomly spread over the right cheek. The delineation of these spots and the bags below the eyes provide a rare example indicating illness.[36]

Examples related to this series have been discovered at both Caere (fig. 13) and Punta della Vipera (Civitavecchia, Museo Archeologico Nazionale). Jiří Frel wrongly assigns the Getty head (fig. 12) to the third quarter of the first century. Simonetta Stopponi dates the head from Punta della Vipera to the beginning of the third century, and Maria Donatella Gentili implies a second-century date for the head from Caere. This last placement agrees with Comella's assignment of a stylistically similar head from Tarquinia (Museo Archeologico Nazionale 4682). All of these heads share a similar handling of the hair, eyes, brow, and nose and should be dated to the first half of the second century.[37]

A Campanian mold series is represented by a well-preserved head in the Getty Museum (fig. 14). An identical votive head from the same mold generation is preserved in the Museo Campano in Capua (fig. 15).[38] The face is softly modeled following Lysippean models. The brow, planes of the nose, and the lips have been gently rounded. The eyes are small, and a slight depression beneath suggests the ridge of the cheekbone and the upward curve of the lower lid. The ears are summarily indicated within the undulating

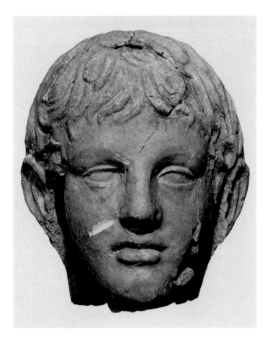

FIGURE 12

Etruscan male head. Height: 20.0 cm. Malibu, J. Paul Getty Museum 75.AD.103.

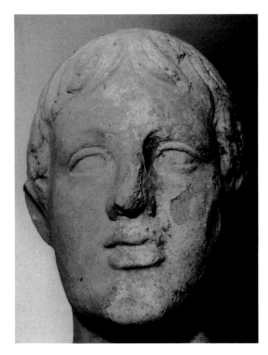

FIGURE 13

Etruscan male head from Caere. Height: 30.6 cm. Cerveteri, Museo Nazionale Cerite 93540. Photo: Author.

waves of hair framing the face down to the level of the chin. Individual locks within this asymmetrical hair mass are rendered by incision. Disk earrings are suggested below the ears. The neck flares outward to form a base, and the veil covering the back of the head follows the contour of both the hair and the neck. The clay body is orange-pink and contains a large quantity of small mica particles. The surface of the terracotta is abraded, but traces of a beige slip are preserved on the left side of the face.

The identical head in Capua is reported to be of local clay as are three other examples found at the same site. A comparison of this series with the head of a statue in the same museum (inv. 2311) indicates the probable source for the mold series. Bonghi Jovino attributes this statue fragment to Cales and assigns it to the first quarter of the third century. The softening of the delineations of the brow, nose, and lips and the freer handling of the hair mass seen in the votive head series indicate that these pieces date slightly later, but probably within this same century. A stylistic comparison with a bronze statuette in the Museo Archeologico in Florence (inv. 554) dated 300–250 B.C. supports this placement. Similar terracotta examples with varying hairstyles have been noted at Cales, Bomarzo, Lavinium, Veii, Tarquinia, Rome, and Caere.[39]

Stylistically related to this Capuan series are two female votive heads in the Kelsey and Getty museums (figs. 16, 17). These terracottas depict a fleshier facial type than that seen in any of the preceding series. A larger example from an earlier generation of this mold series, with a slightly different hairstyle, was excavated at Antera-Casmari, Veroli.[40] The general shape of the face resembles that of the previous Capuan votive heads and of Museo Campano 2311, attributed to Cales. Like the Calean terracotta, the brow and the planes of the nose are strongly delineated. The details of the eyes in both the Getty and the Kelsey examples are blurred due to mold wear. The left eye angles downward at the outside corner and the lips are parted. The hair frames the face in a series of incised, lobed waves that cover the upper portion of the summarily modeled ears; loose strands of hair appear from behind the ears to frame the neck. A fillet with a central knob or jewel encircles the head behind the waves and ahead of the veil. The jaw is fleshy. Fleshy folds in the modeling of the neck suggest the sedentary life led by these women. Similar folds of flesh appear in Hellenistic representations of Aphrodite, following the model of Praxiteles' Aphrodite of Knidos.[41] The veil follows the contour of the hair and

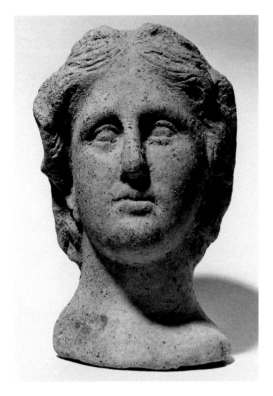

FIGURE 14

Campanian female head. Height: 20.0 cm. Malibu, J. Paul Getty Museum 71.AD.305.

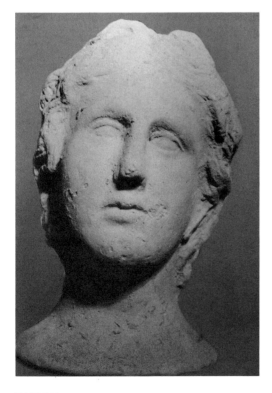

FIGURE 15

Campanian female head from Capua. Height: 19.0 cm. Capua, Museo Campano 2428. Photo: Author.

merges with the edge of a garment to form a base. Above the edge of this garment, a roll of clay forms a necklace encircling the neck. In the Getty piece this necklace is incised to suggest coiled wire. The clay body is orange-pink and contains small particles of mica. A darkened buff-color slip covers the entire head, and a white incrustation covers a large section of the forehead, the central hair locks, the left side of the face, and portions of the back.

The Kelsey terracotta is attributed to Puteoli. The hairstyle worn by both the Kelsey and Getty heads recalls that of Museo Campano 2311 and that of a Capuan oinochoe in the form of a female head dated by Bonghi Jovino to the last quarter of the fourth century. Marcello Rizzello has dated the Antera-Casmari deposit from the end of the third to the first half of the first century B.C. Two busts from Ariccia (Rome, Antiquarium Comunale 112375 and 112376) have the same face shape, handling of the face and hair details, flesh folds of the neck, loose hair strands appearing from behind the ears, and knotted fillet binding the hair. Inv. 112375 also wears a coiled torque similar to the Getty terracotta. Anna Zevi Gallina has dated these busts to shortly after 300 B.C. This dating is supported by two coins from the end of the fourth to the beginning of the third century found in the course of the excavation at Ariccia.[42] A comparison of the Veroli, Kelsey, and Getty terracottas with the examples from Ariccia suggests that Rizzello's dating of the Antera-Casmari deposit is a little late and that all these pieces should be assigned to the first half of the third century. Based on the stylistic similarities this series shares with Capuan and Calean examples, an assignment of both the Getty and Kelsey heads to Campania seems probable.

Another Campanian series is represented by a female head in the Getty Museum (fig. 18). The nose has been repaired. The clay body is beige-pink, with mica and white stone inclusions. An orange-pink slip covers the facial areas, the front of the veil, and the neck. Red-orange flashing from the firing process is evident on the right cheek and neck. This same series is found at Capua in the Museo Campano (inv. 2299 and 2296). All three examples range in height from 21 cm to 22 cm and are of the same mold generation. The hair is rendered in a series of incised waves forming a "melon coiffure." The veil follows the contour of this hair mass and merges with the cylindrical form of the neck. This hairstyle, as well as the shape of the face and the handling of the facial details, is consistent with related examples found at Capua.[43]

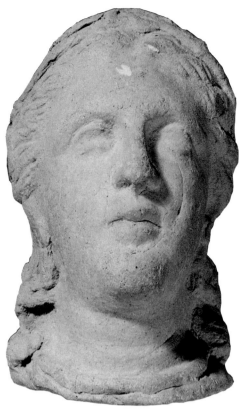

FIGURE 16

Campanian female head attributed to Puteoli. Height: 19.0 cm. Ann Arbor, The University of Michigan, Kelsey Museum of Ancient and Mediaeval Archaeology 2798. Photo courtesy Kelsey Museum of Ancient and Mediaeval Archaeology.

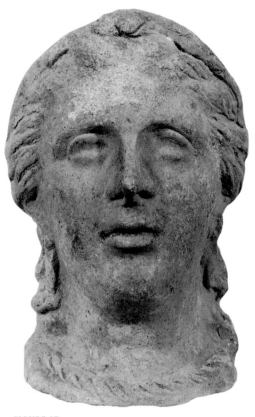

FIGURE 17

Campanian female head. Height: 18.8 cm. Malibu, J. Paul Getty Museum 71.AD.306.

Guido Kaschnitz-Weinberg assigned this type to the end of the fourth or the beginning of the third century. Like the previous series, the lips are parted and a flesh fold is incised into the neck following the tradition of Praxiteles' Knidian Aphrodite. The soft modeling of the facial features is reminiscent of this tradition and of Etruscan bronze heads dating from the first half of the third century. The "melon coiffure" combined with a similar handling of the facial features and with flesh folds on the neck occurs in an Egyptian decadrachm depicting Berenike II (fig. 19), which was minted in Alexandria 235–220 B.C. A stylistic comparison between this coin and the Capuan series indicates that Kaschnitz-Weinberg's dating is too early and that these terracottas should be assigned to the middle or second half of the third century.[44]

In addition to votive heads, female busts are also commonly found in the votive deposits of west-central Italy. Getty Museum 71.AD.238 (fig. 20) is an excellent example of this category. The image pre-sented by the bust is one of delicate, regal beauty. The bust extends below the shoulders and is missing the chest. The head angles slightly to the left. Three large curling locks project asymmetrically over the left portion of the forehead. The hair mass on either side of these curls is swept back from the face and over the ears. Two wavy strands of hair continue down from the ears, flank the neck, and cover the upper edge of the shoulders to the clasps of her garment. A veil covers the hair behind and follows the contour of the head. The ovoid head is placed upon a long, delicate neck. The facial features are finely modeled but do show indications of mold wear. The brow is sharply delineated, especially over the left eye. The eyes are small and have the cornea and pupil indicated in relief. The broad nose curves gently down from the forehead. The contours of the parted lips are blurred as a result of mold wear. A gentle, curving jawline extends back from a strongly modeled chin and up to simple loop earrings that project down from ears hidden by the hair mass. The clay body has been finely levigated

FIGURE 18

Campanian female head. Height: 22.0 cm. Malibu, J. Paul Getty Museum 71.AD.304.

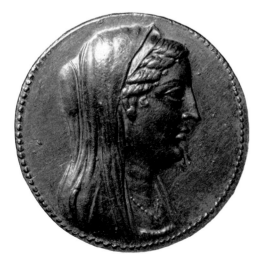

FIGURE 19

Egyptian gold decadrachm depicting Berenike II. Diameter: 35 mm. Boston, Museum of Fine Arts 35.122, Anonymous gift in memory of Zoe Wilbour. Photo courtesy Museum of Fine Arts.

and fired to a red-orange color. The entire piece has been dipped in a white coating, possibly to replicate the appearance of marble. No other pigmentation is preserved.

Numbers of Etruscan female bust-length votives have been found at Caere. Head fragments preserved in the Lowie Museum of Anthropology in Berkeley exhibit a similar handling of details. A badly damaged head (Lowie 8-2889) retains a hairstyle very similar to that of the Getty bust. Three damaged locks evident on the upper left side of the Lowie head may have projected over the forehead similarly to those of Getty 71.AD.238 (fig. 20). Other related hairstyles with thick asymmetrically placed locks projecting over the forehead are found on Lowie 8-2328 (fig. 21), 8-2888, 8-6767, and 8-6768. Lowie 8-2328, 8-2829, and 8-2913 have similar wavy strands of hair flanking the neck down to the shoulders. Strands of hair also flank the necks down to the shoulders on Getty 71.AD.306 (fig. 17), Kelsey 2798 (fig. 16), and a larger female bust from Ariccia (Rome, Antiquarium Comunale 112375). Simple loop earrings are evident on Lowie 8-2913 and 8-7627. A fragmentary statue of a youth excavated at Lucera shares the same general facial shape and elongated neck found in the Getty bust.[45]

The handling of the hair and facial features of Getty 71.AD.238 (fig. 20) again attests to stylistic influences received through contact with Magna Graecia. A similar rendering of the hair at the sides of the head, brow, and eyes is seen in a terracotta head from Taras now in the Museum of Fine Arts in Boston. This Tarentine example has been dated by L. D. Caskey to the late fifth century B.C. Gallina dates the Ariccia bust to a little after 300 B.C. Nagy assigns the highly articulated and often unruly hair and the sense of immediacy it generates in the Lowie examples to the second century B.C. This later date coincides with Filli Rossi's second-century placement of the fragmentary statue from Lucera. The degree of asymmetry seen in the tilting of the head and the rendering of the hair of the Getty bust contrasts with the symmetry of the Ariccia example and suggests it should be dated later. Stylistic elements shared by Getty 71.AD.238 (fig. 20), the votive statue from Lucera, and the Caeretan terracottas in the Lowie Museum indicate that the Getty bust also should be assigned to the second century.[46] Since other examples from the mold series that produced Getty 71.AD.238 have not been published, its provenance remains in question.

Infants in wrappings first appeared in central Italy during the last quarter of the fourth century B.C.

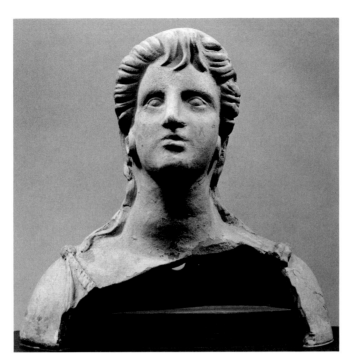

FIGURE 20

Etruscan female bust. Height: 27.0 cm. Malibu, J. Paul Getty Museum
71.AD.238.

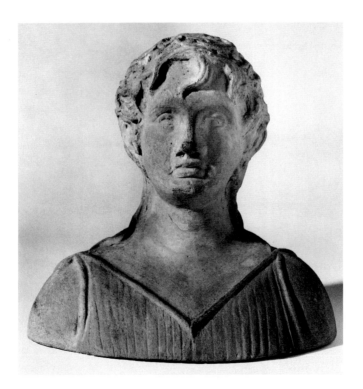

FIGURE 21

Etruscan female bust from Caere. Height: 26.5 cm. Berkeley, University
of California, Robert H. Lowie Museum of Anthropology 8-2328. Photo
courtesy Robert H. Lowie Museum of Anthropology.

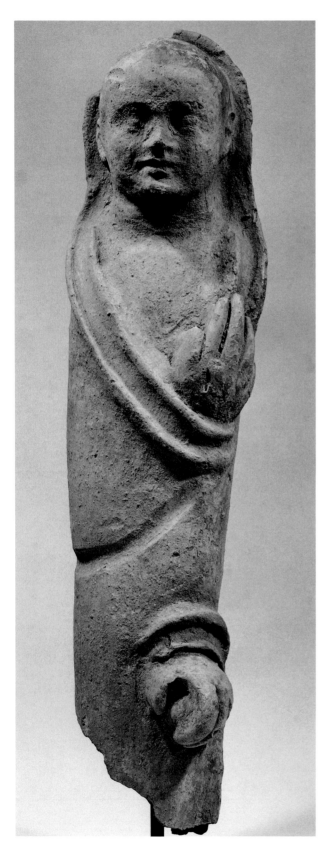

FIGURE 22

Infant wrapped in a mantle. Height: 54.7 cm. Malibu, J. Paul Getty Museum 71.AD.240.

and represent a totally Italian development. These standing or reclining figures are wrapped either in swaddling cloths or in a mantle from which only the hands and feet project. A fragmentary figure of a child in the Getty Museum (fig. 22) is an example of the type wrapped in a mantle. Other fragmentary figures of this category are in the Kelsey Museum (inv. 1768 [fig. 23] and 1770). The left arm of the Getty votive extends along the left side and only the hand, clenched around a sphere (pomegranate?), protrudes from the drapery. The large right hand with extended fingers projects from under the edge of the drapery and rests on the left side of the chest. Like the Kelsey examples, two broad bands indicate the edge of the garment, but these bands proceed at an angle across the chest from the right shoulder. The soft, circular face is framed by a veil and includes a fleshy double chin. The features are summarily modeled and probably were originally enhanced with paint. A greenish-cream slip coats the entire figure. Red pigment indicates the hair, and traces of this same pigment are preserved on the drapery and the index finger of the left hand. A narrow body type similar to that of the Getty *bambino* is seen in a second-century *bambino in fasce* excavated at Veii (Rome, Villa Giulia 2610).[47] The modeling of the Getty *bambino* also suggests a second-century date, but its provenance remains a mystery.

Shortly after 100 B.C. the *bambino in fasce* type disappeared from the sanctuaries of the *kourotrophos* along with the anatomical votives. The end of the practice of dedicating these votives coincides with extensive remodeling programs initiated at the sites under Roman domination. The remodeling programs also reflect a change in sponsorship of these holy sites from a rural agricultural population to an aristocracy with nearby suburban villas and imperial patronage. Rome received its first Greek doctor, Archagathos, son of Lysanias from the Peloponnesos, in 217 B.C. (Pliny the Elder, *N.H.* 29.12). By circa 100–50 B.C. a school of medicine was founded in Rome under the direction of Asklepiades of Bitinia (Pliny the Elder, *N.H.* 7.124, 25.6, 26.12ff.). A gradual increase in the availability of medical treatment removed many ailments from the scope of divine intervention and also contributed to the disappearance of the anatomical votives from the sanctuaries of the *kourotrophos*. Votive heads continued to be produced. Why the *bambini in fasce* disappeared with the anatomical votives remains to be explained.[48]

Scholars have connected the terracotta votive heads and busts with the healing of unseen head ail-

ments or blemishes and the votive *bambini* with requests for a child or the deliverance of a child from disease. These interpretations are based solely on the fact that both votive types are found in a context with anatomical votives. Signs of disease sometimes occur on anatomical votives but rarely on the votive heads or *bambini*.[49] Votive heads tend to be youthful, ideal representations, and only rarely do they show indications of advancing age (e.g., wrinkles) or illness. Those examples that do are relatively late (e.g., fig. 12) and may reflect the influence of Republican veristic portraits. If votive *bambini* were meant to indicate a request for a child, then all examples of the type should represent newborns—but many do not.

It must be remembered that the central Italian *kourotrophos* watched over her followers not only in life but in death as well. Her sanctuaries are sometimes found in or near necropoleis. In this role, the Italian *kourotrophos* parallels the Greek Persephone or the Roman Proserpine as Queen of Hades. Orphic inscriptions found in Southern Italy mention that the deceased will become a god after having been a man and that he must pray to Persephone to send him to the dwelling place of the immortals. The veil worn by most central Italian and Roman votive heads and *bambini in fasce* reflects the *pietas* identified with both Roman and Etruscan religious rite. The veil also serves an apotropaic function by isolating the people depicted from the profane and protecting them from evil forces.[50]

A high mortality rate was a reality in the ancient world. The Roman belief in the family unit existing on both sides of the grave must be considered in the interpretation of these votives since Roman beliefs often reflect those of their Etruscan and Campanian neighbors.[51] For that reason, votive heads may express how the deceased hoped to look in the afterlife just as well as a hope of a cure for some head ailment in life. Both realms fell into the domain of the *kourotrophos*. Similarly, the *bambino in fasce* might be interpreted as a request for the safe passage of a child to the afterlife. The interpretation of these votive types as dedications for the preservation of the physical soul of the deceased is in keeping with both Orphic thoughts on rebirth and the Roman concept of the family. The connection with the perpetuation of the family would explain their discovery in a context with votives concerned with healing, fertility, motherhood, and the family as well as the variety of ages seen in the faces of the *bambini*.

The votive child in figure 22 and numerous

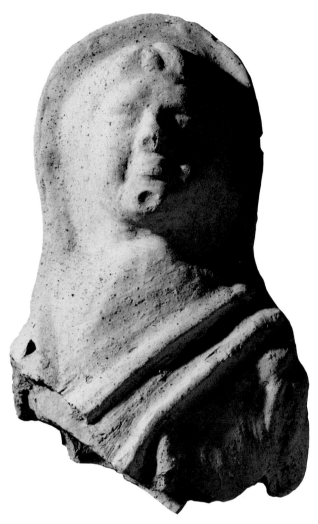

FIGURE 23

Infant wrapped in a mantle, from Veii. Height: 28.0 cm. Ann Arbor, The University of Michigan, Kelsey Museum of Ancient and Mediaeval Archaeology 1768. Photo courtesy Kelsey Museum of Ancient and Mediaeval Archaeology.

other central Italian votive figures clench a pomegranate in their left hand. The pomegranate is an attribute connected with both Persephone and the central Italian *kourotrophos*.[52] Its presence in the hands of these votives further suggests that they enlist the aid of the *kourotrophos* and protectress of the newly deceased.

Prior to the institutionalization of Italian medicine during the first century B.C., the role of the Italian *kourotrophos* embraced all of life's concerns. The countless anatomical votives preserved from her sanctuaries reveal the direct and personal nature of the cult of the *kourotrophos* and the close connection between Hellenistic religion and medicine in Italy. The divinity worked through the priest-physician to effect the necessary cure. When the priest-physician failed or the illness was beyond mortal means to cure, the goddess intervened. In death as well as life, all that believed in her were safely cradled in her arms.

Terre Haute
Indiana State University

### NOTES

Abbreviations:

La Regina    A. La Regina, "Teste fittili votive," in F. Castagnoli, *Lavinium*, vol. 2, *Le tredici are*, pp. 197–252 (Rome, 1975).

Nagy    H. Nagy, *Votive Terracottas from the Vignaccia, Cerveteri, in the Lowie Museum of Anthropology* (Rome, 1988).

Riis, *Etruscan Heads*    P. J. Riis, *Etruscan Types of Heads: A Revised Chronology of the Archaic and Classical Terracottas of Etruscan Campania and Central Italy* (Copenhagen, 1981).

Riis, *Tyrrhenika*    P. J. Riis, *Tyrrhenika: An Archaeological Study of the Etruscan Sculpture in the Archaic and Classical Periods* (Copenhagen, 1941).

I am grateful to Marion True, Marit Jentoft-Nilsen, and Benedicte Gilman for assisting my study of the votive terracottas in the J. Paul Getty Museum. I would also like to thank Richard DePuma for cultivating and encouraging my continued study of Etruscan, Latian, and Campanian terracottas.

1. Bonfante, "Dedicated Mothers," *Popular Cults,* Visible Religion, vol. 3 (Leiden, 1984), pp. 1–3.
2. The Getty Museum has three representations of the *kourotrophos* (inv. 71.AD.141, 71.AD.345, and 71.AD.347), all listed as probably from Gela, Sicily. All three are from worn molds and range in height from 11.0 cm to 13.5 cm.
3. A. Comella, "Tipologia e diffusione dei complessi votivi in Italia in epoca medio- e tardo-repubblicana," *MEFRA* 93.2 (1981), pp. 758–762; idem, *Il deposito votivo presso l'Ara della Regina* (Rome, 1982), pp. 1–2. When discovered in their proper context, these votive offerings are found in either open or closed votive deposits. Open deposits are usually characterized by a mixed chronology due to poorly conducted earlier excavations or cases in which votives were used as fill in antiquity.

Closed deposits are sealed in irregularly shaped pits capped with stone blocks or terracotta tiles. This type of deposit is characterized by a homogenous chronology with well-defined upper and lower limits. At times refuse pits can fit this category, but they often contain a mixture of other objects along with the votives.

4. A. Maggiani, ed., *Artigianato artistico in Etruria,* exh. cat. (Milan, 1985); S. Stopponi, ed., *Case e palazzi d'Etruria,* exh. cat. (Milan, 1985); M. Cristofani, ed., *Civiltà degli etruschi,* exh. cat. (Milan, 1985); A. Carandini, ed., *La romanizzazione dell'Etruria: Il territorio di Vulci,* exh. cat. (Milan, 1985); G. Camporeale, ed., *L'Etruria mineraria,* exh. cat. (Milan, 1985); G. Colonna, ed., *Santuari d'Etruria,* exh. cat. (Milan, 1985); M. Kunze and V. Kästner, eds., *Die Welt der Etrusker,* exh. cat. (Berlin, 1988); Comella, "Tipologia" (above, note 3), pp. 717–803; M. Fenelli, "Contributo per lo studio del votivo anatomico: I votivi anatomici di Lavinio," *ArchCl* 27.2 (1975), pp. 206–252; B. M. Fridh-Haneson, *Le Manteau symbolique* (Stockholm, 1983); and Nagy.
5. R. V. Nicholls, "Type, Group and Series: A Reconsideration of Some Coroplastic Fundamentals," *BSA* 47 (1952), pp. 219–221.
6. Idem, pp. 221–225; S. Steingräber, "Zum Phänomen der Etruskisch-Italienischen Votivköpfe," *RM* 87 (1980), p. 232; S. Karatzas, "Technical Analysis," in Nagy, pp. 3–11.
7. N. A. Winter, "Terracotta Representations of Human Heads Used as Architectural Decoration in the Archaic Period," Ph.D. diss., Bryn Mawr College, 1974, p. 124; idem, "Archaic Architectural Terracottas Decorated with Human Heads," *RM* 85 (1978), p. 57; Riis, *Etruscan Heads,* pp. 36, 59–60.
8. Winter, "Terracotta Representations" (above, note 7), p. 124; R. A. Higgins, *Catalogue of the Terracottas in the Department of Greek and Roman Antiquities, British Museum* (London, 1969), pp. 6–9; M. Bonghi Jovino, *Depositi votivi d'Etruria* (Milan, 1976), pp. 83–88. A double-chamber kiln has also been discovered near the supposed location of the temple of Uni at Caere (Cerveteri). This kiln was used for ceramics for the sanctuary and temple decorations. A storage area for molds has been found. The walls of the kiln were carved into the natural rock of the site and finished off with levigated tufa blocks. The interior is separated into chambers with dividing walls 24.36 cm thick. A layer of clay and sand lines the interior walls, which are red from high temperatures. One chamber was used for firing and one for slow cool-down.
9. J. T. Peña has analyzed the clay fabric of tableware, brick, tile, and various types of vessels from known workshop sites in Etruria Tiberina outside Rome. Two mineralogical techniques, petrographic analysis, X-ray diffraction analysis, and neutron activation analysis were used. Peña also cites the major problems associated with the compositional analysis of terracotta material. See J. T. Peña, "Roman-Period Ceramic Production in Etruria Tiberina: A Geographical and Compositional Study," Ph.D. diss., University of Michigan, 1987.
10. Riis, *Tyrrhenika,* pp. 203–204; H. Herdejürgen, *Götter, Menschen und Dämonen: Terrakotten aus Unteritalien* (Basel, 1978), p. 14. Roman contacts with Etruscan art are interrupted at the middle of the fifth century. Commercial connections between Rome and Athens also decline and do not revive until the end of the century. This decline coincides with a social and constitutional change occurring in Rome circa 450 B.C. See E. Gjerstad, "Origins of the Roman Republic," in *Les Origines de la République Romaine.* Fondation Hardt, entretiens sur l'antiquité classique, vol. 13 (Geneva, 1967), pp. 7–28.
11. Riis, *Tyrrhenika,* p. 187. The destruction of Veii is referred to in Diodorus 14.93.2–5 and Livy 5.21.17, 22.1–8, 50.8, 51–54, and 6.4.5. Late Portonaccio and Campetti finds indicate that the sanctuaries continued in use after the Roman destruction.

A votive deposit discovered on the slope of the akropolis and facing the town contained material dated as late as the second and first centuries B.C. The reticulated walls of the Roman buildings indicate continued activity in the Campetti area until the first century. Such work was common between the second quarter of the first century B.C. and the second half of the first century A.D. A struggle in circa 41 B.C. probably resulted in a massive destruction of the city. Vagnetti has suggested that traces of burning on the latest votives indicate such a violent destruction. See Riis, *Etruscan Heads,* p. 50; Bonghi Jovino (above, note 8), pp. 45–48, 68.

12. Riis, *Tyrrhenika,* p. 197. The paintings of the François Tomb at Vulci (340–310 B.C.) may reflect the encroaching threat of Rome. In these paintings, scenes depicting the victory of the Greeks over the Trojans are paired with scenes of heroes from Vulci vanquishing Romans. See L. Bonfante, "Historical Art: Etruscan and Early Roman," *AJAH* 3 (1978), pp. 136–138. For the most recent study of this tomb, see F. Buranelli, ed., *La tomba François di Vulci* (Rome, 1987).

13. T. F. C. Blagg, "Cult Practice and Its Social Context in the Religious Sanctuaries of Latium and Southern Etruria: The Sanctuary of Diana at Nemi," *Papers in Italian Archaeology,* vol. 4, *BAR* 246 (Oxford, 1985), pp. 37–39.

14. Ibid., pp. 39–41. Blagg associates the appearance of anatomical votives in Etruria and Latium with the influx of some Hellenistic ideas mediated through Rome during a period of intensified Roman influence. He associates the introduction of Greek medical knowledge with the entrance of the cult of Asklepios to Rome in 292 B.C.

15. C. Roebuck has suggested that the votive heads common to the Asklepieion at Corinth as well as the sanctuaries of west-central Italy may generally refer to the removal of blemishes or headaches, ailments not requiring illustration. See C. Roebuck, "The Asklepieion and Lerna," *Corinth* 14 (1951), p. 118. A rare example suggesting a glandular disorder is mentioned in M. Besnier, *L'Île Tiberine dans l'antiquité* (Paris, 1902), p. 235.

16. Riis, *Etruscan Heads,* pp. 75–79; Riis, *Tyrrhenika,* p. 193; Bonghi Jovino (above, note 8), p. 77.

17. L. R. Taylor mentions that two collections of votives were discovered to the west of Caere in 1829 and circa 1886. The second find became part of the Chigi collection. See L. R. Taylor, "Local Cults in Etruria," *PAAR* 2 (1923), p. 118. L. Borsari mentions the discovery of the Chigi votives but does not include detailed descriptions of the individual pieces (see *NSc,* 4th ser., 2 [1886], pp. 38–39). The bearded votive in the Chigi collection was not available during my visit to Siena and is known to me only through a black-and-white photograph provided by the Soprintendenza alle antichità d'Etruria, Florence.

18. M. Sprenger and G. Bartoloni, *The Etruscans: Their History, Art, and Architecture* (New York, 1983), p. 118, pl. 133; A. Andrén, *Architectural Terracottas from Etrusco-Italic Temples* (Lund and Leipzig, 1940), pp. 69, 162, 179, 180, pls. 23.81, 83; 62.201; 68.220, 223; A. Rallo, "Per una nuova classificazione di alcune antefisse provenienti da Pyrgi," *ArchCl* 29 (1977), pp. 202–205, pl. 54.2; La Regina, pp. 219–221, 250, fig. 301. Although the antefixes from Tarquinia and Orvieto seem to be of the same mold series, Andrén contradicts himself by dating the Tarquinian examples to the fourth–third century and the Orvieto examples to the fifth–early fourth century. Mold series do extend over long periods of time, but not over two centuries.

La Regina's dating is based on comparisons with a votive head in the Museo Nazionale Romano dated by Hafner to the fourth century. His mid-fourth-century dating also takes into consideration Roman sources, stating that the general practice of shaving was introduced from Sicily toward the end of the fourth century. For head details of the Artemision Zeus, see J. Boardman, *Greek Sculpture: The Classical Period* (New York, 1985), pl. 5a.

19. A female head with a similar projection of the hair over the temples and then sweeping back over the ears has been found at Lavinium. See M. Torelli, *Lavinio e Roma* (Rome, 1984), fig. 24. Torelli's figures 23–32 illustrate male and female heads with the hair sheared off behind the ears. Torelli links the cut hair evident in these depictions with rites of passage from childhood to adulthood. Also see B. Lincoln, "Treatment of Hair and Fingernails Among the Indo-Europeans," in M. Eliade, J. M. Kitagawa, and J. Z. Smith, eds., *History of Religions,* vol. 16, no. 4 (Chicago, 1977), pp. 351–362.

20. A similar handling of the hair and *polos* is seen in a mid-fifth-century head from Selinous. See M. Sprenger, *Die Etruskische Plastik des V. Jahrhunderts v.Chr. und Ihr Verhältnis zur Griechischen Kunst* (Rome, 1972), pp. 56–57, pl. 27.2.

21. L. Vagnetti, *Il deposito votivo di Campetti a Veio* (Florence, 1971), pp. 41–42.

22. Archaic and Classical Etruscan bronzes show a similar incision of the pupil and cornea. See Riis, *Tyrrhenika,* p. 31.

23. Large and clumsily placed ears also appear on heads found at Lavinium. See Torelli (above, note 19), figs. 24, 28.

24. G. M. A. Richter, *Korai: Archaic Greek Maidens* (New York, 1968), pp. 102–103, figs. 587–590. M. Cristofani, "La 'Mater Matuta' di Chianciano," in Soprintendenza alle antichità d'Etruria, *Nuove letture di monumenti etruschi,* exh. cat. (Florence, 1971), pp. 92–93. V. Kästner wrongly dates a Latian female head antefix with the same hairstyle and similar facial features (Berlin TC 3778) to the second or third quarter of the sixth century B.C. See *Die Welt der Etrusker* (above, note 4), p. 182, pl. B 6.10.

25. M. Cristofani, *Statue-cinerario Chiusine di età classica* (Rome, 1975), pp. 41–72, pls. 26–28.

26. Bonghi Jovino (above, note 8), pp. 65–67. Figure 6 (75.AD.98) is classified as Tarantine by the Getty Museum.

27. Comella, "Tipologia" (above, note 3), fig. 17; M. Mazzolani, *Forma Italiae: Anagnia* (Rome, 1969), fig. 106; G. Hafner, "Frauen- und Mädchenbilder aus Terrakotta im Museo Gregoriano Etrusco," *RM* 72 (1965), pp. 46–47; Nagy, figs. 3–5, 9, 24; La Regina, pp. 197–198, C2–C7; Torelli (above, note 19), fig. 22; Andrén (above, note 18), p. 258, II.4, pls. 87.309, 88.314.

28. L. Fedeli, in *L'Etruria mineraria* (above, note 4), pp. 106–107, pl. 464; Boardman (above, note 18), fig. 144; Hafner (above, note 27), p. 47; Comella, "Tipologia" (above, note 3), p. 782; La Regina, p. 198; Nagy, p. 15; S. Steingräber, *Catalogo ragionato della pittura etrusca* (Milan, 1985), pl. 148; Mazzolani (above, note 27), p. 88.

29. Although this head is probably part of the same mold generation as that seen in the two Getty Museum heads, I was not able to confirm this by measuring the piece.

30. Boardman (above, note 18), pl. 65; J. J. Pollitt, *Art and Experience in Classical Greece* (London, 1974), pl. 63; Riis, *Etruscan Heads,* p. 29, Caeretan type 20B; Rallo (above, note 18), p. 204, pls. LI.1, LIII.2, LIV.1; M. Bonghi Jovino, *Capua preromana: Terrecotte votive,* vol. 1 (Florence, 1965), p. 27; Herdejürgen (above, note 10), p. 97, pl. C17.

31. L. Gatti Lo Guzzo, *Il deposito dall'Esquilino detto di Minerva Medica* (Florence, 1978), p. 89, type GIII; J. N. Svoronos and B. V. Head, *The Illustrations of the Historia Numorum: An Atlas of Greek Numismatics* (Chicago, 1976), pl. VIII.7; M. Cristofani, *I bronzi degli etruschi* (Novara, 1985), pl. 62.

32. Los Angeles County Museum of Art M.82.77.24 is mentioned

here only to illustrate the longevity of this mold series. Heads from the end of a long series often lack the necessary details for stylistic analysis. Nineteen similar heads from the end of various series are included in the Johns Hopkins University Department of Classics and in the Vassar College collections. Incised lines replace worn hair details in many of these late examples.

33. Vagnetti (above, note 21), pl. XXI.CVI; G. Hafner, "Etruskische Togati," *AntP* 9 (1969), pp. 28–29, pl. 13a–c; Riis, *Tyrrhenika,* p. 54, pl. 8.2; Riis, *Etruscan Heads,* p. 47, Veian type 17L; M. A. Rizzo, in *Santuari d'Etruria* (above, note 4), p. 86, no. 4.9 A2; G. Hafner, "Männer- und Jünglingsbilder aus Terrakotta im Museo Gregoriano Etrusco," *RM* 73/74 (1966–1967), p. 39, pls. 7.1–4, 8.1; B. M. Thomasson, "Deposito votivo dell'antica città di Lavinio (Practica di Mare)," *OpRom* 3 (1961), pl. V.26–28; La Regina, figs. 281–286; P. Pensabene, in *Quaderni del Centro di Studio per l'Archeologia Etrusco-Italica* (Archeologia Laziale, vol. 2) 3 (1979), pl. XLV.4; O. J. Brendel, *Etruscan Art* (New York, 1978), pl. 244; M. Cristofani, in *Civiltà degli etruschi* (above, note 4), pp. 301–303, no. II.22; Cristofani (above, note 31), pls. 4.9, 115, 117, 118.

34. Ibid., pp. 106, 220, 224, 226; idem, in *Civiltà deglia etruschi* (above, note 4), pp. 301–303, no. II.22; Hafner, "Etruskische Togati" (above, note 33), p. 29; La Regina, p. 251; Vagnetti (above, note 21), p. 53; Svoronos and Head (above, note 31), p. 22, pl. IX.12.

35. J. Frel, *Roman Portraits in the J. Paul Getty Museum,* exh. cat. (Tulsa, Oklahoma, Philbrook Art Center, and Malibu, The J. Paul Getty Museum, 1981), p. 120.

36. Since few terracotta votives preserve pigmentation to this degree, it is instructive that the illness is not indicated in relief but in paint.

37. Riis, *Tyrrhenika,* pl. 2.2; Riis, *Etruscan Heads,* Caeretan type 22D; R. Mengarelli, "Il tempio del Manganello a Caere," *StEtr* 9 (1935), pl. 19.4; M. D. Gentili, "Deposito votivo del tempio del Manganello a Cerveteri," *Santuari d'Etruria* (above, note 4), p. 152, fig. 8.1 B 2; Frel (above, note 35), p. 15; Comella, *Il deposito* (above, note 3), pp. 63–64, pl. 23a.

38. The example in Capua is listed as the head of a youth. See Bonghi Jovino (above, note 30), p. 121, pl. LVII.3.

39. M. Bonghi Jovino, *Capua preromana: Terrecotte votive,* vol. 2 (Florence, 1971), pp. 75–76, pl. XLII.1, 2; Cristofani (above, note 31), pl. 70; J. M. Blazquez, "Terracotas de santuario de Calés (Calvi), Campania," *Zephyrus* 12 (1961), fig. 14; M. P. Baglione, *Il territorio di Bomarzo* (Rome, 1976), pl. CIV.B3; La Regina, figs. 312–313, C115, C119; Vagnetti (above, note 21), pl. XIX.BIII; Siena, Museo Archeologico 37836. These stylistically related examples have been variously dated from the third to the beginning of the first century B.C.

40. See M. Rizzello, *I santuari della media valle del Liri IV–I sec. a.C.* (Sora, 1980), figs. 75–76.

41. G. Daltrop and F. Roncalli, *The Vatican Museums* (Florence, 1985), p. 61; S. Karouzou, *National Museum* (Athens, 1985), p. 86, no. 3335.

42. Riis, *Etruscan Heads,* Capuan type 15E; M. Bonghi Jovino, "Problemi di artigianato dell'Italia preromana," *Archaeologica: Scritti in onore di Aldo Neppi Modona* (Florence, 1975), p. 35, figs. 1–3; Rizzello (above, note 40), p. 13; A. Z. Gallina, in Assessorato antichità, *Roma medio repubblicana,* exh. cat. (Rome, Antiquarium Comunale, 1973), pp. 321–324, pls. LXII–LXV.

43. Bonghi Jovino (above, note 30), pp. 49–50, pl. XVI.1–3.

44. G. Kaschnitz-Weinberg, "Ritratti fittili etruschi e romani dal sec. III al I a.C.," in *RendPontAcc* (1925), pp. 334–335, figs. 1, 2; Cristofani (above, note 31), pl. 125; M. Bieber, *The Sculpture of the Hellenistic Age* (New York, 1955), pp. 91–92, fig. 344.

45. Nagy, figs. 42, 48, 51, 52, 54, 60, 61, 66; Gallina (above, note 42), pls. LXII–LXIV; F. Rossi, "Un gruppo di terrecotte votive da Lucera," *ArchCl* 32 (1980), pl. XXIX.

46. L. D. Caskey, "Greek Terra-Cottas from Tarentum," *BMFA* 29 (1931), p. 17, fig. 1; Gallina (above, note 42), p. 324; Nagy, pp. 18–19; Rossi (above, note 45), pp. 82–84.

47. Vagnetti (above, note 21), p. 87, pl. XLVII.MI.a.

48. Blagg (above, note 13), pp. 41–46; M. Guarducci, "L'Isola Tiberina e la sua tradizione ospitalieri," *RendLinc* 26 (1971), p. 274. Social change occurred with the rising power of Rome. The aristocracy became the patrons of the sanctuaries of the *kourotrophos.* The same aristocracy began to limit family size through the abandonment or exposure of children to protect the family wealth. See J. Boswell, *The Kindness of Strangers: The Abandonment of Children in Western Europe from Late Antiquity to the Renaissance* (New York, 1988).

49. Comella, "Tipologia" (above, note 3), p. 763. In some cases the appearance of *bambini in fasce* within votive deposits corresponds to an elevation in the number of votive uteri found in the same deposits and may coincide with a stress on maternity and fertility at these sites. At other sites, such as the Porta Caere at Veii, a concentration of votive genitalia is present in the deposits, but examples of *bambini in fasce* are absent.

The almost total lack of signs indicating disease may be partially explained by the Getty votive head 75.AD.103 (fig. 12). Very few heads or *bambini* retain pigmentation to the degree seen in the Getty head. If the practice was to represent signs of illness in paint, these signs are now lost along with the original pigmentation; however many heads and *bambini* were only coated with slip and never painted.

50. Fridh-Haneson (above, note 4), pp. 62–64, 82; W. K. C. Guthrie, *Orpheus and Greek Religion* (New York, 1966), p. 173; Blagg (above, note 13), p. 41.

51. I. A. Richmond, *Archaeology and the After-Life in Pagan and Christian Imagery* (New York, 1950), p. 41.

52. T. H. Price, *Kourotrophos: Cults and Representations of the Greek Nursing Deities* (Leiden, 1978), pp. 166, 173–174; Fridh-Haneson points out the bond between the Orphic statuettes of Southern Italy and Etruscan and Latian terracottas. She links these works together as expressions of religious ideas belonging to the same cult. See Fridh-Haneson (above, note 4), p. 63.

# Ein Terrakottarelief mit Sphinx und Greif

Angelika Dierichs

Im Jahre 1979 übereignete ein privater Spender dem J. Paul Getty Museum ein Terrakottarelief mit Sphinx und Greif, das im Folgenden besprochen werden soll (Abb. 1a–c).[1]

Die Breite des Exponats beträgt 17,5 cm, seine Höhe 10,3 cm und seine Stärke 1,8 cm. Es ist ungebrochen mit originalen Rändern und besteht aus orangefarbenem, glimmerhaltigem Ton, mit gleichmäßigem beigefarbenen Überzug auf Vorderseite und Rändern. Seine Rückseite ist rauh. Die Reliefhöhe variiert. So wölbt sich die Hüfte der Sphinx höher auf als Kopf und Brust. Die Gestalt des Greifen erscheint gleich hoch reliefiert. Nur sein Knauf und Schwanz sind erhabener. An den höchsten Stellen des Reliefs ist der Überzug abgerieben. Anzeichen für eine ursprüngliche Bemalung fehlen. Die Vorderseite der Platte wölbt sich, zwischen 2,5 mm und 3 mm vom äußeren Rand bis zum Zentrum, kaum merklich auf.

Löcher in der linken und rechten oberen Ecke, die zur Befestigung gedient haben mögen, sind mit Gips verschlossen.

Weitere Informationen zu dem Tonrelief, etwa zu Fundort, ursprünglicher Verwendung, künstlerischer Provenienz fehlen, so daß es hier nach ikonographischen und stilistischen Aspekten beurteilt werden muß.

## BESCHREIBUNG DES TERRAKOTTARELIEFS

Dargestellt ist eine Sphinx,[2] Mischwesen aus Frauenkopf[3] und geflügeltem Löwenkörper, gegenüber einem Greifen,[4] Phantasiegeschöpf aus Raubvogelkopf und geflügeltem Löwenkörper. Beide Fabelwesen sind annähernd gleich groß. Sie blicken einander an, schreiten in identisch starrer Haltung aufeinander zu und berühren sich jeweils an der rechten Vorderpfote.[5] Sphinx und Greif bilden so eine antithetische Zweiergruppe. Ihre heraldische Geschlossenheit verstärkt sich durch dünne, waagerechte Doppelwülste bzw. Einkerbungen, die Standlinie und obere Begrenzung der Figuren bilden.

## ALLGEMEINES ZU SPHINX UND GREIF IN ARCHAISCHER ZEIT

Sphinx und Greif gehören zu den üblichen Darstellungsinhalten des griechischen Kunstschaffens archaischer Zeit. Ihre natürlichen, phantastischen und abstrakten Bestandteile machen sie zu rätselhaften Wesen mit vielschichtiger Bedeutung.[6]

In der Funktion als Wächter haben sie unheilabwehrende Kraft. So begegnen uns Sphingen an Grabeingängen[7] und Greifen auf Sarkophagen.[8] In verwandter Bedeutung verzierten sie Rüstungen,[9] Geräte,[10] Gefäße[11] und Schmuckstücke,[12] die den Lebenden dienten oder den Verstorbenen als Grabbeigaben begleiteten. Eine klare Trennung des apotropäischen vom todesdämonischen Machtbereich ist nicht zwingend, weil beide Wirkungsweisen eng miteinander verknüpft sind. Die direkte todesdämonische Aufgabe der Sphinx, nämlich als Ker[13] die getöteten Krieger in den Hades zu geleiten, verrichtet der Greif nicht.

In der Vasenmalerei archaischer Zeit kommen Sphinx und Greif nur vereinzelt in mythologischem Kontext vor. Zuweilen finden wir die das Rätsel aufgebende thebanische Sphinx,[14] seltener den die Arimaspen bekämpfenden Greifen.[15] Ausnahmsweise erscheinen Hermes[16] oder Boreas[17] im Bildzusammenhang mit Sphingen und Greifen. Oft hingegen bilden Sphinx bzw. Greif die einzige figürliche Dekoration einer Vase.[18] Ungleich häufiger noch bevölkern sie die Tierfriese.[19] In diesen für die archaische Zeit typischen Umzügen aus Tieren und Fabelwesen, die nicht nur als Verzierung zu verstehen sind, sondern denen darüberhinaus ein ritueller Gedanke[20] und eine Verbindung zu Gottheiten[21] zugrunde liegen, heben sich Sphingen- und Greifenpaare durch ihre antithetische Komposition heraldisch hervor.[22] Sphinx bzw. Greif ordnen sich auch gleichberechtigt in den Tierfries ein.[23] Des öfteren ist die Gestaltung von Sphinx und Greif derartig ähnlich, daß man bei beschädigter

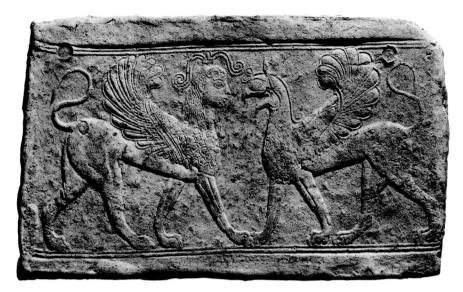

ABB. 1a

Terrakottarelief. Malibu, J. Paul Getty Museum 79.AD.195.

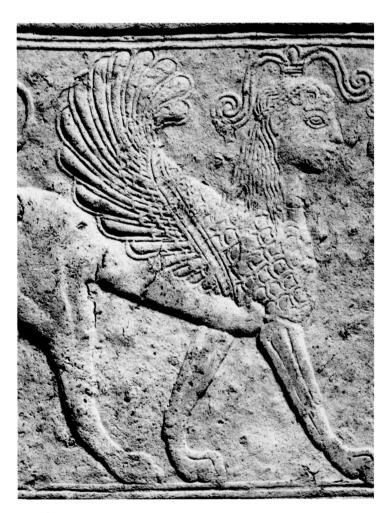

ABB. 1b

Sphinx des Terrakottareliefs, Abb. 1a.

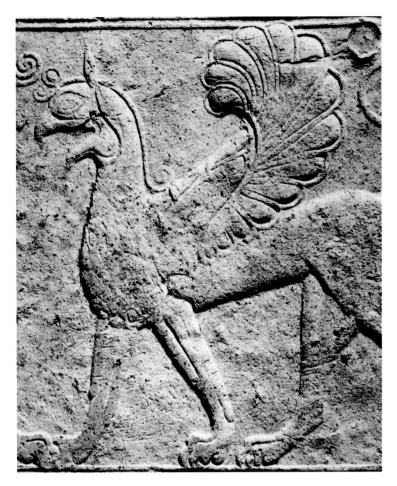

ABB. IC

Greif des Terrakottareliefs, Abb. 1a.

Kopfpartie nicht erkennen kann, ob es sich um eine Sphinx oder einen Greifen handelt.[24]

### VERWANDTE DARSTELLUNGEN AUF TONRELIEFS

Die meisten archaischen Sphingen- und Greifendarstellungen sind auf Vasen erhalten, aber mehr oder minder häufig treffen wir sie in allen Kunstgattungen. Bei dieser starken Verbreitung wundert es nun sehr, daß antithetische Paare aus Sphinx und Greif, wie auf dem Relief in Malibu, in der mutterländischen und großgriechischen Reliefplastik äußerst selten vorkommen. Letztlich lassen sich nur wenige Parallelen auf Tonreliefs finden.

### Kretisches Weihrelief mit Sphinx und Greif aus Praisos

Auf kretischen Reliefpinakes aus Ton begegnen uns schreitende Greifen und Sphingen im 7. Jahrhundert. Nahe verwandt ist ein Votiv aus Praisos (Abb. 2),[25]

wenngleich seine Fabelwesen in anderer Anordnung wiedergegeben sind. Leider ist die profilansichtige Sphinx so schlecht erhalten, daß sich kaum Einzelheiten ablesen lassen. Aber da die senkrechte Mittelfurche zwei Formteile dieses Pinax verrät, ist es methodisch vertretbar, auch Einzeldarstellungen von Sphingen bzw. Greifen auf kretischen Terrakottavotiven[26] zu vergleichen. Die beiden Fabelwesen des Malibu-Reliefs unterscheiden sich erheblich von allen kretischen Sphingen und Greifen. Letztere, meistens in stärkerem Relief, haben eine schlankere Hinterhand und sind hochbeiniger. Sie zeigen schmalere, spitzer auslaufende, zuweilen kaum gekrümmte Sichelflügel mit sparsamer Innengliederung. Diese Details bedingen eine hieratische Strenge, die im Gegensatz zu der felinen Gespanntheit von Sphinx und Greif in Malibu steht.

Die Hälse der Greifen aus Praisos sind wesentlich dünner als beim Malibu-Greifen. Und anstelle ihrer kräftigen, frei schwebenden Locke, die den

ABB. 2

Weihrelief aus Praisos. Agios Nikolaos, Archäologisches Museum 1668 (nach Reed, Taf. 82).

Raum zwischen Hals und Flügel mit einer großen Einrollung ausfüllt, hat der Malibu-Greif eine unscheinbare Locke, die der Halskontur aufliegt und in einer bescheidenen Volute oberhalb des Flügelansatzes endet.

Auch die Kopfdetails stimmen nicht überein. Während sich der Oberschnabel beim Malibu-Greifen in einem sanften Höcker vom Oberkopf abhebt, verschmelzen bei den Greifen aus Praisos Schädelpartie und oberer Schnabel zu einer Wölbung, die sich wie eine Fortsetzung des zarten geschwungenen Halses ausnimmt. Spitzes Ohr, großes Mandelauge und der doppelte, vegetabilisch stilisierte Knauf des Malibu-Greifen haben keine Parallele auf kretischen Tonpinakes.

Die dädalischen Frisuren zahlreicher Sphingen aus Gortyn[27] oder Lato[28] mit ihren steif und einheitlich arrangierten Haarkompartimenten sowie die massigen, schwer auf Hals und Brust herabfallenden Haarsträhnen der Sphingen aus Praisos[29] unterscheiden sich von der gefälliger und kleinteiliger geordneten Haartracht der Malibu-Sphinx.

Auf den kretischen Pinakes findet sich nur selten die glockenförmig ausschwingende Kopfbekrönung[30] der Sphinx in Malibu. Und einzelne Kopflocken, desgleichen Haarbänder bzw. Poloi kretischer Sphingen[31] erscheinen wesentlich strenger als bei der Malibu-Sphinx.

In den kretischen Sphingengesichtern[32] sind Stirn, Augen, Nase, Mund, Kinn, Wangen und Ohr parataktisch modelliert. Dieses stilistische Prinzip, das für Enface- und Profildarstellungen gleichermaßen gilt, bewirkt einen dämonisch starren Ausdruck. Bei der Malibu-Sphinx hingegen hat der Koroplast die einzelnen Teile des Gesichts übergangslos miteinander verbunden und ihr so nicht die furchterregende Ausstrahlung eines Ungeheuers, sondern allenfalls die rätselhaften Züge eines Frauengesichts gegeben.

Der Kopf der Malibu-Sphinx läßt sich also nicht mit den kretischen Sphingenköpfen verbinden, die sich der dädalischen Plastik des 7. Jahrhunderts einfügen.[33] Sogar die jüngsten weiblichen Köpfe der spätdädalischen Zeit um 625 v.Chr. wirken noch zu altertümlich, um mit der Sphinx in Malibu auf eine Stufe gestellt zu werden.

Auch ein bekanntes, kretisches Tonvotiv des 7. Jahrhunderts aus Gortyn,[34] auf dem der Herr der Tiere zwischen ansteigenden Greifen dargestellt ist, zeigt einen gänzlich anderen Stil als das Malibu-Relief und weicht ebenfalls in seiner ikonographischen Formensprache von diesem ab.

Die durchgeführten Vergleiche mit kretischen Terrakottavotiven[35] erlauben somit die Feststellung: Unsere Spinx-Greif-Platte in Malibu ist kein kretisches Weihrelief des 7. Jahrhunderts.

Kretische Reliefgefäße mit Sphingen und Greifen

Da die Fabelwesen von parallelen Linien begrenzt
werden, könnte man versucht sein, die Terrakotta-
platte als Teilabdruck bzw. Ausschnitt von einem
Gefäß zu verstehen, der als Pinax aufgehängt wurde.

Sphingen und Greifen kommen zwar zahlreich
auf kretischer Reliefkeramik vor. Zuweilen durchaus
vereint am gleichen Gefäß (Abb. 3),³⁶ stehen sie sich
aber niemals in direkter heraldischer Anordnung gegen-
über. Meistens sind sie in metopenartigen Feldern der
Hals- oder Bauchzone der Vase angesiedelt. Die
Sphinx erscheint allein oder antithetisch zu einer Art-
genossin, der Greif ausschließlich allein. Die meisten
Sphingen auf Amphoren und Pithoi des 7. Jahrhun-
derts ähneln in ihrer ikonographischen Formensprache
denen der Pinakes (s.O.). Somit läßt sich keine auffäl-
lige Verwandtschaft zwischen der Malibu-Sphinx und
ihren Schwestern auf den reliefierten Tonvasen fest-
stellen. Und der altertümliche Kopftypus der Greifen
mit wulstigen Schnabelteilen, breiten Zahnreihen,
fleischiger Zunge, kugelartigem Auge und polosähnli-
chem Kopfschmuck³⁷ hat nichts mit dem Malibu-
Greifen gemein.

Aus diesen Beobachtungen ist zu folgern: Das
Exponat im J. Paul Getty Museum kann nicht im
Zusammenhang mit einem kretischen Reliefgefäß
gesehen werden.

Sizilische Relieftafel mit Sphinx und Greif
aus Himera

Abgesehen von dem oben diskutierten Votiv aus
Praisos (Abb. 2) gibt es noch ein weiteres gattungsver-
wandtes Denkmal mit Sphinx und Greif, das sich dem
Malibu-Relief vergleichen läßt. Eine in Himera gefun-
dene, sizilische³⁸ Terrakottatafel³⁹ aus dem Beginn des
6. Jahrhunderts zeigt ebenfalls Sphinx und Greif in
antithetischer Position (Abb. 4).

Im Gegensatz zu den Stücken in Malibu und
Agios Nikolaos (Abb. 2) wirkt ihre Wappenformation
jedoch aufgelockert, bedingt durch das unterschiedli-
che Haltungsschema der Fabelwesen. Der Greif
schreitet nach rechts auf die nach links gewendete,
sitzende Sphinx zu. Letztere erscheint dominierender
als ihr Partner, ist sie sitzend doch ebenso groß gebil-
det wie der schreitende Greif. Diese Hervorhebung
entspricht dem Relief in Malibu, auf dem die Sphinx
den Greifen um ein Viertel ihrer Kopfhöhe überragt
und sich zudem noch durch ihren üppigen Kopf-
schmuck auszeichnet.

Das Bildfeld der beiden Mischwesen aus Himera

ABB. 3

Reliefamphora. Basel, Antikenmuseum BS 607.

entspricht ungefähr der querrechteckigen Ausdeh-
nung des Malibu-Reliefs⁴⁰ und liegt desgleichen zwi-
schen horizontalen Linien.

Die aufgezeigten Übereinstimmungen sollen
keinesfalls überbewertet werden. Aber sie dürfen den-
noch Anstoß sein, unser schwierig zu beurteilendes
Stück in Malibu auf eine mögliche sizilische Prove-
nienz hin abzutasten.

Gestaltung von Sphingen- und Greifenkopf,
heraldische Gruppierung der Mischwesen, katzenar-
tige Gespanntheit ihrer Haltung, sorgfältige Innen-
zeichnung von Brust und Gefieder sowie der elegante
Schwung der Schwänze sprechen nicht gegen eine

Datierung der Malibu-Platte ins 1. Jahrzehnt des 6. Jahrhunderts, die für das Relief aus Himera allgemeinhin vorgeschlagen wird.[41] Trotz dieser zeitstilistischen Parallelen vertritt das Malibu-Relief keineswegs die sizilische Formensprache des Stückes in Palermo (Abb. 4). In Ermangelung von geeigneten sizilischen Greifendarstellungen[42] läßt sich das am besten vom Sphingengesicht auf der Platte aus Himera ablesen. Es ist eine grob modellierte fleischige Masse. Der Brauenbogen erscheint unpräzise aus dem Ton herausgeformt. Ausdruckslos bleibt der mittelgroße Mund. Die beutelähnliche Haarmasse führt ihr Eigenleben. Ganz andere Stilzüge charakterisieren den Kopf der Sphinx in Malibu. Die Einzelformen ihres Gesichts vereinen sich straff ohne Wölbungen, ohne dabei hager zu wirken. Der Brauenbogen ist als feiner Wulst aufgelegt, genau so wie die Lidumrandung der Augen. Ernst bleibt der kleine Mund mit den feinen Lippen. Die Haare, differenziert unterteilt, setzen annähernd die Reliefebene des Gesichts fort. Bedingt durch die Ausgewogenheit von zierlichen Details und sanft gestufter Höhe des Reliefs wirkt der Kopf der Malibu-Sphinx beinahe zerbrechlich. Seine stilistische Qualität übertrifft nicht nur das Pendant auf der Himera-Platte, sondern auch die m. E. einzigen vergleichbaren sizilischen Reliefsphingen des frühen 6. Jahrhunderts aus Caltagirone,[43] die in ihrem korinthisierenden Duktus keine Ähnlichkeit mit der Malibu-Sphinx verraten.

### Fragmente tarentinischer Reliefgefäße

Wenn die Teilanalyse der Terrakottaplatte aus Himera (Abb. 4) ergeben hat, daß Sizilien als kunsttopographische Heimat unseres Reliefs ausscheidet, könnte man diese noch im übrigen griechischen Westen, in Unteritalien, suchen. Vergleichsgeeignet sind zwei Fragmente archaischer Reliefgefäße, die M. Borda[44] aufgrund ihrer Herkunft und Tonqualität für tarentinisch hält und bezüglich Bildthematik und Ausführung in die 2. Hälfte des 7. Jahrhunderts datiert.

Ein Bruchstück (Abb. 5)[45] mit einer schreitenden Sphinx ist kretisch beeinflußt. Das andere (Abb. 6)[46] korinthisch geprägt, zeigt außer Tieren den Rest eines Greifenkopfes. Die Darstellungen sind, ähnlich wie im Malibu-Relief, durch waagerechte Linien begrenzt. Aber trotz dieser gewissen Übereinstimmungen gehört unsere Sphinx-Greif-Platte nicht zu einer tarentinischen Denkmälergruppe. Das machen Detailvergleiche deutlich, die anhand der Abb. 1a,c, 5 und 6 leicht realisierbar sind.

Zwei Friesstücke mit Greifenvögeln und geflügelten Meermännern,[47] die mit den von M. Borda bearbeiteten Fragmenten in Zusammenhang stehen könnten, ergeben auch keinen ikonographisch-stilistischen Gleichklang mit unserem Relief, um es als tarentinische Arbeit mit kretischen bzw. korinthischen Zügen zu klassifizieren.

### Tonplatte aus S. Lorenzo del Vallo

Ein weiteres, dem Malibu-Relief vergleichbares Denkmal ist eine Tonplatte aus S. Lorenzo del Vallo.[48] Sie zeigt u. a. eine sitzende Sphinx mit erhobenem Vorderbein gegenüber einem schreitenden Greifen. Alle Darstellungen auf diesem Relief in Crotone offenbaren eine Mischung von griechischem, großgriechischem, etruskischem und indogenem Formengut,[49] das sich bei den Fabelwesen in Malibu nicht feststellen läßt.

Somit ist festzuhalten: Mit dem kretischen Votiv aus Praisos (Abb. 2), der sizilischen Tafel aus Himera (Abb. 4), den Fragmenten tarentinischer Gefäße (Abb. 5, 6) und dem Relief aus S. Lorenzo del Vallo erschöpfen sich die wenigen Denkmäler mit Sphingen bzw. Greifen, die unserem Exponat in Malibu gattungsverwandt sind, ohne seine künstlerische Provenienz bestimmt zu haben.

### VERWANDTE DARSTELLUNGEN AUF BRONZEARBEITEN

Die metallhafte Finesse, mit der Köpfe und Flügel der Fabelwesen im Malibu-Relief (Abb. 1b, c) gestaltet sind, erinnert deutlich an die präzise Detailausarbeitung toreutischer Erzeugnisse. Dieser Tatbestand macht wahrscheinlich, daß der Koroplast sein Tonrelief an Bronzearbeiten orientierte bzw. dieselben imitierte oder vielleicht sogar eine qualitätvolle Bronzeform für seine Schöpfung benutzte.

### Korinthische Bronzearbeiten

Archaische Bronzeformen, die als Matrizen für Tonabzüge gedient haben können, sind selten erhalten. Das hier in Abb. 7 wiedergegebene Stück aus Korfu bezeugt protokorinthisches Kunstschaffen um 650 v.Chr.[50] In einem Bildfeld ist ein Greif zu erkennen, der jedoch im Wesentlichen ohne stilistische und formale Parallelen zu demjenigen in Malibu bleibt.

Alle anderen, mir bekannten Sphingen und Greifen auf korinthischen Bronzearbeiten des 7. und 6. Jahrhunderts,[51] die für die kunsttopographische Eingrenzung unseres Reliefs herangezogen werden

ABB. 4

Terrakottarelief aus Himera. Palermo, Museo Nazionale H.63.7836
(nach N. Boncasa, *ASAtene* 45–46, n.s. 29–30 [1967–1968], 306,
Abb. 4).

ABB. 5

Fragment eines Reliefgefäßes. Amsterdam, Allard Pierson
Museum 2697.

ABB. 6

Fragment eines Reliefgefäßes. Bonn, Akademisches Kunstmuseum
D 25876.

ABB. 7

Bronzeform aus Korfu. Oxford, Ashmolean Museum G.437.

ABB. 8

Bronzeblech aus Eleutherai. London, Britisches Museum.

könnten, stimmen zwar zuweilen im Grundtypus und in diversen typologischen Details mit den Malibu-Fabelwesen überein, aber in ihren Einzelformen sind sie steifer erfaßt. Eine gewisse stilistische Sprödigkeit bindet sie an ihren Bildträger. Das gilt nicht nur für die antithetischen Paare männlicher Sphingen und Greifen auf einem Blech aus Eleutherai (Abb. 8),[52] sondern auch für die Sphingenwappen der korinthisch argivischen Schildbänder,[53] deren heraldisch gruppierte Sphingen unauflöslich miteinander verbunden sind und zuweilen wie verschweißt mit ihrem Mittelornament wirken (Abb. 9).[54]

Besonders diese feste Zentrierung im Wappen, die als auffälliger Stilzug ja ebenso die korinthische Vasenmalerei[55] durchzieht, scheint mir eine Abhängigkeit des Malibu-Reliefs von korinthischen Bronzearbeiten auszuschließen.

### Kretische Bronzerüstungen

Der Terrakottaplatte in Malibu (Abb. 1a–c) mangelt es ferner an einer Verwandtschaft zu Darstellungen auf kretischen Bronzen. Das offenbaren beispielsweise die feingliedrigen Greifen auf einem kretischen Panzer aus Arkades (Abb. 10)[56] oder die unbeweglich wirkenden Sphingen auf einer kretischen Mitra.[57]

### Ostgriechische Bronzebleche

Recht gut vergleichen läßt sich das Malibu-Relief hingegen mit ostgriechischen Bronzeblechen. Es ist angemessen, hier zunächst die weit gefaßte kunsttopographische Benennung ,,ostgriechisch'' zu wählen, weil auch Bleche herangezogen werden, deren genauere künstlerische Provenienz innerhalb des ostgriechischen Raums noch nicht festliegt.

Folgende Bronzebleche aus Olympia bieten sich aufgrund ihrer ähnlichen Darstellungsinhalte für Vergleiche mit der Tonplatte im J. Paul Getty Museum an:

Nr. 1. Potnia-Greifen-Blech (Abb. 11)[58]
In vier Bildfeldern, von unten nach oben angeordnet, erscheinen eine Potnia Theron, Herakles und der Kentaur, antithetische Greifen, drei Adler.

Nr. 2. Blech mit schreitendem Greifen (Abb. 12)[59]
Ein Greif schreitet nach links auf ein vegetabilisches Ornament zu.

Nr. 3. Sphingen-Widder-Blech (Abb. 13)[60]
Antithetische Sphingen, zu Seiten eines Volutenbaumes, werden von Widdern gerahmt.

Nr. 4. Greifen-Reiher-Blech (Abb. 14)[61]
Ein heraldisches Greifenpaar umfängt einen Reiher und wird von Sphingen eingeschlossen.

ABB. 9

Ausgewählte Sphingenwappen von Schildbandreliefs (Zeichnung und Datierung nach E. Kunze, *OlForsch* 2 [1950]).

Zwischen den angeführten Blechen und unserem Tonrelief gibt es eine Reihe interessanter Übereinstimmungen. So erscheinen die antithetischen Greifen des Potnia-Greifen-Blechs Nr. 1 (Abb. 11) zwischen waagerechten Linien wie die Fabelwesen in Malibu. Auch ihre Bildfelder sind von ähnlicher Größe[62] und verjüngen sich leicht zum oberen Rand der Darstellung.

Die so gleich aussehenden Greifen in Nr. 1 sind nicht vollkommen identisch. Dieser Befund läßt sich einfach festschreiben. Faltet man nämlich eine Zeichnung mit den Hauptrelieflinien der Greifen senkrecht in der Mitte, dann decken sich die Linien nicht, sondern variieren geringfügig in ihrem Verlauf. Kaum merkliche Abweichungen von der Achsialsymmetrie, die bei Abb. 15a zwischen Umrißzeichnung und Silhouette sichtbar gemacht werden, scheinen mir mitverantwortlich zu sein für jenes ,,Schwimmen des

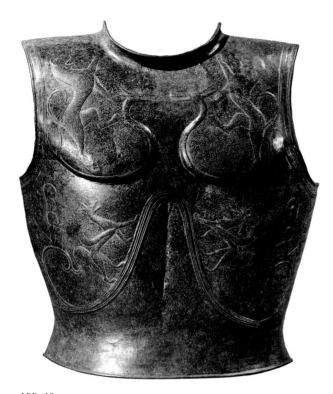

ABB. 10

Bronzepanzer aus Arkades. Hamburg, Museum für Kunst und
Gewerbe 1970.26a.

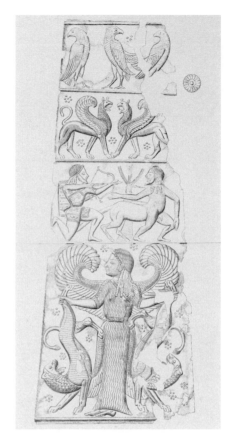

ABB. 11

Bronzeblech aus Olympia. Athen, National-
museum B.6444 (nach Furtwängler, *Olympia,*
Taf. 38).

ABB. 12

Bronzeblech aus Olympia. Olympia, Museum B.4347. Photo:
H.-V. Herrmann, DAI, Athen, Nr. OL.4661.

Bildes" im umgebenden Raum,[63] das als Charakteristikum für Darstellungen auf ostgriechischen Blechen gilt. Dieses Phänomen trifft auch für die Körper der Fabelwesen in Malibu zu, wie Abb. 15b belegt. Obgleich eingebunden in die „symmetrische Bildform,"[64] ruhen sie frei auf dem sie hinterfangenden Reliefgrund.

Die Greifen in Blech Nr. 1 (Abb. 11) und der Greif auf der Terrakottaplatte sind reinster ostgriechischer Prägung mit dem ihnen eigentümlichen Kopftypus[65]: Die Schädelkontur bleibt relativ flach. Sanft gerundet neigt sich die vordere Spitze des oberen Schnabels, bevor sie sich hakig abwärts senkt. Das mäßig hochgezogene Ohr knickt leicht nach vorn oder hinten ab. Fast bildet es eine Einheit mit dem linear angelegten Halspolster. Die üblicherweise spannungsvoll zum Oberschnabel weisende Zunge fehlt beim Malibu-Greifen. Man könnte sie sich gemalt denken.[66]

Eine weitere bezeichnende Parallele zwischen Nr. 1 und dem Relief des J. Paul Getty Museums verraten die Köpfe von Potnia Theron und Sphinx. Ein Blick auf die Abb. 1b und 11 zeigt, daß Gesichts- und Kopfproportionen annähernd übereinstimmen. Göttin und Sphinx tragen ein Haarband. Für beide läßt sich

ABB. 13

Bronzeblech aus Olympia. Olympia, Museum B.4348. Photo: H.-V. Herrmann, DAI, Athen, Nr. OL.4662.

ABB. 14

Bronzeblech aus Olympia. Olympia, Museum B.165 (nach E. Kunze und H. Schleif, *OlBer* 2 [1938], Taf. 55).

jene ostgriechische Haarstilisierung[67] beobachten, bei der das Haupt von fließenden, rieselnden Strähnen umspielt wird.

Der Greif auf dem Blech Nr. 2 (Abb. 12) verbindet sich mit dem des Tonreliefs in Malibu (Abb. 1c) durch den oben beschriebenen ostgriechischen Kopftypus. Beide ziert zudem eine dünne, in bescheidener Volute endende Locke, die ohne besondere Hervorhebung der Halsseite aufliegt bzw. die Halskontur begleitet.

Der Vergleich von Sphingen-Widder-Blech Nr. 3 (Abb. 13) und der Malibu-Platte ergibt eine Parallelität bezüglich der Sphingen. Soweit das Foto erkennen läßt, gilt das besonders für die nach links gewendete Sphinx in Nr. 3. Abgesehen von Profil, Frisurbildung und oben bereits skizzierter ostgriechischer Haarstilisierung, die vergleichbar sind, fällt ferner auf, daß die Enden der herabhängenden Haarsträhnen bei der betreffenden Sphinx ähnlich faserig in die Schuppenzone des Flügels übergehen.

Als weitere Arbeit ostgriechischer Toreuten möchte ich das Greifen-Reiher-Blech Nr. 4 (Abb. 14) unserer Terrakottaplatte in Malibu zur Seite stellen. Das mag in diesem Zusammenhang verwundern.

Nr. 4 galt bislang allgemeinhin als protokorinthisches Werk. Es einer ostgriechischen Bronzeblechgruppe einzureihen, wäre sinnlos. Die von mir bereits früher, wenn auch nur vorsichtig geäußerten Zweifel an der protokorinthischen Faktur des Greifen-Reiher-Blechs[68] haben sich verstärkt. Seine Greifen zeigen eindeutig die Charakteristika ostgriechischer Greifenbilder.[69] Die Komposition gleicht darüberhinaus dem Sphingen-Widder-Blech Nr. 3 (Abb. 13), denn so wie die Sphingen dieses Bleches beidseitig auf den Volutenbaum zuschreiten, flankieren die Greifen in Nr. 4 (Abb. 14) den Wasservogel.[70] Der stilisierte Baum zum einen und der Vogel zum anderen schließen die Sphingen- bzw. Greifenpaare zusammen, ohne sie jedoch fest mit dem entsprechenden Mittelornament zu verketten. Und trotz einer Begrenzung durch das ihnen zugewiesene Bildfeld, das für beide Fabelwesengruppen in seiner Verjüngung zum Ende hin identisch ist, sind die Figuren nicht in einem geschlossenen Achsensystem gefangen wie ihre Verwandten auf korinthischen Denkmälern (s.O., Abb. 8, 9).

Die Flügel der Sphingen und Greifen, ebenso die der Herrin der Tiere auf den Blechen Nr. 1–4 (Abb. 11–14), haben mit denen der Fabelwesen in

ABB. 15a

Greifen des Potnia-Greifen-Blechs (vgl. Abb. 11). Achsialsymmetrische Abweichungen. Zeichnung: Tim Seymour nach Original von A. Dierichs.

ABB. 15b

Körper von Sphinx und Greif des Malibu-Reliefs. Achsialsymmetrische Abweichungen. Zeichnung: Tim Seymour nach Original von A. Dierichs.

Malibu die Stilisierung ostgriechischer Sichelflügel gemein: Diese zeigen oft eine sorgfältig geschuppte Schulterbahn sowie eine starke Endeinkrümmung. Zuweilen charakterisiert sie auch eine Besonderheit ihres Gefieders. So kann die Schwungfederbahn des Sichelflügels zweireihig gebaut sein. Ist das der Fall, schichten sich häufig kürzere Schwungfedern, deren Enden durch kleine Bögen kenntlich gemacht werden, auf längere.[71] Bei der Malibu-Sphinx erkennt man eine noch diffizilere Anordnung der Federn. Die

Grenzlinie zwischen Schuppen und Gefieder ist sogar durch drei Reihen kurzer Federn gesäumt, die filigranhaft auf den üppig gestalteten Schwungfedern ruhen. Solche Details offenbaren besonders deutlich die Abhängigkeit von Bronzearbeiten und stützen die Vermutung, daß unser Relief möglicherweise aus einer Bronzematrize herausgedrückt wurde. Dieser Vorgang würde auch die verunklärte Brustschuppung des Greifen und seinen in der Mittelzone anders gearteten Flügel erhellen. Letzterer hätte gemäß archaischen Gestaltungswillens mit dem Flügel der Sphinx übereinstimmen sollen, kam beim Abdruck jedoch nur bröckelnd oder unscharf und wurde manuell überarbeitet.

Ein weiterer ostgriechischer Zug, der die Fabelwesen der Bleche Nr. 1–4 (Abb. 11–14) mit denen des Malibu-Reliefs verbindet, liegt in der lockeren Berührung an den Vorderpfoten.[72] Sie nimmt den heraldischen Gruppen die oben erwähnte starre Wappenformation vergleichbarer peloponnesischer Denkmäler.

Ostgriechisch sind ferner, sowohl bei den Blechen Nr. 1–4 (Abb. 11–14) als auch auf unserer Terrakottaplatte, die akzentuierte Bildung der Tatzen von Tieren bzw. Fabelwesen: Sie manifestiert sich in wulstigen Zehen, leichten Einziehungen zwischen Wadenbein und Fußwurzelknochen, desgleichen in doppelten Schrägstrichen an den Unterschenkeln.[73]

Als vorerst letztes ostgriechisches Merkmal, das die nun mehrfach erwähnten Bleche Nr. 1–4 (Abb. 11–14) mit unserem Tonrelief verknüpft, ist die raubkatzenartige Gespanntheit der Fabelwesen zu nennen. Sie entsteht aus einem Absenken der Brust auf entsprechend verkürzte Vorderbeine, einem walzenförmig zum Schwanz hin aufsteigenden Rumpf und einem dominierenden Hinterteil auf oft unrealistisch hohen Beinen.[74]

Die Bronzearbeit, die der Künstler des Exponats in Malibu kannte, imitierte oder vielleicht sogar als Matrize benutzte, entstammte einer ostgriechischen Kunstlandschaft. Diese Feststellung läßt sich anhand der diskutierten Analogien zwischen den ostgriechischen Blechen Nr. 1–4 (Abb. 11–14) und unserer Sphinx-Greif-Tafel erhärten, so daß ich mir die imaginäre Bronzearbeit, von der das Malibu-Relief abhängt, in der Art des Potnia-Greifen-Blechs Nr. 1 (Abb. 11), des Blechs mit dem schreitenden Greifen Nr. 2 (Abb. 12), des Sphingen-Widder-Blechs Nr. 3 (Abb. 13) und des Greifen-Reiher-Blechs Nr. 4 (Abb. 14) erschließen möchte.

Bemerkenswert in diesem Zusammenhang erscheint mir die Kombination von Sphinx und Greif

ABB. 16

Bronzepinzette aus Cumae. Boston, Museum of Fine Arts 01.7511a, b (nach Comstock und Vermeule, *Greek, Etruscan and Roman Bronzes,* Nr. 626).

auf der in Abb. 16 wiedergegebenen Bronzepinzette, deren ostgriechisch-südrussischen Mischstil ich an anderer Stelle ausführlich besprach.[75]

### DIE TONPLATTE IN MALIBU: EIN ZEUGNIS DER SAMISCHEN KUNST

Die kunsttopographische Heimat unseres Terrakotta-reliefs, die oben bereits als ostgriechisch festgeschrieben wird, läßt sich noch genauer eingrenzen.

Wie zuvor dargelegt, zeigen Sphinx und Greif in Malibu die meisten Übereinstimmungen mit dem Potnia-Greifen-Blech (Abb. 11), also gerade mit jenem Bronzeblech, dessen ostionischer Stil wohl stets außer Frage stand. Seine samische Faktur, die zuweilen schon vermutet wurde, darf nun seit kurzem durch den spektakulären Neufund des samischen Geryoneus-Blechs (Abb. 17) als gesichert gelten.[76] Die Ähnlichkeiten zwischen dem samischen Potnia-Greifen-Blech (Abb. 11) und der Terrakottaplatte in Malibu erlauben somit, letztere ebenfalls im samischen Kunstkreis anzusiedeln.

Diese kunsttopographische Zuordnung bestätigt sich darüberhinaus durch mehrere Vergleiche zwischen Malibu-Relief und verschiedenen Werken des ostionisch-samischen Kunstschaffens. Das belegen die folgenden Ausführungen.

In der ostionischen Tierfrieskeramik des 7. und 6. Jahrhunderts,[77] als dessen Hauptzentren bekanntlich Rhodos und Samos gelten, gibt es antithetische Paare von Sphingen und Greifen, allerdings im Motiv

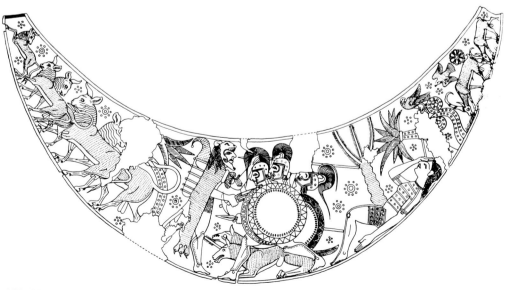

ABB. 17

Bronzeblech. Samos, Archäologisches Museum B 2518 (nach Brize, Beil. 2).

ABB. 18

Fragment eines Kraters (nach H. Walter, *Samos* 5 [1968], Abb. 43).

der Sprungbereitschaft.[78] Sie gehören in die erste Hälfte des 6. Jahrhunderts. Auf der älteren, um 630 v.Chr. entstandenen Oinochoe Lévy[79] findet sich eine dem Fabelwesenpaar in Malibu noch besser vergleichbare Gruppe aus Sphinx und Greif, weil sie ebenfalls schreitend wiedergegeben sind.[80] Der Gesichtstypus der Sphinx auf der Oinochoe Lévy, der annähernd den einer Sphinx auf einem neu gefundenen Vasenfragment aus Samos wiederholt,[81] liegt etwa eine Generation vor dem des Malibu-Reliefs.

Zeitstilistisch näher hingegen und deutlich verwandt in Gesichtsbildung und Haartracht sind die Sphinx unserer Platte und der Flötenspieler auf der zwischen 610 und 580 v.Chr. datierten samischen Reigentanz-Hydria.[82]

Gewisse Entsprechungen für den vegetabilisch ausgeformten Knauf des Malibu-Greifen, der zum einen an einige orientalische[83] Greifenköpfe erinnert und zum anderen die nach innen eingerollte Stirnlocke des Euryton im Geryoneus-Blech (Abb. 17)[84] assoziiert, lassen sich nur in der ostionisch-samischen Vasenmalerei finden. Auf dem Fragment einer Vase aus Milet[85] ist der Knauf eines Greifenkopfes als Blüte stilisiert. Eine ähnliche Kopfzier trägt der Greif auf einem gemalten Pinax aus Bayrakli[86] und ein anderer auf einem samischen Krater (Abb. 18).[87]

Selten haben auch bronzene Greifenprotomen solche blütenartigen Knäufe. Von den wenigen, m.E. nur fünf, bekannten Beispielen stammen nun interessanterweise vier von der Insel Samos,[88] infolgedessen man an ihre Entstehung in einer samischen Werkstatt denken könnte. Die betreffenden Protomen gehören in die erste Hälfte des 7. Jahrhunderts, genau wie einige andere auf Samos gefundene Protomen,[89] die

sich in ihrer Profilansicht recht gut mit dem Greifen in Malibu vergleichen lassen. Man beachte den vom Ohr ausgehenden Wulst. Bei den Protomen läuft er wie der Kehlsack eines Pelikans unter dem Schnabel um, während er sich beim reliefierten Greifen zu einem graphisch wirkenden Halspolster plattdrücken muß. Eine schwunglose, im Relief aufgesetzte Spirallocke der Protomen entspricht der Locke des Malibu-Greifen, die steif auf seiner Halskontur liegt. Der Greifenkopf unseres Reliefs unterwirft sich dem von U. Jantzen[90] für die Protomen der ersten Hälfte des 7. Jahrhunderts beobachteten Diagonalsystem aus verlängerter Knauf- und Ohrlinie. Da das Sphingengesicht in Malibu, wie unten noch zu diskutieren ist, erst ins 6. Jahrhundert datiert, hätte man eher eine Parallelität unseres Greifenkopfes zu ,,späten'' Protomen aus der Wende vom 7. zum 6. Jahrhundert erwartet. Es ist somit festzuhalten, daß der Künstler des Malibu-Reliefs mit dem menschlichen Antlitz der Sphinx dem erreichten Zeitstil folgt, während er im Greifenprofil den älteren Greifenkopftypus aus der Zeit der ersten Hohlgüsse der Protomen tradiert. Dieser Befund bestätigt erneut die Langlebigkeit des hocharchaischen ostionischen Greifenkopftypus[91] und macht die Unsicherheit in der Datierung zahlreicher Greifendarstellungen[92] verständlich.

Ein Ton-Pinax,[93] der mit spät- bis subgeometrischer Keramik auf Samos zutage kam, soll als nächstes mit dem Malibu-Relief in Verbindung gebracht werden. Er belegt frühe gestempelte Tonvotive auf Samos. In ihrer Tradition mag das von der Bronzekunst abhängige, vielleicht aus einer Metallmatrize gewonnene Terrakottarelief des Getty Museums gesehen werden. Als Einzelstück stellt sich unsere Sphinx-Greif-Platte dem älteren singulären Fund zur Seite.

Ein weiblicher Kopf, der zu einem von den Ausgräbern als samisch nachgewiesenen Fund von Terrakotten des frühen 6. Jahrhunderts gehört,[94] zeigt S-förmige Stirnlocken, ganz ähnlich wie sie auch die Sphinx in Malibu trägt. Die Haarmasse des erwähnten Kopfes ist aus der Form gepreßt, während die feinen Haarritzungen nachträglich angebracht sind. Der Koroplast kombinierte also den mechanischen Abdruck aus der Matrize und die Feinarbeit mit dem Modellierstab. Dieselbe Technik—für die oben genannte geschlossene samische Statuettengruppe aus Ton nachgewiesen—scheint auch beim Malibu-Relief angewendet worden zu sein; etwa an der Stelle, wo die aufgefächerten Haarsträhnen der Sphinx die Schuppen des Oberkörpers überlappen.

Von samischen Elfenbeinarbeiten, die sich mit

ABB. 19

Drei Ansichten eines „Schiebers" aus Elfenbein. Samos, Archäologisches Museum E 6. Photo: B. Freyer-Schauenburg und U. Jantzen.

unserer Sphinx-Greif-Platte vergleichen lassen, ist zunächst das Perseus-Relief[95] aus dem letzten Viertel des 7. Jahrhunderts zu nennen. Der ins Profil gewendete Kopf der Athena mutet an, als gehöre er einer älteren Schwester der Sphinx in Malibu, und die Flügelstilisierung der Gorgo stimmt mit jener der Fabelwesen des Terrakottareliefs überein.

Ferner möchte ich auf einen fragmentierten Schieber (Abb. 19) hinweisen, den B. Freyer-Schauenburg als das kunstvolle Werk samischer Schnitzer des letzten Viertels des 7. Jahrhunderts bestimmt.[96] Er könnte m. E. auch erst zu Beginn des 6. Jahrhunderts entstanden sein. Das Gerät bekrönen drei weibliche Protomen mit fein gegliederter Haarmasse, die das Ohr unverdeckt läßt. Diese Stilisierung und Ordnung des Haares kehrt bei der Malibu-Sphinx wieder.

Für einen Vergleich mit dem Malibu-Relief bietet sich als dritte samische Elfenbeinarbeit ein wohl erst um die Mitte des 6. Jahrhunderts zu datierender kleiner männlicher Kopf an, dem nach der vorbehaltlich geäußerten Meinung von U. Sinn eine Schlüsselrolle bei der Bestimmung einer lokalen Schule samischer Elfenbeinschnitzkunst zukommt.[97] Ich meine, das akzentuierte Profil des betreffenden Kopfes spiegelt sich in dem der Malibu-Sphinx wider. Darüber hinaus sind die einzelnen Teile des männlichen und des weib-

lichen Gesichts so geprägt, daß sie das Knochengerüst durch feinste Schwellungen verdecken und eine flächige Wirkung der Physiognomie vermeiden.

Diesen Gesamteindruck wiederholen zwei weitere Denkmäler, deren samischer Duktus feststeht: eine Holzkore (Abb. 20)[98] aus dem ersten Viertel des 6. Jahrhunderts und eine Terrakottamaske (Abb. 21),[99] deren Datierung noch umstritten ist.

C. Rolley beobachtete, daß bei den besten der samischen Bronzen die Entwicklung des Kopfes den Abschluß einer allmählichen Entfaltung der ganzen Gestalt von unten nach oben bilde.[100] Diese für vollplastische Werke formulierte Charakterisierung läßt sich auch auf Bronzebleche des samischen Kunstbereichs übertragen, etwa für die Kentauren und die Potnia des Potnia-Greifen-Blechs (Abb. 11).[101] Ich meine, sie auch bei der Sphinx des von Bronzearbeiten abhängigen Malibu-Reliefs wiederzufinden. Und wenn bei den Fabelwesen in Malibu eine Diskrepanz in der Modellierung auffällt, nämlich zwischen einfachen großflächigen Körperformen und metallartig präzise gearbeiteten Dekorationsdetails, dann scheint mir in diesem Gegensatz abermals ein Reflex samischer Bronzebleche zu liegen.[102]

Aufgrund der zahlreichen, oben angeführten Parallelen, die unsere Terrakottaplatte mit diversen samischen Werken zeigt, darf sie ebenfalls als samisches Produkt angesprochen werden. Besonders durch die Ähnlichkeiten mit toreutischen Erzeugnissen dieses Kunstkreises wage ich die engere Lokalisierung auf Samos vorzuschlagen.[103]

### DATIERUNG

Die Datierung des Malibu-Reliefs basiert auf dem Kopf der Sphinx (Abb. 1b). Er hat zwar die Starrheit der dädalischen Form des 7. Jahrhunderts überwunden, aber er ist noch nicht befreit durch das Lächeln vieler archaischer Gesichter aus dem zweiten Viertel des 6. Jahrhunderts. Eine Entstehung zwischen 600 und 575 v.Chr. halte ich für wahrscheinlich. Somit ergibt sich eine annähernde Zeitgleichheit mit dem Potnia-Greifen-Blech (Abb. 11),[104] das ja auch Ausgangspunkt für die kunsttopographische Einordnung unseres Reliefs war und dem wohl eine Schlüsselstellung bei der stilistischen Beurteilung aller ostgriechischen Bronzebleche einzuräumen ist.[105]

### URSPRÜNGLICHE VERWENDUNG

Das Relief in Malibu könnte als Pinax[106] gedient haben, der in das Heiligtum einer Gottheit geweiht

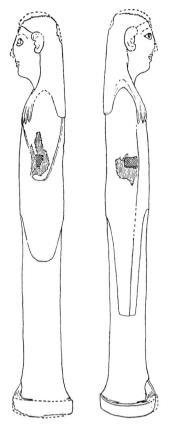

ABB. 20

Holzkore. Samos, Archäologisches Museum
H 42 (nach G. Kopcke, *AM* 82 [1967], 106,
Abb. 1).

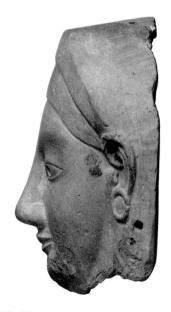

ABB. 21

Weibliche Terrakottamaske. Kassel, Staatliche
Kunstsammlungen S 54.

wurde.[107] Seine Nähe zu Arbeiten aus Metall assoziiert
eine Inschrift auf Samos, die besagt, daß zwei Perin-
ther der Hera ihren Zehnt entrichteten in Form einer
goldenen Gorgo, eines silbernen Sirens, einer Silber-
schale und einer ehernen Lampe.[108] Die ursprünglich
vorhandenen Befestigungslöcher unseres Reliefs spre-
chen für seine Deutung als Pinax, und die zuvor in
anderem Zusammenhang erwähnten Votive[109] belegen
das frühe Vorkommen dieser Denkmälergruppe im
ostgriechischen Raum, wenngleich seine erhaltenen
Weihreliefs zahlenmäßig hinter dem Bestand an
Pinakes aus anderen Kunstlandschaften zurück-
bleiben.[110]

Der gute Erhaltungszustand unserer Terrakotta-
platte deutet möglicherweise darauf hin, daß sie nicht
lange den Witterungseinflüssen in einem offenen Hei-
ligtum ausgesetzt war. Vielleicht stammt sie aus
dem Bereich des Grabkults und wurde als Grabbei-
gabe verwendet. Der chtonische Bezug von Sphinx und
Greif spräche durchaus für eine solche Vermutung.[111]

Da die Vorderseite der Terrakottaplatte in Malibu
eine leichte konvexe Wölbung mit minimalem Krüm-
mungsradius zeigt, ist man versucht, sie mit den
kaum merklich gerundeten Reliefs zu parallelisieren,
auf denen Göttinnen in prächtigen Kultgewändern
stehen. Ob die Matrizen, denen diese Stücke entstam-
men, aus Ton oder Metall bestanden, ist ungewiß. Zu
einem Exemplar in Neapel[112] existiert ein Korrespon-
denzabdruck in Francavilla (Abb. 22).[113] Im Gewand
der Gottheit des letzteren erscheint in der untersten
Stufe ein antithetisches Sphingenpaar. Weihungen
dieser Art—die genannten gehören in den großgrie-
chischen Kunstbereich—sind auch für den ostgriechi-
schen Raum nicht auszuschließen. Verwandtes
zumindest liegt in einer noch im 7. Jahrhundert ent-
standenen Göttinnen- oder Frauenstatuette vor, deren
Gewand mit Tieren und Fabelwesen bemalt ist.[114]
Unser Bildfeld mit Sphinx und Greif, als Bestandteil
eines ähnlichen Göttinnenreliefs zu sehen, bleibt aller-
dings unbefriedigend hypothetisch.

Eine andere ursprüngliche Funktion des Reliefs
in Malibu ist wahrscheinlicher. Da oben gezeigt
wurde, daß unsere Sphinx-Greif-Platte von toreuti-
schen Erzeugnissen abhängt, ist durchaus möglich, in
ihr die Abformung aus einer Bronzematrize zu verste-
hen. Denn gut gelungene toreutische Teilformen wur-
den ja zuweilen in Ton abgenommen.[115] Die ste-
hengebliebenen Tonstreifen ober- und unterhalb der
waagerechten Begrenzungslinien des Bildfeldes wür-
den die Hypothese stützen, das Malibu-Relief als ein
solches kleines, aus einer Bronzematrize gewonnenes

ABB. 22

Terrakottarelief einer Göttin aus Francavilla (nach R. Hampe und E. Simon, *Tausend Jahre frühgriechische Kunst* [1980], 277, Abb. 35).

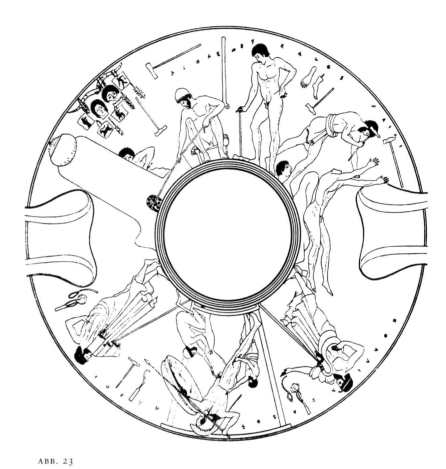

ABB. 23

Außenbild der Erzgießereischale. Berlin, Antikenmuseum F 2294 (nach P. C. Bol, *Antike Bronzetechnik* [1985], 129, Abb. 84).

Tonmodell zu interpretieren, das an einer Werkstattwand hing, wie etwa jene kleinen Täfelchen, die auf der Erzgießereischale (Abb. 23)[116] an einem Gehörn befestigt sind.

Musterabdruck nach einer toreutischen Form (zu Modellzwecken) oder Pinax (als Weihung im Bereich von Grab bzw. Heiligtum), damit dürfte die ursprüngliche Funktion des Malibu-Reliefs am wahrscheinlichsten bestimmt sein.

### ZUSAMMENFASSUNG

Die Terrakottaplatte des Getty Museums, mit ihrer für die griechisch-archaische Flächenkunst typischen Darstellung von Sphinx und Greif, kennt nur wenige gattungsverwandte Denkmäler aus Kreta und der Magna

Graecia. Diese schließen jedoch aus, den Landschaftsstil des Reliefs als kretisch oder großgriechisch festzuschreiben. Mangelnde Übereinstimmungen mit thematisch nahen Bronzearbeiten der korinthischen und kretischen Kunst, aber zahlreiche Bezüge zu Werken aus Bronze und anderen Materialien des ostgriechischen, speziell ostionisch-samischen Kunstschaffens, favorisieren Samos als die kunsttopographische Heimat des Reliefs. Die mit Bronzeblechen dieses Kunstkreises in enger Verwandtschaft stehende Terrakottaplatte in Malibu dürfte im 1. Viertel des 6. Jahrhunderts entstanden sein. Es läßt sich nicht entscheiden, ob sie Weihrelief, Grabbeigabe oder tönerner Abdruck einer bronzenen Teilform war, die als Modell für toreutische Arbeiten diente.

In dem hier besprochenen Stück besitzt das

Getty Museum eine interessante und wertvolle Arbeit der griechisch archaischen Flächenkunst. Erstaunlich, daß ein Werk, dessen Qualität eine künstlerische und handwerkliche Tradition voraussetzt, bis heute vereinzelt dasteht. Aufgrund dieser Singularität der Sphinx-Greif-Platte wurden denn auch Zweifel an der „Echtheit" des Exponats geäußert,[117] so daß es die Verfasserin dieses Artikels für unerläßlich hielt, einen TL–Test zu erbitten. Sein Ergebnis[118] belegte die antike Entstehung der Terrakottaplatte, deren Sonderstellung bestätigt, was P. C. Bol[119] folgendermaßen zusammenfaßt:

Neu bekannt werdende echte Kunstwerke der Antike bieten immer Neues und müssen sich, wenn sie aus düsteren Quellen des Kunsthandels auftauchen, mitunter erst gegen Verdächtigungen durchsetzen. Jede umfangreiche Grabung bringt denn auch Funde an den Tag, die zunächst so befremdlich wirken, daß, wären sie nicht in gut belegten und gut dokumentierten Grabungszusammenhängen, sondern anonym im Kunsthandel aufgetaucht, sie größte Skepsis und Bedenken auf den Plan gerufen hätten.

Münster

### ANMERKUNGEN

Abkürzungen:

| | |
|---|---|
| Brize | P. Brize, „Samos und Stesichoros: Zu dem frühgriechischen Bronzeblech," *AM* 100 (1985), 53–158. |
| Delplace, *Griffon* | C. Delplace, *Le griffon de l'archaïsme à l'époque impériale* (Brüssel und Rom, 1980). |
| Demisch, *Sphinx* | H. Demisch, *Die Sphinx: Geschichte ihrer Darstellung von den Anfängen bis zur Gegenwart* (Stuttgart, 1977). |
| Dierichs | A. Dierichs, „Das Bild des Greifen in der frühgriechischen Flächenkunst: Nachträge," *Boreas* 8 (1985), 5–32. |
| Dierichs, *Bild des Greifen* | A. Dierichs, *Das Bild des Greifen in der frühgriechischen Flächenkunst* (Münster, 1981). |
| Dörig | J. Dörig u. A., *Dädalische Kunst auf Kreta im 7. Jahrhundert v. Chr.* (Mainz, 1970). |
| Eals | N. Eals, *Griffins in Post-Minoan Cretan Art* (University of Missouri, Columbia, 1973). |
| *Funde aus Olympia* | A. Mallwitz und H.-V. Herrmann, *Die Funde aus Olympia* (Athen, 1980). |
| Müller | P. Müller, *Löwen und Mischwesen in der archaischen griechischen Kunst: Eine Untersuchung über ihre Bedeutung* (Zürich, 1981). |
| Payne | H. Payne, *Necrocorinthia: A Study of Corinthian Art in the Archaic Period* (Oxford, 1931). |

| | |
|---|---|
| Reed | N. B. Reed, "Griffins in Post-Minoan Cretan Art," *Hesperia* 45 (1976), 365–379. |
| Rizza und Scrinari | G. Rizza und V. Santa Maria Scrinari, *Il Santuario sull'acropole di Gortina,* Bd. 1 (Rom, 1968). |

Um die Anmerkungsteil nicht noch zu verlängern, wurde D. A. Amyx, *Corinthian Vase Painting of the Archaic Period* (Berkeley, 1988) gar nicht und W. Fuchs und J. Floren, *Die geometrische und archaische Plastik,* Bd. 1, *Die griechische Plastik* (München, 1987) nur vereinzelt zitiert.

1. Inv. Nr. 79.AD.195. Als Anzeige der Galerie „Palladion" (Basel) abgebildet in H. Schlögel, *Geschenke des Nils: Aegyptische Kunstwerke aus Schweizer Besitz* (Basel, 1978); erwähnt und abgebildet: Dierichs, 28, Taf. 1.3.

   Die Anregung zu diesem Artikel verdanke ich M. True. Ihr und K. Manchester, die mir hilfreiche Auskünfte erteilten, fühle ich mich besonders verpflichtet. Für wertvolle Hinweise danke ich ebenfalls E. Böhr, J. Floren, L. Frey, W. Fuchs, P. Gercke, H.-V. Herrmann, G. Kopcke, J. R. Mertens, F. Prayon und M. Schmidt. B. Freyer-Schauenburg und dem J. Paul Getty Museum, ferner den Staatlichen Kunstsammlungen (Kassel), dem Allard Pierson Museum (Amsterdam), dem Antikenmuseum (Basel), dem Akademischen Kunstmuseum (Bonn), dem Museum für Kunst und Gewerbe (Hamburg), dem Britischen Museum (London), dem Ashmolean Museum (Oxford) habe ich für Fotomaterial, C. Newman Bohn und E. Mandell für Korrekturhilfe, zu danken.

2. Literatur zu archaischen Sphingen: N. Verdélis, „L'apparition du sphinx dans l'art grec aux 8ᵉ et 7ᵉ siècles avant J.Ch.," *BCH* (1951), 1ff.; *EAA,* Bd. 7 (Rom, 1966), 230ff., s.v. sfinge (S. Donadoni und L. Banti); W. Schiering, *Werkstätten orientalisierender Keramik auf Rhodos* (Berlin, 1957), 57ff.; H. Walter, *Antike und Abendland* 9 (1960), 63 ff.; C. Kardara, *Rodiaki Angeiographia* (Athen, 1963), 153f. und passim; Demisch, *Sphinx;* Müller, 56ff., 158ff. und passim.

3. Nur die frühe Kleinkunst kennt vereinzelt Sphingen mit bärtigem Männergesicht. Bronzeblech: Demisch, *Sphinx,* Abb. 220 = Dierichs, *Bild des Greifen,* Abb. 33 (hier Abb. 8); Aryballos: J. L. Benson, *Die Geschichte der korinthischen Vasen* (Basel, 1953), Taf. 7.

4. Literatur zu archaischen Greifen: Roscher, *ML* 1, 1742ff., s.v. Gryps (A. Furtwängler); *RE,* Bd. 7 (Stuttgart, 1912), 1902ff., s.v. Gryps (H. Prinz und K. Ziegler); *EAA,* Bd. 3 (Rom, 1960), 1056ff., s.v. grifo (M. G. Marunti, S. I. Rudenko und G. Manganaro); *Reallexikon für Antike und Christentum* 12 (Stuttgart, 1983), 951ff., s.v. Greif (H. Brandenburg); Schiering (a.O., Anm. 2), 57ff.; B. Goldman, „The Development of the Lion-Griffin," *AJA* 64 (1960), 319ff.; P. Amandry, *AM* 77 (1962), 56ff.; Kardara (a.O., Anm. 2), 154ff.; A. M. Bisi, *Il Grifone: Storia di un motivo iconografico nell'antico oriente mediterraneo* (Rom, 1965), 197ff.; Müller, 73ff., 123ff., 201ff.; Delplace, *Griffon,* 13ff.; Dierichs; Dierichs, *Bild des Greifen;* dies., *Boreas* 7 (1984), 15ff.

5. Ein häufiges Haltungsmotiv bei Fabelwesen der archaischen Kunst. Vgl. exemplarisch: Demisch, *Sphinx,* Abb. 228 = *Funde aus Olympia,* Taf. 59.

6. Zur Deutung von Sphingen: Demisch, *Sphinx,* 76ff. passim; Müller, 56ff., 158ff. und passim; Deutungsfacette unter erotischem Aspekt: G. Koch-Harnack, *Knabenliebe und Tiergeschenke: Ihre Bedeutung im päderastischen Erziehungssystem Athens* (Berlin, 1983), 211ff.; A. Dierichs, *Erotik in der Kunst Griechenlands. AntW,* Sonderheft, 1988, 82f. Zur Deutung von Greifen: Demisch, *Sphinx,* 76ff.; Müller, 73ff., 123ff., 201ff. und passim; Dierichs, *Bild des Greifen,* 270ff.

7. Demisch, *Sphinx,* 85f.; Müller, 155f. erwähnt ein Epigramm des späten 6. Jahrhunderts aus Thessalien, das die Sphinx als Wächterin des Grabes überliefert.

8. Demisch, *Sphinx,* 86; Dierichs, *Bild des Greifen,* 188ff. O Sark (Ostgriechenland. Klazomenische Sarkophage), 1–4 = R. M. Cook, *Clazomenian Sarcophagi* (Mainz, 1981), Nr. 29, Fig. 32, Taf. 67; Nr. 12, Taf. 53; Nr. 3; Nr. 28, Taf. 64; s. auch Taf. 8.2, 56, 68, 73, 75.

9. Panzer: H. Hoffmann, *Early Cretan Armorers* (Mainz, 1972), 7f., C1; 37ff., Taf. 21; J. Dörig u. A., *Dädalische Kunst auf Kreta im 7. Jahrhundert v.Chr.* (Mainz, 1970), 33, A6, Taf. 1–4; Dierichs, *Bild des Greifen,* 144ff., Kr B 2, Abb. 56; Mitra: Dörig, a.O., A11, Taf. 10; O. White Muscarella, Hrsg., *Ancient Art: The Norbert Schimmel Collection* (Mainz, 1974), Nr. 11 mit Abb.; Knöchelschiene: *Funde aus Olympia,* Taf. 64.

10. Bronzepinzette: M. Comstock und C. Vermeule, *Greek, Etruscan and Roman Bronzes in the Museum of Fine Arts* (Boston, 1971), Nr. 626 mit Abb. = Dierichs, 21ff., Abb. 8 (hier Abb. 23); Bronzespiegel: H. Metzger, *Anatolien,* Bd. 2 (München, 1969) = Dierichs, *Bild des Greifen,* 212ff., O B 3, Abb. 105, 105a; Marmorlampe: J. D. Beazley, *JHS* 60 (1940), 41f., Fig. 21, Taf. 7 = Dierichs, *Bild des Greifen,* 228ff., O Rel 1, Abb. 122, 122a.

11. Beispiele liefert die gesamte griechisch-archaische Vasenmalerei.

12. R. Laffineur, *L'orfèvrerie orientalisante* (Paris, 1978), 71ff., 231, Nr. 203, Taf. 23.4 = Dierichs, *Bild des Greifen,* 216ff., O Go 7, Abb. 111, 111a; Laffineur, a.O., 69ff., 199f., Nr. 36, 37, 41, 42, Taf. 6.1–3.

13. Protokorinthischer Aryballos: A.-F. Laurens, *Céramique corinthienne et étrusco-corinthienne,* Catalogue des collections, Bd. 1 (Montpellier, 1984), Nr. 7 mit Abb.

14. Demisch, *Sphinx,* 83; umfassend zur thebanischen Sphinx: J. M. Moret, *Oedipe, la sphinx et les thébains: Essai de mythologie iconographique* (Rom, 1984).

15. Kylix: M. F. Vos, *Scythian Archers in Archaic Attic Vase Painting* (Utrecht, 1963) = Dierichs, *Bild des Greifen,* Abb. 37, 37a, 37b; Caeretaner Hydria: T. B. L. Webster, *JHS* 48 (1928), 200, Taf. 11.1 = Dierichs, *Bild des Greifen,* 181, 183ff., O V sonst 7, Abb. 91; Frgt.: R. M. Cook, *BSA* 60 (1965), 137, Nr. 138, Taf. 40 = Dierichs, *Bild des Greifen,* 182ff., O V sonst 8.

16. T. J. Dunbabin, *The Sanctuaries of Hera Akraia and Hera Limenia,* Perachora, Bd. 2 (Oxford, 1962), Nr. 2161, Taf. 86 = Dierichs, *Bild des Greifen,* 17, 59f., K V 59.

17. Dunbabin (a.O., Anm. 16), Nr. 2434, Taf. 97 = Dierichs, *Bild des Greifen,* 13, 42ff., K V 35; F. G. Lo Porto, *ASAtene* 37–38, n.s. 21–22 (1959–1960), 227, Fig. 200a, b = Dierichs, *Bild des Greifen,* 39, 49ff., K V 193, Abb. 31, 31a.

18. Demisch, *Sphinx,* Abb. 222f.; *CVA* Frankreich 12, Louvre 8, III Ca, Taf. 19.2, 7, 8 = Dierichs, *Bild des Greifen,* 9, 42ff., K V 9, Abb. 1; *CVA* Deutschland 15, Mainz 1, Taf. 28 = Dierichs, *Bild des Greifen,* 12, 42ff., K V 25, Abb. 4.

19. Einzelne Greifen im Tierfries: *CVA* Italien 18, Tarent 2, III Cd, Taf. 1.1–3, 3; J. Sieveking und R. Hackl, *Die königliche Vasensammlung zu München,* Bd. 1, *Die älteren nicht attischen Vasen* (München, 1912), 13, Nr. 235, Abb. 19f. = Dierichs, *Bild des Greifen,* 17, 42ff., K V 56–60; K. Friis Johansen, *Les vases sicyoniens* (Rom, 1966), Nr. 55, Taf. 34.2; M. Robertson, *BSA* 43 (1948), 39, Abb. 26, 146; Dunbabin (a.O., Anm. 16), Nr. 2161, Taf. 86; einzelne Sphingen im Tierfries: Payne, passim; Dunbabin (a.O., Anm. 16), passim.

20. Demisch, *Sphinx,* 81, vgl. in diesem Zusammenhang I. E. M. Edlund, *Meded* 42 (1980), 31ff.

21. E. Simon, *Die Götter der Griechen* (München, 1969), 169ff., bes. 172.

22. I. Scheibler, *Die symmetrische Bildform in der frühgriechischen*

*Flächenkunst* (Kallmünz, 1960), 22: in der gesamten frübarchaischen Wappenkomposition sind Sphingen- und Löwenwappen am häufigsten; Dierichs, *Bild des Greifen,* 58, 99, 162f., 179, 187: zu den antithetischen Greifengruppen auf korinthischen, attischen und ostgriechischen Vasen.

23. s. Anm. 19.

24. Dörig, Kat. 39(b), Taf. 38c.

25. Agios Nikolaos, Arch. Mus. 1668: Reed, Nr. 7, Taf. 82 = Dierichs, *Bild des Greifen,* 138, 141ff., Kr T 9 (hier Abb. 2).

26. Sphingen aus Gortyn: Rizza und Scrinari, Taf. 14.79a, 19.108, 20.122. Greifen aus Praisos: Paris, Louvre AM 839. S. Mollard-Besques, *Catalogue raisonné des figurines et reliefs en terre cuite grecs, étrusques et romains,* Bd. 1 (Paris, 1954), 31, B 178, Taf. 22 = Reed, 369 und Nr. 6 = Dierichs, *Bild des Greifen,* 138, 141ff., Kr T 8; Herakleion, Arch. Mus. 1395: Reed, Nr. 11, Taf. 83 = Dierichs, *Bild des Greifen,* 139, 141ff., Kr T 11; Agios Nikolaos, Arch. Mus. 19: Reed, Nr. 8, Taf. 83 = Dierichs, *Bild des Greifen,* 139, 141ff., Kr T 12. Literatur zu kretischen Reliefpinakes: Dörig, 94f. (mit ausführlicher Bibliographie).

27. s. Anm. 26 und Rizza und Scrinari, passim.

28. P. Demargne, *BCH* 53 (1929), 420, Fig. 34; Paris, Louvre AM 1696: Dörig, 31, Taf. 46a; Oxford, Ashmolean Museum G. 488: Dörig, D 25, Taf. 46; Herakleion, Arch. Mus.: F. Matz, *Geschichte der griechischen Kunst,* Bd. 1 (Frankfurt, 1950), Taf. 287b.

29. s. Anm. 25; Herakleion, Arch. Mus.: Matz (a.O., Anm. 28), Abb. 287a.

30. Rizza und Scrinari, Taf. 26.169a.

31. Ibid., Taf. 27.172.

32. s. Anm. 25–31.

33. Exemplarisch: Rizza und Scrinari, Taf. 30.190, 201; Dedalico antico 700–670, Dedalico medio 670–640, Dedalico tardo 640–620 (Ibid., 244); Mittel- bis Spätdädalisch 655–625 (W. Hornbostel in Dörig, 65; weitere Literatur zur dädalischen Plastik: Hornbostel, a.O., 67, Anm. 23).

34. D. Levi, *BdA* 41 (1956), 271, Fig. 57; Rizza und Scrinari, Taf. 21.127; Eals, 46, Nr. 13, Fig. 48; Reed, Nr. 13; Delplace, *Griffon,* Fig. 77; Dierichs, *Bild des Greifen,* 139ff., Kr T 15; U. M. Lux, *Beiträge zur Darstellung des ,,Herrn der Tiere" im griechischen, etruskischen und römischen Bereich vom 8. Jh. v.Chr. an* (Georgenthal, 1962), 24.

35. Weiteres Vergleichsmaterial (Votive): E. H. Dohan, ,,Archaic Cretan Terracottas in America," *MMS* 3 (1931), Fig. 33–37; J. Boardman, *The Cretan Collection in Oxford* (Oxford, 1961), Taf. 39.500; Mollard-Besques (a.O., Anm. 26), Taf. 22, B 1777.179; Rizza und Scrinari, Taf. 14.79c, 19.107, 27.171, 30.207; Dörig, D 25–32, Taf. 46a, 47d; Demisch, *Sphinx,* 70, Abb. 191f. Literatur zu kretischen Reliefpinakes: Dohan, a.O., 209ff.; R. A. Higgins, *Catalogue of the Terracottas in the British Museum,* Bd. 1 (London, 1954), 157ff.; Mollard-Besques, a.O., 28ff.; Boardman, a.O., 108ff.; Rizza und Scrinari, 204ff.

36. Amphora: Basel, Antikenmuseum BS 607 (hier Abb. 3): K. Schefold, *Führer durch das Antikenmuseum Basel* (Basel, 1966), Nr. 66; Eals, Nr. 4, Fig. 34–36; Dierichs, *Bild des Greifen,* 137, 140ff., Kr T 3, Abb, 55, 55a. Amphora: P. Aubert, *BCH* 100 (1976), Fig. 351; Dierichs, 16, Nr. 1. Amphora: Kassel, Staatliche Kunstsammlungen T 765: P. Gercke, *AA,* 1983, 487f., Abb. 15, 16b; Frgt. einer Amphora. University of Missouri, Columbia, Museum of Art and Archeology 67-49: Reed, Nr. 3, Taf. 82.3; Dierichs, *Bild des Greifen,* 137, 140ff., Kr T 1. Weitere Reliefgefäße oder Frgte. mit Sphingen: D. Levi, *Hesperia* 14 (1945), Taf. 30.2, 31.1–2; T. J. Dunbabin, *BSA* 48 (1952), 153ff.; J. Schäfer, *Studien zu den griechischen Reliefpithoi des 8.–6. Jahrhunderts v.Chr. aus Kreta, Rhodos, Tenos und Boeotien* (Kallmünz, 1957), Taf. 3.3, 4.1, 5.1–2, 6.1–2;

Boardman (a.O., Anm. 35), Taf. 40, 50I; D. Levi, *Early Hellenic Pottery of Crete* (Amsterdam, 1969), Taf. 30, 31.1–2; S. Doeringer, D. G. Mitten und A. Steinberg, Hrsg., *Art and Technology: A Symposium on Classical Bronzes* (Cambridge, Mass., 1970), 146, Fig. 1 (M. Gjodesen); Dörig, Taf. 25, 26c–e, 27, 28a, 31, 33, 35, 37b; M. Brouscari, *BCH* 99 (1975), 390ff., Fig. 3–11; L. Hillman Anderson, *Relief Pithoi from the Archaic Period of Greek Art* (Boulder, Colo., 1979), 41ff. Weitere Reliefgefäße oder Frgte. mit Greifen: Eals, Nr. 5, Fig. 37–39 = Dierichs, *Bild des Greifen,* 137, 140ff., Kr T 2, Abb. 54; Brouscari, a.O., 388, Nr. 2, Fig. 2 = Dierichs, *Bild des Greifen,* 137f., 140ff., Kr T 4; Brouscari, a.O., 387, Nr. 1, Fig. 1 = R. Hampe und E. Simon, *Tausend Jahre frühgriechische Kunst* (München, 1980), Abb. 412 = Dierichs, *Bild des Greifen,* 138, 140ff., Kr T 5; Eals, 43 = Dierichs, *Bild des Greifen,* Kr T 6; Reed, Nr. 15, Taf. 84a–c = Dierichs, *Bild des Greifen,* 139ff., Kr T 16. Literatur zu kretischen Reliefgefäßen: Dörig, 56ff., Bibliographie 68f.

37. Dierichs, *Bild des Greifen,* 140ff.

38. Die Bezeichnung „sizilisch" wird hier in dem Bewußtsein gebraucht, daß eine homogene sizilische Formensprache fehlt. Vgl. E. Langlotz, *Die Kunst der Westgriechen* (München, 1963), 16.

39. Palermo, Museo Nazionale H. 63.7836: A. Adriani u.A., *Himera,* Bd. 1 (Rom, 1970), 119, Taf. 80.1; P. G. Guzzo, *BdA* 58 (1973), Abb. 11; Dierichs, *Bild des Greifen,* 241f., T 2; N. Boncasa, *ASAtene* 45–46, n.s. 29–30 (1967–1968), 306, Fig. 4, 311ff.; ders., *ASAtene* 59, n.s. 43 (1981), 332f., Fig. 18.

40. Bei einer Gesamthöhe des Himera-Reliefs von 21,5 cm liegt die Höhe des Feldes mit Sphinx und Greif zwischen den horizontalen Begrenzungen bei annähernd 5 cm; die Höhe des entsprechenden Bildfeldes in Malibu beträgt ca. 7 cm.

41. s. Anm. 39.

42. Ganz anders die antithetischen Greifen auf einem Stamnos: J. Boardman, *The Greeks Overseas* (London, 1964), Fig. 217; R. Bianchi Bandinelli und A. Giuliano, *Etrusker und Italiker* (München, 1974), Abb. 84; E. de Miro, „Gela Protoarcaica," *ASAtene* 61, n.s. 45 (1983), 97, Fig. 102b.

43. Langlotz (a.O., Anm. 38), Taf. 13.

44. M. Borda, *Arte Dedalico a Taranto* (Pordenone, 1979), 77ff.

45. Amsterdam, Allard Pierson Museum 2697: Borda (a.O., Anm. 44), 90, Fig. 26 (hier Abb. 5).

46. Bonn, Akademisches Kunstmuseum D 25876: Borda (a.O., Anm. 44), 91, Fig. 27 (hier Abb. 6).

47. Tarent, Museo Nazionale 12572, 12573: Q. Quagliati, *Il Museo Nazionale di Taranto* (Rom, 1932), 50; Delplace, *Griffon,* 50, Fig. 71.

48. Ibid., 54, Fig. 78 (Crotone, Museum 2049).

49. Vgl. exemplarisch: Ars Antiqua, Luzern (1961), Auktion 3, Nr. 113, Taf. 46; M. Sprenger und G. Bartoloni, *Die Etrusker* (München, 1977), Abb. 34, 42, 44; Delplace, *Griffon,* Fig. 79.

50. Oxford, Ashmolean Museum G.437: R. A. Higgins, *Greek and Roman Jewellery* (London, 1961), Taf. 15c; Dierichs, *Bild des Greifen,* 84, Abb. 34 (hier Abb. 7); eine weitere Bronzematrize aus archaischer Zeit: H. Marion, *AJA* 53 (1949), 124, Taf. 20A (abgebildet mit Gipsabdruck); zu archaischen Bronzematrizen: P. C. Bol, *Antike Bronzetechnik* (München, 1985), 116.

51. Helm: Payne, 284, Fig. 122; Fibel: ders., *The Sanctuaries of Hera Akraia and Limenia,* Perachora, Bd. 1 (Oxford, 1940), 146, Taf. 48.1–3; Bleche: M. Holleaux, *BCH* 16 (1892), Taf. 14f.; A. Furtwängler, *AA,* 1894, 117, Abb. 7–9; s. auch Anm. 52; *Funde aus Olympia,* Taf. 46 = *OlBer,* Bd. 5, 93f., Taf. 50; Spiegelgriffe: Payne, Fig. 101f.; Anhänger: Payne, *Perachora,* a.O., 145, Taf. 47.1, 2.

52. London, British Museum: Payne, 228, Fig. 104a, b = Dierichs, *Bild des Greifen,* 77, 80ff., K B 2, Abb. 33 (hier Abb. 8);

Delplace, *Griffon,* 84, Fig. 112f.; vgl. ferner ein Blech aus Orchomenos, Athen, Nationalmuseum: A. De Ridder, *BCH* 19 (1895), 219ff., 221, Fig. 23 = Dierichs, *Bild des Greifen,* 78, 80ff., K B 3 (Sphinx bzw. Greif in einem Bildfeld).

53. E. Kunze, „Archaische Schildbänder: Ein Beitrag zur frühgriechischen Bildgeschichte und Sagenüberlieferung," *OlForsch* 2 (Berlin, 1950); P. C. Bol, „Argivische Schilde," *OlForsch* 17 (Berlin, 1989), 43f.; die Zahl der Sphingenwappen verdoppelte sich aber bestätigte die Geschlossenheit der ganzen Reihe.

54. Zusammenstellung und Datierung der Sphingenwappen in Abb. 9 nach Kunze (a.O., Anm. 53).

55. Beispiele mit Sphingen und Greifen: Payne, Taf. 3.1–3, 11.1–5, 15.3–6, 22.5–7, 23.3–5, 28.10, 33.1, 34.1, 35.1–4, 40.1. Den meisten Sphingen der korinthischen Vasenmalerei fehlt eine Kopfbekrönung: vgl. Payne, Taf. 4.6, 8.2, 10.2–4, 12.2 13.3, 29.7, 37.1, 2, 4. Zuweilen tragen Sphingen einen Polos: vgl. Payne, Taf. 15.1, 16.13, 28.9. Sphingen mit Kopfflocken (Ranken) sind selten: vgl. Payne, Taf. 4.2, 34.1; T. J. Dunbabin, *The Sanctuaries of Hera Akraia and Limenia,* Perachora, Bd. 2 (Oxford, 1962), Taf. 12.229, 13.230, 30.637.

56. Hamburg, Museum für Kunst und Gewerbe 1970.26a: s. Anm. 9.

57. New York, Sammlung Schimmel: Dörig, A 11, Taf. 10; O. White Muscarella, Hrsg., *Ancient Art: The Norbert Schimmel Collection* (Mainz, 1974), Nr. 18 mit Abb.

58. Athen, Nationalmuseum B 6444 (hier Abb. 11): A. Furtwängler, *Olympia,* Bd. 4 (reprint, Amsterdam, 1966), Taf. 38; Payne, 230f.; E. Kunze und H. Schleif, *OlBer* 2 (Berlin, 1938), 127; P. Amandry, *AM* 77 (1962), 57f., 59, 61 Beil. 5; E. Spartz, *Das Wappenbild des Herrn und der Herrin der Tiere in der minoisch-mykenischen und frühgriechischen Kunst* (München, 1962), Nr. 135; A. M. Bisi, *Il Grifone: Storia di un motivo iconografico nell'antico oriente mediterraneo* (Rom, 1965), 224; A. Akerström, *Die architektonischen Terrakotten Kleinasiens* (Lund, 1966), 89, Abb. 27.3; C. Christou, *Potnia Theron* (Thessaloniki, 1968), 87, 221, Nr. 24; K. Fittschen, *Untersuchungen zum Beginn der Sagendarstellungen bei den Griechen* (Berlin, 1969), 119, SB 26; A. Yalouris, *AEphem,* 1972, Taf. 50; Eals, 77, Fig. 78f.; Müller, 144, 201, 204, 206; Delplace, *Griffon,* 82; Dierichs, *Bild des Greifen,* 212ff., O B 1; dies. *Boreas* 7 (1984), 17, Nr. 4, Abb. 4a, b; Brize, 76, OL 1, Taf. 23.2.

59. Olympia, Museum B 4347 (hier Abb. 12): W. Gauer, *OlForsch* 8 (Berlin, 1975), 9; *Funde aus Olympia,* Taf. 44; Dierichs, *Bild des Greifen,* 212ff., O B 2, Abb. 104; dies. *Boreas* 7 (1984), 19, Nr. 5, Abb. 5; Brize, 77, OL 7.

60. Olympia, Museum B 4348 (hier Abb. 13): E. Kunze, *Archaiologikon Deltion* 17 (1961–1962), Chron. 116, Taf. 128b; *Funde aus Olympia,* Taf. 45; Brize, 77, OL 8.

61. Olympia, Museum B 165 (hier Abb. 14): Kunze und Schleif, *OlBer* 2 (a.O., Anm. 58), 126f., Taf. 55; I. Scheibler, *Die symmetrische Bildform in der frühgriechischen Flächenkunst* (Kallmünz, 1960), 95, Anm. 74; Müller, 74.; Delplace, *Griffon,* 83, Fig. 108; Dierichs, *Bild des Greifen,* 77, 80f., K B 1; dies., *Boreas* 7 (1984), 16, Nr. 2, Abb. 2.

62. Potnia-Greifen-Blech: etwa 25 cm × 15 cm; Malibu-Relief: etwa 17,5 cm × 8 cm.

63. Zum „Schwimmen im Raum": R. Hampe und U. Jantzen, *OlBer* 1 (Berlin, 1936), 90.

64. Zur „symmetrischen Bildform": Scheibler (a.O., Anm. 61), passim.

65. Dieser Kopftypus läßt sich in der gesamten ostgriechischen Flächenkunst belegen. Vgl. Dierichs, *Bild des Greifen,* 151ff., O V R, 2.4–7, 9, 10, 14–17, Abb. 57f., 60f., 64ff.; 180, O V sonst 1, Abb. 90, 90a; 182, O V sonst 9, 12; 195, O T 1, 5, 6, Abb. 93–95; 216 O Go 6 mit Abbildungsverweisen und weiterer Literatur; dies., *Boreas* 7 (1984), 20ff.

66. Vgl. die Greifen auf Verkleidungsplatten aus Düver, bei denen die Kombination aus bemaltem Relief und nur gemalten Details vorliegt: Dierichs, *Bild des Greifen,* 194, 201ff., O T 1–9, Abb. 93–95; Dierichs, 22f.; Sotheby's, London, *Auktionskatalog* 23 (Mai 1991), Abb. 75.

67. Als Belege gelten nicht nur das oben angeführte Sphingen-Widder-Blech (Olympia B 4348, hier Abb. 13, s. Anm. 60), sondern auch einige Figuren auf anderen Bronzeblechen. Samos, Vathy B 1680: E. Homann-Wedeking, *AA,* 1966, 161, Abb. 5; A. Yalouris, *AEphem,* 1972, Taf. 57a; G. Kopcke, *AM* 83 (1968), Taf. 118.1; Brize, 74, SA 2. Olympia M 77: E. Willemsen, *OlBer* 7 (Berlin, 1961), 19; K. Schefold, *Frühgriechische Sagenbilder* (München, 1964), Taf. 80; Yalouris, a.O., Taf. 59; *Funde aus Olympia,* Taf. 48; Brize, 77, OL 9. Olympia M 78: A. Yalouris, *AJA* 75 (1971), Taf. 64; dies. *AEphem,* 1972, Taf. 55f.; Brize, 77, OL 10. Olympia M 108: A. Yalouris, *AEphem,* 1972, Taf. 58; Brize, 77, OL 11. Bezeichnenderweise ordnet Brize (S. 83) die Bleche Olympia 77.108 einem samischen Werkstattkreis Anfang des 6. Jahrhunderts, das Blech Olympia M 78 einem samischen Werkstattkreis des 1. Viertels des 6. Jahrhunderts zu. Auch auf die Haarstilisierung des Eurytion im Geryoneus-Blech (hier Abb. 17), das Brize einem im 4. Viertel des 7. Jahrhunderts arbeitenden samischen Werkstattkreis zuschreibt, ist zu verweisen (s. auch Anm. 76).

68. A. Dierichs, *Boreas* 7 (1984), 26, 33.

69. Vgl. hier Abb. 12, 14 und Anm. 65.

70. Die Beschreibung dieses Wasservogels als ,,prächtiger Reiher" und ,,bezeichnende Tiergestalt der frühprotokorinthischen Kunst" (E. Kunze und H. Schleif, *OlBer* 2 [Berlin, 1938], 127) ist nicht haltbar; vgl. Dierichs, *Bild des Greifen,* 26. Weitere Forschungen könnten möglicherweise auch eine andere kunsttopographische Zuordnung einer in Olympia gefundenen Knöchelschiene ergeben. Zumindest die auf ihr dargestellte hockende Sphinx scheint mir nicht vollends den bislang so eindeutig ausgesprochenen peloponnesischen Stil des betreffenden Stückes zu unterstreichen (E. Kunze und H. Schleif, a.O., 100f., Abb. 63, Taf. 43; *Funde aus Olympia,* Taf. 64).

71. Beispiele aus der Toreutik. Vgl. *Greifen und Potnia des Potnia-Greifen-Blechs* (hier Abb. 11) und Anm. 58; Potnia eines Blechs: W. Wrede, A. v. Gerkan, R. Hampe und U. Jantzen, *OlBer* 1 (Berlin, 1937), 88f., Taf. 32; A. Yalouris, *AEphem,* 1972, Taf. 49; Dierichs *Bild des Greifen,* 23, Abb. 9.; Gorgo eines Elfenbeinreliefs, s. Anm. 95; Flügelpferd eines Schildzeichens: *Funde aus Olympia,* 109, Taf. 71; Fabelwesen auf Goldblechen: P. Amandry, *AM* 77 (1962), Beil. 6–9; Dierichs, *Bild des Greifen,* 216, 220ff., O Go 5–6a, Abb. 110. Belege aus der Vasenmalerei: Kardara (a.O., Anm. 2), Abb. 6, 73, 118, 217 (Sphingen); E. Akurgal, in *Festschrift H. Vetters* (Wien, 1985), Taf. IX, Abb. 5; Dierichs, *Bild des Greifen,* O V sonst 9 = E. Walter-Karydi, *Samos* 6.1 (Bonn, 1973), 25, Nr. 445, Taf. 50.445a; Dierichs, 20, Nr. 6 (Greifen).

72. Ähnlich: Greifen des Potnia-Greifen-Blechs (hier Abb. 11) und Anm. 58; Greifen einer samischen Schale: Walter-Karydi (a.O., Anm. 71), 25, Nr. 445, Taf. 50.445a; Löwen einer kykladisch-ostgriechischen Schale: P. Demargne, *Die Geburt der griechischen Kunst,* 2. Aufg. (München, 1975), Abb. 234.

73. Einziehungen: vgl. Schiering (a.O., Anm. 2), 58f., Taf. 11.2, 16; Dierichs, *Bild des Greifen,* 159, Fig. 14; Schrägstriche: vgl. Greifen des Potnia-Greifen-Blechs, hier Abb. 11 und Anm. 58; Löwen der Potnia eines Blechs: Wrede, v. Gerkan, Hampe und Jantzen (a.O., Anm. 71), Taf. 32; Kentauren des Kaineus-Blechs: *Funde aus Olympia,* Taf. 42 (ausführliche Literaturhinweise, *Funde aus Olympia,* 78); Fabelwesen auf Goldblechen: Amandry (a.O., Anm. 71).

74. Besonders deutlich: *CVA* Belgien 3, Brüssel, Musée Cinquantennaire 3, II D, Taf. 2.1, 3.1 = Dierichs, *Bild des Greifen,* 152,

158ff., O V R 7, Abb. 58 (Greif); *Funde aus Olympia,* Taf. 45 (Sphingen und Widder), hier Abb. 13 und Anm. 60.

75. Boston, Museum of Fine Arts 01.7511a, b: Comstock und Vermeule (a.O., Anm. 10), Nr. 626 mit Abb.; Dierichs, 25ff., Abb. 8a, b (hier Abb. 16).

76. Brize, bes. 65ff.; J. Keck, *Studien zur Rezeption fremder Einflüsse in der chalkidischen Keramik: Ein Beitrag zur Lokalisierungsfrage* (Frankfurt, 1988), 96.

77. Ausgewählte Literatur: Schiering (a.O., Anm. 2); Kardara (a.O., Anm. 2); H. Walter, *Samos* 5 (Bonn, 1968); Walter-Karydi (a.O., Anm. 71); ferner hier Anm. 20.

78. Dierichs, *Bild des Greifen,* 154ff., O V R 19–31, Abb. 66–72a; 158ff. passim.

79. Paris, Louvre CA 350 (E 658): *CVA* Frankreich 1, Louvre 1, II Dc, Taf. 6, 7 = Dierichs, *Bild des Greifen,* 152, O V R 9, Abb. 60.

80. Sie blicken sich jedoch nicht an, sondern wenden sich den ,,Rücken" zu. Vgl. eine Goldmünze mit Sphinx- und Greifenprotome, ebenfalls voneinander abgewendet: E. Langlotz, *Studien zur nordostgriechischen Kunst* (Mainz, 1975), 30, Taf. 2.5.

81. Heraion K 5986: Brize, 66, Taf. 22.1.

82. A. E. Furtwängler, *AM* 95 (1980), Taf. 55; Profilzeichnung des Flötenspielers: ibid., 194, Abb. 11.

83. Verwandte Knaufformationen: I. Bolz-Augenstein, Hrsg., *Kunstschätze aus dem Irak,* Ausstellungskatalog Köln (Köln, 1965), Nr. 123, Abb. 48; W. Orthmann, *Der alte Orient,* Propyläen Kunstgeschichte, Bd. 14 (Frankfurt, 1975), Abb. 259, 381a; M. J. Mellink, *AJA* 69 (1965), Taf. 36.5; T. Özgüç, *Altıntepe* 2 (Ankara, 1969), Taf. 32f.; R. D. Barnett, *A Catalogue of the Nimrud Ivories with Other Examples of Ancient Near Eastern Ivories in the British Museum* (London, 1957), Taf. 131; E. Akurgal, *Orient und Okzident* (Baden-Baden, 1966), 183, Abb. 117. Verwandter Ohransatz: Orthmann, a.O., Farbtaf. 30; Akurgal, a.O., 99, Fig. 63; ders. *Die Kunst der Hethiter* (München, 1976), Abb. 111.

84. s. Anm. 76.

85. Kardara (a.O., Anm. 2), 86, Abb. 55; Dierichs, *Bild des Greifen,* 182ff., O V sonst 12.

86. *The Anatolian Civilisations,* Bd. 2 (Istanbul, 1983), B 66 (Ausstellungskatalog); E. Akurgal, *Alt-Smyrna* 1 (Ankara, 1983), 142, Taf. 108b; ders., *Griechische und römische Kunst in der Türkei* (München, 1987), Taf. 3c (Farbabbildung); Dierichs, 20, Nr. 18, Abb. 6.

87. H. Walter, *Samos* 5 (Bonn, 1968), Taf. 108f., Abb. 43 = Dierichs, *Bild des Greifen,* 151, O V R 2 (hier Abb. 18).

88. Samos B.470; B.554; B.84: U. Jantzen, *Griechische Greifenkessel* (Berlin, 1955), Nr. 36, 40, Taf. 13.3, 14.3; ders., *AM* 73 (1958), Beil.31; *Samos,* B.1873: H. P. Isler, *Samos* 6 (Bonn, 1978), Nr. 17, Taf. 38.17. Das Exemplar aus Olympia, B.5650: H.-V. Herrmann, *OlForsch* 11 (Berlin, 1979), 37, G 69, Taf. 42.2–3.

89. Jantzen (a.O., Anm. 88), Taf. 22.1–4; s. auch Herrmann (a.O., Anm. 88), 216f. (Register zu Samos). Verweisen möchte ich hier noch auf eine tönerne Greifenprotome ostgriechischer Prägung aus Gravisca, die dem Malibu-Greifen sehr ähnlich ist. D. Ridgway, *ARepLondon,* 1979–1980, 66, Abb. 16; H.-V. Herrmann, *JdI* 99 (1984), 32, Anm. 92.

90. Jantzen (a.O., Anm. 88), 62, 64.

91. Vgl. noch spätarchaische Beispiele mit diesem kanonischen Kopftypus: etwa die Greifen auf den Verkleidungsplatten aus Düver, s. Anm. 66.

92. Ein sehr schwierig zu datierendes Stück scheint mir ein vollplastischer Greifenkopf aus Kalkstein zu sein: Basel, Münzen und Medaillen, Auktion 40 (13-12-1969), 96, Nr. 162 mit Abb. (Anfang 6. Jahrhundert) = Delplace, *Griffon,* Fig. 219ff. (klassisch, hellenistisch).

93. D. Ohly, *AM* 66 (1941), Taf. 11.416 (sechs Bildfelder, jeweils ein Krieger mit einem Toten über den Schultern); zu sami-

schen Tonmatrizen: ibid., 35.

94. Ohly (a.O., Anm. 93), Taf. 34.1372 = ders., *AM* 68 (1953), Beil. 41.

95. Schefold (a.O., Anm. 67), Abb. 17; B. Freyer-Schauenburg, *Elfenbeine aus dem samischen Heraion* (Hamburg, 1966), 4, 14, 30ff., 124, Taf. 6a; Hampe und Simon (a.O., Anm. 36), Abb. 348; H. Kyrieleis, *Führer durch das Heraion von Samos* (Athen, 1981), Abb. 27. Zum möglicherweise noch nicht endgültig geklärten Landschaftsstil dieses Reliefs: Hampe und Simon (a.O., Anm. 36), 229.

96. Freyer-Schauenburg (a.O., Anm. 95), 6, 15, 45f., 123, Taf. 10 (hier Abb. 19).

97. H. Kyrieleis, *AA*, 1980, 348, Abb. 18; U. Sinn, *AM* 97 (1982), 35ff., Taf. 11.1–3, 12.1–2; ders., *AM* 100 (1985), Taf. 40. J. Burr Carter (*Greek Ivory Carving in the Orientalizing and Archaic Periods* [New York, 1985], 258ff., Abb. 95) charakterisiert den betreffenden Kopf allgemeiner als „ostgriechisch."

98. H. Walter, *Deltion* 18 (1963), Chronika II 291, Taf. 335b; ders., *Das griechische Heiligtum* (München, 1965), 66, Abb. 67; G. Kopcke, *AM* 82 (1967), 106, Abb. 1; Beil. 48–51; H.-V. Herrmann in: *Wandlungen: Studien zur antiken und neueren Kunst. Festschrift für E. Homann-Wedeking* (Waldsassen, 1975), Taf. 4d (hier Abb. 20).

99. Kassel, Staatliche Kunstsammlungen S 54 (hier Abb. 21): R. Tölle, *Die antike Stadt Samos* (Mainz, 1969), Abb. 50: um 560 v.Chr.; U. Sinn, *Antike Terrakotten, Kataloge der Staatlichen Kunstsammlungen, Kassel,* Nr. 8 (Kassel, 1977), 43, Nr. 86, Taf. 27: um 500 v.Chr.

100. C. Rolley, *Die griechischen Bronzen* (München, 1984), 114.

101. s. Anm. 58.

102. Vgl. A. E. Furtwängler, *AM* 96 (1981), 91 (in Bezug auf ein in Samos gefundenes Stierblech, Abb. 8, a.O.; Taf. 24). Interessant in diesem Zusammenhang erscheint mir ein aus der Mitte des 7. Jahrhunderts stammendes, samisches Bronzeblech mit einem Flügelpferd. Samos, B 446: H. Walter und K. Vierneisel, *AM* 74 (1959), 18, Beil. 28. Die von U. Jantzen (*Samos 8* [Bonn, 1972], 53) angenommene phrygische Faktur des Flügelpferd-Blechs überzeugt mich nicht. Zustimmen möchte ich hingegen F. Prayon, der das betreffende Stück für westanatolisch-griechisch hält (persönliche Mitteilung, 1985); zur phrygischen Plastik: F. Prayon, *Phrygische Plastik* (Tübingen, 1987).

103. Eine Klassifizierung, die auch durch die Tatsache unterstützt wird, daß das seit etwa fünfzig Jahren systematisch erforschte Heraion von Samos die an Bronzen reichste Stätte des ostgriechischen Raumes ist, die bis hin zum Sturz des Polykrates (522 v.Chr.) von allergrößter Bedeutung bleibt. Vgl. hierzu: Rolley (a.O., Anm. 100), 114. W. Fuchs und J. Floren, *Die geometrische und archaische Plastik,* Die griechische Plastik, Bd. 1 (München, 1987), bes. 358. Auch ein Verweis auf die monumentale Altararchitektur mit Reliefsphingen im Heraion von Samos scheint mir an dieser Stelle angebracht: vgl. H. Schleif, *AM* 58 (1933), 174ff.; E. Buschor, *AM* 72 (1957), 24ff.; U. Sinn, *AM* 99 (1984), 79.

104. Meine früher vorgeschlagene Datierung für das Potnia-Greifen-Blech (Dierichs, *Bild des Greifen,* 214: 2. Hälfte des 7. Jahrhunderts) ist entschieden zu hoch. Im folgenden zitiere ich einige andere Datierungen. Wende vom 7. zum 6. Jahrhundert, bzw. um 600 v.Chr.: H.-V. Herrmann, *Olympia: Heiligtum und Wettkampfstätte* (München, 1972), 88f.; um 600 v.Chr.: K. Fittschen, *Untersuchungen zum Beginn der Sagendarstellungen bei den Griechen* (Berlin, 1969), 119; Brize, 83; frühes 6. Jahrhundert: F. Matz, *Geschichte der griechischen Kunst,* Bd. 1 (Frankfurt, 1950), 498; 2. Viertel des 6. Jarhunderts: Payne, 230f.; A. Akerström, *Die architektonischen Terrakotten Kleinasiens* (Lund, 1966), 89; Eals, 77; Fuchs und Floren (a.O.,

105. Vgl. Brize, bes. 77.

106. Literatur zu archaischen Votivpinakes: U. Hausmann, *Griechische Weihreliefs* (Berlin, 1960), 15ff.; korinthisch: V. Stais, *AEphem,* 1917, 208f.; E. Rohde, *Griechische Terrakotten* (Tübingen, 1968), 36; H. A. Geagan, *AA,* 1970, 31ff.; G. Zimmer, *Antike Werkstattbilder* (Berlin, 1982), 26ff.; attisch: D. Burr, *Hesperia* 2 (1933), 604ff.; O. Broneer, *Hesperia* 7 (1938), 224ff.; G. M. A. Richter, *AJA* 40 (1936), 304; C. Roebuck, *Hesperia* 9 (1940), 164ff.; melisch: s. Anm. 110; kretisch: s. Anm. 35.

107. Vgl. Vasenbilder mit Votivpinakes (Heiligtümer, Grabkult): *CVA,* Deutschland 12, München 4, Nr. 2315, Taf. 190f.; K. Schefold, *JdI* 52 (1937), 49, Abb. 10; D. Burr Thompson, *Miniature Sculpture from the Athenian Agora* (Princeton, 1967), Frontispiz; *ARV²,* 685, Nr. 164; 749, Nr. 3; N. Leipen u.A., *A Selection of Greek Vases and Bronzes from the Elie Borowski Collection: Special Exhibition, Royal Ontario Museum 1984–1985* (Toronto, 1984), Nr. 15 mit Abb.

108. E. Buschor, *AM* 55 (1930), 46f. Zu den Weihungen einfacher Leute (Miniaturgreifenprotome aus Bronzeblechschichten) in das Heraion von Samos: A. E. Furtwängler, *AM* 96 (1981), 99, Taf. 31.1, Abb. 10 = Dierichs, 25, 30, Nr. 1 (O B 4); vgl. in diesem Zusammenhang U. Kron, in *Festschrift J. Inan* (Istanbul, 1989), 373ff.

109. s. Anm. 86, 93.

110. Die große Gruppe der melischen Reliefs, die vorzugsweise zum Schmuck von hölzernen Kästchen (Grabbeigaben) gedient haben, entstand so spät (475–450 v.Chr.), um dem Malibu-Relief zur Seite gestellt zu werden. Vgl. P. Jacobsthal, *Die melischen Reliefs* (Berlin, 1931); G. Bruns, *Antike Terrakotten* (Berlin, 1946), 18; G. M. A. Richter, *Korai* (New York, 1968), 265ff. Ein neuerlich bekannt gemachtes ostgriechisches Votiv aus Andros (A. Cambitoglou, *Archaeological Museum of Andros* [Athen, o.J.], Kat. 289, Abb. 49) zeigt Reste einer weiblichen Figur neben einem kleinen Weihetäfelchen. Bei dem interessanten Stück handelt es sich m.E. sowohl um die einzige tönerne Darstellung eines Votivreliefs (Pinakes in Vasenbildern sind häufiger, s. Anm. 107) als auch um die singuläre Abbildung eines „Pinax im Pinax."

111. s. Anm. 7, 8.

112. Schefold (a.O., Anm. 67), Taf. 32b.

113. Hampe und Simon (a.O., Anm. 36), 277, Fig. 35 (hier Abb. 22).

114. J. K. Brock, *BSA* 44 (1949), 19f., Taf. 7.1–3, 8.4–5; E. Karydi, *AA,* 1964, 275; C. Christou, *Potnia Theron* (Thessaloniki, 1968), 20; Müller, 75, 79; Dierichs, *Bild des Greifen,* 120ff., Ky V 4; vgl. in diesem Zusammenhang die Goldbleche aus Delphi als mögliche Gewandverzierung einer delphischen Trias, Dierichs, *Bild des Greifen,* 224.

115. U. Jantzen, *Bronzewerkstätten in Großgriechenland und Sizilien, JdI,* 13. Ergh. (1937), 25f., Anm. 1, Taf. 6.29; D. Burr Thompson, *Hesperia,* Suppl. 8 (1949), 365ff.; W. Züchner, *JdI* 65–66 (1950–1951), 175ff., bes. 205; E. R. Williams, *Hesperia* 45 (1976), 41ff., Kat. Nr. 2, Taf. 5.2; Zimmer (a.O., Anm. 106), 35f., Taf. 10, 16.1–2.

116. U. Gehrig, A. Greifenhagen und N. Kunisch, *Führer durch die Antikenabteilung, Staatliche Museen Preussischer Kulturbesitz, Berlin* (Berlin, 1968), 138, F 2294, Abb. S. 74f.; G. S. Korres, *AEphem,* 1971, Taf. 52; Zimmer (a.O., Anm. 106), 24, 41, Abb. 9, Taf. 3.1; P. C. Bol, *Antike Bronzetechnik* (München, 1984), 129, Abb. 84 (hier Abb. 23).

117. H. Brandenburg und K. Stähler, *Kolloquium Archäologisches Seminar Münster* (Herbst, 1985).

118. K. Manchester, Briefliche Nachricht, 3.3.1986.

119. Bol (a.O., Anm. 116), 194.

# Some Ionic Architectural Elements from Selinus in the Getty Museum

Barbara A. Barletta

The Getty Museum recently acquired some architectural elements from the ancient Greek settlement of Selinus, on the southwestern coast of Sicily. The material was brought to the United States in the 1920s as part of a private collection. Included among the pieces are some members in Ionic style, which are especially significant as representatives of an order rarely employed in the West.[1]

The Ionic elements consist of a column base, a dentil block, and fragments of two different moldings. All are executed in a whitish limestone and are relatively small. The column base[2] (figs. 1a, b) comprises within a single piece both the spira and torus as well as a smooth astragal and the apophyge of the shaft. While its upper surface is marked by an empolion cutting, the torus has an ovolo profile and the typical horizontal fluting, and the spira takes on a somewhat unusual form. Rather than the single scotia of Attic bases, the two of Ephesian, or the multiple flutes of the Samian type, the Getty base has three scotiae separated by double arrises. Another characteristic of this piece is the sharp profile of each of its moldings.

The fragmentary dentil block[3] (fig. 2) likewise incorporates two different elements: the dentil course crowned by a smooth fascia and an ovolo base molding carved with an egg and dart. Two other pieces of an ovolo[4] (fig. 3a) probably belonged to the same molding, since they correspond in size and rendering. In addition, there exists a single block, in two joining fragments, from a molding of ovolo profile, but carved with a series of alternating lotuses and palmettes rising above confronted volutes[5] (fig. 3b). Each motif is comprised of five petals of similarly angular shape, although the palmette is distinguished by its greater curvature. Behind the ornament, the surface of this block has been cut down. The ornament itself, however, is comparable in height and spacing to that of the egg and dart.

On stylistic and other grounds, these pieces could date anywhere from the late sixth through the middle of the fifth century B.C., although an assignment in the early fifth century seems preferable. Instructive in this regard are the profile of the ovolo and the shape of its egg-and-dart decoration.[6] As a development from the half-round, the ovolo displays an increasingly higher point of greatest projection with time. By the late sixth century and continuing through the fifth it takes on an oval form,[7] as exemplified in the Getty fragments by the strong projection at the top and the taut curve of the lower profile.[8] The ornament likewise changes over time: In general, the egg becomes more triangular, each element is rendered in greater relief, and spacing between the elements increases. Parallels for the treatment of the Getty ornament range in date from the late sixth to the middle of the fifth century. Among the closest examples is one from another site in Magna Graecia, Metapontion, which is placed in the second quarter of the fifth century B.C.[9] By the late fifth century, the forms have become more angular and the spacing much wider than in the Getty ovolo.[10]

The rendering of the anthemion decorating the second ovolo likewise suggests an assignment for this molding within the fifth century B.C. Whereas sixth-century examples usually display wide, rounded leaves for the palmettes and plump stalks for the lotus flowers, in the fifth century these forms undergo a general stiffening and slenderizing process. Those traits are exemplified here in the flat, angular petals of both elements, as well as in the overall slenderness of the lotuses. However, in other ways our palmette stands outside the usual development of its type. By the fifth century, palmettes have generally become ornate, with a large number of leaves and considerable curvature.[11] In contrast, the Getty example is simplified, having only five slightly bent petals and thus

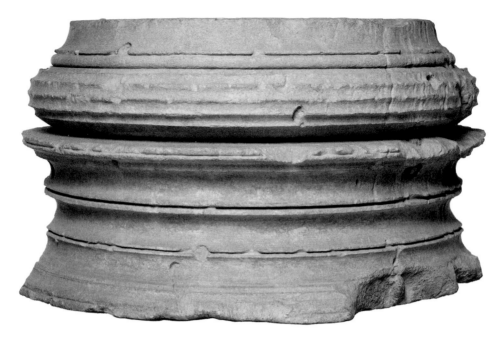

FIGURE 1a

Ionic column base. Limestone. Malibu, J. Paul Getty Museum 82.AA.47.

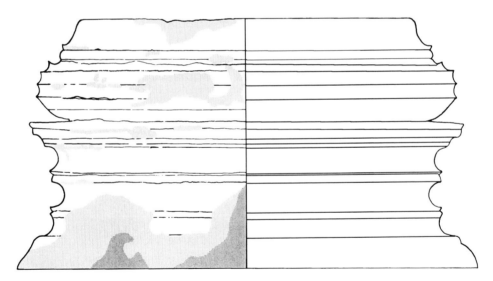

FIGURE 1b

Profile of column base, figure 1a. Drawing by Tim Seymour after original by Karen Manchester.

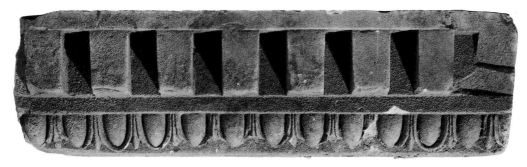

FIGURE 2

Dentil block. Limestone. Malibu, J. Paul Getty Museum 81.AA.144.

resembling much more the adjacent lotuses than other palmettes.[12] Further indications of chronology may be given by the rendering of the volutes linking these elements. In particular, the harsh transition between their raised borders and concave interiors points to a date in the first half of the fifth century.[13]

Three separate criteria may be used to determine the date of the Getty column base: proportions, style, and historical evidence. Over time, the Ionic base underwent certain proportional changes. One was the gradual increase in the height of the disc or spira in relation to that of the torus. The torus:spira ratio in the Getty piece, almost 1:2.5, is characteristic of examples executed after 475 B.C.[14] Another change occurs within the disc, an increase in height in proportion to its diameter. The ratio here, 1:3.3, finds comparison with bases datable from the last quarter of the sixth century until after the first quarter of the fifth century.[15]

Stylistic considerations point to a more specific date within this period. The general development in Ionic bases is toward increasingly greater concavity in the fluting of both torus and disc, and in the overall profile of the disc.[16] For the fluting of the Getty torus, the closest parallels appear in the late sixth and especially in the early fifth centuries.[17] The deeply carved scotiae of the disc likewise seem most at home at this time.[18] In its overall profile, the disc displays a pronounced concavity and strong splay, both of which are documented in the sixth century, but are perhaps more typical of the fifth century.[19] Such evidence allows us to narrow the chronological limits of the Getty base to the late sixth and, more probably, early fifth centuries.

A terminus ante quem for the piece is suggested by historical data. A nearly identical base has been recovered further west, at the Punic site of Motya, on a small island off the coast of Sicily.[20] That city was

destroyed in 397 B.C., and although its inhabitants subsequently resettled in a nearby location on the mainland of Sicily, Motya's architectural remains are generally assumed to predate the destruction.[21] This, along with stylistic evidence, led Shoe to assign the Motya base to the fifth century B.C., and apparently early within that century.[22] The Selinuntine example is unlikely to be any later.

Similarities among the various Getty fragments in findspot, material, and date raise the possibility that all belonged to a single structure. This would seem to be indicated as well by the uniformly small dimensions of these members. Here, however, caution must be exercised. The only Getty pieces suitable for a study of proportional relationships are the dentil block and the column base. In order to test their compatibility, we must compare the relative sizes of these pieces with those of members from contemporary buildings. Yet, during the late sixth and early fifth centuries B.C., little architecture was actually produced in the homeland of the Ionic style, and what did exist is now very fragmentary.[23] Ionic buildings occasionally appeared elsewhere, as somewhat later on the Akropolis of Athens, but here regional variations, such as the substitution of a frieze for the dentil course, render comparisons with our material almost impossible. Keeping in mind the limitations of our evidence, we can nevertheless offer the following observations.

Three Ionic structures of the fifth century B.C., which are sufficiently preserved or can be reliably restored, may be used for comparison. These are the Ionic Temple D in Metapontion, dated about 480–475; the Ionic temple at Lokroi Epizephyrioi, generally placed in the second quarter of the fifth century; and the South or Karyatid Porch of the Erechtheion on the Athenian akropolis, erected in the last quarter of the

fifth century. We may also include the Temple of Athena Polias at Priene, which, although of considerably later date—just after 350 B.C.—is well preserved.[24] Where evidence is available, the ratios between the width and spacing of the dentils and the diameter of the column bases, on the one hand, and between the height of the dentil course and that of the bases, on the other, are comparable in each of these buildings to those of our pieces.[25]

Assuming, then, that the remains preserved in the Getty Museum belonged to a single building, what evidence do we have for its appearance? The dentil block would have served in the entablature, most likely above the architrave, in accord with traditions of Asiatic-Ionic architecture. Its ovolo base molding would then crown the architrave. The only possible exception occurs if the building possessed both dentils and a frieze, in which case the frieze would appear between the architrave and the dentil course. Such an arrangement is documented only one time before the fourth century, in the Ionic temple at Metapontion.[26] However, because of the geographical proximity of this South Italian site to Selinus, along with the nearly contemporary dating of its building, the possibility must be raised of a similar composition of the entablature. The second molding, decorated with a lotus and palmette band in an inverted position, must also have acted as a crowning element, as shown by its greater projection at the top. If it belonged to the same structure, it might have been placed above the walls, door, or dentil course, or, depending upon the arrangement, even between architrave and frieze.[27] The configuration of the columns in this building is likewise impossible to determine with any certainty. Using the diameter of the base, we can, however, calculate the height of the columns at between 3.6 and 4.3 m.[28] The columns would thus be roughly comparable to those of the Athenian Stoa at Delphi or the Nike Temple in Athens.[29] Such small supports are more suitable for a porch than for a peristyle. No further evidence concerning the appearance or even the possible location of the building at Selinus can be discerned.

Despite its small size, the presence of an Ionic structure in Selinus is significant. For the most part, Sicilian architects used the Doric order of Mainland Greece. Where Ionic, or East Greek, elements do appear, they are often relegated to a subsidiary role. Toward the end of the sixth century, however, the popularity of the Ionic style increased dramatically in Western Greek architecture. A sculptured frieze was incorporated into a building at Sybaris around 530 B.C.[30] Ionic porches appeared about 510 B.C. in South Italy, in the Temple of Athena at Paestum and perhaps also that of Hera at Foce del Sele, as well as in Sicily, in a building on the akropolis of Gela.[31] Around the same time, Syracuse began construction of an entire temple in the Ionic order.[32] By the fifth century, Ionic temples made appearances in South Italy as well, in as many as four different sites: Metapontion, Lokroi, and probably Elea, during the first half of the century, and the Lokrian colony of Hipponion in the second half.[33] One would expect to find comparable developments in Sicily for this period, but so far that has not been the case.

That the Ionic order continued to be employed in fifth-century Sicily is clear from fragmentary remains. Selinus in particular has yielded an entire series of Ionic capitals spanning the second half of the fifth century.[34] Yet for the most part these served a votive, instead of an architectural, function. The two capitals that did belong to a building are of very small dimensions, suggesting a naiskos or portico.[35] Elsewhere in Sicily, the site of Akragas has yielded a block ornamented with dentils and carved moldings in the Ionic tradition. However, this block was apparently not used in the typical manner within the entablature, but rather as a wall crown, and in an otherwise Doric structure.[36] Against such a background, the Getty pieces become all the more important. They help to demonstrate the continued use of the Ionic order into the early fifth century in Sicilian architecture. Furthermore, they may provide the most complete evidence so far available for a fifth-century Ionic building on that island.

The pieces are also informative in regard to sources of influence. Remains of the Ionic temples at Syracuse and Lokroi suggest that for those buildings much of the inspiration came from Samos or the nearby coast of Asia Minor. Column bases are of the Samian type, while the published form of the capital of the Syracusan temple and the use of an anthemion necking in the Lokrian building are both paralleled in the so-called Polykratean (fourth) Temple of Hera at Samos, begun in the later sixth century.[37] A second area of influence, around northern Asia Minor, is indicated by other Ionic architectural remains. In particular, a series of capitals from both South Italy and Sicily, dating from the late sixth until the middle of the fifth century, is characterized by a purely local combination of traits, but with certain key features, such as the abacus, convex canalis, and volute eye,

FIGURE 3a

Ovolo molding. Limestone. Malibu, J. Paul Getty Museum 81.AA.146a, b.

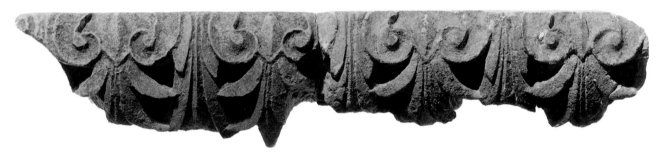

FIGURE 3b

Ovolo molding with lotus and palmette chain. Limestone. Malibu, J. Paul Getty Museum 81.AA.146c.

apparently derived from the northeast Aegean.[38] It is within this more northerly tradition that the Getty pieces should be placed.[39]

A specific source of influence in northern Ionia is suggested by the lotus and palmette decoration on one of the moldings. Generally, the surface of an ovolo profile is carved with the egg-and-dart ornament. The substitution of an inverted floral chain, as here, is unusual. However, it appears so often on the island of Chios that it is considered a characteristic of that school.[40] Chian connections are further exemplified in the Getty base. We have already noted that its profile, consisting of a triple scotia, is rare. Only one close parallel exists, from the Punic site of Motya. Yet that piece is so similar to the Getty base that one wonders whether it was not the work of an outside, and probably Selinuntine, craftsman.[41] Of the two major East Greek schools of architecture, that centered in Samos decorated its bases with a series of horizontal flutes, while the Ephesian school made use of two large scotiae. The Getty base seems to represent an intermediate form between these two traditions. A similar solution is found on Chios.[42] Remains of at least three bases from that island display discs carved with three

scotiae.[43] These examples have been dated to the end of the sixth century, thus sufficiently early to be reflected in the Getty piece.

Although fragmentary, the Ionic architectural remains in the Getty Museum contribute significantly to our knowledge of Sicilian architecture. They attest to the popularity of Ionic buildings in Sicily into the early fifth century B.C. Their stylistic associations with northern Ionia demonstrate the continued impact of this region on the West. More importantly, the Getty pieces point to a localization of that influence in Chios. At the same time, the unique interpretation of Eastern models by the Selinuntine architect underlines once again the creativity and independence of the Western Greek architectural tradition.

University of Florida
Gainesville

## NOTES

Abbreviations:

Boardman    J. Boardman, "Chian and Early Ionic Architecture,"
            *AntJ* 39 (1959), pp. 170–218.
Mertens     D. Mertens, *RM* 86 (1979), pp. 103–139.

I wish to thank Jiří Frel and Marion True, former and current Curator of Antiquities, respectively, at the J. Paul Getty Museum, for allowing me to publish these objects. Karen Manchester of the Department of Antiquities has been especially helpful in answering questions and providing illustrations. The material was first brought to my attention by Brunilde S. Ridgway, who also read and offered valuable comments on the manuscript. Additional thanks go to Barbara Tsakirgis for her useful suggestions.

1. The acquisition also included architectural elements in Doric style. I have corresponded with Vincenzo Tusa, retired Superintendent of Antiquities for Western Sicily, concerning the existence of these pieces and their Selinuntine origin. He has no objection to their publication.

2. J. Paul Getty Museum 82.AA.47. Approximate dimensions: H: 30.8 cm; Diam at top: 45.6 cm; Diam at base: 59 cm.

3. J. Paul Getty Museum 81.AA.144. Approximate dimensions: Max. pres. L: 65.5 cm; H: 16.8 cm; D: 25 cm; H of ovolo: 5 cm; spacing of eggs: 5.4 cm.

4. J. Paul Getty Museum 81.AA.146a, b. Approximate dimensions: Max. pres. L: 9.1 cm and 11.7; max. pres. H: 4.6 cm to 4.7 cm; spacing of eggs: 5.5 cm. It should be noted that the ovolo molding is not preserved to its entire original height.

5. J. Paul Getty Museum 81.AA.146c. Approximate dimensions: Max. pres. L: 22.3 cm; max. pres. H: 4.9 cm; spacing of motif: 5.4 cm.

6. It is generally acknowledged that moldings change over time, both in their profiles and in the renderings of their ornament. Dates associated with those changes are, however, only approximate. Regional variations and other factors may play a significant role in determining profile, as pointed out by both L. T. Shoe, *Profiles of Greek Mouldings* (Cambridge, Mass., 1936), p. 13, and Boardman, p. 212. Another potential source of information, the relationship of height, width, and spacing of dentils, has recently been shown to be of little use in assessing chronology or even regional associations. See P. Roos, "Observations on the Internal Proportions of the Ionic Dentil in the Aegean," *RA*, 1976, pp. 103–112, esp. p. 110.

7. Shoe (above, note 6), pp. 15, 22.

8. Profile drawings are not available for the Getty moldings. Observations presented here are based on photographs and should not be considered conclusive. We may cite as parallels, however, two moldings from Metapontion. Published photographs of two roofs show on each an ovolo molding fairly similar to that of the Getty example. Roof B is dated to the first quarter of the fifth century, and Roof A is apparently placed 480–450 B.C. (D. Mertens, in *Neue Forschungen in griechischen Heiligtümern* [Tübingen, 1976], p. 178 and figs. 6–7; *NSc* 29 [1975], Suppl., pp. 344–352).

9. A molding from the island of Naxos, dated 530–520 B.C., is comparable in the strong plasticity and independent rendering of the egg, as well as in the spacing of the individual elements. See G. Gruben, *MJb* 23 (1972), p. 8 and fig. 9. Similar traits are also found in a molding from Thessalonike, associated with an early fifth-century temple perhaps dedicated to Dionysos (G. Bakalakis, "Therme—Thessaloniki," *AntK*, Beiheft 1 [1963], p. 33 and pl. 18.2, 3). Perhaps the closest parallel for the execution and spacing of both eggs and darts appears in the ovolo of Roof A from Metapontion, discussed above (note 8). This molding is particularly significant for our study because of its geographical origin in Magna Graecia.

10. The wider spacing of late fifth-century ovolos is exemplified by those of the Erechtheion. See J. M. Paton et al., *The Erechtheum* (Cambridge, Mass., 1927), pp. 211–212, fig. 139.

11. Boardman, pp. 192–193. E. Buschor, *AM* 58 (1933), pp. 43–46, also discusses the development of palmettes, but on grave stelai, during the Early Classical period.

12. In fact, the only difference between the palmettes and lotuses of the Getty molding lies in the arrangement of the petals, not in their forms.

13. Note, for example, an anthemion molding in the Argos Museum dated to the first or second decade of the fifth century: J. des Courtils, *BCH* 107 (1983), pp. 133–148; a fifth-century anthemion from the Herakleion on Thasos: Ecole française d'Athènes, *Guide de Thasos* (Paris, 1968), p. 72 and fig. 39; as well as two moldings from Chios: Boardman, pp. 191–193, pl. 30, moldings G and J, dated to the first quarter of the fifth century and toward the middle of the fifth century, respectively. See also J. Boardman, *Excavations in Chios 1952–1955* (London, 1957), p. 78.

14. According to the table published by Boardman, p. 184. The Ionic temple from Lokroi, dated by Boardman to the mid-fifth century and listed with the proportion 1:2.25, is the latest example listed before the early Imperial peripteron from Samos, for which the proportion is 1:2.5. No explanation is given for this gap. By its proportions, the Getty base would fit somewhere between these two monuments. It should be noted, however, that the Ionic temple at Lokroi has recently been redated to the period 480–470 B.C.: G. Gullini, *La cultura architettonica di Locri Epizefirii* (Taranto, 1980), p. 104.

15. Boardman, p. 184, and B. Wesenberg, *Kapitelle und Basen* (Düsseldorf, 1971), p. 125. Using Boardman's table, the proportions of the disc would once again place the Getty base later than the Ionic temple at Lokroi and before the early Imperial Samian peripteron. Although Boardman gives a ratio for the Lokrian temple disc of 1:3.75, Gullini (above, note 14), p. 92, suggests that it is 1:3.6. In addition, as both Boardman and Wesenberg indicate, ratios similar to ours are found in bases from the Klazomenian and Massiliot treasuries at Delphi, both of which are datable within the last third or quarter of the sixth century. Because so little evidence is available for the change in ratios over time, we must accept a wide latitude in these dates.

16. Boardman, pp. 175–176; Wesenberg (above, note 15), pp. 117, 126–127. This development in the profile of the disc pertains to the Samian type, of which the Getty base, according to Wesenberg, may be considered a variant. Both Boardman and Wesenberg note that regional variations also play a role in determining the treatment of the flutes. Even the shape of the torus, that is, whether the greater diameter appears in the upper or lower half of the profile, seems to be a result of location rather than chronology, as often assumed.

17. Perhaps the closest parallel is to be found in a base from Thessalonike dated to the beginning of the fifth century: Bakalakis (above, note 9), p. 33, fig. 2. Additional, but less closely related, examples appear in the late sixth century at Chios and toward the end of the first quarter of the fifth century at Metapontion in South Italy. See Boardman, p. 182, no. 34 and fig. 1c, and Mertens, fig. 2, respectively.

18. Two bases from Chios show strongly concave scotiae already in the sixth century (Shoe [above, note 6], pl. 72.8, dated to the second half of the sixth century; Boardman, pp. 182–184, nos. 35, 36 [same as Shoe], figs. 1c, d, respectively, both dated to the late sixth century). On the other hand, a late sixth-century base from Pantikapaion on the Black Sea, which is very similar to the Getty base in composition, displays relatively shallow scotiae (Wesenberg [above, note 15], pp. 119,

125). Most significant for our study is a nearly identical base from the nearby Sicilian site of Motya. See J. I. S. Whitaker, *Motya: A Phoenician Colony in Sicily* (London, 1921), p. 200 and fig. 26, and L. T. Shoe, *Profiles of Western Greek Mouldings* (Rome, 1952), pp. 17, 180, 182, and pl. 31.14. Whitaker does not offer a date for the piece; Shoe offers two: the sixth century (p. 17) and the fifth century (pp. 180, 182).

19. These characteristics appear in the sixth century in a base from Delos (Shoe [above, note 6], pp. 155, 180, and pl. 71.26; Wesenberg [above, note 15], pp. 118, 126, fig. 240). However, they would seem to be more typical of the fifth century, as exemplified in a base from the Athenian akropolis, dated by recent studies to the early fifth century (Wesenberg [above, note 15], p. 127) or sometime between 500 and 450 B.C. (Boardman, p. 184), and in early fifth-century bases from the Polykratean Heraion on Samos (O. Reuther, *Der Heratempel von Samos* [Berlin, 1957], reviewed by F. E. Winter, *AJA* 64 [1960], pp. 89–95, who dates the bases in question to the beginning of the fifth century [p. 91]).

20. Above, note 18.

21. Controversy has arisen lately in regard to the dating of certain architectural remains, including the so-called House of the Mosaics. On the basis of its plan and mosaic decoration, V. Tusa has argued for a date in the middle or even second half of the fourth century, thus indicating construction in the area following the 397 B.C. destruction. Such an argument is significant for our study because it negates the long-accepted terminus ante quem for material found on the island. It also raises the possibility of a later date for the Ionic base, since it was in fact recovered in the vicinity of the House of the Mosaics. However, Whitaker did not associate the base with the house itself, nor does Tusa, in his re-evaluation of the house, suggest any change in the dating of the base. See especially V. Tusa, "Mozia dopo il 397 B.C.," in *Mozia,* vol. 3 (Rome, 1967), pp. 85–95, and his subsequent discussions in *Mozia,* vol. 5 (Rome, 1969), pp. 7–34, and *Mozia,* vol. 6 (Rome, 1970), pp. 51–62. Note also the reaction to Tusa's argument in B. S. J. Isserlin and J. du Plat Taylor, *Motya,* vol. 1 (Leiden, 1974), pp. 89–90.

22. As discussed above (note 18), Shoe gives two different dates for the Motya base. Since she wavers between the sixth and fifth centuries but seems to prefer the latter, we may perhaps interpret the fifth-century assignment as referring to an early part of that century.

23. See, for example, the brief survey given by W. B. Dinsmoor, *The Architecture of Ancient Greece* (London, 1950), p. 136. Boardman, p. 212, suggests that the apparent scarcity of fifth-century Asiatic Ionic architecture may arise at least in part from the incorrect assignment of buildings to the sixth century B.C. A good discussion of the evidence for fifth-century Ionic architecture in Mainland and Western Greece, as well as the East, is provided by Mertens, pp. 122–125.

24. Ionic Temple (D), Metapontion: Mertens, pp. 103–139. Ionic Temple at Lokroi: E. Petersen, *RM* 5 (1890), pp. 161–227; R. Koldewey and O. Puchstein, *Die griechischen Tempel in Unteritalien und Sicilien* (Berlin, 1899), pp. 1–8; Gullini (above, note 14), pp. 45–109. The Erechtheion: Paton et al. (above, note 10). Temple of Athena Polias, Priene: T. Wiegand and H. Schrader, *Priene* (Berlin, 1904), pp. 88–104. Even many of the fourth-century Ionic buildings are too fragmentary to be used for comparison, as for example, the Propylon at Samothrace, where the column bases are lacking (below, note 26, p. 59), or the Temple of Hemithea at Kastabos, which has yielded no dentils and may in fact have had none (J. M. Cook and W. H. Plommer, *The Sanctuary of Hemithea at Kastabos* [Cambridge, 1966], pp. 96–102).

25. For the Lokroi temple, the dimensions given by different sources may vary considerably, particularly in regard to the dentils. Koldewey and Puchstein (above, note 24) state that each dentil is 11.5 cm wide. On the other hand, Gullini (above, note 14) shows an equal width for each dentil and its adjoining space and gives a dimension for both of 33 cm; thus the dentil itself would be 16.5 cm wide. Since no fragment of the dentil course is now extant, these measurements cannot be verified, but it is very unlikely that the dentils and spaces are of equal size. I have therefore chosen to use Koldewey and Puchstein's dimensions for the dentil and to calculate the interval as approximately two-thirds of the dentil width, as found in the other temples noted above. The South or Karyatid Porch of the Erechtheion has, of course, human figures in place of columns. Since they do not stand on bases, I have substituted the average dimension of the length and width of the plinths beneath their feet for the base diameter. The porch was not used in comparing the relative heights of the dentil course and base.

26. Mertens, pp. 103–139. There is some controversy as to the date of the next appearance of a frieze and dentil course within the same entablature. The combination has been identified in the Temple of Messa on Lesbos, which, according to Plommer, may date as early as 400 B.C. (H. Plommer, "The Temple of Messa on Lesbos," in L. Casson and M. Price, eds., *Coins, Culture, and History in the Ancient World* [Detroit, 1981], pp. 177–186). On the other hand, P. W. Lehmann argues that the Propylon to the Temenos at Samothrace marks the earliest appearance of the frieze and dentils together (P. W. Lehmann and D. Spittle, *The Temenos,* Samothrace, vol. 5 [Princeton, 1982], esp. pp. 113–118). She discounts an early fourth-century date for the Messa Temple, assigning it instead to the Hellenistic period, and follows others in suggesting that the frieze is "misplaced." The date she gives for the Propylon, about 340 B.C., would make it slightly older than the Philippeion at Olympia, long considered to be the first building to display the combination of frieze and dentils, and the Monument of Lysikrates in Athens. Such evidence would make the Samothracian propylon the earliest fourth-century example of this feature, but not, as Lehmann asserts, the earliest overall.

27. Boardman (above, note 13), p. 78, proposes the first two uses for a molding from Chios with a similar profile and decoration. He assigns its slightly larger counterpart to the architrave crown.

28. The ratio of lower diameter to column height in Ionic buildings of the late sixth and early fifth centuries B.C. usually varies between 1:8 and 1:9.5. See Mertens, pp. 138–139, for a table of proportions.

29. Ibid. It should be noted that an argument has recently been made for redating the Athenian Stoa at Delphi between 460 and 450 B.C.: J. Walsh, "The Date of the Athenian Stoa at Delphi," *AJA* 90 (1986), pp. 319–336.

30. P. Zancani Montuoro, *AttiMGrecia* 13–14 (1972–1973), pp. 62–66.

31. Temple of Athena, Paestum: F. Krauss, *Der Athenatempel,* Die Tempel von Paestum, vol. 1 (Berlin, 1959). Temple of Hera, Foce del Sele: P. Zancani Montuoro and U. Zanotti-Bianco, *Heraion alla Foce del Sele,* vol. 1 (Rome, 1951), pp. 104–105. Geloan Porch: D. Adamesteanu, *NSc* 14 (1960), pp. 79–82, and most recently B. Barletta, *RM* 92 (1985), pp. 9–17. In addition, a block preserving part of a two-fascia architrave and moldings may represent the remains of a late sixth-century Ionic structure at Katane: G. Libertini, *Il Museo Biscari* (Milan, 1930), p. 81, no. 185, pl. 41; Shoe (above, note 18), pp. 150–151, 177–178, pl. 26.1. Further west, the site of Massalia has yielded an Ionic capital that once served an architectural function, but no other evidence of the building has been found. The piece has been dated as early as 540 B.C. (F. Benoit, *RA* 43 [1954],

pp. 17–43), although others have placed it in the late sixth or even early fifth century B.C. (Boardman [above, note 13], p. 211, and P. Pederson, "Zwei ornamentierte Säulenhälse aus Halikarnassos," *JdI* 98 [1983], pp. 87–121, esp. pp. 111–112, respectively).

32. G. V. Gentili, *Palladio* 17 (1967), pp. 61–84. The temple is not yet fully published. The reconstruction of a capital in the exhibit in the Palazzo Vermexio differs from that given by Gentili in the presence of an eye rather than a simple point as the termination of the volute, but no explanation is provided.

33. Metapontion: Mertens, pp. 103–137, and D. Adamesteanu et al., *BdA* 60 (1975), pp. 26–49. Elea: see Mertens, p. 125. Lokroi: above, note 24. Hipponion: P. Orsi, *NSc*, 1921, pp. 473–485.

34. D. Theodorescu, *Chapiteaux ioniques de la Sicile méridionale* (Naples, 1974), pp. 13–20, 40–42, nos. II–V, dated from the middle to the end of the fifth century or beginning of the fourth century B.C.

35. As noted by Theodorescu (above, note 34), p. 20. It is unclear from the circumstances of discovery exactly how the column base from Motya was employed. Along with other architectural elements found nearby, it may have comprised the inventory of a workshop. See Whitaker (above, note 18), pp. 194–200.

36. P. Marconi, *Agrigento arcaica* (Rome, 1933), p. 122, who assigns this block to Temple G (Vulcan), dated by him in the last third of the fifth century B.C. Marconi also notes the existence at Akragas of other cornices with dentils but does not assign dates to them. Shoe (above, note 18), p. 108, pl. 17.10, labels the block a frieze crown or *epikranitis*, and places it slightly later, between 425 and 406 B.C.

37. Temple of Hera IV (Polykratean Heraion): Reuther (above, note 19). The beginning of construction on this building is traditionally dated to the time of Polykrates, about 530 B.C. Recent excavation has shown, however, that only the foundations of the cella date to this period, while the majority of the building was not begun until the end of the sixth century (*JHS-Archaeological Reports*, 1989–1990, p. 68). Even so, construction was interrupted periodically and never reached completion. Pederson, in his discussion of the development of the anthemion necking (above, note 31, esp. pp. 112–119) attributes the origin of this feature to Samos. He suggests that it was first introduced in bronze, perhaps on Hekatompedon I, and appeared in stone with the Polykratean temple. According to this argument, even the earliest known anthemion necking—

from the Temple of Apollo at Naukratis, dated to the second quarter of the sixth century B.C.—would be dependent on Samian prototypes. The Lokrian necking would likewise result from Samian influence, but reflect a variant group in the substitution of simple volutes for the lyre motif. It should also be noted that the Ionic temple at Metapontion bears a relief necking, although it is decorated with a running spiral between meanders. Other, but less thorough, discussions of the anthemion necking are presented by A. Peschlow-Bindokat, "Ein hellenistisches Säulenhalsstück in Gelibolu," in U. Höckmann and A. Krug, eds., *Festschrift für Frank Brommer* (Mainz, 1977), pp. 237–240, and Lehmann and Spittle (above, note 26), pp. 106–111.

38. Such capitals are known from Paestum, Gela, and Massalia in the sixth century, and from Metapontion and Lokroi during the fifth century B.C. See Barletta (above, note 31).

39. It should be kept in mind that our evidence for regional variations in Ionic architecture during this period is still limited. In particular, the Cycladic tradition remains imprecisely known but, if the sixth-century Ionic temple in Naxos may be used as an example, important contributions can be expected from this area. For the Naxian temple, see G. Gruben, *AA*, 1972, pp. 319–379.

40. Boardman, pp. 193, 196–197, has determined that such moldings first appeared on Chios in the late sixth century and continued at least until the middle of the fifth century B.C.

41. Considerable evidence exists for the presence of Greek workmen at Motya. An example is the House of the Mosaics, which is believed by Whitaker to have been constructed by Greeks, although it may be much later in date than the column base (above, note 21). Material recovered near the base included components of the Doric and Corinthian, thus Greek, architectural orders. The Doric order is represented at Motya even in the Archaic period by a capital, the profile of which is most closely paralleled in examples from Temple F at Selinus: Isserlin and du Plat Taylor (above, note 21), pp. 70–72.

42. Boardman, p. 182, refers to this type of base as "a Chian compromise" between the Samian and Ephesian traditions. As noted above (note 16), Wesenberg has classified it as a variant of the Samian type.

43. Boardman, pp. 182–183, nos. 35–37, figs. 1c, d. Chios has also produced fragments of at least one base with four scotiae (idem, pp. 173–174, no. 11, fig. 1a).

# Bellerophon and the Chimaira in Malibu:
# A Greek Myth and an Archaeological Context

Herbert Hoffmann

A Tarentine box-bezel ring of the fourth century B.C. in the Getty Museum (figs. 1a–c) is the subject of this article. I shall describe, attribute, and date the object, and then move on to some more recondite issues.[1]

## DESCRIPTION AND TECHNOLOGICAL COMMENTARY

The following description is based on a methodological model developed by Patricia F. Davidson and myself for the catalogue publication *Greek Gold* (1965).[2] While the ensuing description may seem overly punctilious, it is designed to enable the student to re-create the process of the ring's crafting as though the object were examined under high magnification. For specialist nomenclature see drawing figure 2.

The bezel has the shape of an oval box the top sheet of which bears a stamped and applied relief device depicting Bellerophon defeating the Chimaira (fig. 1a). A small three-petal flower—actually a rudimentary palmette—rises from the ground beneath the Chimaira, and a rinceau of tendrils—open scrolls made of short lengths of fine strip-twisted wires—rises to the right and left of this plant. A plain wire and a thick beaded wire constitute the oval frame. The underside of the bezel (fig. 1b)—an oval sheet like the bezel's top—is finely decorated with two addorsed nine-petal palmettes, two bell-shaped flowers pointing respectively up and down, and two tight wire coils to the right and left, the last manufactured by twisting a flat wire back on itself and then flattening the cone-shaped spiral thus produced. Four plain wires bent in double-helix form are arranged in a circle around a central hole (see below). Seen as two addorsed pairs, they become the floral calyxes from which the palmettes issue. The bezel's sides (fig. 1c) are decorated with alternately upright and reversed buds—short lengths of wire bent into calyx form—with a drop-shaped element set in the cleave and framed by tendril scrolls. This decorative motif is framed by a plain wire and a "rope braid"—two plain wires tightly twisted and laid side by side so as to appear as braiding (see fig. 2.c).

The ring's hoop is made of a wire core to which several rows of "rope braiding" are applied, producing the effect of a plaited chain. At each end, where the hoop joins the bezel, it is capped by a "cuff" cut from a narrow sheet of foil to which rows of beaded wire, "rope braid," plain wire, and pointed tongues are applied. The two "cuffs" are surmounted by a palmette anthemion of fine strip-twisted wires on a roughly cut base sheet curved so as to clasp the bezel and mask the brazed joint to the hoop. The thick beaded wires framing the top and bottom oval sheets mask the seams of the box construction. The stamped Bellerophon relief is fastened in place by the wire tendrils framing it. The various filigree motifs—palmettes, bell-flowers, tongues, scrolls, tendrils—were once inlaid with aquamarine and turquoise paste. Traces of these former inlays remain in the petals of both palmettes on the bezel's bottom surface.

The round hole in the center of the bottom surface (present also in the British Museum parallels, see below) served a practical function: It permitted the escape of gases during joining, thereby preventing the seams from bursting. The reason this precaution was necessary has to do with the closed-box shape of the ring and the chemical nature of the ancient "welding" (colloidal hard-soldering) process: All parts—including the myriad of decorative wires—were glued in place with a mixture of tragacanth and a powdered cupric salt. When the finished assembly was carefully heated over a bed of charcoal embers, the tragacanth burned away and the cupric salt ($CuCo_3$) became copper (Cu), which lowered the surface melting point sufficiently for all joints to become invisibly "welded" together. Two thick wire clamps, bent over and "welded" to the beaded wire frame to the right and

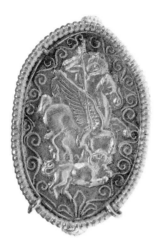

FIGURE 1a

Box-bezel ring. Top. Malibu, J.
Paul Getty Museum 88.AM.104.

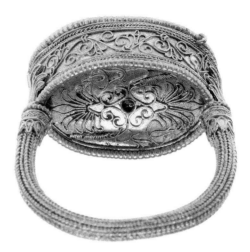

FIGURE 1b

Underside of box-bezel ring, figure 1a.

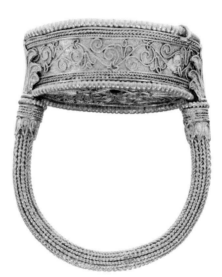

FIGURE 1c

Side view of box-bezel ring, figure 1a.

a.

b.

c.

d.

e.

f.

g.

h.

FIGURE 2

Various types of wire used for decoration. *a:* strip-twisted wire. *b:* two wires entwined into a rope. *c:* two ropes laid side by side to form a rope braid. *d:* beaded wire. *e:* spool wire. *f:* elaboration on beaded wire. *g:* elaboration on spool wire. *h:* spiral-spool wire. Drawings by Kurt Hauser after H. Hoffmann and P. F. Davidson, *Greek Gold* (note 2), figs. H–M, R–S.

left of the central axis (beneath the Chimaira), serve no functional or aesthetic purpose. They were apparently added to bring the gold content of the ring—that is, its value—up to a preestablished standard, namely 8.02 g, or one Tarentine *nommos* (this being the name given to the most common Tarentine silver coin, equivalent to slightly less than one Attic didrachm).

### STYLE AND DATE

While the ring's provenance remains unknown, it can, due to the perfect state of preservation, be assumed to be part of a tomb deposit. The object appears to be of Tarentine workmanship and to date from the second half of the fourth century B.C. This tentative attribution is founded on a comparison with three closely related finger rings in the British Museum, which, together with the Bellerophon ring, in effect form a cohesive stylistic "group." They are illustrated and discussed by Dyfri Williams.[3]

1. GR 1872.6-4.146, Williams, p. 77, pl. 32.2–3; here figures 3a, b. Seated goddess or woman with scepter; reverse like Getty ring. From the Tomb of the Taranto Priestess

2. GR 1923.4-21.3, Williams, pp. 79–80, pl. 34.1–2. Dancing maenad. From the Avola hoard

3. GR 1934.11-15.1, Williams, pp. 87–88 and note 21, pl. 38.3–4. Naked woman or Aphrodite leaning on a pillar. According to Dyfri Williams by the same goldsmith as the preceding two

Number 1 shares a distinctive "stylistic" feature with the Getty ring, namely the palmettes grouped around the central hole on the underside. Also of significance—as supporting the argument for Tarentine workmanship—is the fact that the weight of number 1, 7.9 g, tallies closely with the weight of the Getty ring, both corresponding almost exactly to the weight of the *nommos,* or Tarentine standard.

Somewhat earlier than the preceding rings and likewise probably of Tarentine workmanship is a swivel-bezel ring now in Berlin, acquired by the museum from the late Charles Morley of St. Moritz, Switzerland, and said by him (to the writer) to be from Tarentum.[4]

In *Greek Gold*[5] I wrote as follows regarding the style and provenance of Late Classical/Early Hellenistic gold jewelry referred to—perhaps overconfidently—as "Tarentine" in various catalogue publications:

FIGURE 3a

Box-bezel ring. Side view. London, British Museum GR 1872.6-4.146. Photos courtesy Trustees of the British Museum.

FIGURE 3b

Top of box-bezel ring, figure 3a.

The development of Tarentine jewelry runs remarkably parallel to that of Northern Greece and Asia Minor, and virtually every type known from those areas is represented. The connections between Greece and Southern Italy in the field of jewelry appear to be so close as to suggest that Greek models were regularly imported and imitated in much the same way as today the models of the "grands couturiers" in Paris annually set the style for wear throughout the world; at the same time it is necessary for us to ask ourselves whether some of the gold objects found in Greece and Asia Minor from this period may not, perhaps, have come ultimately from Southern Italy.

This cautious assessment still seems valid. I therefore append four other box-bezel rings with stationary or turnable bezels that seem to me to belong in the wider penumbra of this "Tarentine group":

1. Pforzheim, Schmuckmuseum 1960, 180. Deppert-Lippitz (see note 2), fig. 113 ("from Kephallenia")

2. Chr. Alexander, *The Art of the Goldsmith in Classical Times as Illustrated in the Museum Collection,* Metropolitan Museum (New York, 1928), p. 19, no. 110

3. T. Hackens, *Catalog of the Classical Collection: Classical Jewelry,* Rhode Island School of Design (Providence, 1976), no. 38 (with glass-paste bezel)

4. *Melvin Gutman Collection of Ancient and Medieval Gold, Allen Memorial Art Museum Bulletin* 18 (n.d.), no. 97. For the "braided" hoop, cf. also *Greek Gold* (see note 2), no. 101. The history of the box-bezel ring as a type is discussed by R. A. Higgins, *Greek and Roman Jewellery* (London, 1961), pp. 169–170

### THE ICONOLOGY

This much is tangible and empirically verifiable, and this is as far as my expertise as an archaeologist would normally take me. But I am curious to know more. A fundamental question—indeed to me the most interesting question that this object poses—has not been dealt with, namely that of the former function and significance of the ring. It shows no signs of wear even under high magnification, and it was evidently quite new when buried together with the corpse whose finger it adorned. From this I conclude that the object was specially purchased—and indeed probably created—to be worn by a man or a woman in his or her tomb. Lavish funerals—the destruction of wealth by burial—were the rule rather than the exception in semi-"barbarian" Apulia—quite unlike the norm in

frugal Athens, where special legislation limited such expenditures for the dead. The Apulian (Tarentine) practice of adorning corpses with valuable jewelry corresponds more to burial practices known from Balkan Illyria, a region with which Apulia maintained close ties.[6] I should like to know more, in other words, about the object's mortuary context: about the meaning that the motif of Bellerophon and the Chimaira might have held as a funeral offering—to be seen and admired by the living during *prothesis* (the display of the corpse) but primarily intended to accompany the deceased in his or her new life.

In searching for an answer to this compelling question, my attention right at the outset is riveted by a set of puzzling statistics that, while duly registered by previous investigators, has never been explained:

1. In the Archaic period of Greek art Bellerophon defeating the Chimaira was, like Herakles wrestling with the lion and Perseus pursuing the Gorgon, part and parcel of the standard iconographic repertory of heroic myth. The motif appears on numerous Protocorinthian, Corinthian, and Early Attic vases, and Pausanias 3.18.3 tells us that it was figured (along with the labors of Herakles and of Perseus) on Bathykles' throne of Apollo at Amyklai, a work of about 530 B.C. Bellerophon must, furthermore, at some time have been worshiped at Corinth, for he appears on Corinthian coinage, and Pausanias was shown his hero-precinct (2.2.4).

2. Subsequently—in the fifth century B.C.—Bellerophon's imagery almost disappears from mainland Greece. We know very few representations of his myth in Athenian red-figured vase-painting of the Severe Style and none whatsoever in Attic fourth-century. The hero's iconography "survives" on the periphery of the Greek world, however: in two "Melian" terracottas, on a silver cup from South Russia, and in the Chimaira from Arezzo.[7]

3. Precisely at the time of his eclipse in Athens and mainland Greece—and this is what I find so interesting and begging for an explanation—Bellerophon is immensely popular in South Italy. There are more than thirty representations of the hero defeating the Chimaira on the fourth-century vases of Tarentum alone. No single deed of Herakles, that most ubiquitous of all Greek heroes, is represented in Magna Grecia in nearly so many examples.

What, then, might be the reason for Bellerophon's decline in metropolitan Greece and contemporaneous proliferation abroad, notably in Italy?

In searching for an answer, let us next look at the myth itself.[8] The following is condensed from *Iliad* 6.155–203, this being the most detailed early account. Bellerophon, the descendent of Sisyphos via Glaukos (also called the son of Poseidon by Homer and Hesiod) appears as a suppliant at the court of Proitos, King of Argos, where Anteia, Proitos's wife, falls in love with him. When he refuses her advances, she accuses him of having tried to seduce her, and Proitos believes her story. Yet he hesitates to kill Bellerophon, and instead sends the hero to his brother-in-law Iobates, King of Lycia, with a sealed letter requesting his elimination. Iobates, however, likewise does not wish to kill a guest outright and sends Bellerophon on a series of missions designed to bring about his death. Among these is the task of slaying the Chimaira, a fire-breathing monster "in her forepart a lion, in her hindpart a serpent, and in her middle a goat" (Hesiod). The gods intervene: Poseidon sends the hero the winged horse Pegasos and Athena provides a magic bridle. Bellerophon is now able to overcome the Chimaira by spearing her from above, and he goes on successfully to complete the further various dangerous tasks assigned him. Iobates thereupon recognizes Bellerophon's divinity and repents: He gives the hero his daughter in marriage and half his kingdom.

At this point in the narrative the Homeric account becomes inconsistent and obscure. After all his marvelous accomplishments—defeating the Amazons and the Solymi, killing the Chimaira, marrying Iobates' daughter and fathering three children by her—Bellerophon suddenly and without warning is said in lines 200–203 (the end of the Bellerophon digression) to be "hated by all the gods" and to have gone on henceforth "wandering alone," "avoiding the paths of men." This seems very strange, indeed, for Greek heroes are usually called the *beloveds* of the gods. They normally die violently and go on to take their place at the immortals' eternal symposium. Bellerophon, in contrast, simply fades away. What could have happened to our hero to warrant such an abrupt and inglorious end to his promising career?

Pindar, that eloquent spokesman of conservatism in politics, morals, and religion—and prolific commentator on Homeric myth—offers what seems a plausible explanation: In the seventh *Isthmian Ode,* probably written in 456 B.C., he takes up the story where the Homeric account leaves off. True to his

deep-rooted belief that the gods punish the presumptuous, the poet has the winged horse Pegasos throw off his rider, "who would have ascended to heaven" (46). There follows a characteristically Pindaric moral pronouncement: *luku pikrotata menei teleuta,* "a bitter end awaits stolen sweets." Pindar is censuring Bellerophon for having tried to bypass the tomb (or, worse still, for having succeeded!). By providing a tragic end to the Homeric account—making Bellerophon an *anti-hero* brought to fall by the gods—Pindar brings the myth in line with contemporary fifth-century *polis* ideology.

The Pindaric version of Bellerophon's end is adopted by Euripides in his lost tragedy the *Bellerophon,* of which some fragments survive.[9] The lamed hero appears on the stage convinced now that it is "best never to have been born, but once born next best to die young." This famous adage, attributed to various sages (Herod. 1.33), was often quoted in support of the aristocratic ideal of heroic self-sacrifice in battle. Both Pindar and Euripides, as defenders of the Athenian state religion, represent Bellerophon in negative terms, as a renegade. His spirited flight to heaven—anticipating Mohammed's mystic ride by more than a thousand years—runs counter to the ideal of *thanatos kalos* as demanded by Perikles in the *Funeral Oration.* For Pindar and Euripides, as for most Athenians of their time, Bellerophon was clearly hubristic (from *hubris* = outrageous wantonness, insolence toward the gods). The religion of "glorious death," which was pervasive in Athens during the Golden Age, may explain why Athenian red-figure vase-painters were nearly unanimous in purging Bellerophon's myth from their repertory of politico-religious themes. Indeed, there is good reason to believe that *Iliad* 3.200–203 is a fifth-century interpolation.[10]

Returning now to the scene on the South Italian bezel: Whereas in fifth-century Athens Bellerophon was suspected of having circumvented the "Olympian" religion based on immortality through soldierly achievement, we find that in South Italy the hero was quite apparently seen with different eyes. Nowhere is there any hint of his fall or of any "hubristic" association. The prominence given Bellerophon in South Italian vase-painting suggests, rather, that here the old tradition of the divine celestial rider was still alive. Not only Bellerophon's victory over the Chimaira is represented on innumerable vases, especially on the pateras and oinochoai, two shapes most closely connected with the mortuary ritual, but also his triumphant reception by Iobates.[11] On Apulian vases

Bellerophon is crowned by Eros and by Nike; he is surrounded by satyrs; he is even welcomed by Dionysos himself. On the Getty ring we see Bellerophon and the Chimaira as on numerous South Italian vases: celestial hero above, terrestrial (chthonic) monster below, their vertical above/below alignment expressing the victory of good (life) over evil (death), this corresponding to pagan mystery religion's basic doctrine of redemption.

The reason for Bellerophon's "celebration" in South Italy has to do with the fact (or so it would seem to me) that religion in this frontier region took place on a more private and individual level than in contemporary Greece. In addition to the official cults of the Greek *polis* there were also numerous private sects or religious communities that offered an alternative to orthodox *polis* religion. Of these, the Bacchics and the Orphics were certainly the most prominent and established, and the myth of the celestial highrider harmonized with their individualistic theology. We might even go so far as to consider the possibility of the man or woman buried with the golden "icon" of Bellerophon and the Chimaira on his or her finger having been affiliated with one of these influential alternative cults. As to the question posed at the outset—why an image of Bellerophon might have accompanied someone to the grave—the answer seems to be that Bellerophon in fourth-century South Italy possessed the status of a patron, or hero-benefactor, making him both theologically and iconologically speaking the godfather of Saint George (fig. 4). Bellerophon's *ascent*—his heaven-bound ride on the back of the divine horse Pegasos—endorsed, probably, by a tradition of equestrian divinities native to horse-breeding Apulia[12]—may have been regarded in a similar way as the *descent* of Orpheus, who brought back his wife from the dead. Although neither figure seems to have had an official cult in Italy, both were apparently venerated privately as quasi-divine *iatromanteis,* miracle workers with the power to travel between "worlds" and intercede on behalf of the dead. As part of a mortuary complex of offerings (grave goods), the image of Bellerophon and the Chimaira mediated—that is, helped bridge the gap—between the visible and the invisible worlds, and by mentally opening the way for passage between one realm and the other, the hero's "icon" in effect *created* immortality.[13]

Radda in Chianti
Siena

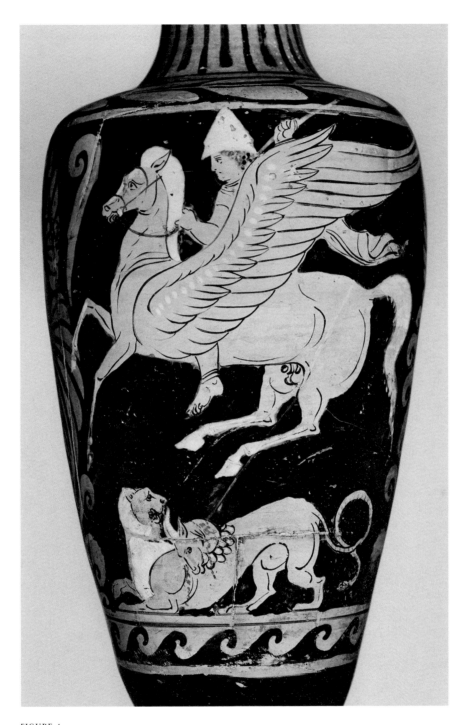

FIGURE 4

Campanian bail-amphora. Detail. Bellerophon killing the Chimaira. New York, The Metropolitan Museum of Art, Rogers Fund, 1906, 06.1021.240. Photo courtesy The Metropolitan Museum of Art.

## NOTES

1. Marion True invited me to Malibu and asked me to publish this recent acquisition. Dieter Metzler discussed fifth-century revisions of early Greek myth with me and helped convince me of the basic validity of my orientation. Herbert A. Cahn contributed his invaluable numismatic expertise. I should like to thank all of them.

   The ring is Malibu, J. Paul Getty Museum 88.AM.104. H: 2.7 cm, W: 2.2 cm, H of bezel: 0.85 cm, H of bezel image: 2.1 cm, Weight: 8.02 g. See J. Spier, *Ancient Gems and Finger Rings: Catalogue of the Collections, The J. Paul Getty Museum* (Malibu, 1992), pp. 6, 41.

2. H. Hoffmann and P. F. Davidson, *Greek Gold: Jewelry from the Age of Alexander,* exh. cat., Museum of Fine Arts, Boston, and other institutions, November 1965–May 1966 (Mainz, 1965), pp. 15, 266ff. On Tarentine jewelry generally, see E. M. De Juliis, ed., *Gli ori di Taranto in età ellenistica,* exh. cat., Milan, Brera Museum, December 1984–March 1985; W. D. Heilmeyer, *Jahrbuch der Stiftung Preußischer Kulturbesitz* 17 (1980), pp. 199ff.; B. Deppert-Lippitz, *Griechischer Goldschmuck* (Mainz, 1985), p. 307.

3. D. Williams, "Three Groups of Fourth Century South Italian Jewellery in the British Museum," *RM* 95 (1988), pp. 75–95, pls. 30–39, with references to earlier literature.

4. *Greek Gold* (above, note 2), no. 99; A. Greifenhagen, *Schmuckarbeiten in Edelmetall,* vol. 1 (Berlin, 1970), pl. 17; S. G. Miller, "Two Groups of Thessalian Gold," *University of California Classical Studies* 18 (1979), pl. 11a–c.

5. *Greek Gold* (above, note 2), p. 15.

6. On Apulia's "Illyrian connection," see D. Metzler, "Zur Geschichte Apuliens im Altertum," in K. Stähler, ed., *Apulien: Kulturberührung in griechischer Zeit* (Münster, 1985), pp. 14ff. On Apulian interest in horses and equestrian divinities, see H. Hoffmann, "Rhyta and Kantharoi in Greek Ritual," *Greek Vases in the J. Paul Getty Museum* 4 (1989), p. 145.

7. K. Schefold, *Urkönige: Perseus, Bellerophon, Herakles und Theseus in der klassischen und hellenistischen Kunst* (Munich, 1988).

8. Bellerophon's myth—the ancient sources: Homer, *Iliad,* 6.155–203; Hesiod, *Theogony,* 319ff.; Pindar, *Olympian Odes,* 13.63–90; idem, *Isthmian Odes,* 7.44; Plutarch, *On the Virtues of Women,* 247–248. Significantly, Virgil, *Aeneid,* 6.288, and Lucian, *Dialogi Mortuorum,* 30.1, both locate the Chimaira in the Underworld. See also R. Graves, *The Greek Myths,* vol. 1 (Harmondsworth, 1960), p. 253. On Bellerophon as a "faded" celestial divinity, esp. L. Malten, *Hermes: Zeitschrift für klassische Philologie* 79 (1944), pp. 1ff. On the rationalistic interpretation of pre-Greek myths in the fifth century B.C., see now A. Kottaredu, *Kirke und Medea* (Mainz, 1990), brought to my attention by Dieter Metzler. For a divergent view of Bellerophon, see Schefold (above, note 7), who argues for Bellerophon's fall as being integral to early Greek myth and cites a pithos relief (H. Hoffmann, ed., *Dädalische Kunst auf Kreta im 7. Jahrhundert v. Chr.,* exh. cat., Hamburg, Museum für Kunst und Gewerbe, 1970, pl. 266, C12) as evidence.

9. H. von Arnim, *Supplementum Euripideum* (Bonn, 1913), pp. 43ff.

10. Cf. Leaf's comment on these problematic lines, which interrupt the Homeric narrative: W. Leaf, ed., *Homer, The Iliad* (London, 1900), p. 272.

11. Bellerophon in art: F. Brommer, "Bellerophon," *MarbWPr* 1952–1954, pp. 3ff.; *Heldensage³,* pp. 292ff.; K. Schauenburg, "Bellerophon in der unteritalischen Vasenmalerei," *JdI* 71 (1956), pp. 59ff., figs. 1–27. Schefold (above, note 7) explains the paucity of Bellerophon's imagery in Attic red-figure by arguing that the subject was not adapted to the vase medium (p. 116: "eignet sich besser für tektonische und emblematische Verwendung").

12. See note 6. On the religion of Late Classical South Italy, see W. Burkert, *Griechische Religion der archaischen und klassischen Epoche* (Stuttgart, 1977), pp. 432ff.; idem, "Craft versus Sect: The Problem of Orphics and Pythagoreans," in B. F. Meyer and E. P. Sander, eds., *Self-Definition of the Graeco-Roman World* (London, 1982), pp. 1ff.; W. K. C. Guthrie, *Orphism and Greek Religion* (1935; London, 1952); M. L. West, *The Orphic Poems* (Oxford, 1983). Further: *Orfismo in Magna Grecia,* Atti del 14. Convegno di Studi sulla Magna Grecia, Taranto, 1974 (Naples, 1979), esp. pp. 139ff., pls. 18–20.

13. On the role of imagery in the creation of symbolic immortality, see H. Hoffmann, "The Riddle of the Sphinx: A Case Study in Athenian Immortality Symbolism," in I. Morris, ed., *Classical Greece: Ancient History and Modern Archaeology* (Cambridge, forthcoming).

# Quattro statue in terracotta provenienti da Canosa

Maria Lucia Ferruzza-Giacommara

La collezione di sculture in terracotta del J. Paul Getty Museum comprende quattro statue provenienti da Canosa e rappresentanti delle figure femminili in atteggiamento di preghiera o di lamento (fig. 1).

1. STATUA (figg. 2a–d).
Dimensioni: h. tot. cm 96.02; largh. max. cm 23.5; h. tot. del viso cm 12.3; spessore delle pareti max. cm 6.5, min. cm 1.9.
85.AD.76.1
Stato di conservazione: integra e leggermente abrasa.
Argilla: beige con sfumature arancio pallido.
Policromia: ingubbiatura; una striscia verticale di colore rosa lungo il lato sinistro del peplo, rosso mattone usato per i capelli, le labbra e i calzari, sporadiche tracce di colore nero sul peplo e sull'himation.
Dettagli tecnici: presenza di tre fori circolari (diametro cm 1.5 circa): due sul margine inferiore del peplo (metà anteriore e posteriore), il terzo sul lato destro della figura.
Descrizione: la figura si presenta in posizione stante con il peso sulla gamba destra e la sinistra leggermente avanzata e flessa. Le braccia piegate al gomito sono alzate ai lati della figura, le dita delle mani sono aperte e ben distinte. La testa è leggermente inclinata e volta verso sinistra. Il viso è ovale e scarno, il mento appuntito, la fronte alta; le sopracciglia sono corrugate, le palpebre ben evidenziate e la bocca, il cui labbro inferiore è più sporgente rispetto al superiore, è tesa in un'espressione di tristezza (fig. 2a). I capelli, resi con incisioni, sono divisi sulla fronte e, lasciando le orecchie scoperte, sono raccolti indietro in una morbida coda di cavallo (fig. 2b).
La figura indossa un peplo che scende in più pieghe, di cui una più scanalata delle altre, e un corto himation portato come scialle, un lembo del quale viene lasciato cadere dalla spalla sinistra sul busto della figura.[1]
L'himation ricopre le braccia fino al gomito e *l'apop-tygma* del peplo sottostante, che si lascia intravvedere attraverso le aperture dell'himation sui due lati, formando sul davanti larghe pieghe semicircolari (fig. 2c). Il peplo è decorato con una banda verticale di colore rosa.[2] Sul lato posteriore sono messe in evidenza solo le pieghe stilizzate dell'himation e del peplo.

Sul busto si osservano un segno graffito (fig. 2d).

2. STATUA (figg. 3a–d).
Dimensioni: h. tot. cm 95.06; largh. max. cm 31.9; h. tot. del viso cm 11.6; spessore delle pareti max. cm 9.5, min. cm 1.4.
85.AD.76.2
Stato di conservazione: manca la punta del dito mignolo della mano sinistra, restaurati il dito medio, anulare e mignolo della mano destra. La superficie è abrasa.
Argilla e policromia: come sopra.
Dettagli tecnici: presenza di due fori circolari sui lati del bordo inferiore della figura nella metà posteriore.
Descrizione: la posizione e la ponderazione del corpo sono simili alla figura precedente. La testa, al contrario, è inclinata verso destra e il ginocchio della gamba flessa è più ruotato verso sinistra; le sopracciglia sono maggiormente corrugate e formano due rughe al centro della fronte, il labbro superiore, più carnoso, si delinea in una curva ondulata. Nell'insieme tale accentuazione dei lineamenti del volto evidenzia maggiormente l'espressione di compianto (fig. 3c).

Sul bordo inferiore dell'himation si osserva un segno graffito (fig. 3d).

3. STATUA (figg. 4a–d).
Dimensioni: h. tot. cm 93.04; largh. max. cm 31.2; h. tot. del viso cm 12.5; spessore delle pareti max. cm 6.4, min. cm 1.4.
85.AD.76.3

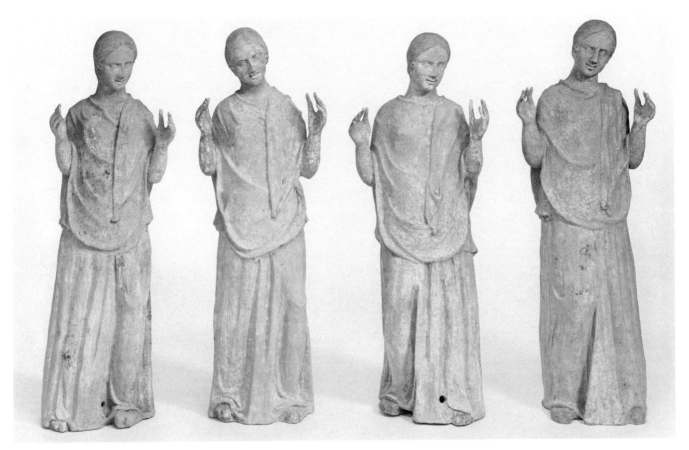

FIGURA I

Quattro statue in terracotta. Malibu, J. Paul Getty Museum 85.AD.76.1–4.

Stato di conservazione: intatta con superficie abrasa.
Argilla e policromia: come sopra.
Dettagli tecnici: due fori circolari, uno sul bordo inferiore del peplo nella metà anteriore, l'altro sul lato destro della figura.
Descrizione: la figura è simile nelle caratteristiche generali alle precedenti, tuttavia il peso del corpo poggia sulla gamba sinistra, mentre la destra è portata indietro e flessa; la testa poi è leggermente volta verso sinistra. I lineamenti sono analoghi a quelli della figura n. 1 (labbro superiore dritto, sopracciglia lineari ed espressione triste) (fig. 4c).

Sul lato inferiore destro dell'himation nella parte anteriore si osserva un segno graffito (fig. 4d).

4. STATUA (figg. 5a–d).
Dimensioni: h. tot. cm 95.05; largh. max. cm 32.1; h. tot. del viso cm 12.2; spessore delle pareti max. cm 8.4, min. cm 2.1.
85.AD.76.4
Stato di conservazione: intatta con superficie abrasa.

Argilla e policromia: come sopra.
Dettagli tecnici: un foro circolare sul bordo inferiore del peplo nel lato posteriore della figura.
Descrizione: la figura è simile alla statua n. 3, ma la gamba destra è meno arretrata e la testa è inclinata verso sinistra. Simile è la disposizione del panneggio; si osservi ad esempio, in entrambe le figure, il lieve incavo e l'ondulazione della piega sul seno destro. I lineamenti e le fattezze del viso, tuttavia, sono più somiglianti a quelli della figura n. 2, soprattutto per quanto riguarda la linea delle sopracciglia e la resa delle labbra (fig. 5c).

Sull'himation sono incisi due segni (fig. 5d).

Nei laboratori del J. Paul Getty Museum è stata di recente restaurata una quinta figura, che da una prima analisi si presenta simile alle statue qui presentate.

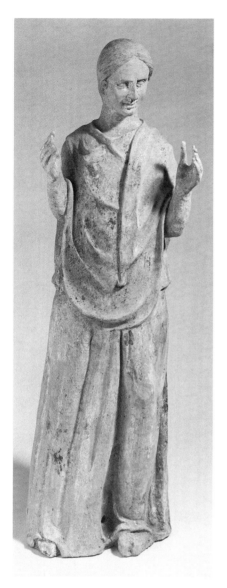

FIGURA 2a

Statua n. 1. Parte frontale. Malibu, J. Paul Getty Museum 85.AD.76.1.

FIGURA 2b

Parte posteriore della statua fig. n. 2a.

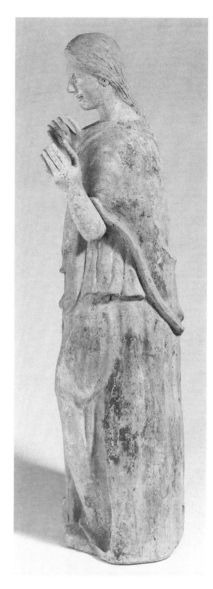

FIGURA 2c

Parte laterale sinistra della statua fig. n. 2a.

FIGURA 2d

Segno graffito sul busto della statua fig. n. 2a.

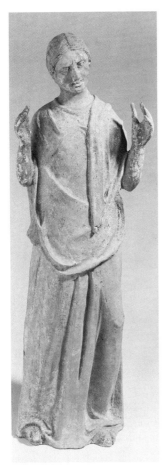

FIGURA 3a

Statua n. 2. Parte frontale. Malibu, J. Paul Getty Museum 85.AD.76.2.

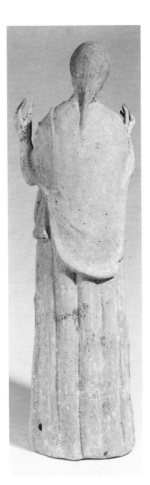

FIGURA 3b

Parte posteriore della statua fig. n. 3a.

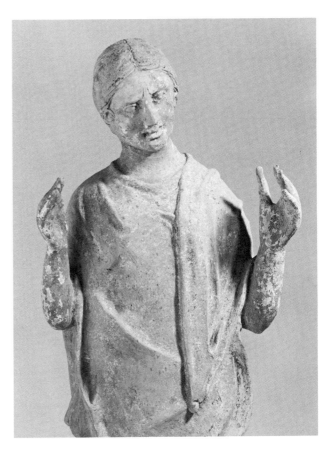

FIGURA 3c

Particolare della parte frontale della statua fig. n. 3a.

FIGURA 3d

Segno graffito sul busto della statua fig. n. 3a.

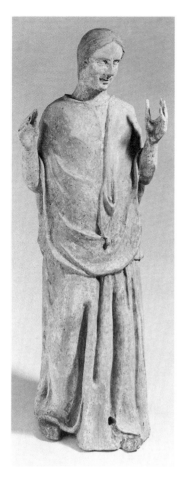

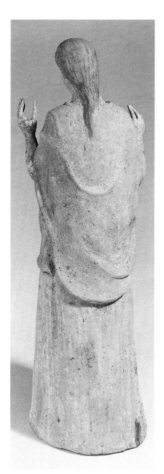

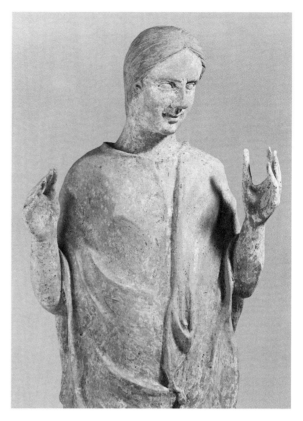

FIGURA 4C

Particolare della parte frontale della statua fig. n. 4a.

FIGURA 4a

Statua n. 3. Parte frontale. Malibu, J. Paul Getty Museum 85.AD.76.3.

FIGURA 4b

Parte posteriore della statua fig. n. 4a.

FIGURA 4d

Segno graffito sul busto della statua fig. n. 4a.

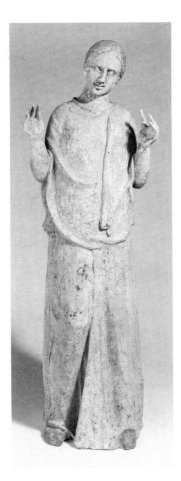

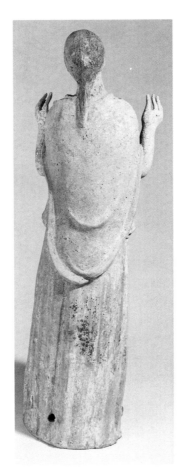

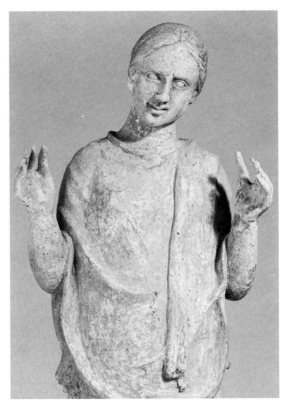

FIGURA 5C

Particolare della parte frontale della statua fig. n. 5a.

FIGURA 5a

Statua n. 4. Parte frontale. Malibu, J. Paul Getty Museum 85.AD.76.4.

FIGURA 5b

Parte posteriore della statua fig. n. 5a.

FIGURA 5d

Segno inciso sul busto della statua fig. n. 5a.

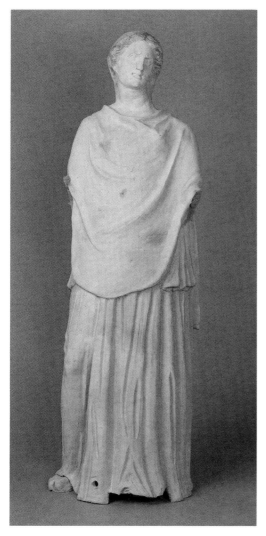

FIGURA 6a

Statua in terracotta. Parte frontale. Malibu, J. Paul Getty Museum 79.AD.194.

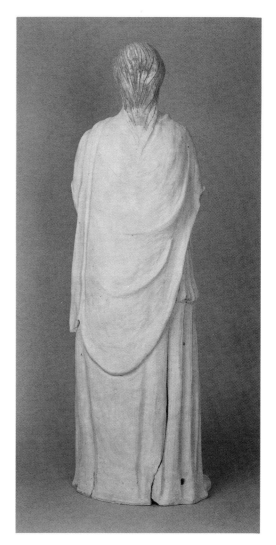

FIGURA 6b

Parte posteriore della statua fig. n. 6a.

5. STATUA (figg. 6a, b).

Dimensioni: h. max. cm 96.5; largh. max. cm 31.

79.AD.194

Stato di conservazione: Mancano le braccie e il piede sinistro.

Argilla: internamente beige pallido, all'esterno marrone chiaro tendente al rossiccio.

Policromia: rosso mattone usato per i capelli.

Descrizione: la posizione e l'abbigliamento sono simili alle figure nn. 3 e 4. Il viso è modellato con maggiore libertà espressiva, i capelli, resi sempre attraverso stilizzate incisioni, si dispongono sulla fronte in più morbide ondulazioni. La testa è inclinata verso sinistra, il corrugamento della fronte è reso più esplicito da quattro rughe incise nel suo centro e ai lati delle sopracciglia che, profondamente arcuate, accentuano la cavità degli occhi.

Ogni statua è stata eseguita con l'impiego di due matrici, una per il lato anteriore, l'altra per il posteriore, ma non è escluso che il coroplasta abbia preferito usare quattro matrici, due per le metà posteriore e anteriore della parte superiore del corpo, le altre due per la parte inferiore (metà posteriore e anteriore). Lo spessore delle pieghe del bordo dell'himation, infatti, rappresentava un punto conveniente per celare il più possibile la linea di congiunzione e le imperfezioni della modellazione.

Tuttavia ci si aspetterebbe di trovare con più evidenza i segni della lavorazione e le sbavature

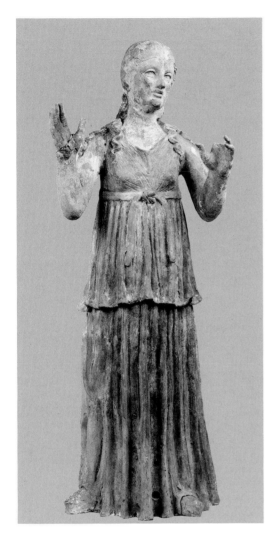

FIGURA 7

Statua in terracotta proveniente da Canosa. Rouen,
Musée des Antiquités 2054.

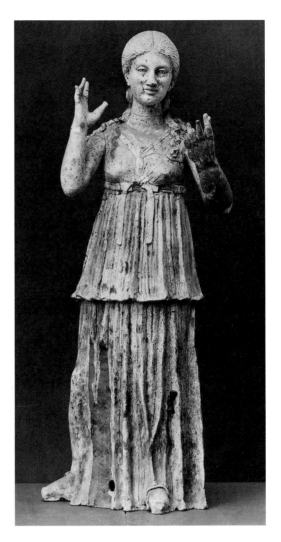

FIGURA 8

Statua in terracotta proveniente da Canosa. Copena-
ghen, Nationalmuseum 4995.

dell'argilla, laddove invece è quasi impossibile verifi-
care al tatto, nella sezione interna delle pareti, la linea
di congiunzione delle due metà all'altezza del bordo
inferiore del corto himation. Non si comprende dun-
que perchè il coroplasta abbia curato di smussare e
modellare una parte che in ogni caso restava nascosta.
Le braccia, la testa e i piedi venivano aggiunti separa-
tamente.[3] Le figure nn. 1 e 2 sembrano ricavate dalle
stesse matrici, presentandosi infatti nella medesima
posizione e trovando confronti nel tipo di panneggio;
per le stesse ragioni altre identiche matrici sono state
con ogni probabilità impiegate per le figure nn. 3 e 4.[4]

   Il coroplasta poi è intervenuto su ogni singolo
fittile variando e ritoccando alcuni dettagli per perso-
nalizzare con più accuratezza la sua produzione.

L'accorgimento preferito sembra sia stato l'alterazione
della posizione della testa e il ritocco dei lineamenti
del viso e del panneggio.[5]

   Tali espedienti permettevano di elaborare par-
zialmente un tipo di statua senza doverne creare uno
ex-novo, facilitando e alleggerendo così l'economia
della produzione.

   L'argilla è quella tipica dell'area di Canosa, di
colore beige pallido con sfumature arancio chiaro
attribuibili all'intensità della temperatura di cottura e
alla minore o maggiore lontananza dell'esemplare ris-
petto alla fonte di calore.[6]

   I colori applicati dopo la cottura erano stesi sopra
un'ingubbiatura costituita probabilmente da latte di
calce e conservatasi in più punti.[7]

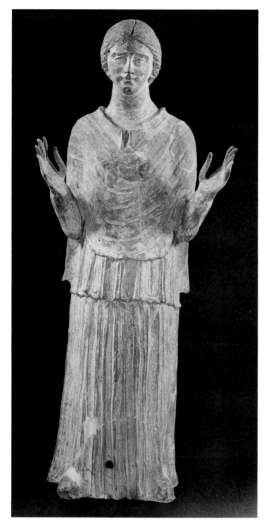

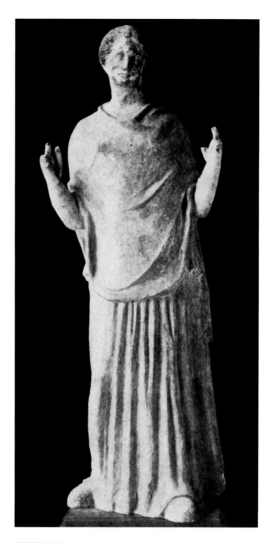

FIGURA 9

Statua in terracotta proveniente da Canosa. Bari, Museo 455.

FIGURA 10

Statua in terracotta proveniente da Canosa. Napoli, Museo Nazionale 22246–2224.

La tavolozza non è molto varia, attestando per le quattro statue le stesse tonalità: rosa, rosso bruno e nero.

I fori circolari notati sul bordo inferiore delle figure servivano con ogni probabilità a fissarle alla base sopra cui erano collocate.

Gli stessi fori circolari sono presenti anche nelle statue provenienti dalla tomba Scocchera B di Canosa[8] e conservate nei musei di Rouen (fig. 7),[9] Copenaghen (fig. 8),[10] Bari (fig. 9)[11] e in un'altra statua, simile nella tipologia, attualmente al Museo di Napoli.[12]

Le statue sono internamente cave e prive dei fori sfiatatoi. Come è già stato osservato, in ognuna di esse sono ben visibili uno o due segni incisi direttamente sull'argilla fresca.[13] Mi pare che l'interpretazione più appropriata possa essere quella di marchi di fabbrica o

indicazioni con valore numerico dell'ordine secondo il quale dovevano venire collocate le statue: segni cioè destinati all'utilità pratica della bottega o comunque del commercio specializzato.[14]

Il confronto più attinente per le statue qui in esame si può stabilire con la figura attualmente al Museo di Bari (fig. 9). Simile è infatti l'andamento stilizzato delle pieghe del corto himation, l'acconciatura dei capelli e la posizione delle mani.[15] Le statue di Rouen e Copenaghen, invece, oltre a essere qualitativamente superiori nella cura dei dettagli e della modellazione, presentano più spiccate differenze, come ad esempio il lungo *apoptygma* legato sotto i seni con una cintura e i capelli ricadenti in plastici boccoli sulle spalle.

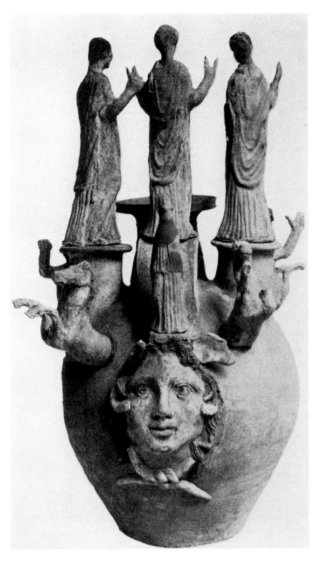

FIGURA 11

Askos canosino. Taranto, Museo.

Un altro gruppo di cosiddette oranti da Canosa è conservato al Museo di Napoli, tra le quali una in particolare richiama la nostra attenzione (fig. 10).[16] Analogo è infatti rispetto alle statue del Getty non solo il tipo di corto himation indossato dalla figura, ma la resa dei lineamenti, la struttura del viso e il particolare tecnico dei fori, che suggeriscono la provenienza da un medesimo atelier.

Le sculture sono attribuibili con ogni verosimiglianza a maestranze locali; è evidente infatti la vivacità e l'ingenuità compositiva espressa, per esempio, dalla mancanza di proporzioni tra mani e braccia; la costruzione poi si presenta disorganica e noncurante dei singoli elementi, così da rendere troppo statica la posa, incerta l'espressione, poco compatta la struttura

interna.[17] I caratteri di questa visione artistica tipica di un particolarismo regionale sembrano generati da un atteggiamento di indipendenza e di reazione culturale nei confronti della penetrazione greca. D'altro canto sarà bene sottolineare che nel IV e III secolo a.C. i corredi funerari dei centri apuli mostrano una chiara ellenizzazione, certo filtrata attraverso scambi commerciali; le statue quindi sono da considerarsi come l'espressione di un artigianato indigeno incline a reagire alla suggestione dei modelli greci e a esprimersi così in un linguaggio artistico originale.[18] Questa scelta stilistica si riscontra anche nella decorazione degli askoi con le tipiche applicazioni di statuette a tutto tondo, per lo più figure femminili, nikai ed eroti alati.[19] La loro diffusione testimonia una stretta collaborazione esistente in questo periodo tra vasai, pittori e coroplasti che, attraverso scambi di esperienze tecniche e artistiche, avevano potuto così elaborare una sostanziale unità di linguaggio espressivo.[20]

Esemplari, al nostro proposito, sono le statuette che decorano l'askos conservato al Museo di Taranto, le quali presentano lo stesso tipo di panneggio ricadente in pieghe semicircolari e il medesimo particolare iconografico delle braccia alzate (fig. 11).[21] Tali statuette che, spesso, oltre ad avere le braccia sollevate e aperte ai lati, sono rappresentate anche con le mani alla testa, vengono interpretate per lo più come lamentatrici, oranti o sacerdotesse.[22]

Interessante è il confronto proposto dalla Tinè Bertocchi tra queste statuette e le figure dipinte sulla parete della tomba a camera databile alla prima metà del III secolo a.C. in località S. Aloia, entrambe "espressione locale di un soggetto apulo o più ancora canosino."[23] Del resto, i tratti del viso marcati, i capelli lisci e divisi sul capo evidenziati in queste figure, si riscontrano anche nelle statue qui in esame.

Esse dovevano rappresentare un'offerta funeraria particolarmente costosa, probabile appannaggio di un nucleo familiare di un certo rilievo economico, che attraverso l'ostentazione dei rituali funebri metteva in risalto il proprio potere economico e politico.[24] Poste all'interno di ipogei o tombe a camera, esse sembrano rappresentare l'immagine contrita dei parenti o delle persone care della defunta, configurandosi come presenza visibile del legame affettivo di fronte alla morte.[25]

Tuttavia desta qualche perplessità non trovare, nella rappresentazione di un nucleo familiare, immagini di anziani parenti o di bambini; le statue infatti rappresentano invariabilmente lo stesso tipo di figura femminile in giovane età, così da essere interpretate

con più verosimiglianza quali lamentatrici che, durante i rituali funebri, e soprattutto in occasione della *prothesis,* venivano pagate appositamente dalla famiglia come ultimo atto di rispetto verso il proprio caro.[26]

Un confronto interessante ci viene proposto dall'analisi di alcune scene dipinte sui vasi a figure rosse provenienti dalla Magna Grecia. Tra i repertori preferiti dai ceramografi compaiono spesso figure ritratte all'esterno di naiskoi e colte per lo più nell'atto di recare un'offerta. Come M. Schmidt puntualizza, manca anche in questo caso una caratterizzazione individuale delle singole figure, così da suggerire non tanto personaggi di un nucleo familiare, quanto membri di una comunità religiosa alla quale la defunta apparteneva in vita, e che attraverso la loro immagine, più in atteggiamento di preghiera che di lamentazione, confortavano la speranza di una vita ultraterrena.[27]

Le statue tuttavia non presentano nessun attributo che le identifichi come tali ed è così difficile accertare, nel nostro caso, se i coroplasti abbiano preso in prestito dai ceramografi uno spunto iconografico simile.[28]

Per quanto riguarda il problema cronologico, non avendo nel nostro caso nessun riferimento al contesto originario e ai materiali ad esso associati, mi sembra del tutto inopportuno cercare di stabilire una datazione troppo circostanziata. Il riesame degli oggetti appartenenti al medesimo corredo delle statue di Rouen, Copenaghen e Bari attesta una datazione tra la fine del III e la prima metà del II secolo a.C., sebbene le statue siano riferibili a un periodo leggermente anteriore.[29]

La stessa discrepanza cronologica presenta la tomba Barbarossa, con la presenza da una parte di ceramica a figure rosse e statue di oranti, dall'altra di vetri, oro e un'anfora rodia.[30] Anche nell'ipogeo Lagrasta I, assieme alla ceramica a figure rosse sono stati trovati sia vetri e ori riferibili al II secolo a.C., sia un'iscrizione latina databile al 67 a.C. Tali discordanze sono state spiegate ammettendo una continuità d'uso di questi ipogei nell'arco di più generazioni.[31] Per la tomba degli Ori invece, una datazione alla fine del III secolo a.C. sembra per lo più accettata dalla maggior parte degli studiosi.[32]

Se però il tipo dell'orante è attribuibile alla fine del IV o ai primi decenni del III secolo a.C., per le statue qui in esame si dovrà annotare che presentano una qualità stilistica più scadente rispetto, per esempio, a quelle della tomba Scocchera B. Esse quindi, rappresentando una degenerazione del tipo, causata,

come spesso avviene nella coroplastica, da un uso troppo prolungato del medesimo prototipo, potrebbero essere riferite a una generazione posteriore, forse inquadrabile nella seconda metà del III secolo a.C.

Palermo

NOTE

1. Il modo di indossare l'himation come scialle è riscontrabile sulle figure dipinte dal Pittore della Patera: A. D. Trendall e A. Cambitoglou, *The Red-Figured Vases in Apulia* (Oxford, 1982), p. 723, tav. 267.1. Probabilmente è riferibile a un costume greco con forti accenti locali. Si veda: M. De Wailly, "Les femmes des guerriers," *MEFRA* 94.2 (1982), p. 606.

2. L'abito femminile ornato da una o più bande di uno stesso colore è caratteristico della zona apula e compare spesso nella decorazione dei vasi a figure rosse, ad esempio sulle figure dipinte dal Pittore della Patera e dal Pittore di Baltimora: Trendall e Cambitoglou (nota 1), p. 723, tav. 275.5, 6, e p. 856.

Si veda in proposito anche L. Forti, "La produzione ceramica e la pittura funeraria a Ruvo," *Archivio storico pugliese* 30 (1977), pp. 113–43.

3. In questo caso l'orlo della manica serviva a mascherare l'attaccatura del braccio. La testa era ricavata con altri due stampi. Per quanto riguarda i piedi, il restauro della figura n. 5 ha messo in evidenza con chiarezza i punti di attacco alla figura.

4. Le differenze di altezza e larghezza tra un esemplare e l'altro sono determinate dal restringimento della figura nel processo di cottura e di essiccamento.

5. Le stesse coppie di matrici sono state usate per le teste delle statue nn. 1 e 3 e nn. 2 e 4. Come ha osservato la Bonghi Jovino, si preferiva apportare le modifiche direttamente sugli esemplari piuttosto che sulle matrici: M. Bonghi Jovino, *Capua preromana,* Terrecotte votive, vol. 2, *Le statue* (Firenze, 1971), pp. 15–16.

6. L'argilla della statua n. 5 si presenta più rossa e la superficie è molto levigata senza alcuna traccia di ingubbiatura o di pigmento, forse a causa di una pulitura eccessivamente aggressiva.

7. L'analisi chimica dell'ingubbiatura prelevata da quattro askoi da Canosa ha attestato che essa era costituita per la maggior parte da argille, ma, data la diversità delle tecniche di fabbricazione di tali vasi, non sembra escluso anche l'impiego di latte di calce. Si veda a questo proposito: A. Rinuy e F. Schweizer, "Analyse de l'engobe blanc et des traces d'adhesifs anciens preleves sur des vases de Canosa," *Genava*, n.s. 28 (1978), pp. 162–69.

8. A. Oliver Drew, Jr., *The Reconstruction of Two Apulian Tomb Groups* (Bern, 1981), p. 16.

9. N. Inv. 1965, h. cm 99. La pubblicazione delle fotografie mi è stata concessa gentilmente da Mme G. Dennequier del Musée des Antiquités de Rouen. Si veda anche il catalogo della mostra *Hommes, dieux et héros de la Grèce* (Musée des Antiquités, Rouen, 1982), p. 153, n. 66, con inclusa bibl.

10. N. Inv. 4995, h. cm 97. Si ringrazia Ms. M. Kollund per avermi fornito la fotografia dell'esemplare e per averne permesso la pubblicazione. N. Breitenstein, *Danish National Museum: Catalogue of Terracottas* (Copenaghen, 1941), tav. 80. 659.

11. N. Inv. 455, h. cm 87. La pubblicazione è stata consentita per cortesia del Soprintendente alle antichità di Puglia, prof. E. De Juliis.

12. A. Levi, *Le terrecotte figurate del Museo Nazionale di Napoli* (Firenze, 1926), tav. II.1.

13. Sarà inoltre più opportuno considerarli più semplicemente contrassegni di tipo alfabetico (in particolare quelli sulle statue nn. 1, 2 e 3, interpretabili come un'eta, una iota e un'alfa).

14. G. Siebert, "Signatures d'artistes, d'artisans et des fabricants," *Ktema*, 1978, p. 124.

    Perchè poi il coroplasta abbia inciso tali segni proprio nella parte frontale della figura si può facilmente spiegare immaginando che, dopo lo strato di ingubbiatura e di policromia, esse erano comunque destinate a scomparire.

15. Un simile manierismo di stile nella resa del panneggio trova confronti nelle figure dipinte sui vasi del Pittore di Baltimora e del pittore del cosiddetto del "White Saccos," entrambi attivi alla fine del IV secolo a.C. nella zona di Canosa: Trendall e Cambitoglou (nota 1), n. 24, tav. 324.2; n. 30, tav. 326.3.

16. N. Inv. 22246–2224: Levi (nota 12), tav. II.3. Probabilmente proveniente dall'Ipogeo Barbarossa di Canosa, la statua è databile tra la fine del IV e gli inizi del III secolo a.C. per la presenza nello stesso corredo di vasi apuli a figure rosse. Si veda a tal proposito: A. Ciancio, "I vetri alessandrini rinvenuti a Canosa," *Canosa*, vol. 1 (Bari, 1980), p. 46, nota n. 74. Per la discussione della datazione dell'ipogeo si veda più oltre alla nota n. 25.

    Altre statue da Canosa rappresentanti la stessa tipologia di figura femminile si trovano a Londra: H. B. Walthers, *Catalogue of the Terracottas in the Department of Greek and Roman Antiquities, British Museum* (London, 1903), p. 317, D. 124–25; a Parigi: Musée du Louvre S 347 (esemplare ancora inedito); a Vienna: K. Masner, *Die Sammlung antiken Vasen und Terrakotten im königlichen Österreichischen Museum* (Vienna, 1891), p. 92, n. 877.

17. Si veda Bernabò Brea, "I rilievi tarantini in pietra tenera," *Rivista dell'Istituto di Archeologia e Storia dell'arte di Roma* 1 (1952), pp. 165–66, dove si sottolinea come "la pesantezza assunta dalle stoffe, l'arrangiamento complicato dei mantelli e l'andamento del tutto innaturale delle pieghe, siano caratteristiche comuni di tutta la produzione apula del III a.C."

    Questa mancanza di attenzione per le proporzioni naturalistiche, comune nelle opere dell'ellenismo italico, troverà una continuazione nella corrente d'arte romana repubblicana detta plebea: T. Kraus, "Strömungen hellenistischer Kunst," *Dialoghi di Archeologia* 4–5, nn. 2–3 (1970–1971), pp. 221–23.

18. Anche a Capua nello stesso periodo la produzione coroplastica era caratterizzata "dall'alternarsi di varie correnti formali: alcune con forti legami con la scultura greca, altre autenticamente locali, altre inseribili in una struttura ellenizzata, ma con forti tendenze locali": Bonghi Jovino (nota 5), pp. 27–28. P. Orlandini, "Aspetti dell'arte indigena in Magna Grecia," in *Atti dell'XI Convegno di Studi sulla Magna Grecia 1971* (Napoli, 1972), p. 308. Si vedano anche le annotazioni meto-

19. O. Elia, in *Enciclopedia dell'arte antica*, vol. 2 (Roma, 1959), pp. 317–18 con bibl. inclusa e F. Van Der Wielen, "Canosa et sa production ceramique," *Genava*, n.s. 28 (1978), pp. 142–49.

20. La collaborazione tra officine di coroplasti e vasai è attestata anche per la creazione di oinochoai plastiche sia a Canosa che a Capua: A. Riccardi, "Vasi configurati a testa umana di provenienza o produzione canosina," in *Canosa*, vol. 1 (Bari, 1980), pp. 7–21, e M. Bonghi Jovino, "Problemi di artigianato nell'Italia preromana," in *Archeologica: Scritti in onore di Aldo Neppi Modona* (Firenze, 1975), pp. 29–36.

21. Elia (nota 19), fig. 462.

22. M. Borda, *Ceramiche apule* (Bergamo, 1966), p. 60, fig. 49. Per quanto riguarda l'interpretazione di tali decorazioni si veda Van Der Wielen (nota 19), p. 148.

23. F. Tinè Bertocchi, *La pittura funeraria apula* (Napoli, 1964), pp. 17–18, fig. 2.

24. E. De Juliis, in *Gli ori di Taranto in età ellenistica*, catalogo della mostra (Milano, 1982), pp. 19–21.

25. La provenienza da Canosa, e più in particolare da un contesto funerario, è avvalorata anche dal confronto offerto dagli esemplari inquadrabili nello stesso schema tipologico e di cui abbiamo più precisi dettagli riguardo alle loro provenienze. Così gli esemplari di Rouen, Copenaghen e Bari, come si è accennato sopra, provengono dalla tomba Scocchera B (si veda nota 11). L'ipogeo Barbarossa ha restituito tre esemplari ora al Museo di Napoli, Vienna e Londra (nota 16); dall'ipogeo Lagrasta I proviene un'orante, forse la stessa conservata al Louvre. Infine la tomba degli Ori ha restituito altre quattro statue di oranti: R. Bartoccini, "La tomba degli Ori a Canosa," *Japigia* 6 (1935), pp. 225–62.

26. D. C. Kurtz e J. Boardman, *Greek Burial Customs* (London, 1971), pp. 143–44.

27. M. Schmidt, "Some Remarks on the Subjects of South Italian Vases," *The Art of South Italy: Vases from Magna Grecia*, catalogo della mostra (Richmond, 1982), pp. 24–25.

28. J. Carter, "Relief Sculptures from the Necropolis of Taranto," *AJA* 74 (1970), pp. 125–38. Bernabò Brea (nota 17), p. 219. La riproduzione di naiskoi è frequentissima sia nella decorazione dei vasi a figure rosse della zona apula sia in quella delle tombe canosine; si veda a questo proposito Tinè Bertocchi (nota 23), p. 15.

    Ringrazio con gratitudine il prof. A. D. Trendall per i consigli e l'attenzione prestata alla redazione di questo scritto.

29. *Gli ori di Taranto* (nota 24), p. 454.

30. M. Mazzei e E. Lippolis, "Dall'ellenizzazione all'età tardo repubblicana," in *La Daunia dalla preistoria all'alto medioevo* (Milano, 1984), pp. 191–92.

31. Ibid., p. 191.

32. E. Lippolis, in *Gli ori di Taranto* (nota 24), p. 454.

# Ein Horosspeer in Malibu

LAUS PARLASCA

Während der intensiven Ausbauphase in den vergangenen Jahrzehnten erwarb die archäologische Abteilung des J. Paul Getty Museums auch verschiedene ägyptische Altertümer. Sie tangieren die Spezialgebiete dieser Sektion nur wenig, jedoch verdienen einige von ihnen die Aufmerksamkeit benachbarter Fachkollegen. Hierzu gehört auch ein merkwürdiges Gebilde aus Holz, das bei den Ägyptologen unter der Bezeichnung Horosspeer bekannt ist (Abb. 1a, b).[1] Im archäologischen Bereich begegnen sie zumeist nur als Amulett, also in Miniaturformat.[2]

Daneben gibt es Beispiele in größeren Abmessungen. Sie sind allerdings auffallend selten und wurden bisher noch nie im Zusammenhang behandelt. Eine Ausnahme bildet die Studie von H. Schäfer, der zu Beginn des Jahrhunderts einen Horosspeer des Ägyptischen Museums in Berlin publiziert hat.[3] Dieses von ihm nur in einer Zeichnung vorgelegte Exemplar gehört zu den beträchtlichen Kriegsverlusten dieser Abteilung der Staatlichen Museen, die im Frühjahr 1945 bei den letzten Kampfhandlungen des Zweiten Weltkrieges im mecklenburgischen Auslagerungsort Sophienhof—zusammen mit zwei später erworbenen Gegenstücken—verbrannt sind.[4] Mir ist nur eine weitere Parallele dieser großen Horosspeere, in Mainz, bekannt.[5] Vielleicht gibt es weitere, in der Fachliteratur noch nicht erfaßte Stücke. Die Veröffentlichung des vorliegenden Exemplars im J. Paul Getty Museum lenkt vielleicht die Aufmerksamkeit auf weitere Inedita.

Der Ausgangspunkt unserer Studie kann besonderes Interesse beanspruchen. Das durchbrochen gearbeitete doppelseitige Relief zeigt spiegelbildlich jeweils dieselbe Darstellung. Oben und unten ist das Ganze unvollständig; außerdem wurden Absplitterungen an den Seiten, wie die hellere Holzfärbung an den Kanten erkennen läßt, nachträglich geglättet. Die erhaltene Partie umfaßt zwei Felder. Oben sieht man einen

stehenden Gott mit Vogelkopf. Er hält diagonal vor dem Körper eine Lanze, mit der er ein Krokodil tötet, von dem nur noch der Mittelteil hinter den Beinen erhalten ist. Der Gott trägt einen kurzen Chiton und eine Art von Schuppenpanzer, mit dem auch Arme und Beine bekleidet sind.

Ein mit Blattdekor verzierter Streifen dient als Sockel und bildet zugleich den Übergang zum zweiten Feld. Hier sehen wir einen Raubvogel; das Tier sieht wie ein Adler aus, doch spricht der gebogene Schnabel eher für einen Falken. Auf seinem Kopf befindet sich eine undeutlich ausgearbeitete Verzierung; vielleicht sind Doppelfedern gemeint. Der vordere hornartige Ansatz ist unklar. Zwischen den Krallen findet sich eine Andeutung von Gelände; die runden Gebilde sehen aus wie Geröll, doch ist vielleicht nur felsiger Grund gemeint. Die kleine Ansatzstelle am unteren Rand gibt einen Hinweis darauf, daß sich hier noch ein drittes Feld befunden hat.

Die obere Darstellung ist religionsgeschichtlich klar zu interpretieren.[6] Der anthropomorphe Falkengott Horos tötet den Mörder seines Vaters Osiris, dessen Bruder Seth, der sich im Verlauf des Rachekampfes in ein Krokodil verwandelt hatte. Der Göttervogel des unteren Feldes ist ebenfalls Horos zu benennen. Die Kombination beider Darstellungen illustriert die weitgehende Verschmelzung der beiden im Griechischen namensgleichen Gottheiten, des Falkengottes mit dem Sohn der Isis und des Osiris.

Das Ägyptische Museum in Berlin besaß vor 1945, wie bereits erwähnt, nicht weniger als drei Exemplare dieser Art. Nr. 1 ist als einziges, wenn auch nur in einer Umrißzeichnung, veröffentlicht (Abb. 2).[7] Von Nr. 2 existieren Photos beider Seiten (Abb. 3a, b),[8] während Nr. 3 ausschließlich durch eine detaillierte Zeichnung im Inventar dokumentiert ist (Abb. 4).[9] Die ursprüngliche Länge dieser drei Stücke muß ca. 1,25 m betragen haben. Sie bieten einige

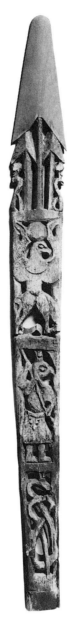

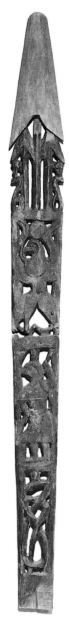

ABB. 2

Horosspeer. Holz. Ehemals Berlin, Ägypti-
sches Museum 13889 (nach Schäfer [1904],
68, Abb. 1).

ABB. 3a

Horosspeer. Holz. Vorderseite. Ehemals
Berlin, Ägyptisches Museum 17338.

ABB. 3b

Rückseite des Horosspeers, Abb. 3a.

Anhaltspunkte, wie die fehlenden Teile des Gegen-
stücks in Malibu (Abb. 1a, b) zu ergänzen sind. Die
Dekoration dieser wenigen Exemplare ist nicht ein-
heitlich, aber stets in mehrere Abschnitte gegliedert.
Entsprechend der Gattungsbezeichnung gehört aber
unbedingt eine Art von Speerspitzen dazu. Allerdings
ist die Anordnung der zumeist dreifachen Spitzen für
reale Waffen ungeeignet. Nach H. Schäfers ansprechen-
der Vermutung handelt es sich dabei um die bildliche
Umsetzung einer falschen Etymologie des Wortes.[10]

Unterhalb der kleinen, äußeren Spitzen sind Uräen
angebracht.

Manche Einzelheit der Darstellung bleibt
unklar, zumal eine Nachprüfung an den Originalen
nicht mehr möglich ist. Nr. 1 zeigt im oberen Feld
einen Falken mit ausgebreiteten Flügeln und Doppel-
krone, der auf einem Krokodil zu stehen scheint.
Offenbar ist gemeint, daß Horos das sethianische
Krokodil siegreich in den Fängen hält. Nach einem
ornamental verzierten Feld mit fünfblättriger Rosette—

ABB. 4

Horosspeer. Holz. Ehemals Berlin, Ägypti-
sches Museum 17339 (nach Zeichnung im
Inventar, Kopie von K.-H. Priese. Neue Zeich-
nung von Tim Seymour).

das Motiv ist von dem Muster verschränkter Kreise abgeleitet—wiederholt sich das mythische Thema im 3. Feld. Die Darstellung des z.T. ausgebrochenen 4. Feldes läßt sich nicht mehr bestimmen. Der Horosspeer Nr. 2 zeigt ähnliche Motive, aber in unterschiedlicher Ausformung. Nach Ausweis der Inventar-Skizze fehlte die mittlere Speerspitze; ihre breite, dreieckige Form wurde, wie die Photographien lehren (Abb. 3a, b), nach Analogie von Nr. 1 ergänzt. Das erste Feld zeigt einen Falken mit ausgebreiteten Flügeln und Sonnenscheibe. Zwischen seinen Klauen ringelt sich ein Schlange, die sich am linken Rand der besser ausgearbeiteten Seite aufgerichtet hat. Das zweite Feld enthält eine Darstellung des anthropomorphen Horos mit Falkenkopf und Doppelkrone. Er ist nur mit einem Schurz bekleidet, der vorn eine blattartige Verzierung aufweist. Der Gott hält seine Lanze stoßbereit, doch ist kein Gegner angegeben. Vielleicht ist als solcher die Schlange im untersten Feld gemeint. In diesem Falle muß allerdings das Attribut der Doppelkrone auf einem Fehler des Holzschnitzers oder seiner Vorlage beruhen.

Das Exemplar Nr. 3 ist abweichend verziert. Hier sind nur zwei Lanzenspitzen angegeben; das eigentliche Brett ist im erhaltenen Teil mit einer durchlaufenden Weinblattranke dekoriert. Das Muster spricht dafür, daß diese Partie nicht à jour gearbeitet ist.

Es ist interessant, daß alle bekannten Exemplare sich mehr oder minder stark von einander unterscheiden. Trotz des offenkundigen thematischen Zusammenhangs—abgesehen von Berlin Nr. 3—liegt offenbar kein festes ikonographisches Schema vor.

Nicht ganz klar ist die Frage des Verwendungszwecks. Die früheren Berliner Gelehrten, A. Erman als Verfasser des anonym publizierten Museumskatalogs und H. Schäfer,[11] ordneten die Horosspeere den römischen Leichenbrettern zu. Damals war allerdings nur Berlin Nr. 1 bekannt. Die von Schäfer zu Beginn seines Aufsatzes beiläufig erwähnten Exemplare sind offenbar identisch mit den beiden von Erman in derselben Gruppe aufgeführten Berliner Leichenbrettern, Inv. 787 und 13318.[12] Auch sie gehören zu den Kriegsverlusten des Museums. Die Sitte, die Verstorbenen— wohl zumeist nur notdürftig einbalsamiert—auf einfachen Totenbrettern zu befestigen, ist für die Kaiserzeit auch sonst nachzuweisen. Das British Museum besitzt zwei bemerkenswerte Exemplare dieser Art.[13] Die einfache Form der Totenbretter bietet lediglich eine Andeutung des Kopfumrisses. Die Wiedergabe einer Totenbahre auf der ovalen Fläche und längere Beischriften erläutern die Zweckbestimmung. G. Vittmann hat

die beide Bretter kürzlich eingehend analysiert.[14]

Gegen die Annahme, daß die Horosspeere den Mumien zur Versteifung auf den Rücken gebunden wurden, spricht m.E. die Technik. Die relativ schmalen, durchbrochen gearbeiteten Bretter waren ihrerseits ziemlich bruchempfindlich; in der Tat ist kein Exemplar vollständig auf uns gekommen! Eine sepulkrale Zweckbestimmung ist trotzdem wahrscheinlich. Ich möchte allerdings annehmen, daß die Horosspeere als magischer Schutz eher *auf* den Mumien befestigt waren.

Die Horosspeere gehören zweifellos in die Spätphase der ägyptischen Grabkunst. Vermutlich stammen sie sogar erst aus der jüngeren römischen Kaiserzeit. Trotz ihres ausgeprägt paganen Charakters sind stilistische Beziehungen zur koptischen Kunst nicht zu übersehen. So haben z.B. die Falken mit ausgebreiteten Flügeln eine unverkennbare Ähnlichkeit mit entsprechenden Motiven auf koptischen Grabstelen.[15] Das Mainzer Examplar (Abb. 5)[16] gehört möglicherweise auch schon in den Bereich der christlichen Sepulkralkunst. Die an Horos erinnernden Elemente sind reduziert, so z.B. der anscheinend bereits zu einem Adler umgedeutete Falke. Die ,,Rosette'' in der Mitte ähnelt wohl nicht zufällig einem griechischen Kreuz, wie es in ähnlicher Form nicht selten in der koptischen Kunst auftritt.[17] Die bekrönenden Spitzen wirken rein ornamental.

Die Praxis, Mumien auf längliche Holzbretter zu binden, hat offenbar bis in christliche Zeit gedauert. Verschiedene koptische Holzschnitzereien verdanken diesem Verwendungszweck ihre Erhaltung.[18] Verschiedentlich haben solche geschnitzten Bretter auch in zweiter Verwendung als Mumiendekor gedient.[19] In allen diesen Fällen dürfen wir annehmen, daß die mumifizierten Toten ohne einen Sarg begraben wurden. Die meisten Beispiele koptischer Zeit stammen aus unkontrollierten oder nicht ausreichend publizierten Grabungen. Es ist deshalb verständlich, daß die Zweckbestimmung als Mumienbretter bei Exemplaren in zweiter Verwendung häufig nicht erkannt wurde. Die relativ schmale Form der in Längsrichtung seitlich verkürzten Stücke gibt aber häufig einen sicheren Hinweis auf die Tatsache, daß dieser Befund nicht auf einer zufälligen Beschädigung, sondern auf einer absichtlichen Reduktion der Breite beruht.

Über die Herkunft der geschnitzten Horosspeere ist kaum etwas bekannt. Für das eine Berliner Stück wurde die Provenienz Edfu vermutet. Im Hinblick auf den Erwerbungsort Theben, ein Zentrum des damaligen Antikenhandels, ist mindestens eine oberägyptische Provenienz sehr wahrscheinlich. Dabei

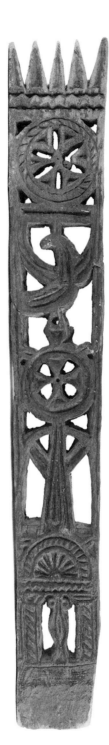

ABB. 5

Koptisches Mumienbrett im Typus eines Horosspeers. Mainz, Prinz Johann Georg-Sammlung der Universität 38.

Kaiserzeitliche Gaumünze aus Unterägypten (nach J. F. Tochon d'Annecy, *Recherches historiques et géographiques sur les médailles des nomes . . . d'Egypte* [Paris, 1822], Abb. S. 179).

ABB. 7

Kaiserzeitliche Gaumünze aus Unterägypten (nach J. F. Tochon d'Annecy, *Recherches historiques et géographiques sur les médailles des nomes . . . d'Egypte* [Paris, 1822], Abb. S. 181).

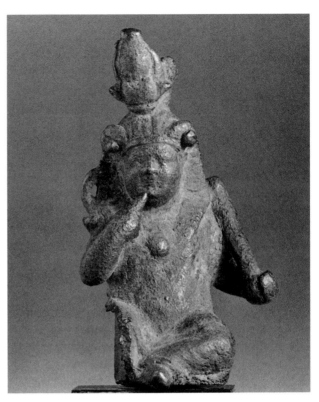

ABB. 8

Bronzefigur des Harpokrates. Privatbesitz. Photo: Archäologisches Institut der Universität Erlangen.

a.            b.            c.            d.            e.

ABB. 9a–e

Späthellenistische Siegelabdrücke mit Darstellungen eines Horosspeers aus Edfu. Toronto, Royal Ontario Museum 906.12.281, 906.12.288, 906.12.277, 906.12.283, 906.12.305 (nach Murray [1907], Taf. 4, Nr. 43–45, 47, 53).

spricht die relative Seltenheit dieser Gruppe für ein begrenztes Verbreitungsgebiet. Hierfür kommt in der Tat vor allem Edfu in Betracht, wo sich verschiedene Analogien nachweisen lassen.

Der Horosspeer ist vielfach in religiösen Texten belegt—allerdings nicht in sepulkralem Kontext. Im Festkalender des Horostempels von Edfu erscheint als Gottesattribut ein Holz des Horos.[20] In diesem Zusammenhang findet man in der Sekundärliteratur Hinweise auf kaiserzeitliche Münzen des prosopitischen Gaues in Unterägypten.[21] Hier gibt es auf Prägungen des Hadrian zwei Typen von Rückseitendarstellungen, ein stehender Harpokrates mit geschulterter Keule (Abb. 6) bzw. eine einzelne Keule (Abb. 7).[22] Da in beiden Fällen auf der Waffe ein Falke sitzt, ist der Attribut-Charakter der Keule offenkundig. Die häufige Kontamination von Horos-Harpokrates als Sohn des Osiris und der Isis mit dem ursprünglich nicht anthropomorphen Falkengott von Edfu[23] wird auch hier deutlich. Auf einer Emission fehlt allerdings der Falke.[24]

In einem früheren Beitrag hatte ich mich mit dem auffallenden Keulenattribut bei bestimmten Harpokrates-Darstellungen befaßt und die Interpretation als Herakles-Harpokrates begründet.[25] Als seltenere Variante sei an dieser Stelle auf eine Bronzefigur in einer deutschen Privatsammlung hingewiesen; sie zeigt den kindlichen Gott sitzend (Abb. 8).[26] Meine frühere Deutung muß vermutlich modifiziert werden. Die Verbindung des Harpokrates mit dem kindlichen Herakles ist anscheinend nur eine sekundäre Erweiterung der synkretistischen Erscheinungsformen dieses Gottes. Der von mir im selben Zusammenhang besprochene männliche Torso in Heidelberg aus el-Hibe[27] stellt vermutlich trotz der auffallenden solaren Motive auf dem Schurz nicht Harpokrates-Harsaphes dar, sondern einen römischen Kaiser, vielleicht Commodus.[28]

Sichere bildliche Zeugnisse für den Horosspeer aus Edfu sind in der umfangreichen Serie späthellenistischer Siegelabdrücke erhalten (Abb. 9a–e).[29] Die verschiedenen Varianten machen deutlich, daß es keinen kanonischen Typus gegeben hat. Die Beliebtheit dieses Attributs wird ferner illustriert durch eine Serie kleiner Amulette, bei denen allerdings keine kultgeographische Eingrenzung möglich zu sein scheint.[30] In jedem Falle sind die großen, hölzernen Horosspeere ikonographisch bereicherte Weiterbildungen.

Eine Gruppe interessanter Parallelen des Berliner Museums wurde in Koptos ausgegraben: drei Bronzegeräte, die wie Spitzen von Harpunen aussehen

(Abb. 10–12).[31] Sie sind offenbar als Votive zu interpretieren, da sie aufgrund ihrer Formgebung als Waffen ungeeignet sind. Der untere Teil besteht jeweils aus einer runden Tülle, die zur Aufnahme eines dünnen hölzernen Schafts bestimmt war. Der vierkantige, schmalere Teil darüber zeigt eine unregelmäßige Bekrönung, die in einem Falle deutlich als Falkenprotome ausgearbeitet ist (Abb. 12). Die beiden anderen Spitzen haben eine unregelmäßige Form, sind aber deutlich als Abstraktion einer Vogelprotome kenntlich (Abb. 10, 11). In zwei Fällen erkennt man auf dem Absatz in der Mitte eine figürliche Gruppe. Der falkenköpfige Horos mit Doppelkrone hat ein Krokodil gefesselt (Abb. 10, 12). Bei zwei Stücken ist am Tüllenteil eine Königssphinx (Abb. 10)[32] bzw. ein Falke (Abb. 11) angebracht. Alle drei Objekte haben am Absatz eine Ringöse, die bei echten Waffen wohl für die Harpunenleine bestimmt war. Eine Variante mit Falkenprotome wurde vor einigen Jahren vom Ashmolean Museum in Oxford erworben (Abb. 13).[33] Die spezifische Rolle des Horosspeers in Edfu wird durch bildliche Wiedergaben und Texte im dortigen Horostempel belegt.[34] Eine entsprechende Darstellung findet sich auch im Hathortempel von Dendera (Abb. 14), dort mit der Beischrift „der ehrwürdige Stock des Horos von Edfu, des großen Gottes, des Herrn des Himmels."[35] In Edfu selbst wird der hölzerne, kultische Pfahl des Falkengottes bei entsprechenden Darstellungen als *Faucon au visage puissant* bezeichnet.[36] Diese und andere Epitheta machen auch die besondere Eignung des Falkengottes für apotropäische Zwecke aus und gehören demnach in das weite Feld paganer Grabkunst während der späten, kaiserzeitlichen Kulturperiode des Nillandes. Damals erlebte die stark von magischen Komponenten geprägte Sepulkralsymbolik Ägyptens ihre letzte Blüte.

*Frankfurt am Main*

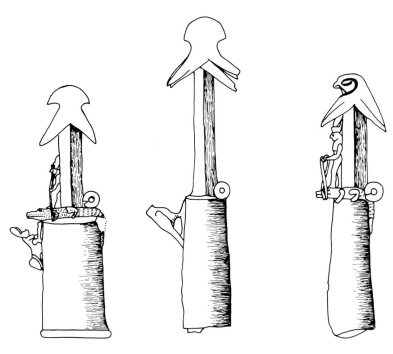

ABB. 10–12

Drei Bronzegeräte in Form von Harpunenspitzen. Berlin, Ägyptisches Museum 22571, 22570, und 22569 (nach Petrie, *Koptos,* Taf. 21, Nr. 4–6).

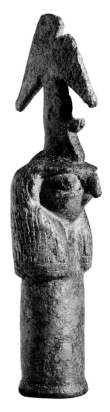

ABB. 13

Stabaufsatz aus Bronze (Horosspeer). Oxford, Ashmolean Museum 1986.14.

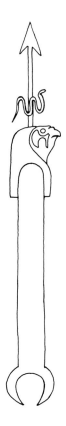

ABB. 14

Horosstab. Detail eines Reliefs am Hathortempel zu Dendera (nach Schäfer [1904], 69, Abb. 7).

ANMERKUNGEN

1. Malibu, J. Paul Getty Museum 71.AI.334; L: 79,3 cm, B: 14 cm; erworben 1971 von der Firma J. Eisenberg, New York und Los Angeles. Marion True verdanke ich Photos und die bereitwillig erteilte Publikationserlaubnis, Karen Manchester einige ergänzende Informationen.

2. a.U., Anm. 30.

3. H. Schäfer, ,,Der Speer des Horus als Rückenbrett von Mumien und als Amulett,'' *Zeitschrift für ägyptische Sprache* 41 (1904), 68–70.

4. Andere, in der Mehrzahl zuvor unpublizierte Aegyptiaca unter den Kriegsverlusten der Staatlichen Museen in Berlin habe ich in folgenden Beiträgen behandelt: ,,Zur Stellung der Terenuthis-Stelen—Eine Gruppe römischer Grabreliefs aus Ägypten in Berlin,'' *MDIK* 26 (1970), 173–198, Taf. 60–69; ,,Eine Gruppe römischer Sepulkralreliefs aus Ägypten,'' *FuB* 14 (1972), 72–78, Taf. 5–8; ,,Falkenstelen aus Edfu: Bemerkungen zu einer Gruppe zerstörter Reliefs des Berliner Museums,'' *Festschrift zum 150-jährigen Bestehen des Berliner Ägyptischen Museums* (Berlin, 1975), 483–487, Taf. 82–88; ,,Ägyptisierende Bauglieder und Reliefs aus Rom im Ägyptischen Museum,'' *FuB* 18 (1977), 59–65, Taf. 10–14.

5. Prinz Johann Georg-Sammlung des Kunsthistorischen Instituts der Universität Mainz als Leihgabe im Landesmuseum Mainz, Inv. 38; erworben 1928 in Luxor; H: 80,7 cm, B: 12 cm. Johann Georg, Herzog zu Sachsen, *Neue Streifzüge durch die Kirchen und Klöster Ägyptens* (Leipzig und Berlin, 1930), 58, Taf. 78.169 (die Abbildung steht auf dem Kopf!). Die Datierung des Verfassers in das 8.–10. Jahrhundert n.Chr. ist zu spät, selbst wenn man seine christliche Interpretation akzeptiert. K. V. Decker verdanke ich die Photographie und die freundliche Reproduktionserlaubnis.

6. Zum mythologischen Hintergrund vgl. H. Bonnet, *Reallexikon der ägyptischen Religionsgeschichte* (Berlin, 1952), 317; J. Gwyn Griffiths, *Reallexikon der Ägyptologie,* Bd. 3 (Wiesbaden, 1977), 60, s.v. Horusspeer, bespricht nur Amulette und Tempelreliefs in Edfu. Ausführlichere Nachweise in der früheren Publikation desselben Autors, *The Conflict of Horus and Seth from Egyptian and Classical Sources* (Liverpool, 1960), 110.

7. Inv. 13889; erworben 1897 in Theben. Erhaltene L: 0,93 m. Schäfer (a.O., Anm. 3), 68ff., Abb. 1 (Zeichnung); A. Erman, *Ausführliches Verzeichnis der ägyptischen Altertümer,* 2. Aufl. (Berlin, 1899), 358; Valdemar Schmidt, *Levende og døde i det gamle Ægypten: Album* (Kopenhagen, 1919), 233, Abb. 1345 (auch enthalten im Teildruck unter dem Titel *Sarkofager, Mumiekister, Mumiehylstre og lign.,* 175, Abb. 1345).

8. Inv. 17338; erworben in Luxor für die koptische Sammlung des Kaiser-Friedrich-Museums (ohne Inv. Nr.); 1905 an das Ägyptische Museum überwiesen, L: 1,11 m.

9. Inv. 17339; Herkunft wie bei vorigem Stück, L: 0,77 m. W. Müller sei auch an dieser Stelle für die Publikationserlaubnis der Berliner Exemplare gedankt. Abb. 4 nach einer K. H. Priese verdankten Kopie der Skizze im Inventar des Museums, der bereitwillig alle ergänzenden Fragen beantwortete.

10. Schäfer (a.O., Anm. 3), 69.

11. a.O., Anm. 7, bzw. 3.

12. Ausführliches Verzeichnis a.O. (Anm. 7), 358.

13. E. A. W. Budge, *A Guide to the First, Second and Third Egyptian Rooms,* 3. Aufl. (London, 1924), 138f., Nr. 4 und 5; ders., *The Mummy* (Cambridge, 1925), 220f.; I. E. S. Edwards, *A Handbook to the Egyptian Mummies and Coffins in the British Museum* (London, 1938), 57, Inv. 36502 und 35464; von beiden Autoren als ,,memorial boards'' bezeichnet.

14. *Zeitschrift für ägyptische Sprache* 117 (1990), 79ff., Taf. 3–5

(Inv. 35464), bzw. *Festschrift für Gertrud Thausing* (im Druck = Inv. 36502). Dem Verfasser verdanke ich ergänzende Hinweise zu seinen Studien.

15. E. Lucchesi Palli, in *Etudes Nubiennes—Colloque de Chantilly 2.–6. Juli 1975* (Kairo, 1978), 175ff. mit weiteren Nachweisen zur ornithologischen Bestimmung von Vogel-Darstellungen in der koptischen Kunst.

16. a.O., Anm. 5.

17. An dieser Stelle genügt der Hinweis auf einige anschauliche Parallelen: M. Cramer, *Das altägyptische Lebenszeichen im christlichen (koptischen) Ägypten,* 3. Aufl. (Wiesbaden, 1955), 9, Taf. 4.7, bzw. 29; 48, Taf. 18.38; dies., *Archäologische und epigraphische Klassifikation koptischer Denkmäler des Metropolitan Museum of Art, New York, und des Museum of Fine Arts, Boston* (Wiesbaden, 1957), 13f., Taf. 14f., Abb. 23–25 ( = Boston, Museum of Fine Arts 04.1846 und 04.1848, sowie New York, Metropolitan Museum of Art 10.176.31); ferner A. Effenberger, *Koptische Kunst* (Leipzig, 1975), 210, Taf. 37, 39 und 41 ( = Berlin, Inv. 4481, 4486 und 4482); A. Badawy, *Coptic Art and Archaeology* (Cambridge, Mass., 1978), 213, 216–218, und 215, Abb. 3.211.

18. A. L. Schmitz, ,,Das Totenwesen der Kopten,'' *Zeitschrift für ägyptische Sprache* 65 (1930), 12f., mit Hinweis auf O. Wulff und W. F. Volbach, *Die altchristlichen . . . Bildwerke,* Ergänzungsband (Berlin und Leipzig, 1923), 11, Nr. 6692, Abb.

19. Vgl. L. Keimer, ,,Note sur une planchette en bois sculpté des IVᵉ ou Vᵉ siècles après J.–C.,'' *Bulletin de l'Institut d'Egypte* 28 (1945–1946), 48, der allerdings derartige Holzfunde als Teile von Särgen interpretiert. Das Thema verdient eine systematische Untersuchung. Auch die neueste Publikation koptischer Holzfunde enthält anscheinend entsprechende Beispiele, M.-H. Rutschowscaya, *Catalogue des bois de l'Egypte copte, Musée du Louvre* (Paris, 1986), 99ff., Nr. 336 und 339, mit Abb. (Die Objekte Nr. 359–363 sind meiner Ansicht nach falsch!).

20. H. Brugsch, *Drei Fest-Kalender des Tempels von Apollinopolis Magna in Ober-Ägypten* (Leipzig, 1877), Taf. 7.III, col. 3, und Taf. 10, col. 5. Neuere Literatur, s.u., Anm. 34–35.

21. So z.B. Bonnet (a.O., Anm. 6), 317.

22. F. Feuardent, *Collection G. di Demetrio—Numismatique—Egypte ancienne,* Bd. 2 (Paris, 1872), 319f., Nr. 3561 bzw. 3562, mit Abb.; zuletzt mit weiteren Nachweisen A. Geissen und W. Weiser, *Katalog Alexandrinischer Kaisermünzen . . . der Universität Köln,* Bd. 4 (Opladen, 1983), 144ff., Nr. 3423–3425 bzw. 3426, mit Abb.

23. Vgl. die bis in die Kaiserzeit reichende Entwicklung bei den Votivstelen: Parlasca, ,,Falkenstelen'' (a.O., Anm. 4), 486 mit weiteren Nachweisen.

24. Feuardent (a.O., Anm. 22), 320, Nr. 3563, mit Abb.; danach K. Parlasca, *Akten des 24. Internationalen Orientalistenkongresses München, 1957* (Wiesbaden, 1959), 72, Abb. S. 74.

25. Parlasca (a.O., Anm. 24), 71ff. Zur Liste 72, Anm. 3, einige Nachträge: Das Goldfigürchen, Taf. 9 rechts, wurde in Luzern versteigert: *Ars Antiqua,* Auktion IV (7. Dez. 1962), 7, Nr. 10, Taf. 5, jetzt in Schloß Fasanerie bei Fulda, Kurhessische Hausstiftung. Zum verschollenen, bereits von J. J. Winckelmann edierten Relief, vgl. jetzt A. Roullet, *The Egyptian and Egyptianizing Monuments of Imperial Rome* (Leiden, 1972), 64, Nr. 46, Taf. 49.65 mit weiterer Lit. Die Gemme des Ägyptischen Museums in Berlin, Inv. 9767, H. Philipp, *Mira et Magica* (Mainz, 1986), 72, Nr. 88, Taf. 21, ohne Diskussion des ikonographischen Problems.

26. Ehemals Sammlung H. Seyrig; Basel, Münzen und Medaillen, Auktion 60, *Kunstwerke der Antike* (19. September 1982), 62, Nr. 125, mit Abb.: ,,Pantheistischer Harpokrates,'' H: 9,2 cm. Der Erhaltungszustand—die untere Partie ist abgebrochen—spricht dafür, daß die Figur Teil einer größeren (Isis-)Statuette gewesen ist. Ein vollständiges Exemplar dieses

Typus hat kürzlich J. Quaegebuer publiziert (s.u., Anm. 28), a.O. 161, Abb. 2 (Oxford, Ashmolean Museum 1973.569).

27. Ägyptologisches Institut der Universität, Inv. 1028; H. Ranke, *Koptische Friedhöfe bei Karâra und der Amontempel Scheschonks I. bei el-Hibe* (Berlin, 1926), 41f., Taf. 12.1, 2; Parlasca (a.O., Anm. 24), 73, Taf. 10 (Ausschnitt).

28. J. Quaegebuer, in E. Feucht, Hrsg., *Vom Nil zum Neckar: Kunstschätze Ägyptens aus pharaonischer und koptischer Zeit an der Universität Heidelberg* (Berlin, Heidelberg und New York, 1986), 118f., Nr. 268, Abb.; ders., ,,Une statue égyptienne représentant Héraclès-Melqart?" *Studia Phoenicia* 5, *Orientalia Lovaniensia analecta* 22 (Leuven, 1987), 157ff., Abb. 1.

29. M. A. Murray, ,,Ptolemaic Clay-Sealings," *Zeitschrift für Ägyptische Sprache* 44 (1907), 69f., Nr. 43–47, und 53, Taf. 4 ( = Toronto, Royal Ontario Museum; die hier abgebildeten Exemplare: 906.12.281 ( = Nr. 43); 906.12.288 und .289 ( = Nr. 44); 906.12.277 und .278 ( = Nr. 45); 906.12.283, .284 und .285 ( = Nr. 47); 906.12.305 und .306 ( = Nr. 53).

30. Schäfer (a.O., Anm. 3), 69f., Abb. 4 (Berlin, Inv. 15125); danach Bonnet (a.O., Anm. 6), 317, Abb. 80; W. M. F. Petrie, *Amulets* (London, 1914, Reprint, 1972), 48, Nr. 243, Taf. 41a–d. Im reichen Material der betreffenden Bände des Kairiner General-Katalogs von G. A. Reisner, *Amulets*, vols. 1, 2 (Kairo,

1907, 1958) ist dieser Typus nicht vertreten.

31. W. M. F. Petrie, *Koptos* (London, 1896), 23f., Taf. 21.4–6 (danach unsere Abb. 10–12, nach Frau M. Kempers verdankten Vorlagen); Schäfer (a.O., Anm. 3), 69, Abb. 5.6 ( = Petrie, Taf. 21.6, bzw. 21.5); G. Roeder, *Ägyptische Bronzefiguren* (Berlin, 1956), 435f., § 600; 457f., § 624, Abb. 696 ( = Inv. 20569), Abb. 697 ( = Inv. 20571), ferner Inv. 20570, ohne Abb. Ebendort 457, Abb. 654 und 655 zwei ähnliche Exemplare im British Museum ( = Inv. 51/5498 und 52/5499).

32. Petrie (a.O., Anm. 31), Taf. 21.4; Roeder (a.O., Anm. 31), 458, Abb. 697. Diese interessante Variante ist bei Schäfer (a.O., Anm. 3) nicht erwähnt.

33. Inv. 1986.14; H: 10,7 cm; *Annual Report of the Ashmolean Museum* (1985–1986), 25, Taf. 2 (,,Ptolemaic").

34. a.O., Anm. 20. Zuletzt J.–C. Goyon, *Les soixantes dieux-gardiens du temple d'Edfou*, Bibliothèque d'études, 93.1 (Kairo, 1985), 32, nach einem E. Winter verdankten Hinweis.

35. W. Spiegelberg, ,,Der Stabkultus bei den Aegyptern," *Recueil des Travaux relatifs à la philologie et à l'archéologie égyptiennes et assyriennes* 25 = n.s. 9 (1903), 186 mit Skizze; danach Schäfer (a.O., Anm. 3), 70, Anm. 7; Goyon (a.O., Anm. 34), 32, Anm. 5, Abb. 4 mit weiteren Nachweisen.

36. Goyon (a.O., Anm. 34), 32.

# The Getty Homer Fragment

Marianina Olcott

Now in residence at the Getty Museum is a rather small but potentially significant papyrus fragment identified as having been written sometime in the late second or early first century B.C., which possibly may be attributed to a scribe working in the Fayum sometime during that period (figs. 1a, b).[1] Although the recto text has previously been identified as Homer *Odyssey* 10.397–403, the verso text has thus far eluded identification.[2]

Of the seven lines of writing across the vertical fibers of the rougher, verso surface, which Brashear published in 1983,[3] four appear to contain a *lemma* (λῆμμα, direct quote from the text under discussion), and I have tentatively identified them as *Odyssey* 21.91–94 = Getty verso lines 4–7; we might even add *Odyssey* 21.89 = Getty verso line 3. Thus, verso lines 3–7 can, with the customary caution, be reconstructed according to Brashear's reading.[4] In the reconstruction that follows, Brashear's reading of the verso is set into the passage from *Odyssey* 21.91–94.[5]

line 1   ν = Too little remains for identification.
line 2   .ερειθ = Does not appear to be identifiable.
line 3   .μενο<u>υ</u> = ἀλλ ἀκέων δαίνυσθε κα<u>θήμενοι</u> ἠὲ θύραζε = *Od.*21.89
(*Od.*21.90 is not represented in the verso fragment.)
line 4   ον = μνηστήρεσσιν ἄεθλον ἀάα<u>τον</u> · οὐ γὰρ οἴω = *Od.*21.91
line 5   γεντα = ῥηϊδίως τόδε τόξον ἐΰξοο<u>ν</u> ἐντανύεσθαι = *Od.*21.92
line 6   ιεντο<u>ι</u> = οὐ γάρ τις μέτα τοῖος ἀνὴρ <u>ἐν</u> τοίσδεσι πᾶσιν = *Od.*21.93
line 7   ναυτον = οἶος Ὀδυσσεὺς ἔσκεν· ἐγὼ δέ <u>μιν αὐτὸν</u>* ὄπωπα = *Od.*21.94[6]
line 8   <u>ο</u> βασιλ = cannot be identified with any verse in the vicinity of *Od.*21.1–200.

I have adopted Brashear's suggestions for line 6, where the final letter may be an iota. Furthermore, the

final letter of line 3 is too mutilated to be useful.[7]

The Getty verso presents some interesting divergences from the text of Homer as we find it today. The most obvious difference is the omission of *Odyssey* 21.90. In addition, line 8 of the Getty verso cannot be identified with any verse in the immediate context of the passage *Odyssey* 21.1–200, although subsequent examination of the verso text offers some suggestions for a tentative reconstruction. We also find that verso line 7 departs from the text in our current editions of Homer (see note 6). In the verso text the pronoun αὐτὸν qualifies the Ionic form of the third person singular pronoun μιν, a frequent occurrence in Homer.[8] Thus, this departure from our modern editions may represent a true variant to the text of this passage. The only other attested instance of *Odyssey* 21.91–94 is a parchment codex of the third century A.D. listed as *Papyrus Rylands* I.53 ( = Pack no. 1106), in which the text of these specific lines has been extensively restored by the editors.[9]

What precisely the situation presented in the verso may be, is difficult to decide. However, a tentative interpretation of the text featured in the Getty verso may be offered. If we are dealing with a so-called subliterary text, as I suspect we are, then all but one of the discrepancies (i.e., the variant reading αὐτὸν for αὐτὸς) between the text of the Getty verso and the *textus receptus* of our modern editions can be explained. Precisely which type of subliterary text this may be cannot be determined, since all types of subliterary texts (i.e., hypomnemata, scholia, lexica, and summaries) provide formats pertinent to a complete description of the verso text.

A salient feature of the Getty verso is the blank space at line 4. Blank spaces occur frequently in papyri in a variety of circumstances in subliterary texts. For example, blank spaces set off the *lemma* from the surrounding commentary. An excellent example of this

use of blank space is found in E. G. Turner's collection, *Greek Manuscripts of the Ancient World* (Oxford, 1971), no. 61 ( = *Oxyrhynchus Papyri* 31.2536). Here, in the hypomnema (scholarly commentary with *lemma*), the direct quote from the text excerpted for comment is set off by blank space. Or, the blank space may be used to punctuate the *lemma,* as in *Papyrus Michigan* inv. 4832c col. I, line 6, and col. II, line 5.[10] In this example, we find a paraphrase or summary of books 18 and 19 of the *Iliad* in which several quotes from the closing portions of book 18 and the opening of book 19 are incorporated into the summary.

Perhaps for our purposes the most instructive example of the use of blank space is found in a first-century-B.C. papyrus fragment, *POxy* 8.1086 ( = Pack no. 1173). This extensive fragment (410 × 232 mm), reproduced in facsimile in Turner's collection as no. 58[11] and first published in volume 8 of the *POxy* by A. S. Hunt, is particularly interesting for several reasons.[12] First, according to Hunt, it marks an important stage in the transmission of the scholarly tradition concerning the text of Homer initiated by the famous Alexandrian scholar Aristarchos (217/215–145/143 B.C.). Second, it offers a format that shares several features with the Getty verso. In this text (*POxy* 8.1086) of a commentary on book 2 of the *Iliad,* lines 751ff., we find blank spaces used to set off words in the *lemma,* which are then the focus for subsequent comment. For example, in column I, lines 38 and 39, blank space is used to mark the focus of the explanatory comment on πεπυσμενα = *Iliad* 2.777. Again in column II, lines 51 and 53, spaces mark the verb στεναχιζετο (*Il.* 2.784) and the comment on that word. Similarly, spaces at column II, line 56, mark the word αλεγεινηι (*Il.* 2.787) and again in column III, line 91, the focus of the comment, κολωνη, is set off by blank space.[13] From these last examples it seems reasonable to conclude that the space at Getty verso line 4 is used to focus attention on the word immediately preceding the space, namely, the curious Greek adjective ἀάατος/ἀάατον.

Despite the ambiguity over what type of subliterary text we are dealing with, it seems reasonable to assume that at Getty verso line 4 the Homeric *lemma* continues after the blank space with οὐ γὰρ ὀΐω (*Od.* 21.91), for the subsequent lines, 5, 6, and 7, appear to quote an uninterrupted text (i.e., *Od.* 21.91–94). Thus, although the purpose of the space at Getty verso line 4 is ambiguous given its varied use in all types of subliterary texts, one is nonetheless tempted to conclude that the space indicates the focus of a

commentary on verso lines 1–3 and 8, namely, the word ἀάατος/ἀάατον, in much the same way that blank space was used in *POxy* 8.1086.

There is no doubt that, aside from its morphology, ἀάατος/ἀάατον presents serious problems of interpretation. In the three known Homeric instances, a meaning appropriate to *Odyssey* 21.91 and 22.5 will not fit with *Iliad* 14.271. And none of these choices appears to fit with the occurrence of the word in Apollonius Rhodius.[14] That these semantic difficulties were noticed early on in the scholarly tradition is no doubt reflected in the wealth of commentary on ἀάατος/ἀάατον, both ancient and modern (see below, note 16).

If this is the case (i.e., that the Getty verso represents an hypomnema on ἀάατος/ἀάατον), then we have here the earliest extant example of commentary upon a word that receives attention, to some extent, out of proportion to its five occurrences in extant Greek literature (see note 14). A later papyrus fragment in the British Museum, attributed by H. J. M. Milne to the atticizing lexicographer Phrynichus Arabius (second century A.D.), focuses on another instance of ἀάατος/ἀάατον from Homer *Odyssey* 22.5.[15] This latter instance of an hypomnema on ἀάατος/ἀάατον confirms the interest that the word has exercised on successive generations of scholars from the very beginnings of classical scholarship.[16]

This conjecture that the Getty verso represents an hypomnema is very attractive for several reasons. First of all, ἀάατος/ἀάατον, the conjectured focus of the hypomnema preserved on the Getty verso, still excites scholarly debate today, as it has in the past. Central to the discussions found in every period is the attempt to fix the derivation of this word and its related noun ἄτη (or ἀάτη as in Hesiod *Theogonia* 230). Throughout this tradition, from the ancient lexicographers to modern researchers in linguistics, different scholars provide different Greek verbs as the source of ἄτη/ἀάτη (usually peril, ruin, destruction) and its related adjective ἀάατος/ἀάατον.[17]

But etymology is not the only area where this word elicits debate. A consideration of its four occurrences in Greek—and I add a fifth, the variant reading of Apollonius Rhodius 1.803—reveals that no one metrical pattern will fit all occurrences. Indeed, *Iliad* 14.271 presents a scansion not shared by other examples: u– –X versus u–u X for all other instances. Perhaps of significance is the fact that in *Iliad* 14.271 this strange word is used as the epithet of Styx's water, which according to the ancient mythological tradition

FIGURE 1a

Papyrus fragment. Recto. Malibu, J. Paul Getty
Museum 76.AI.56. Reproduced 2:1.

FIGURE 1b

Verso of papyrus fragment, figure 1a.

was the most sacred oath of the Gods on Mount
Olympos (Hesiod *Theogonia* 400). Just as prosody and
etymology present a confused picture, just so we note
that all of the current, modern translations for even
one of the occurrences of the word, *Odyssey* 22.5,
offer renderings that are mutually exclusive:

> "That match is played and won!" (E. V. Rieu,
> Penguin Classics, 1946, reprint 1964)
> "At last, at last the ending of this fearful strain."
> (T. E. Lawrence, Oxford, 1969)
> "So much for that. Your clean-cut game is over."
> (R. Fitzgerald, Anchor, 1963)
> "This inviolable contest has been brought to an
> end." (A. Cook, Norton, 1967)

Thus it is very tempting to conclude that what
we have here is indeed some sort of scholarly com-
mentary on the word ἀάατος/ἀάατον in which a sig-
nificant portion (three lines) of the surrounding text is
quoted and incorporated into the commentary.

If, as I have suggested, the Getty verso is an
hypomnema with *lemmata* quoted ad libitum similar

to *PMich* inv. 4832c (second–first century B.C., see
note 10), where *lemmata* are interspersed throughout
the narrative, we may identify one additional line in
our reconstruction, *Odyssey* 21.89 = Getty verso
line 3.

As for the last line of the Getty verso, line 8, ọ
βασιλ, some tentative but possible reconstructions
may be brought forward. First, the letters βασιλ are
clearly related to the Greek noun for "king,"
βασιλεύς, and the adjective derived from that noun,
βασιλικός, "royal." Both these words are found fre-
quently in closures to hypomnemata, where the
scribe, in citing either his own name or the name of
the scholar quoted in the comment, presents the fol-
lowing format, as in *POxy* 47.3345, line 43:

ὁ τοῦ νομοῦ βασιλικός γραμματεύς Ἀμμώνιος.

In some cases the formula in the genitive to denote
time is used to date the document, as in *POxy* 46.3279,
line 15:

Νικάνδρου βασιλικοῦ γραμματέως

As Brashear noted, the recto text appears to
reach to the bottom margin of the papyrus roll, while

the verso text extends into the bottom margin. It still seems safe to conclude that Getty verso line 8, ọ βασιλ, is indeed the last line of the verso text and that our fragmentary text includes some form of the customary formula for closing hypomnemata.

As far as the physical disposition of the verso text as a whole is concerned, the verso *lemma,* arranged verse by verse (κατὰ στίχον) and in continuous script (i.e., no word divisions except for the space at line 4), occupies approximately the same position in the column as the recto text, and, similarly, preserves initial portions of the second hemistich (i.e., second half of the verse).[18]

A consideration of the verso script confirms Brashear's statement that the slightly larger letters of the verso (0.65 cm vs. 0.47 cm) may stem "from the same hand especially if one compares the letter forms of tau, epsilon and rho in the last lines of the recto with the same letters on the verso. Upsilon on both sides is similar."[19] In comparison with other hands, ligatures[20] of tau/omicron at verso lines 6 and 7 (and possibly recto line 7) appear similar to those found in another first-century-B.C. papyrus, *POxy* 8.1086.[21]

Similarly, alphas at Getty verso lines 5 and 7 and *POxy* 8.1086, col. II, lines 75 and 79, form their left members in one looped sequence[22] and suggest the conclusion that the two texts are contemporary.

When we consider the Getty papyrus fragment as a whole, the fact that one hand may have written both the recto and verso has important implications for our description of this papyrus fragment. The firm upright capitals of the recto script share certain palaeographical features with another first-century-B.C. papyrus fragment, also of Homer (*Il.* 8.332–336 and 362–369), from the Fayum in Egypt (*PFayum* 4, see note 1). The similarities in letter forms suggest that the same scribe may have written each of these three texts.

In his analysis of the Getty recto, Brashear[23] noted "the heterogenous letter forms of tau (line 1) formed with two strokes, one horizontal and one vertical, and tau (line 7) with one curved stroke as the left half of the cross bar and vertical hasta and another horizontal stroke for the right half of the cross bar." Similarly, *PFayum* 4 presents heterogenous taus. In *PFayum* 4 (lines 2 and 7) taus are written as in the Getty recto (line 7), with one curved stroke forming the left portions of the letter while a second horizontal stroke completes the right half of the crossbar. Another form of tau, again similar to taus in the Getty recto (line 1), at *PFayum* 4.3, 6, (possibly 9), and 11 is

formed with two strokes: vertical hasta capped by a horizontal bar, which in *PFayum* 4.3 and 6 and Getty recto line 1 exhibit serifs on the horizontal left member.

Interestingly enough taus of the Getty verso text lines 5, 6, and 7 are also presented as a curved stroke forming left portions while the right member is a horizontal stroke, which, as was noted by Brashear,[24] suggests that the hands of the Getty recto and verso may be the same despite the larger letters of the verso text.

Serifs are a regular feature of letters in both the Getty and the *PFayum* 4 papyrus fragments. Upsila, similarly formed in all, are decorated with serifs on the base of the vertical stroke at *PFayum* 4.11, Getty recto line 1, and Getty verso line 7. Likewise gammas at *PFayum* 4.10 and Getty recto line 2 appear very similar and again exhibit serifs decorating the base of the vertical strokes. Nus are well formed, again with decorative serifs at the heads and bases of left vertical strokes in *PFayum* 4.3 and 11, and Getty recto lines 1, 6, and 7. Nus in the Getty verso text possibly exhibit the same characteristics as the recto and *PFayum* 4 but the rougher texture of the verso makes certain identification difficult.

Like the well-formed nus, the letter forms for alpha, delta, and lambda of both the Fayum papyrus and the Getty recto tend to be aligned along a vertical axis with equilateral sides. Compare deltas in *PFayum* 4.6 with Getty recto lines 3 and 4. Compare alphas in *PFayum* 4.3 with the Getty recto lines 2 and 3. Alphas, partially missing in the Getty verso text, however, appear completely different: Left members are formed by a narrow loop slanting upward to the right; the letter as a whole tilts to the left in stark contrast to alphas of *PFayum* 4 and the Getty recto, which are aligned along a vertical axis. However, the rougher texture of the verso may have dictated this variation from the pleasing symmetrical alphas of the Getty recto and *PFayum* 4.

Epsila in the Getty recto lines 3 and 7 and *PFayum* 4.3, 4, 6, 7, 9, and 12 receive similar treatment. In all examples a tendency toward angularity is modified by smooth curves where horizontal members meet the vertical shaft. Isolated examples, however, in *PFayum* 4.10 and 11, are the clearly squared epsila pointed out as a "remarkable palaeographical feature" by Grenfell and Hunt.[25] Compare epsila in the Getty recto text lines 1 and 3, where a tendency toward angularity can be observed.

Overall both fragments, *PFayum* 4 and the Getty recto, offer such striking similarities in their upright, well-formed letters that one is tempted to assign the

hand of the same scribe to both texts. In addition, the same hand may also have executed the Getty verso text, given the similar execution of nu, upsilon, tau, and rho, as Brashear has already noted.

Thus what at first glance appeared to be a rather unremarkable fragment of ancient Greek writing has been shown to have implications for three separate disciplines. First, as an hypomnema on the rare Greek adjective ἀάατος, our little fragment represents one of the earliest extant comments on a word that has received constant attention throughout the scholarly tradition relating to Greek literature. Second, this hypomnema may be assigned to the same hand as another extant fragment of Homer (*PFayum* 4), previously published by Grenfell and Hunt in a collection of papyri from the Fayum (see note 1). Last, the Getty verso presents an otherwise unattested variant to the text of this passage in our modern editions, namely, αὐτόν for the modern αὐτός.

California State University
San Jose

### NOTES

Abbreviations:

Brashear    W. Brashear, "Homer in Malibu," *GettyMusJ* 11 (1983), pp. 158–160.

Pack    R. A. Pack, *The Greek and Latin Literary Texts from Greco-Roman Egypt,* 2nd ed. (Ann Arbor, 1965).

1. Malibu 76.AI.56. The size of the fragment is 4.4 × 1.9 cm. B. P. Grenfell and A. S. Hunt, *Fayum Towns and Their Papyri* (London, Egypt Exploration Fund, 1900), no. 4, pl. V (second–first century B.C.) = Pack no. 830. *PFayum* 4 has been identified as portions of *Iliad* 8.332–336, and in the second column portions of 362–369, a facsimile of which is reproduced in plate V. Corrigendum: The text accompanying the description of no. 4, p. 89, incorrectly lists the facsimile plate as VI.

2. The recto text was identified by J. Frel (*Antiquities in the J. Paul Getty Museum,* pamphlet 2 [Malibu, 1977]), as *Odyssey* 10.397–403. I would like to thank Dr. Frel for giving me the opportunity to study the fragment and for putting Brashear's article at my disposal.

3. Brashear, pp. 159–160.

4. Brashear, p. 159.

5. T. W. Allen, ed., *Homeri Opera* (Oxford, 1958). Book 21: The Test of the Bow.

Od.21.89    ἀλλ ἀκέων δαίνυσθε καθήμενοι, ἠὲ θύραζε
Od.21.90    κλαίετον ἐξελθόντε κατ᾽ αὐτόθι τόξα λιπόντε
Od.21.91    μνηστήρεσσιν ἄεθλον ἀάατον · οὐ γὰρ ὀίω
Od.21.92    ῥηϊδίως τόδε τόξον ἐΰξοον ἐντανύεσθαι.
Od.21.93    οὐ γάρ τις μέτα τοῖος ἀνὴρ ἐν τοίσδεσι πᾶσιν
Od.21.94    οἷος Ὀδυσσεὺς ἔσκεν· ἐγὼ δέ μιν αὐτὸς ὄπωπα

. . . Sit down.
Get on with dinner quietly, or cry about it
outside, if you must. Leave us the bow.
A clean-cut game, it looks to me.
Nobody bends that bowstave easily
in this company. Is there a man here
made like Odysseus? I remember him
from childhood: I can see him even now.

(R. Fitzgerald, Anchor, 1963)

6. Allen (above, note 5), *Odyssey* 21.94, has αὐτὸς rather than αὐτὸν.

7. Brashear, p. 159.

8. Liddell and Scott, *Greek–English Lexicon* (Oxford, 1966), s.v. μιν.

9. A. S. Hunt, ed., *Catalogue of the Papyri in the John Rylands Library,* vol. 1 (London, 1911), no. I.53 ( = Pack no. 1106).

10. T. Renner, *Harvard Studies* 83 (1979), p. 331, col. i.6.

11. E. G. Turner, *Greek Manuscripts of the Ancient World* (Oxford, 1971), pp. 98–99.

12. B. P. Grenfell, A. S. Hunt, et al., eds., *The Oxyrhynchus Papyri* (London, 1848–1967).

13. *POxy* 8.1086, pp. 8off.

14. Homer *Iliad* 14.271; *Odyssey* 21.91, 22.5. Apollonius Rhodius *Argonautica* 2.77, and the textual variant to 1.803. See H. Fränkel, *Apollonii Rhodii Argonautica* (Oxford, 1961), the critical apparatus to 1.801ff.

*Il.*14.271    ἄγρει νῦν μοι ὄμοσσον ἀάατον Στυγὸς ὕδωρ
"Swear it to me on Styx' ineluctable water."
(R. Lattimore, Chicago, 1951)

*Od.*21.91    μνηστήρεσσιν ἄεθλον ἀάατον οὐ γὰρ ὀίω
"(Leave us the bow.) A clean-cut game, it looks to me." (R. Fitzgerald, Anchor, 1963)

*Od.*22.5    οὗτος μὲν δὴ ἄεθλος ἀάατος ἐκτετέλεσται
"So much for that. Your clean-cut game is over." (R. Fitzgerald, Anchor, 1963)

*Ap.Rh.* 2.77    πυγμαχίην ἢ κάρτος ἀάατος ἢ τε χερείων
"But there were weak points as well as strong in his opponent's savage style." (E. V. Rieu, Penguin, 1959)

*Ap.Rh.*1.803    (ἐν δὲ τῇ προεκδόσει) . . . καὶ τότ᾽ ἔπειτ᾽ ἀνὰ δῆμον ἀάατος ἔμπεσε λύσσα
"And then 'not subject to Ate' Madness fell upon the people." (Olcott tr.)

15. H. J. M. Milne, ed., *Catalogue of the Literary Papyri in the British Museum* (London, 1927), no. 183 (second century A.D.?) = British Museum inv. no. 885 = Pack no. 2291.

16. Lexicographical:

1. T. Gaisford, ed., *Etymologicum Magnum* (Amsterdam, 1967), s.v. αατος (quotes Methodius)

2. Apion, A. Ludwich, ed., *Philologus* 74 (1918), pp. 205–248, and 75 (1919), pp. 95–217

3. I. Bekker, ed., *Suidae Lexicon* (Berlin, 1854)

4. H. Sell, ed., *Symeon* (Meisenheim, 1968)

5. I. Bekker, ed., *Apollonius Sophista, Lexicon* (Berlin, 1833)

6. M. Schmidt, rec., *Hesychii Alexandrini Lexicon* (Jena, 1858)

7. B. Snell, *Lexikon des frühgriechischen Epos* (Göttingen, 1955)

Scholia:

1. H. Erbse, rec., *Scholia Graeca in Homeri Iliadem* (Berlin, 1973), to *Iliad* 14.271

2. M. van der Valk, ed., *Eustathii Commentarii ad Homeri Iliadem Pertinentes* (Leiden, 1971), section 985.15

3. *Eustathii Commentarii ad Homeri Odysseam* (Leipzig, 1825), sections 618.40, 749.20, and 770.30

4. C. Wendel, rec., *Scholia in Apollonium Rhodium Vetera* (Berlin, 1958), to *Argonautica* 1.459; 2.77, 2.232

5. See also *Argonautica* 1.801–804. See critical apparatus to Fränkel (above, note 14).

Modern:

1. P. Buttmann, *Lexilogus oder Beiträge zur griechischen Wort-erklarung,* vol. 1 (Berlin, 1865), pp. 216–220

2. E. D. Francis, "Virtue, Folly, and Greek Etymology," in C. Rubino and C. Shelmerdine, eds., *Approaches to Homer* (Austin, 1983), pp. 74–121

3. R. Doyle, *ʽCUI, Its Use and Meaning* (New York, 1984)

4. W. Wyatt, "Homeric *ʽCUI,*" *AJP* 103 (1982), pp. 247–276

5. R. Dawe, "Some Reflections on Ate and Hamartia," *HSCP* 72 (1964), pp. 89–123

6. A. Moorhouse, "*ʽCCCUQT* and Some Other Negative Compounds," *CQ* n.s. 11 (1961), pp. 10–17

7. M. Olcott, "Ἀάατος, *Odyssey* 22.5: Greek and Indo-European Oath," forthcoming in *Word*

17. On derivation of the related noun ἄτη as:

1. ἄημι = "to blast," see Francis (above, note 16), pp. 74–121

2. ἄτη = "blindness, infatuation," see Doyle (above, note 16)

3. ἄω = "to sate," see Wyatt (above, note 16) and Moorhouse (above, note 16)

4. ἄτη = "ruin," see Dawe (above, note 16)

18. It is tempting to conclude that the recto lower margin is the *bottom* margin of the roll. However, broad bands appear to interrupt Homeric texts usually at the end or beginning of a book. See the so-called Harris Homer (British Museum Papyri 126 = Pack no. 634 [later third century A.D.]) in Turner (above, note 11), pl. 14. But *POxy* 2535, pl. IV (late first century A.D.), uses a broad band to precede an hypomnema to an historical epigram. In *POxy* 2536 (second century A.D.) the band interrupts the *lemma* (1.26) of an hypomnema by Theon to Pindar, *Pythian Odes* (Turner [note 11], pl. 61).

19. Brashear, p. 159, "The larger letters (0.65 cm) of the verso side appear at first glance to be different from the ones of the recto side. Yet the case can be made for their stemming from the same hand, especially if one compares the letter forms of tau, epsilon and rho in the last line of the recto with the same letters on the verso."

20. I would like to take this opportunity to thank Professor Susan Stephens of Stanford University for confirming this fact and for her help and advice in the preparation of this article.

21. *POxy* 8.1086 = Pack no. 1173, reproduced in Turner (above, note 11), pp. 98–99, pl. 58.

22. Turner (above, note 11), p. 98, on pl. 58 (*POxy* 8.1086), "Alpha is often large and pointed; its first movements in one looped sequence."

23. Brashear, p. 159.

24. Ibid.

25. Grenfell and Hunt (above, note 1), p. 89.

# A Silver Triton Handle in the Getty Museum

BERYL BARR-SHARRAR

A large silver handle in the shape of a fish-tailed Triton recently acquired by the Getty Museum is a welcome addition to the small group of decorative objects in precious metal that has survived from the Hellenistic period (figs. 1a–f ). Its shape and size—24 cm in length from the top of the Triton's head to the tip of his arched and flipping tail (figs. 1a–c)—suggest the handle was designed to fit onto the curving body of a container for liquid. This container could have been any of several shapes: a tall oinochoe or pitcher, which seems most likely, in which case the Getty Triton would have been the only handle; or some wide-mouthed vessel from which liquid was ladled rather than poured, in which case our handle would have been one of two. The sea motif could conceivably indicate that this putative vessel was used for water rather than wine, which would imply a pitcher, but there are apotropaic aspects to the iconography of the handle that suggest it was associated with wine. While the vessel could have served to pour the water added to wine at symposia, the private drinking parties traditional to Greek-speaking households and appropriate occasions for use of elaborate silverware, it is more likely that it was used for wine, and perhaps in an area which, while influenced by Hellenistic Greek life, may have been geographically somewhat removed from its traditions. There is no known provenance for the handle.

The handle was once even more striking than it appears today, as much of its surface was originally gilded. Traces of gold leaf, applied, burnished, and possibly heated to fuse it to the silver surface, remain on the Triton's beard and hair, on the calyx from which his torso springs, and on his tail. Only the torso, arms, and face of the sea creature were left ungilded, the cool gray color of the silver and its variety of reflections suggesting the Triton's "sea-hued" flesh (Ovid, *Met.*, 1.333). The vessel to which this elaborate handle was attached was undoubtedly also made of silver, completely or partially gilded. The entire assemblage was conceived and produced as a unique item for luxury use by wealthy individuals.

The cast silver protome (fig. 1d) has a hollow torso and solid-cast head and arms. It would have been placed and affixed just over the rim of the vessel for which it served as handle, facing inward. The muscular torso of the Triton, which broadens slightly at its base just below the waist, emerges from a double calyx of acanthus leaves, a ring of smaller leaves lying closest to the torso, a second ring of larger leaves projecting out below. At the Triton's back (fig. 1e), the leaves of the calyx are slightly raised to conceal the join of his torso to the separately fashioned fish tail, which arches up slightly to form a graspable handle before descending in a graceful S-curve (fig. 1b). The tail was made in two parts: 1) a hollow tube, made from a single sheet of silver, cast and then rolled, a "lap" seam holding it together on the underside,[1] and 2) the flipper at the end of the tail (fig. 1f), which is solid cast and fits with a tenon into the tail tube. The tail would have met the side of the vessel body and been affixed to it at the point just above the flipper's elegant twist to the side, a join that would presumably have allowed use of the handle. Seen in profile, this movement of the tail suggests the propulsion of the Triton into his upright position (figs. 1a, b). The flipper itself is an elaborate fan-shaped fin. Several large "scales" suggestive of the acanthus leaves in the calyx descend onto it from the curving spine and divide the fin into two halves made up of feathery elements of unequal lengths, longer at the outer edges. The underside of this fin is not finished, for it would not have been seen. The tail itself is covered with multiple small scales with a spine of short fins running down the back (figs. 1b, e). These little fins reduce slightly in size as the tail narrows toward the end; their alternating

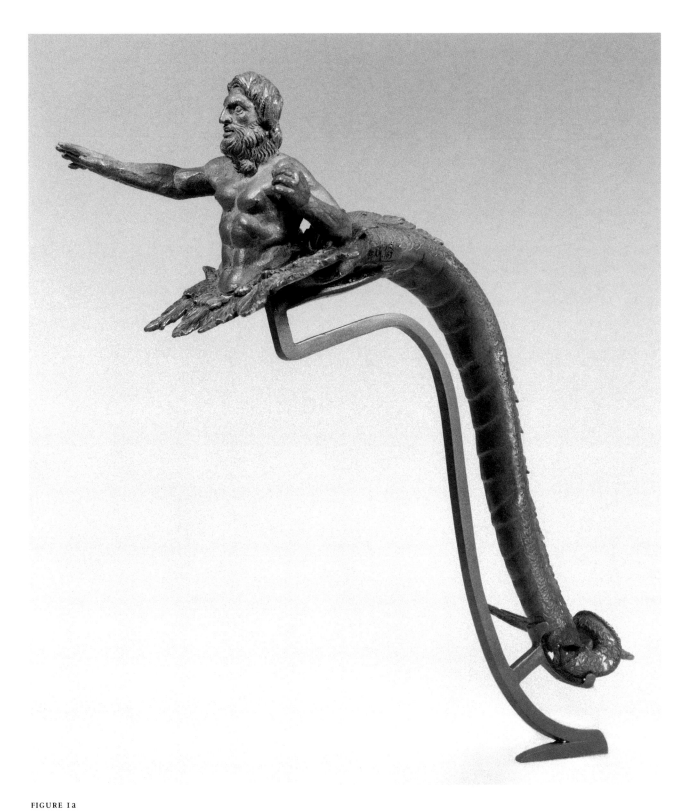

FIGURE 1a

Silver vessel handle in the shape of a Triton. Left side. Malibu, J. Paul Getty Museum 85.AM.163.

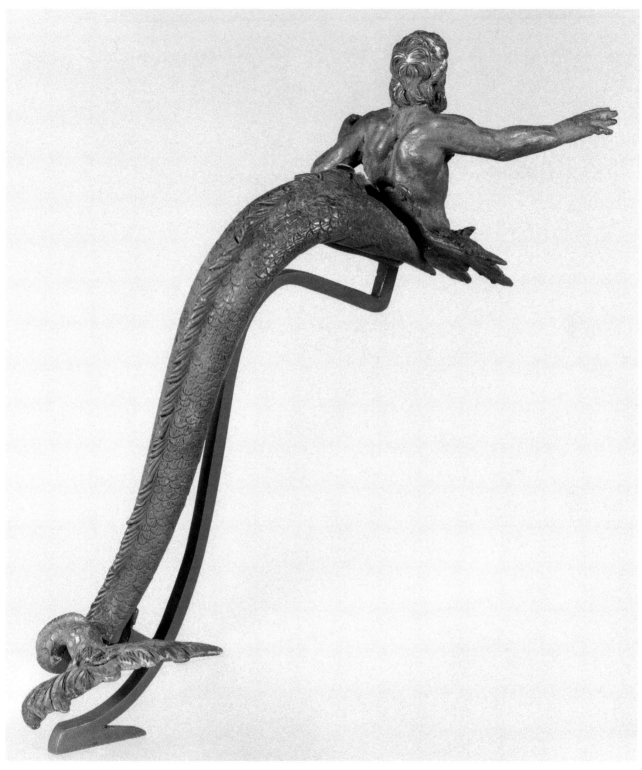

Back of Triton handle, figure 1a.

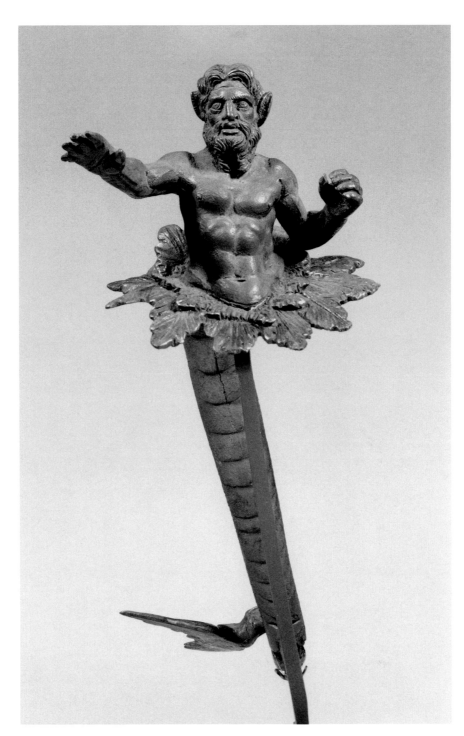

FIGURE IC

Front of Triton handle, figure 1a.

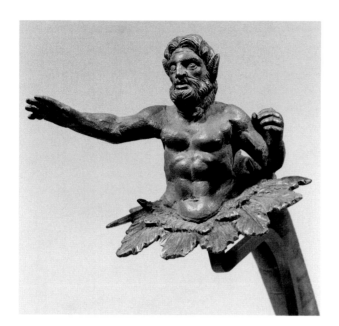

FIGURE 1d

Front of Triton on handle, figure 1a.

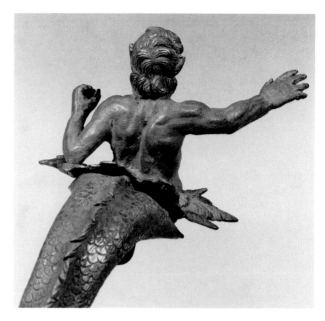

FIGURE 1e

Back of Triton on handle, figure 1a.

FIGURE 1f

Flipper of tail on Triton handle, figure 1a.

directions at the height of the tail's arch, and their division into irregular groups as the spine descends, masterfully suggest the fins are rippling as if responding to some action upon them like the flow and drift of water. The underside of the tail is smooth with lateral divisions, like a snake's (figs. 1a, c).

Besides the appropriately decorative aspect of this sea creature as a handle on a container for liquid, the Triton's presence—with his torso, head, and gesturing arms positioned over the open mouth of the vessel, above its contents—was surely to some extent apotropaic. The fierce expression on the heavy-featured, bearded face suggests this, as does his gesture. His right arm reaches out, the hand open with palm down in warning, as if guarding the liquid below from contamination. His left arm is bent at the elbow and only partially extended with the hand closed. In this hand, the Triton originally held an object. Given his protective posture, it was probably a trident, but a hollow, spiral conch shell, an instrument traditional to the prototypical Triton who blew loud resounding notes to calm the floods after the creation of the world (Ovid, *Met.* 1.329–347), would have been an equally appropriate attribute.

The creature's demonic nature is expressed both in his stern and threatening demeanor and by certain animalistic traits in the human-looking head (fig. 1d). His large eyes, with irises and pupils indicated, are open unnaturally wide under the heavy and somewhat

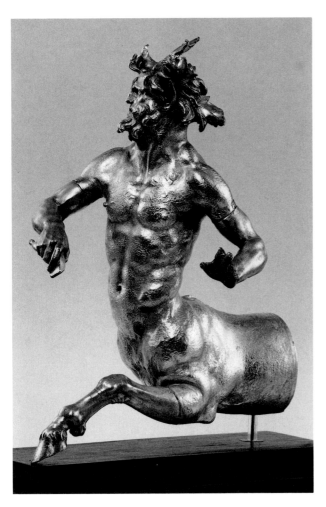

Silver protome in the shape of a Centaur, from a rhyton. Vienna, Kunsthistorisches Museum, Antikensammlung. Photos courtesy Kunsthistorisches Museum.

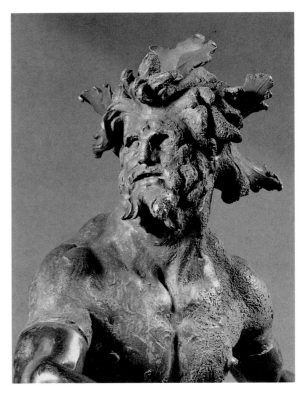

FIGURE 2b

Detail of front of Centaur protome, figure 2a.

protruding, vertically striated brows that meet at the bridge of his nose. His features are crude and exaggerated in size; his beard is unusually heavy, locks dividing in the middle of the chin and covering his neck completely. His mustache is divided into two fin-shaped segments that start just below the outer edge of each flaring nostril and sweep back and down to join the thick beard. His ears, once gilded, are those of a horse: large, pointed, and covered with hair (indicated by deep horizontal grooves). The boney forehead is creased with a single deep line, and the thick-lipped mouth is open as if speaking. The originally gilded hair on his head is held together as a heavy mass, dividing over his forehead into two irregular locks. Curling locks fall low on his neck in back and, on the crown of his somewhat flat skull, there is a four-point star pattern (fig. 1e).

Like the animalistic traits of the small-faced, hollow-cast silver Centaur protome in Vienna, originally the forepart of a rhyton[2] (figs. 2a, b), a toreutic work directly dependent in style on the giants in the Gigantomachie of the Pergamon Altar, the Getty Triton's animalistic traits are expressed by indications of special strength, energy, and movement, as well as by

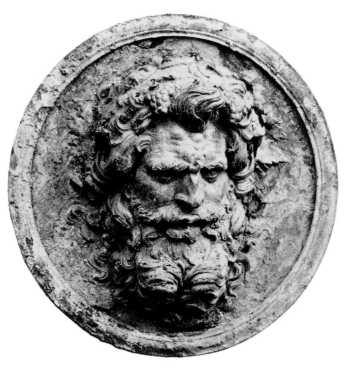

FIGURE 3

Silver medallion from a phiale with the mask of a satyr. Berlin, Staatliche Museen Preußischer Kulturbesitz, Antikenabteilung, Charlottenburg. Photo courtesy Staatliche Museen Preußischer Kulturbesitz.

the exaggeration of features and expression. While the Triton's torso and face do not express the sublime animal restlessness of the silver Centaur, and while he lacks that creature's extraordinary pathos, he is related to him in general conception. His demonic energy is revealed in the taut, muscular torso and his authoritative gesture, as well as the subtle movement of the spine fins and the lively flip of his tail.

The smoothing out of High Hellenistic pathos in the Getty Triton, however, and its tough, crude, somewhat dry style—the differentiation of forms dependent more on line than on modeling—suggest an execution removed both geographically and in time from that of the Vienna Centaur and other works close in both conception and history to the creation of the Pergamon Altar frieze.[3] The face of the Getty Triton may be compared to the silver mask of a satyr found in Miletopolis, near Pergamon, now in the Antikenabteilung in Charlottenburg in Berlin (fig. 3),[4] whose physiognomy suggests the giants on the Pergamon frieze. The structure of the Triton's face and the shapes of his large features are similar to the satyr's in general outline only. His stylistic dependence on prototypes like this mask is probable, however. The

strength but toughness (as opposed to delicacy) in the modeling of head, torso, and arms of the Getty Triton, with areas of awkwardness in the hands, where nails are indicated but the fingers are not clearly articulated, as well as the eccentricity in the shape of the head, further suggest the provenance of this small sculpture at some distance from the High Hellenistic inspiration that informs it. In contrast to the human parts of the Triton, the long fish tail is executed with great skill and sensitivity to detail. This dichotomy recalls the mastery evident in the toreutic art of some ancient peoples such as the Scythians and, to some extent, the Thracians, in their superior depiction of animals in contrast to their relative difficulty with human physiognomy.

A considerable amount of Hellenistic silver discovered in Italy early in the nineteenth century, including the silver Centaur protome (figs. 2a, b), is believed to have been produced in Pergamon and, after Attalos III bequeathed the kingdom of Pergamon to Rome in 133 B.C., to have been taken by the Romans to Italy, where it was no doubt widely copied. While Pergamene silver itself may not have found its way to the farthest-flung areas of the expanding

Roman Empire at this time, it is likely that the Pergamene style was well known by then, or shortly afterward, in centers in Magna Graecia, as well as in the Roman protectorates along the Adriatic and inland from it. If the Getty silver Triton handle is a copy or adaptation of a prototype made in Pergamon sometime after the erection of the Great Altar[5] and—given its removal from the Pergamene style—probably after 133 B.C. and at some distance from the origin of the prototype—we might look to Magna Graecia for the origin of the handle, or even to somewhat more remote Hellenic areas, such as Macedonia or Illyria, which had been under Roman protection since 148 B.C. Undoubtedly many Hellenistic toreutic centers—some, like Tarentum, known to us, others not—were capable of producing a silver vessel with a handle of the stylistic heritage and strength of design of the Getty Triton. It is perhaps easier to suggest a tentative date for the Triton, 100–50 B.C., than a workshop origin.

New York City

NOTES

1. I am grateful to Jerry Podany of the Department of Antiquities Conservation of the J. Paul Getty Museum, who examined the Triton, for his answers to my questions concerning techniques of execution.
2. Vienna, Kunsthistorisches Museum, Antikensammlung. K. Gschwantler, *Guß und Form: Bronzen aus der Antikensammlung* (Vienna, 1986), no. 35, color pl. 2, figs. 76–77, pp. 42–43 with bibl. Found in the Cività Castellana. I am grateful to Kurt Gschwantler for the photographs.
3. Traditionally dated 180–160 B.C. Recent attempts to lower the date of the Pergamon Altar are so far inconclusive. See W. Hoepfner, "Zu den großen Altären von Magnesia und Pergamon," *AA*, Beiheft 4, 1989, pp. 633–634. For the most recent summary of the archaeological arguments for a date of 166–159 B.C., see T.-M. Schmidt, "Der späte Beginn und der vorzeitige Abbruch der Arbeiten am Pergamonaltar," in B. Andreae, *Phyromachos-Probleme* (Mainz, 1990), pp. 141–146.
4. H. Winnefeld, *Hellenistische Silberreliefs, 68. Berliner Winckelmann-Programm,* 1908, pp. 1ff., pl. 1.
5. See above, note 3.

# A Group of Late Antique Jewelry
# in the Getty Museum

BARBARA DEPPERT-LIPPITZ

Little is known about the jewelry of the Late Roman to Early Byzantine period. Although precious ornaments must have played an important role in the conspicuous display of wealth and luxurious life-style that were an important aspect of Late Roman life, relatively little gold jewelry from the period has been preserved. Coined gold and jewels were given as imperial gifts to loyal retainers and to the heads of barbarian tribes controlling the borders. Gold jewelry was a symbol of the private wealth and social position of its owner. However, most of the gold apparently was melted down and reused, the precious gems and pearls reset. The majority of Late Roman and Early Byzantine jewelry that we do have has no known provenance and is undated. Our knowledge of jewelry of the period is based mainly on a few larger hoards with recorded find spots but without any external evidence for dating. It is therefore fortunate that in 1983 the Getty Museum was able to acquire a group of fifteen pieces of jewelry buried around A.D. 400.[1] As all pieces had a similar patina, it need not be doubted that the group was, indeed, found together. They are all in very good condition, except for missing pearls on some items. Nothing is known about the previous history of this hoard, but no treasure corresponding to the present one is recorded as having been excavated anywhere during this century. There are, however, certain indications that the hoard must have come from the eastern part of the Roman Empire.

Like silver plate, the documentary importance of jewelry transcends its aesthetic value. A precise understanding of the place jewelry holds in the history of metalwork and of its relationship to other works depends upon its proper dating. The difficulties that attend the dating of Late Roman jewelry and its arrangement in anything like a convincing chronological sequence are in part mitigated by a small group of supposedly datable works. The Getty hoard belongs among the well-known treasures from the Hill of Saint Louis in Carthage[2] and from Ténès in Algeria,[3] both now generally agreed to belong to the period around A.D. 400, and the one from Thetford, dated to the late fourth century A.D.[4] All these hoards are dated on a purely stylistic basis, with no external evidence. In contrast, the Getty hoard includes a series of twenty-three coins covering the period from Constans I (337–350) to Theodosius I (379–395), which provide valuable confirmation of the stylistic date of the hoard.

The relationship between the present treasure and the other important hoards will be discussed below. It should, however, be added here that they all differ considerably in style as well as in types. One of the characteristics of the present treasure is that it comprises some articles in pristine condition alongside others that show signs of extensive wear. Such a juxtaposition of newly made and already worn items can be explained by the fact that a group of precious objects was not necessarily acquired all at once.

Some of the pieces show the influence of barbarian jewelry, but most of them reflect their Roman heritage. This is not surprising in a hoard accumulated during a period of dramatic political changes and fluctuations. To a certain extent it might illustrate the infiltration of the Classical world by what is called the "migration of nations." Another important aspect of the hoard is that it was buried at a period when the Christian culture was firmly established, yet, none of the objects is influenced by it.

For convenience of presentation, the material is grouped typologically. Necklaces are followed by bracelets, finger rings, and the probably most important object of the hoard, a belt.

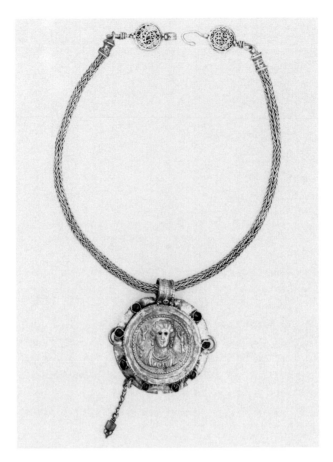

**FIGURE Ia**

Necklace with circular pendant. Front. Malibu, J. Paul Getty Museum 83.AM.225.1.

## I. NECKLACE WITH CIRCULAR MEDALLION PENDANT

(figs. 1a–c)

L: 42.4 cm; pendant 6.3 × 5.4 cm; pendant chain L: 4 cm; Wt: 112.46 g

Lit: *GettyMusJ* 12 (1984), p. 257, no. 143.2

83.AM.225.1

A ropelike multiple loop-in-loop chain terminates in cylinders made of ribbed gold, with an additional decoration of beaded wire. Each cylinder is linked to an ornamental disc with filigree decoration. One disc is fitted with a hoop, the other with an eye, both braced with clusters of gold granules at the joint and an outer border of beaded wire. The filigree decoration consists of a central motif of four C-volutes arranged in pairs and bound by a circle and an outer border with similar volutes.

Multiple loop-in-loop chains have a long history in ancient jewelry, and it is hardly possible to date them on stylistic grounds. In comparison to many other examples of the Roman period, this chain is of particularly fine quality. The single links are made of strip-cut wire, showing the "seam" lines typical for ancient wire, made before the invention of the draw plate.[5] In contrast, the filigree ornaments are made of square-section wire. Cufflike terminals are characteristic of Roman and Early Byzantine chains. The final links of such a chain are inserted into the cylinder and fixed by a rivet. Particularly similar are the necklaces from the fifth-century A.D. treasures from Trivolzio[6] and Reggio Emilia.[7] Openwork circlets with addorsed C-scrolls occur already on third-century necklaces.[8] A fourth-century example is the filigree-decorated clasp of a necklace from a grave in Steeg at the Hallstätter Lake in Austria.[9] Later examples are found on necklaces from Constantinople and Syria or Egypt.[10] A similarly decorated disc from a grave in Visnjica in Yugoslavia is dated to the sixth or early seventh century A.D.[11] Pendant and chain, showing a remarkable difference in quality, were obviously not created as a unit, but they were joined already in

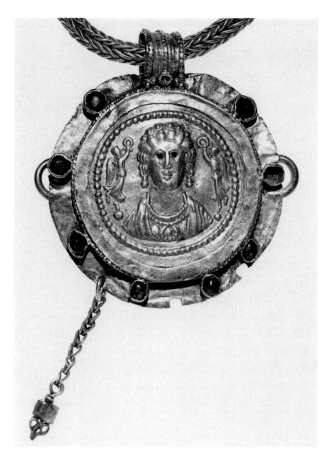

FIGURE 1b

Front of pendant, figure 1a.

FIGURE 1C

Back of pendant, figure 1a.

antiquity. Furthermore, the pendant doubtlessly has been altered at least once, indicating an earlier history. The medallion and the inner frame together with the loop represent the original pendant. The outer frame—with a row of rather primitive box settings—the three chain pendants, and the two strong rings attached to either side are a later addition. The rings originally fitted matching elements on a chain, proving that this pendant could also be worn as a central element of a necklace.[12] The circular box settings on the outer frame contain garnets and green and blue glass. Three pendant chains were originally attached to the outer frame. The only one remaining, which holds an emerald and terminates in a decorative scroll ornament, is of a higher quality than the frame. It may have belonged to a different piece of jewelry before being attached to this pendant.

The Getty medallion represents the *en face* bust of a woman of mature years, flanked on each side by a victory on a globe crowning her with a wreath. All

details are rendered in repoussé. The pupils, however, are drilled holes, similar to those of Late Roman and Early Byzantine ivory diptychs. The woman is dressed in a tunic and cloak. Her wavy hair, parted in the middle, covers her ears but not her circular earrings with large pendants. The hairstyle recalls that of female busts on marriage rings in Dumbarton Oaks and in the British Museum, dated to the late fourth or early fifth century A.D.[13] A pearl necklace around her neck holds a circular pendant not unlike this piece. Most distinctive is the rather unusual diadem, consisting of a row of circular elements, apparently cabochons set in flat frames.

The representation is essentially imperial in character. The crowning victories, the diadem, and the hierarchical image suggest an empress or at least a member of the imperial family.[14] Unfortunately, the paucity of reliable portraits of empresses of the fourth and fifth centuries makes an identification difficult. In general, portraits of the Late Roman period are so

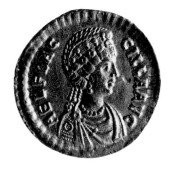

FIGURE 2

Solidus of Aelia Flacilla. Mint of Constantinople, A.D. 383. London, British Museum 1867-1-1-945, Duc de Blacas gift. Photo courtesy Trustees of the British Museum. Reproduced 2:1.

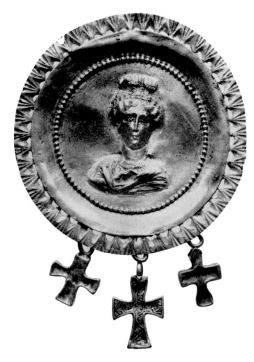

FIGURE 3

Brooch from Ténès (from J. Heurgon, *Le Trésor de Ténès*, pl. I). Reproduced 1:1.

stylized that different personalities have been suggested for the same monumental sculpture. Coin portraits are likewise of no great help, for the highly stylized coinage of the fourth and fifth centuries A.D. hardly allows any personal traits. Particularly in the fifth century, the imperial image has lost most of its individuality.

However, a small but significant detail, the diadem, offers valuable information. According to numismatic evidence, similar diadems have been worn only by the empresses Aelia Flacilla, wife of Theodosius I, whose coinage commenced in A.D. 383 and who died in 386, and by her daughter-in-law Eudoxia, wife of Arcadius (A.D. 383–408).[15] This narrows the chronological range of the medallion pendant to the last two decades of the fourth century A.D. The differences between the coin portraits of Flacilla and of Eudoxia are marginal. However, the oval face with short straight nose, small mouth with thick lips, and energetic chin seems to be closer to the portrait on certain issues of Flacilla than to that of Eudoxia (fig. 2).[16]

The earliest examples of circular Roman pendants with the frontal representation of a female bust are jet pendants found in third-century graves in Cologne.[17] They represent private portraits and are of rather simple quality, proving, however, that this was a common subject already at a relatively early date. Outstanding workmanship is shown on a gold brooch from the Ténès hoard with the relief of a female bust *en face,* surrounded by an ornamental frame with the classical egg-and-dart motif (fig. 3). The representation has been interpreted as a portrait of the empress Galla Placidia.[18] The type and style of this piece could hardly be more different from the representation on the Getty pendant. Its subtle posture, softly waving hair, and natural appearance betray the classicizing tendencies developed in Rome toward the end of the fourth century, whereas the lifeless and schematic representation on the Getty pendant foreshadows Byzantine principles. This difference does not necessarily exclude the possibility that both pieces have been created about the same time. Visual art was never homogenous and particularly not during the Late Roman period. Stylistically, the chief characteristics of the female bust on the Getty pendant are the simplified notation of facial detail, the staring eyes, and the relation of the full neck and large head to the ill-coordinated torso. As on the Ténès portrait, the neck emerges from constricted, drooping shoulders. These can be observed on fourth-century coin portraits

as well as on other works of art. Characteristic examples are the chalcedony bust of Julian Apostata in the Hermitage[19] and the Rothschild cameo in the Louvre.[20] The contrast between the shrunken chest and the broad planes of the head with its dilated eyes was apparently used for the general scheme of transforming an individual portrait into an abstract hierarchical image, thus evoking the impression of imperial power.

A further parallel to the Getty pendant is an Early Byzantine ornament in Baltimore with a summary representation of an *en face* female bust with drop-shaped earrings, a beaded necklace, and the turreted crown of a Tyche.[21] It seems that the standard formula for representing an empress was used here for the personification of the Tyche of Constantinople. A further parallel is seen in the clasps of a fifth-century necklace from the so-called Olbia treasure in Dumbarton Oaks, each decorated with the frontal representation of the bust of a woman with earrings and necklace.[22]

## 2. NECKLACE WITH CAMEO PENDANT (figs. 4a–c)

L: 55.5 cm; pendant 4.2 × 3.8, resp. 4.4 cm; Wt: 61.95 g

Lit.: *GettyMusJ* 12 (1984), p. 257, no. 143.3

83.AM.225.2

A ropelike multiple loop-in-loop chain terminates in ribbed cylindrical tubes. One tube has a beaded wire decoration at both ends, the other only at the top. Each tube holds a ring, one of them serving as a loop, the other linked to a large hook, which is partly masked by a leaf-shaped plate of gold. Rivets with beaded heads hold chain and tubes together. Although basically of the same type as the chain of the first necklace, this chain was created by a less able goldsmith. Its most characteristic feature, the leaf-shaped gold plate, is not unusual for Roman chains, but their finials usually have a symmetrical decoration, for instance, a leaf-shaped ornament on the hook and on the eye. The closest parallel to this chain has been found in the grave of a wealthy lady of Germanic origin in Nasoburky (Assmeritz) in Czechoslovakia.[23] The very similar necklace consists of a multiple chain, ribbed cylinder terminals framed by beaded wire, and a leaf-shaped gold plate masking the hook. Although the leaf is more delicate, with a carefully executed repoussé decoration, both necklaces obviously represent variations of the same Byzantine type. Also closely related is an impressive necklace from the particularly rich grave of another Germanic lady, buried

at the very beginning of the fifth century in Untersiebenbrunn in Austria.[24] Here the hook is masked with a very stylized leaf-shaped box setting inlaid in cloisonné technique with four garnets.[25]

The chain is combined with an oval pendant held by two coarse ribbed suspension loops. Their puzzling aspect can only be explained by the fact that they are a later addition, attached to what was originally a brooch, by a craftsman who was not trained in fine goldwork (figs. 4b, c). The catchplate and parts of a hinge can still be seen on the back of the brooch. The front shows a large cameo mounted in plain gold with a pronounced ridge, surrounded by a broad frame of openwork decoration and oval box settings inlaid with keeled garnets.[26] The suspension loops have been folded over this openwork frame and are held by wires stuck through openings in the decoration; their ends are flattened on the front and coiled on the back. Three loops attached to the outer frame may have been part of the original brooch; only one of them is completely preserved. Two punched holes near the outer border seem to be later additions.

The four oval box settings divide the frame into four zones decorated with different patterns. Two facing zones show identical double cables, the third zone has lozenges interspersed with tiny rosettes and heart-shaped leaves, and the last one has a zigzag scroll circumscribing stylized sprouts. The lacelike effect of openwork decoration, the Roman *opus interrasile,* enjoyed unrivaled popularity during the third and fourth centuries A.D.[27] The design was laid out with a series of drilled or punched holes—still visible on the back of the frame of this pendant (fig. 4c)—and then opened out on the front by means of a small chisel.[28] Apparently a number of workshops in all parts of the Roman Empire specialized in this technique, borrowing freely from each other the same motifs, but sometimes differing considerably in quality. Although no direct parallel is known for the openwork of the Getty pendant, the cable border, lozenge, and zigzag scrolls are quite typical for openwork jewelry.[29]

The decorative frame and the cameo of this pendant-brooch seem to be contemporary. The representation of facing portraits is rare but not unknown in the history of Roman glyptics. Particularly brilliant examples are a large cameo in Vienna with Claudius and the younger Agrippina on the left and Germanicus with Agrippina Major on the right[30] and a cameo in the Cabinet des Médailles in Paris with Septimius Severus and his wife Julia Domna on the left facing their sons Caracalla and Geta.[31] In the late

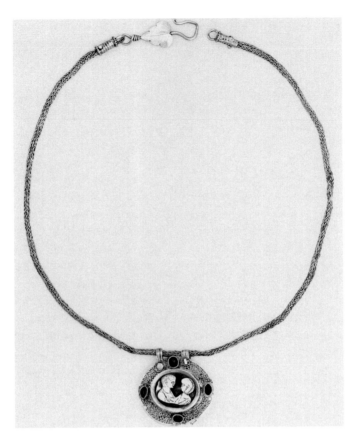

FIGURE 4a

Necklace with cameo pendant. Front. Malibu, J. Paul Getty Museum 83.AM.225.2.

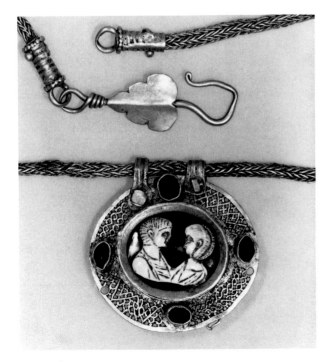

FIGURE 4b

Front of pendant and ends of chain, figure 4a.

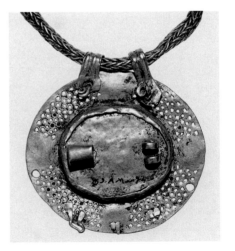

FIGURE 4C

Back of pendant, figure 4a.

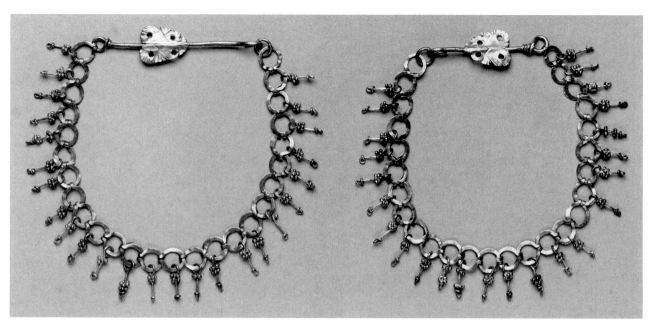

FIGURE 5

Two chains with pendants. Malibu, J. Paul Getty Museum 83.AM.226.1–2.

second century and first half of the third century, large cameos were generally used for pendants as well as for brooches.[32] The cameo of the Getty pendant represents the busts of a couple with their noses broken off. It is difficult to decide whether this happened by accident or as the result of a *damnatio memoriae*. The man is wearing a paludamentum, the woman a palla over a tunic. Her coiffure places the cameo in the mid-third century A.D. It is similar to that of the Roman empresses Otacilia Severa (A.D. 244–249), Herennia Etruscilla (A.D. 249–251), and Salonina (A.D. 253–268).[33] Closely related in design and quality is an unmounted cameo with a facing couple, dated to the first quarter of the third century, from a grave in Cologne.[34] Even more similar is a pendant with a cameo representing two female heads, possibly those of Julia Maesa and Julia Mamaea, and an openwork frame with four settings holding garnets.[35] A more refined version of the same subject is found on a cameo pendant from a grave in Viminacium, the modern Kostolac in Yugoslavia.[36] Both portraits can be dated to about A.D. 230. Much simpler are the numerous jet pendants with representations of husband and wife found in the Rhine provinces and in Britain. Most of them can be dated to the fourth century A.D.[37] They differ from the earlier pieces mentioned here in that the couple is typically shown *en face* rather than facing one another.

### 3. TWO CHAINS WITH PENDANTS (fig. 5)

L: 23 cm and 24.5 cm; finials L: 4 cm and 5.7 cm; one link 0.8 cm; pendant 1.12 cm; Wt: 18.05 g and 18.21 g
Lit.: *GettyMusJ* 12 (1984), p. 257, nos. 3, 4
83.AM.226.1, 2

Each chain consists of twenty-six flattened figure-of-eight links. One end is attached to a small, possibly modern ring, the other terminates in a hook, which is partly masked by a leaf-shaped gold plate, recalling the finial of the chain described above. The two hooks differ in length but are otherwise identical. Each one is made of a round wire, one end of which is fastened to the chain, the other one bent. The two plates are the same size. Their leaflike effect is underlined by additional openwork and incised lines. Each link of the chains supports a small pendant consisting of a short length of round wire forming a loop at the top and coiled at the lower end. The pearls that these pendants probably held have not been preserved, but nearly all the circlets of gold granules that stopped the pearls from slipping off are still there. The way the wire ends of the pendants are coiled is still very much in the Roman tradition. In contrast, Byzantine goldsmiths preferred to flatten the ends, creating a sort of pin. Except for dark stains on several pendants and links on one chain—the other chain may have been cleaned by the former owner—both are in perfect condition. Only one pendant is missing.

Chains with a row of identical pendants have a certain tradition in Greek and Roman jewelry, although not many pieces have survived. A characteristic example of the second century A.D. is a gold wire necklace with green glass pendants found in a sarcophagus in Rome.[38] A large hoard of Roman jewelry deposited in Lyons, probably in A.D. 197, contained several splendid necklaces with rows of amethyst and garnet pendants.[39] A necklace from a princely grave from Bakodpuszta in Hungary[40] and another from the previously mentioned late fourth- to early fifth-century Germanic grave from Untersiebenbrunn in Austria[41] represent local imitations of the Early Byzantine version of the type.

Judging by their representation on mosaics, pearls, which were already appreciated in Early Roman times, must have been tremendously in demand in the Late Antique and Byzantine periods. As they are subject to decay, they do not often survive. Usually only their empty settings are left. Among the few examples with pearls perfectly preserved are two pairs of earrings from a fourth-century A.D. grave in Armaziskhevi in Georgia, both with the same circlets of gold granules as on our chains.[42]

The exact purpose of these two chains can only be guessed at. They are too short to form individual necklaces, and the way the two hooks are constructed and attached to the chains excludes the possibility that the two chains were meant to form a single necklace. Our knowledge of Late Antique and Early Byzantine costume is based mainly on representations in mosaics, which do not necessarily give the full picture. We can, however, presume that there was a number of possibilities for the use of chains. Already in Hellenistic times chains sometimes connected a pair of earrings. Apparently this fashion was repeated in the Early Byzantine period. A little hoard from Chios, dated to the sixth or early seventh century A.D., contains a pair of earrings connected by a gold chain 39 cm long.[43] To the center of this chain is attached a shorter length of chain of similar make, terminating in a hook. It is masked with a leaf-shaped gold plate, which typologically is very close to the finials of our two chains. The exact purpose of the hook of the Chios chain has never been established. It might have joined the chain with a headdress, a breastchain, or a fibula. However, none of these possibilities explains the different lengths of the finials on the two Getty chains.

A short chain with several pendants, said to have been found in a Visigothic context in Spain or in the South of France and definitely coming from a Byzantine workshop, also recalls our pair of chains.[44] Two elaborate leaf-shaped ornaments, each fitted with a hoop, serve as finials. Here again the exact purpose is unknown.

## 4. OPENWORK-DECORATED BANGLE (figs. 6a, b)

H: 2.82 cm; inner Diam: 5.16 × 4.64 cm; outer Diam: 6.21 × 5.76 cm; hinge pin H: 2.54 cm; Wt: 65.69 g
Lit.: *GettyMusJ* 12 (1984), p. 257, no. 143.5
83.AM.227.2

The two parts of this penannular bracelet with a movable section are joined at one side by a permanently set clasp and at the other by a hinge consisting of three interlocking joints and a removable screw pin instead of a fixed rivet. The pin is made of round wire, encircled in its upper part by a flat wire, forming the thread (fig. 6b).[45] Probably for technical reasons the pin and thread are of different gold alloys. The pin has a reddish color, whereas the encircling flat wire has a yellowish tint. A flat wire soldered to the inside of the top chenier corresponds to the thread of the screw. The screw head, surrounded by small gold granules, supports a box setting with a small cabochon sapphire.

Hinges secured by screw pins are not unusual during the Late Roman to Early Byzantine period. One of the finest examples is a bracelet found in a Germanic grave at Bakodpuszta, which was certainly made by a Roman goldsmith.[46] A pair of fifth-century Byzantine bracelets with screws belong to the Malaia Pereschepina treasure.[47] Several Late Roman crossbow fibulae are fitted with similar screws.[48]

The bracelet consists of a band forming the hoop, edged by borders that are turned inward, thus reinforcing the hoop and at the same time creating the impression of a bulged cross-section. The band is completely covered with a pattern of fine openworked decoration coupled with colored gems. The openwork is so minute in scale and so tightly crowded together in a narrow space that no empty ground remains. The piece, in fact, is reminiscent of filigree work or very fine lace. It has been suggested by several scholars that the openwork of these bracelets was enhanced by a colored lining, secured to the interior of the pieces.[49] However, tests have proved that a lining would hardly be visible as the pierced holes are extremely fine. The borders are left plain and serve as background for a series of precious and semiprecious gems as well as glass inlays, most of them now missing.

FIGURE 6a

Bracelet with openwork and colored stones. Malibu, J. Paul Getty Museum 83.AM.227.2.

FIGURE 6b

Screw pin closure of bracelet, figure 6a.

The open-work decoration is divided into different fields separated by pairs of now-empty pearl settings. Each pearl was partly covered by round collets. In accordance with the traditional Roman way of setting pearls, they were pierced and strung on short wire ends, which were rather carelessly stuck through small openings in the collets. The predilection for the division of the surface into ornamental zones, separated by straight reserved lines, betrays a distinctive characteristic of Late Roman minor art in general. At the center of each ornamental zone is an elaborate setting holding a gem. Large emeralds in square settings supported by a jour-decorated crown settings alternate with circular claw settings with blue glass,

no doubt meant to imitate cabochon sapphires. The four projecting prongs of these claw settings are cut into the collet.

All settings are mounted on a plain, open base, which is surrounded by a circular a jour-decorated border framed by a straight reserved line. The emerald settings are combined with a design of tiny vine leaves, the "sapphires" with alternating lozenges and rosettes. All interstices are filled with the delicate lines of a tightly organized scrollwork of the greatest intricacy, repeated between the different sections. It consists of scroll spirals with turned-back sprigs developing from tiny peltae. The pelta is a semicircular or heart-shaped decorative device that enjoyed great

popularity in Roman mosaics as well as in minor arts. The peltae on the Getty bracelet are characterized by an oval opening in their center, reminiscent of the peltae on the a jour-decorated frame of a coin pendant from a late third-century necklace in Chicago.[50]

The type of the Getty bracelet is well known in Roman jewelry. In fact, bulged, articulated bangles represent the most frequent type of bracelet in the third and fourth centuries A.D. However, most of the known pieces are plain or decorated in repoussé.[51] Particularly charming are jet bracelets of this type, often decorated with golden cuffs at their joints.[52] The earliest datable example is a jet bracelet found in Belgium with a carved relief decoration, including a portrait of Caracalla (A.D. 198–217).[53] Plain gold bangles of this type were part of a treasure hidden in Nicolaevo in Rumania soon after A.D. 248/249.[54] Examples from a hoard from Monaco, dated through coins up to A.D. 276, prove the popularity of the type during the second half of the third century.[55] There is also sufficient proof that the type was still in vogue during the fourth century A.D. The most spectacular piece, a jet bangle with an additional decoration of gold and garnet cloisonné, was found in a fourth-century A.D. grave in Mtskheta in Georgia.[56] A wall-painting in the tomb of Aelia Arisuth in Gargaresh in North Africa, dated to the fourth century A.D., represents the deceased with a bulgy bangle on her right wrist.[57] Her portrait is surrounded by a wreath decorated like a bracelet with oval sapphires and square emeralds in matching settings.

Penannular bracelets with open-work decoration can be divided into two main contemporary groups. One comprises rigid bangles that have to be slipped over the hand, the other articulated bracelets with a movable section like the piece in the Getty Museum. A splendid representative of the rigid type is a pair of bracelets, one of which is in St. Louis, the other in Berlin.[58] In both groups there are bracelets restricted to plain gold and others marked by the use of colorful gemstones. A pair in the Virginia Museum of Art in Richmond is a fine example of the articulated version (fig. 7).[59] Although different in detail from the Getty bracelet, the well-balanced compositional design of the pair in the Virginia museum, combining openwork and settings with square emeralds alternating with oval or circular sapphires, repeats the basic concept of the Getty bracelet. The outer borders, however, are not encrusted but decorated with a flowing vegetal scroll in openwork.

Particularly close to the Getty bracelet is an

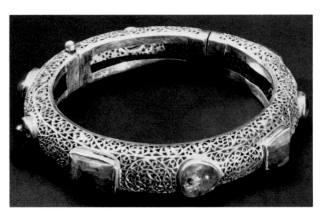

FIGURE 7

Bracelet with openwork and colored stones. Richmond, Virginia Museum, The Williams Fund, 67.5231/1. Photo courtesy Virginia Museum.

articulated bracelet found in Cologne and now in the Römisch-Germanisches Museum (fig. 8).[60] It consists of a flat band fully covered with open-worked ornaments except for small areas reserved for settings for alternately emeralds and pearls. A jour-decorated borders with beaded edges are added and turned inward at a right angle.

Although they fit into the general pattern of third- and fourth-century-A.D. jewelry, none of the openwork-decorated bracelets mentioned so far can be dated on external evidence. The only piece to which an approximate date can be assigned is a bracelet of related type and comparable decoration belonging to a hoard said to have been found in Sidi-bou-Zid near Al Marj in Libya (fig. 9).[61] A series of gold coins ranging from A.D. 351/361 to 388 dates the jewelry in this hoard to the latter half of the fourth century.

The bracelet from Sidi-bou-Zid appears to be the earliest known example of a type that was to become extremely successful during the following two centuries.[62] It consists of a flat band with reinforced rims and an articulated square section. The a jour-decorated surface of the hoop is divided into a series of geometric ornaments, the interstices filled with vegetal scrolls. The dense openwork of the square section is encrusted with a large amethyst surrounded by pearls in box settings. The lacelike effect of the pierced decoration of this bracelet is closer to that of the Getty bracelet than to any other known bracelet.

The goldsmith to whom we owe the bracelet in the Getty Museum distinguished himself by some

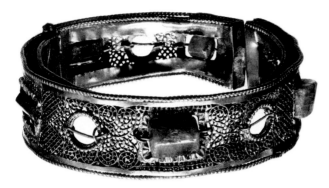

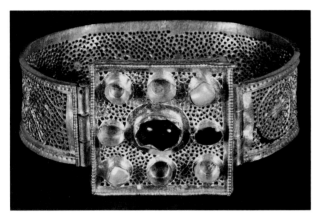

remarkable innovations. The importance of the hinge pin with an elaborate screw and ornamental head has already been stressed. However, his settings deserve even more attention. With the exception of the bracelet from Cologne (fig. 8), the gemstones on all related bracelets are inserted in simple, undecorated collets, the pearls held by wire and set into an opening or a cavity. The emeralds of the Cologne bracelet are pierced, strung on wire, and set into a square opening surrounded by an ornamental frame. In contrast, the Getty bracelet features a cut-down claw setting for the sapphire-blue glass, a raised setting with openwork that could be called a covered crown setting for the emeralds, and plain truncated cones for the pearls. In comparison to the usual Roman box setting, these elaborate settings betray a sense of experiment and a new attitude toward the colored stones. The cut-down claw setting used for the blue glass allows a maximum of translucence, thus enhancing the color of the glass. The emeralds are safely secured by a collet, while the openwork of the supporting square coronet adds to their translucence.

The custom of mounting sapphires in crown settings with strong prongs and emeralds in solid square settings became standard in the Early Byzantine period. However, the earliest examples of this method of securing inlays can be found already in the late third century. Although rare in number, they definitely prove that Roman goldsmiths of this period successfully mastered different ways of replacing the simple box setting. An aquamarine in a finger ring from the Beaurains treasure, hidden not later than A.D. 312, is secured by four claws cut into a square collet.[63] The metal between the claws is pared down, creating a sort of volute-shaped crown. A finger ring from a rich grave in Cologne, coin-dated to the third quarter of the third century A.D., shows a small sapphire secured by six claws.[64]

5. GOLDEN BANGLE WITH COLORED GEMS
(figs. 10a, b)
H (larger sector): 3.24 cm; H (smaller sector): 3.18 cm; inner Diam: 6.39 × 5.23 cm; outer Diam: 7.30 × 6.38 cm; hinge pin L: 3.45 cm; Wt: 116.27 g
Lit.: *GettyMusJ* 12 (1984), p. 257, no. 143.5
83.AM.227.1

This bracelet is probably the most curious and intriguing object of the hoard. Although basically a Roman shape, it has a barbaric glamor that appeals to the modern eye. In fact, the shape affiliates it with the openwork-decorated bracelet described before and the

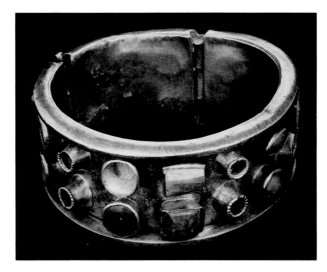

FIGURE 10a

Bracelet with encrustation. Malibu, J. Paul Getty Museum
83.AM.227.1.

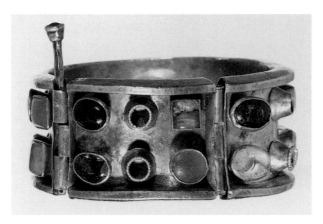

FIGURE 10b

Removable pin closure on bracelet, figure 10a.

other related pieces. It is an articulated bangle with movable sections. However, the artist did not hesitate to use the conventional shape for a completely different concept. The hoop consists of a heavy flat gold band the edges of which are bent outward at a right angle. The larger section, which tapers slightly toward the ends, is connected to the smaller one by tripartite hinges fitted with pins. On one side is a simple rivet, on the other side is a removable pin consisting of a strip of gold sheet both ends of which are inserted into a tiny box setting with green glass inlay. The smaller, back section of the bracelet appears lower than the larger, front section, although the difference is only .6 mm. However, the gold in the smaller sec-

tion is somewhat thinner, and the outward-bent edges of the gold band are somewhat lower than in the larger section, thus reducing the overall weight of the bracelet. This would have made the unusually heavy bracelet more comfortable to wear, and, in fact, similar differences between front and back sections are seen quite often on articulated bangles—the openwork-decorated bracelet from Cologne described above (fig. 8) being one example.

The outward-bent edges form a ledge 0.59 cm wide, which protects the protruding settings spread over the hoop. These settings consist of plain circular, oval, or square collets arranged in pairs. The rims are folded over the edge of the inlays, sometimes forming

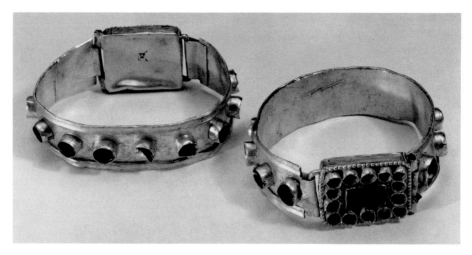

FIGURE 11

Pair of bracelets from Malaia Pereschepina. St. Petersburg, Hermitage Museum 1930/8.9. Photo courtesy Hermitage Museum.

a small border. In displaying the different settings, the goldsmith strictly observed the rules of symmetry and created a balanced composition. Two pairs of settings with colored inlays alternate with a pair of a truncated cones, each with a circlet of beaded wire around the top. They possibly contained pearls. All other settings are slightly smaller at the base than at the top.

The small sector (fig. 10b) is decorated with a pair of truncated cones framed by a pair of oval settings with blue glass and one square and one oval setting with green glass. The larger sector displays seven pairs of oval, square, and circular settings, alternating with pairs of truncated cones. The settings contain red, blue, and green glass inlays and, in three cases, emeralds. The colored glass imitates cabochons, the emeralds are used in their natural shape.

The artisan who created this bracelet used the well-established type of a bangle with opening section, however, treating the set formula in a completely different manner. Bending the edges outward seems to be quite unusual, but it offers a brilliant solution to the problem of protecting the protruding settings. In creating this bracelet, the goldsmith obviously had mainly the display of the multicolored inlays in mind. Although different from the other open-worked bracelet in the hoard, this bracelet shares the former's lavish attitude toward precious stones.

No direct parallel to this bracelet is on record. In shape it recalls the already mentioned bracelet from Cologne. The two pieces represent different versions of a common Late Roman type, and they are furthermore linked by certain details, for instance, the

smaller width of the movable sector and the tapering ends of the larger part. This analogy is of special importance for the dating of our piece. The typological as well as stylistic aspects of the Cologne bracelet argue for an origin in the third to fourth century A.D., a date that can also be proposed for the second bracelet from the Getty hoard. At the same time the differences between the two pieces are great. In spite of its obvious Roman shape, the Getty bracelet is fundamentally un-Roman in character. This might best be explained by assuming that it is of provincial origin or even created beyond the borders. In fact, it occupies a curious position halfway between the Late Roman sphere and another, which may be described as either Oriental or barbaric.[65] Perhaps the closest parallel is provided by a pair of bracelets from the Malaia Pereschepina hoard, buried during the second half of the seventh century A.D. in Southern Russia but comprising a number of earlier pieces (fig. 11).[66] Rather flimsy and of slipshod craftsmanship, the bracelets are proportioned in a different way with a movable sector treated as a separate element. The decoration as well as the overall aspect are, however, very similar.

The hoard from Malaia Pereschepina possibly represents the grave-goods of Kuvrat, who in the mid-seventh century A.D. as ruler of a Bulgarian tribe founded an empire on the steppes of South Russia.[67] To judge by the number of Byzantine objects in the hoard, Kuvrat must have had very close relations to Byzantium. The pair of bracelets described above is either a barbaric imitation of the Byzantine type or was made by a Byzantine goldsmith in one of the

provincial centers. The ledge of the Getty bracelet, protecting the protruding settings, has degenerated to a simple flange, and a plain row of circular settings has replaced the balanced arrangement of inlays of different shapes. However, the general scheme of composition is similar, and the pair from Malaia Pereschepina still reveals the same enthusiasm for polychromy and vigorous design as the Getty bracelet. Whoever created this peculiar piece was perfectly well trained. He drew a bold design, and the execution shows no signs of untidiness.

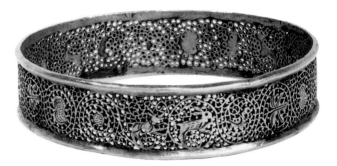

FIGURE 12a

Openwork bracelet. Malibu, J. Paul Getty Museum 83.AM.227.3.

### 6. OPENWORK BANGLE WITH PEOPLED SCROLLS
(figs. 12a–c)
H: 1.4–1.43 cm; Diam: 6.3 cm; Wt: 27.06 g
Lit.: *GettyMusJ* 12 (1984), p. 257, no. 5
83.AM.227.3

The third bracelet of the Getty hoard consists of a completely circular hoop made of a strip of gold sheet and bordered on each edge by a plain flange. Its surface is covered all over with the carefully composed framework of a formal vegetal scroll. Formed by a single narrow stem, it loops alternately to the right and to the left creating circular volutes. These contain vine and ivy leaves, korymbes, and a pelta. Every spandrel between the spirals is occupied by fine scrollwork. The stylized scroll of this bracelet has little life of its own. Twice, however, it is interrupted by a hunting scene. On one side a diminutive hound is chasing a deer (fig. 12b), on the other side a second hound pursues a hare (fig. 12c), each contained within the whorls. In spite of the small scale and undistinguished workmanship, the creatures are vigorous and lively in their movement.

Filling floral scrolls with living creatures is a decorative device that enjoyed great popularity throughout the history of Hellenistic and Roman art.[68] The motif is found in wall-paintings and architecture and on floor mosaics, but probably the minor arts provided an important element of its continuity. As Roman jewelry of the first and second century A.D. tends to be rather abstract in its design, it is understandable that the motif turns up rather late in jewelry. A particularly popular commonplace subject of later Roman art is the vine scroll with harvesting putti. Less common is the combination of the animated scroll with another favorite subject in many media of Late Roman art, the hunt, which is considered to be symbolic of transcendent victory.[69] The Getty bracelet represents an abbreviated version of the hunting scene, with the hunter himself not shown and the

concept of the hunt translated into scenes of the chase. The complete concept of a hunt, rendered in openwork, can be seen on a gold plaque in the British Museum, with the figures of a mounted huntress and a lioness in front of a pierced background of vegetal scrollwork.[70] This plaque, which was used as the tab of a belt, is part of a small hoard of gold objects found in Asia Minor together with coins of Constantius Gallus (A.D. 351–354) and Constantius II (A.D. 337–361).[71] Two more bracelets of this type are known. One belongs to the hoard from Desana in Northern Italy (fig. 13),[72] the other one, in the British Museum, is of unknown provenance (fig. 14).[73] The Desana hoard is a group of Gothic and Late Roman jewelry said to have been found together and dated to the end of the fifth century A.D. The circular hoop of the openwork bracelet from Desana, reinforced by a plain flange, is decorated with an undulating vine scroll with leaves and grapes that divides the surface into semicircular sections, each circumscribing a vintage scene or a bird pecking a grape.

The bracelet in the British Museum, broken into two parts, is divided into four sections by means of plain gold discs surrounded by openwork. The four genre scenes of vintage and hunting, set against a scrollwork background, possibly represent the four seasons. This piece has a very characteristic border decoration, which relates it to an even more elaborate bracelet from the Ténès hoard, which has recently been attributed by K. R. Brown to a workshop in Rome and dated about A.D. 400.[74]

Two more bracelets are affiliated with this group. One, formerly in the Dutuit collection in Paris, is said to have been found in Cologne,[75] the other, found in Jülich, is now in Berlin (fig. 15).[76] In both cases plain circular medallions divide the hoop into several sections, each with a different openwork pattern.

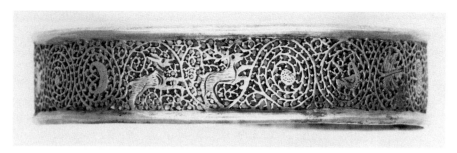

FIGURE 12b

Hound and deer decoration on bracelet, figure 12a.

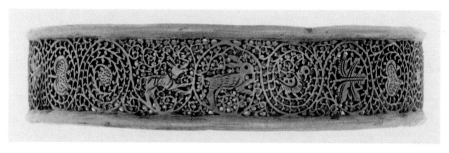

FIGURE 12c

Hound and hare decoration on bracelet, figure 12a.

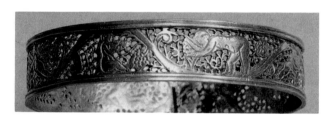

FIGURE 13

Openwork-decorated bracelet from Desana. Turin, Museo Civico, no inv. no. Photo courtesy Museo Civico.

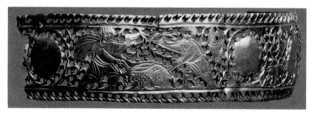

FIGURE 14

Openwork-decorated bracelet. London, British Museum BMCJ 2817. Photo courtesy Trustees of the British Museum.

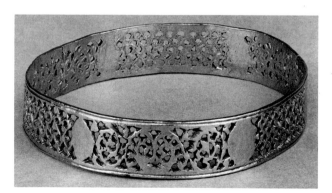

FIGURE 15

Openwork-decorated bracelet. Berlin, Kunstgewerbemuseum 98,46. Photo courtesy Kunstgewerbemuseum.

### 7. SEVEN GOLD FINGER RINGS

Finger rings of the fourth and fifth centuries are relatively rare.[77] There is none in the Ténès treasure nor in the hoard from Carthage. In contrast, the Thetford treasure contains twenty-two finger rings, forming several highly distinctive groups. Some of the pieces show affinities to finger rings from the Desana group and to the hoard from Reggio Emilia.[78] With one exception all the rings from the Getty hoard are of nearly identical type and size. They are not altogether in the ordinary line of Late Roman finger rings, which tend to feature either round shanks or filigree-decorated ones. Because of the dearth of published material of the later fourth and fifth centuries, it might, however, be misleading to draw final conclusions. In any case, with the exception of one piece, our rings seem to come from a single workshop.

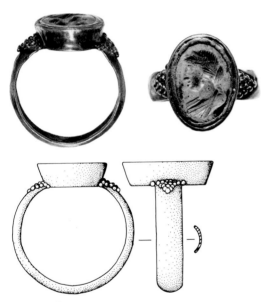

FIGURES 16a–c

Finger ring with Roman carnelian intaglio. Malibu, J. Paul Getty Museum 83.AM.228.1. Drawing by Martha Breen.

a. *Gold ring with engraved carnelian* (figs. 16a–c)
H: 2.47 cm; Diam: 2.29 cm; bezel 1.76 × 1.38 cm; Wt: 6.21 g
Lit. for this and the following finger rings: *GettyMusJ* 12 (1984), p. 257, no. 6
83.AM.228.1

Like all but one of the rings from the Getty hoard this one consists of two parts, a circular band—the so-called hoop or shank—and a bezel, which supports the collet for setting a gemstone. The plain hoop is of equal width throughout, the outside slightly con-

vex, the inside concave. The oval bezel holds a reused Roman calcified carnelian intaglio with a female head facing to the left, set separately in gold. The joint between the hoop and the bezel is braced with a granulated triangle. The shape of this ring is close to one of the finger rings from the Thetford treasure.[79] It also resembles a piece from Tuddenham, Suffolk, found together with coins ranging from Constantius II to Honorius.[80] The reuse of Classical intaglios, quite common already in the Roman period, can also be observed in Merovingian and Frankish jewelry.[81]

Beaded joints are occasionally found on Roman finger rings as early as the first century A.D. They usually consist of little pellets soldered to each side of the hoop where it joins the bezel. A more elaborate beading did not seem to be fashionable before the late fourth century A.D. The finger rings in this hoard appear to be among the earliest examples of the triangle decoration. However, in the early Byzantine period this decorative device became so common that it was imitated even beyond the borders. A splendid example of a later stage in its use is a Byzantine gold ring in the Melvin Gutman collection.[82] On this ring as on some of the Getty specimens, a larger pellet is added to the upper angles of the triangle.[83]

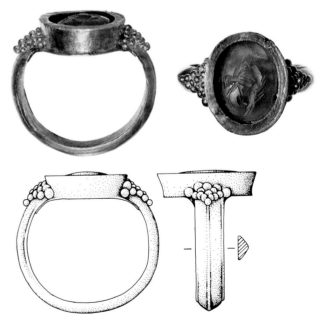

FIGURES 17a–c

Finger ring with Roman carnelian intaglio. Malibu, J. Paul Getty Museum 83.AM.228.3. Drawing by Martha Breen.

b. *Gold ring with engraved carnelian* (figs. 17a–c)
H: 2.7 cm; Diam: 2.9 cm; bezel 1.91 × 1.65 cm;
Wt: 16.13 g
83.AM.228.3

    The shape of this relatively large ring is similar to the preceding ring's. The boxlike bezel contains a reused Roman carnelian intaglio showing a male seated on a dolphin. Granulated triangles accentuate the junction of the bezel and hoop, the outside of which is marked by a central ridge.

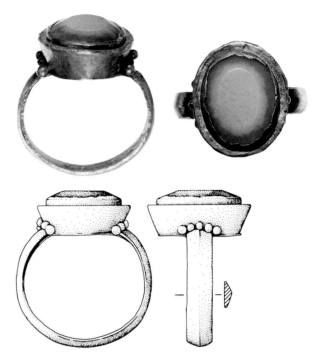

FIGURES 19a–c

Finger ring with agate. Malibu, J. Paul Getty Museum 83.AM.228.6. Drawing by Martha Breen.

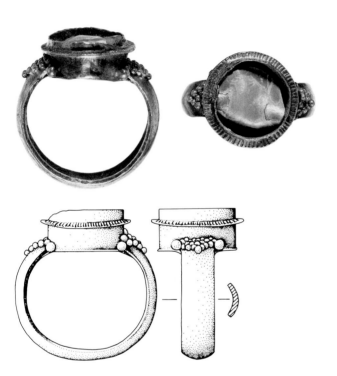

FIGURES 18a–c

Finger ring with mother-of-pearl inlay. Malibu, J. Paul Getty Museum 83.AM.228.5. Drawing by Martha Breen.

c. *Gold ring with mother-of-pearl inlay* (figs. 18a–c)
H: 3 cm; Diam: 2.77 cm; bezel Diam: 1.89 cm;
Wt: 13.12 g
83.AM.228.5

    Same type as the preceding rings. The circular bezel, which contains a piece of mother-of-pearl, is decorated with a flange, corrugated on the upper side. There are larger pellets at the upper edges of the granulated triangle. A collarlike flange is occasionally found on Late Roman finger rings. There are several similar though more elaborate pieces in the Thetford treasure.[84]

d. *Gold ring with agate inlay* (figs. 19a–c)
H: 2.98 cm; Diam: 2.68 cm; bezel: 2.17 × 1.85 cm;
Wt: 12.61 g
83.AM.228.6

    Same type as the preceding rings. An agate in the shape of a truncated cone is mounted separately in gold and set into the boxlike bezel. A central ridge accentuates the hoop. On each side of the beaded joints there are larger pellets. A similar ring has been found in Mainz,[85] another one in Cologne.[86]

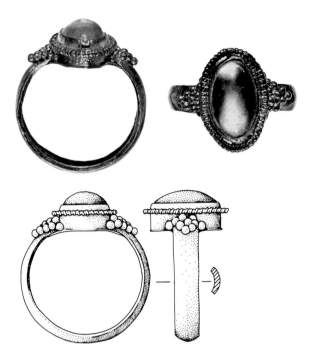

FIGURES 20a–c

Finger ring with rock crystal. Malibu, J. Paul Getty Museum 83.AM.228.7. Drawing by Martha Breen.

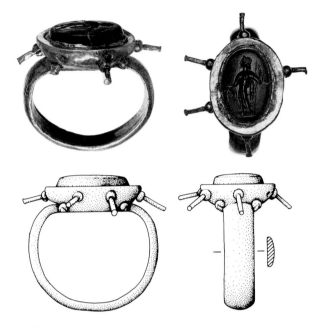

FIGURES 21a–c

Finger ring with Roman carnelian intaglio. Malibu, J. Paul Getty Museum 83.AM.228.2. Drawing by Martha Breen.

e. *Gold ring with rock crystal* (figs. 20a–c)
H: 2.93 cm; Diam: 2.54 cm; bezel: 1.81 × 1.32 cm; Wt: 10.69 g
83.AM.228.7

    Same type as the preceding rings, with slightly convex plain hoop and oval bezel. The joints are decorated with granulated triangles, the bezel surrounded by a beaded wire. A cabochon rock crystal serves as an inlay. Similar to this piece is a finger ring from a jewelry treasure said to be found in Constantinople and coin dated to the sixth century A.D.[87] Here the beaded wire encircles a box setting containing an agate, while gold globules are attached to the joint. In spite of the absence of granulated triangles, the closest parallel seems to be a finger ring from the Untersiebenbrunn grave, dated to the early fifth century A.D.[88]

f. *Gold ring with engraved carnelian* (figs. 21a–c)
H: 2.54 cm; Diam: 2.56 cm; bezel: 1.9 × 1.49 cm; Wt: 15.92 g
83.AM.228.2

    Oval, bowl-shaped bezel with flat rim and plain hoop, convex on the outside, concave on the inside. On each side of the joints of the hoop and the bezel there is a pellet. Six hollow pellets, one now missing, were soldered to the side wall of the bezel, each supporting a heavy gold pin with a flattened end. Originally pearls were mounted on these protruding pins. The older Roman engraved carnelian with the figure of a standing Mercury is set separately in gold and rises considerably above the setting.

    Pearls played an important role in Roman jewelry. It seems, however, that not until the first half of the third century A.D. were they used as a frame for colored stones or paste. They were always pierced and strung on gold wire, which, when used as a frame, was attached to the setting by several loops. Pearls mounted on projecting pins represent a later step in the development.[89] One of the few well-dated examples is a circular ornament from a fifth-century grave in Cluj-Someseni in Transsylvania.[90] It is a boxlike ornament surrounded by the same type of gold pins with flattened heads as those on the Getty ring.

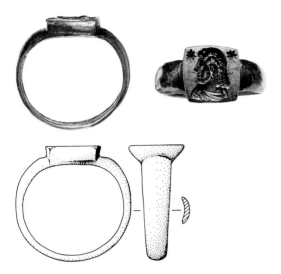

FIGURES 22a–c

Gold finger ring with engraved portrait. Malibu, J. Paul Getty Museum 83.AM.228.4. Drawing by Martha Breen.

g. *Gold finger ring* (figs. 22a–c)
H: 1.9 cm; Diam: 2.55 cm; bezel: 0.8 × 0.8 cm;
Wt: 10.73 g
83.AM.228.4

Solid gold ring of comparatively small size with plain hoop and flat, square bezel with the engraved bust of a man in Roman military attire to the right, the head turned to the left, showing his profile. The two upper corners of the square field contain a star. The engraving shows the portrait of a man with straight nose, large round eye, and thick lips. His curly hair falls down in three tight curls, leaving the ear visible. A dotted line around the chin and jaw indicates a beard. In spite of his official Roman military attire with a paludamentum held by a circular fibula and a cuirass, of which the leather straps over the shoulder are visible, the portrait is stylistically closer to Sasanian than to Roman representations. The way the profile is turned to one side and the bust to the other and particularly the treatment of the hair recall male busts on Sasanian stamp seals of the late third and fourth centuries A.D.[91] Very close, though of inferior quality, is the portrait on a related Sasanian bronze ring said to have been found in Lebanon.[92] Additional stars—or a star and a crescent—can be found on Sasanian as well as on Roman intaglios. They are a symbol whose true meaning remains open.

Contrary to Sasanian male portraits, the man represented on the Getty ring does not wear an earring. For this reason the portrait may have been cut by a Sasanian goldsmith to represent either a Roman or a barbarian entitled to official Roman military attire.

Typologically this finger ring belongs to a group that is well represented by a similar piece with an engraved male bust from the hoard of Velp, dated to the early fifth century A.D.[93] Also closely related is a gold ring in Trier showing the engraved bust of a woman with a coiffure of the late fourth century A.D.[94] These two rings and the Getty ring can be compared with the so-called marriage rings, a group of finger rings with not a single but a double portrait of a facing couple engraved in the square bezel.[95] Further parallels attributable to the late fourth century A.D. are a silver ring from South Ferriby, Lincolnshire, found together with fourth-century silver coins down to Honorius[96]; a silver ring from Whorlton, Yorkshire, found with coins of the same period[97]; and three silver rings found in Amesbury, Wiltshire, together with a hoard of coins, the latest being issues of Theodosius I (A.D. 379–395) (fig. 23).[98] These rings from British sites apparently represent local versions of a widespread Late Roman type. Interestingly enough, two of them show an additional decoration of beaded triangles, reminiscent of the other finger rings from the Getty hoard.

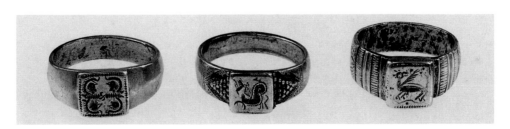

FIGURE 23

Three silver rings from Amesbury. London, British Museum P&RB 1857.6-30.1–3. Photo courtesy Trustees of the British Museum.

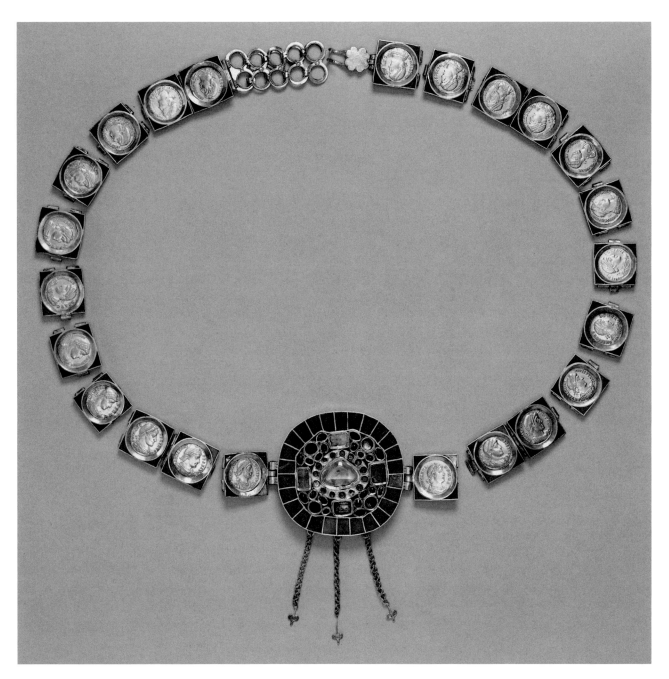

FIGURE 24a

Belt with mounted coins and central ornament. Malibu, J. Paul Getty Museum 83.AM.224.

8. BELT WITH MOUNTED COINS (figs. 24a–o)

L: 77.8 cm; central ornament maximum Diam:
7.5 cm; each setting: 2.7 × 2.6 cm; total Wt: 389.94 g
83.AM.224

Of all coin belts to have survived from antiquity,
this is the most elaborate. It is composed of several
elements, the principal one being a large central orna-
ment with polychrome encrustation and three pendant
chains (figs. 24a–d). On each side it is flanked by a

series of square settings with coins and green glass
inlays. Slender hinges secure the settings to one
another, and a short double chain and matching hook
finials allow the lengthening or shortening of the belt.

The central ornament is a quasi-circular gold
box inlaid with green glass, emeralds, and garnets
(fig. 24c). In the very center is a large magnificent cab-
ochon Ceylon sapphire of triangular shape inserted in
a box setting with a flat, slightly grooved border. This

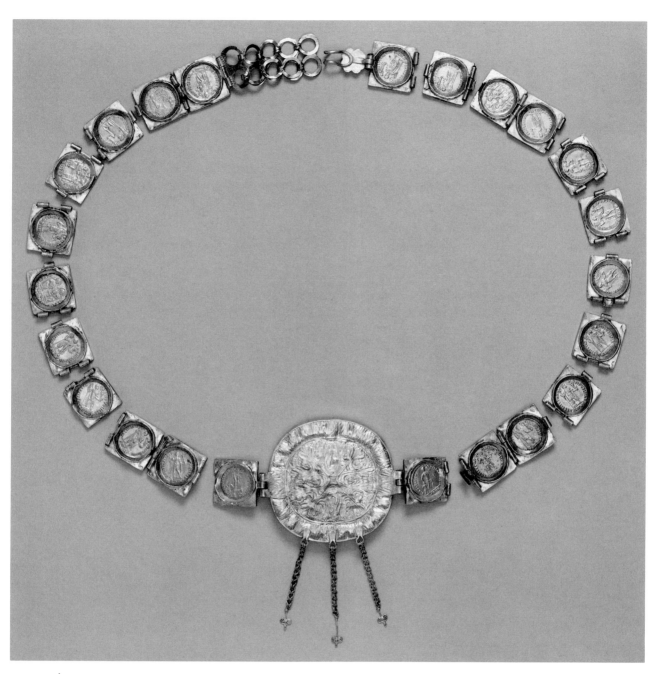

FIGURE 24b

Back of belt, figure 24a.

is surrounded by a frame with a row of round recesses that may be presumed originally to have held small cabochon garnets or pearls. The pale color of the frame is due to a higher percentage of silver in this alloy than elsewhere in the ornament. The addition of silver to the gold created a harder alloy better suited for the flush settings. This rather unusual type of setting hardly occurs on Roman jewelry, but it is quite frequent in Early Byzantine goldwork.[99]

The central decoration is surrounded by a zone filled with an arrangement of box settings. Four square settings forming opposite pairs determine the layout. Two of them contain emeralds and one opaque green glass; the last one is empty. Each inlay is framed by a slightly grooved border, similar to the one surrounding the sapphire. The square settings alternate with four circular box settings, constructed in the same way and all now empty. Between these larger settings

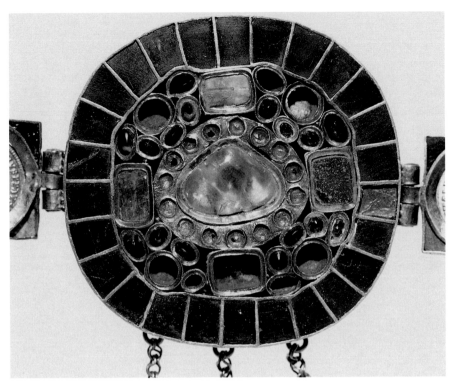

FIGURE 24C

Front of central ornament of belt, figure 24a.

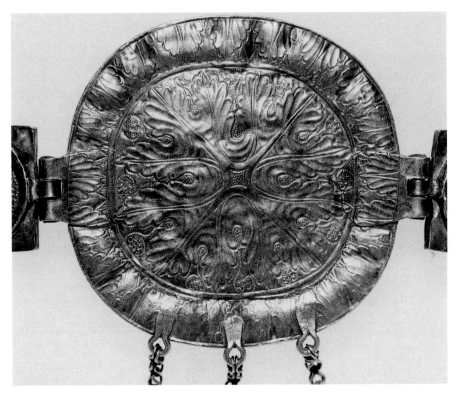

FIGURE 24d

Back of central ornament of belt, figure 24a.

FIGURE 24e

Graffiti on the sides of the mountings of the coins in belt, figure 24a. Drawing by Tim Seymour after original by Ifigenia Diogissiadu.

are semicircular clusters of smaller oval box settings of the same make, containing cabochon garnets.

This variegated arrangement of colored gems and glass is held together by an outer border of green glass cloisonné, the inner wall of which is irregular as it follows the pattern of the different box settings.[100] Short bands of gold, individually secured to the backplate, divide the border into cells of rectangular or trapezoidal shape. One cell is now empty, the others contain flat slices of opaque green glass.

Whereas the front is entirely covered with different settings, the underside of the central ornament bears a petaled rosette of fully opened acanthus leaves, done in a distinct though flat relief with clearly defined outlines (fig. 24d). The interstices are embellished by vegetal scrolls rendered in stippled lines. Such a combination of repoussé work and additional stippled lines is quite often seen on Late Antique and Early Byzantine silverwork.[101] The closest analogy for the acanthus leaves is found on a silver jug from the Water Newton hoard of Early Christian silver, deposited in the early part of the fourth century.[102]

An outer border, corresponding to the cloisonné border of the front, repeats the floral theme by showing a row of stylized acanthus leaves pointing toward the center. Such bands of acanthus leaves are a common motif in Late Antique metalwork. Foliage design on the back of a piece of jewelry seems to be a particular feature of the Early Byzantine period.[103] It is, however, difficult to decide when this first started. A particularly interesting parallel is a pendant from the so-called Olbia treasure, now in Dumbarton Oaks.[104] The face is set with a large garnet framed by a cell-work border originally inlaid with smaller garnets, many of which are now missing. The back is decorated in repoussé with a central rosette and four palm branches. Matching earrings show a similar decoration. The pendant is attached to a gold necklace terminating in characteristic fourth-century lion's heads and a disc with the bust of a woman in relief.[105] Also closely related is a pair of earrings in the Walters Art Gallery in Baltimore, each consisting of semi-precious stones and pearls in gold settings, backed by a thin sheet of gold decorated in repoussé with an elaborate floral motif.[106] Said to have been found in Extremadura in Spain, the pair is no doubt the product of an Early Byzantine workshop.

Three short link-in-link chains terminating in

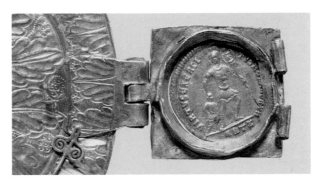

**FIGURES 24f, g**

Mounted solidi of Valentinianus I (left) and Constans (right) from belt, figure 24a. (Acc. nos. 83.AM.224.2a [left] and 83.AM.224.2b [right].)

**FIGURES 24h, i**

Mounted solidus of Julianus II from belt, figure 24a. (Acc. no. 83.AM.224.1a.)

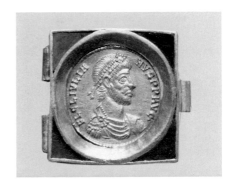

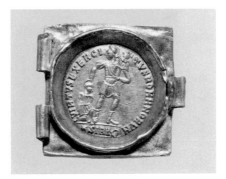

**FIGURES 24j, k**

Mounted solidus of Julianus II from belt, figure 24a. (Acc. no. 83.AM.224.14.)

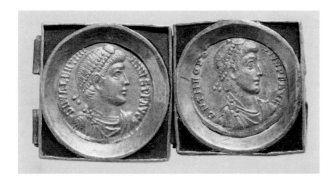

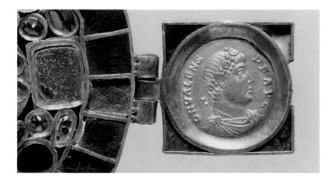

Mounted solidi of Valentinianus I (left) and Theodosius I (right) from belt, figure 24a. (Acc. nos. 83.AM.224.6a [left] and 83.AM.224.6b [right].)

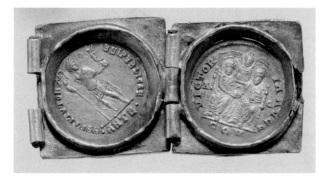

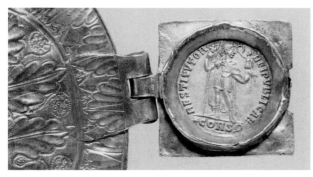

FIGURES 24n, o

Mounted solidus of Valens from belt, figure 24a. (Acc. no. 83.AM.224.1b.)

filigree finials are suspended from the lower edge of the central piece of the Getty belt. The central chain is slightly longer than the outer ones. Originally they were fitted with pierced pearls. Similar tassels are found on Palmyrene brooches of the second and third century A.D.[107] In the fourth century they appear to be part of the imperial fibula, as can be seen on all coin portraits of this period. If this has an implication for the interpretation of the belt, it is, however, difficult to prove. Tasseled belts can occasionally be seen on Early Byzantine representations. Good examples are the figures of Roma and Constantinopolis on fifth-century ivories in Vienna[108] and of an Ariadne in Paris.[109]

Attached to either side of the central piece is a tripartite hinge with two cheniers made from a single gold sheet with a tongue-shaped extension soldered to the back (see figs. 24g, o). Its engraved decoration matches the foliate frieze on the border of the back plate. On the front three tiny gold granules mark the joint (see figs. 24f, n). These hinges correspond to similar ones connecting the single square settings that form the belt. Each of the settings consists of a square gold box with low walls and a central, circular opening filled by a mounted gold coin. The four corners of the setting contain the same opaque green glass that was used for the cloisonné border of the central ornament. The size of each single setting is 2.7 × 2.6 cm, the weight of one setting and coin ranges from 11.04 g to 11.78 g.

A decorative design similar to that of the central element of the Getty belt can be seen on a bracelet in the British Museum, found in Tunis together with other jewelry.[110] It consists of a central disc made up of a series of box settings arranged in circles. On either side are two open-work hinged bands. A third-century A.D. date has been proposed for this group, but it might be a bit too early for the bracelet.

A further step in the development is represented by a somewhat later bracelet from the Assiud hoard, now in Berlin.[111] The arrangement of settings on its clasp recalls that of the central ornament of our belt. In spite of close affinities, none of the pieces mentioned so far shows a similar cloisonné inlay. This is found on what might be considered the most convincing parallel, a boxlike circular ornament from the Cluj-Someseni hoard (figs. 25a–b). This is a Germanic grave find for which a burial date in the third quarter of the fifth century A.D. has been proposed.[112] While the front of the object is completely covered by a network of cloisonné, with the inlays now lost, the back

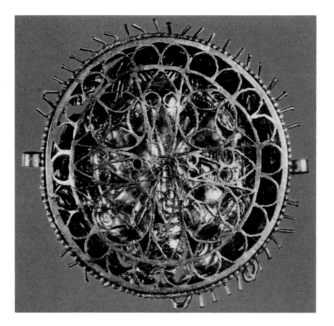

FIGURES 25a, b

Circular gold ornament from Cluj-Someseni. *Top:* front; *bottom:* back. Bucharest, National Museum, no inv. no. Photos courtesy National Museum.

shows a less elaborate though basically similar repoussé decoration. In addition, the piece is surrounded by a series of small gold pins, originally fitted with pearls. This is a very particular decoration found also on the finger ring Getty 83.AM.228.2 (figs. 21a, b) in connection with which the Cluj-Someseni ornament was already mentioned. Three loops at the lower rim, meant to hold chain pendants, stress the similarity with the central piece of the Getty belt.

The square settings that form the Getty belt find their closest parallels in two pairs of bracelets from fourth-century graves in Armaziskhevi in Georgia.[113] Both consist of square elements, held together by hinges. Their decoration is even more colorful than that of the settings of the Getty belt, as it combines gold, garnets, green glass, and turquoise inlays. The comparable material quoted here ranges from the early fourth to the fifth century A.D. This is the period dur-

ing which the polychrome style, marked by the encrusting of gold with precious and semiprecious stones or colored glass, spread over the whole of Europe. A narrower chronological range is provided by the coins used. The belt—as it exists—consists of twenty-three settings containing coins of various emperors who reigned during the fourth century A.D., with the latest coin dating from the reign of Theodosius I (A.D. 379–395). The graffiti on the sides of the mountings (which may or may not be Greek letters) are in part illegible, but they may correspond to the sequence of the settings in the belt (fig. 24e).[114] In the following the coins are listed in chronological order.[115]

*Constans* (A.D. 337–350)

1. 83.AM.224.2b (figs. 24f, g, right). Second setting beside chain terminal: Slightly worn solidus issued A.D. 337–347 in Antioch. Obv. FL IUL CONS–TANS PER AUG. Bust of emperor with beaded diadem, cuirass, and paludamentum. Rev. VICTORIA AUGUSTORUM. Victory seated to the right, pointing to the inscription on a shield supported by cupid VOT V/MULT X. *RIC*, vol. 8, p. 513, no. 2g.

*Julianus II* (A.D. 361–363)

2. 83.AM.224.1a (figs. 24h, i). Setting on the left of the central ornament: Solidus in perfect condition, undated. Issued in Antioch. Obv. FL CL IULIA–NUS PP AUG. Bust of emperor with pearled diadem, cuirass, and paludamentum to the right. Rev. VIRTUS EXERCI–TUS ROMANORUM. Emperor with captive and tropaion to the right. In exergue ANTE. *RIC*, vol. 8, p. 530, no. 195.

3. 83.AM.224.14 (figs. 24j, k). Solidus in very good condition, issued in Sirmium A.D. 361–363. Obv. FL CL IULIANUS PP AUG. Same type as before. Rev. same legend and type as before. In exergue SIRM between star and wreath. *RIC*, vol. 8, p. 391, no. 95.

*Valentinianus I* (A.D. 364–375)

4. 83.AM.224.17. Solidus in very good condition, issued in Antioch A.D. 364–367. Obv. DN VAL-ENTINI–ANUS PF AUG. Bust of emperor with beaded diadem, cuirass, and paludamentum to the right. Rev. RESTITUTOR REIPUBLICAE. Standing emperor with vexillum and crowning Victory. In exergue ANTA. *RIC*, vol. 9, p. 272, no. 2(a).

5. 83.AM.224.6a (figs. 24l, m, left). Solidus in good condition, issued in Antioch A.D. 364–367. Obv. same legend and type as before. Rev. same legend and type as before. In exergue ANTE. *RIC*, vol. 9, p. 272, no. 2(a).

6. 83.AM.224.2a (figs. 24f, g, left). Setting beside chain terminal: Solidus in perfect condition issued in Constantinople A.D. 364–367. Obv. same legend as before. Bust of emperor as before with rosette diadem. Rev. same legend and type as before. In exergue CONS. *RIC*, vol. 9, p. 209, no. 3(a) var.

7. 83.AM.224.4b. Solidus in good condition, issued in Nicomedia A.D. 364–367. Obv. same legend as before. Bust of emperor with beaded diadem. Rev. same legend and type as before. In exergue SMNE. *RIC*, vol. 9, p. 250, no. 2(a).

8. 83.AM.224.16. Solidus in good condition, issued in Nicomedia A.D. 364–367. Obv. same legend and type as before. Rev. same legend and type as before. In exergue SMNE. *RIC*, vol. 9, p. 250, no. 2(a).

9. 83.AM.224.10. Solidus in good condition, issued in Nicomedia A.D. 364–367. Obv. same legend and type as before. Rev. same legend and type as before. In exergue SMNE. *RIC*, vol. 9, p. 250, no. 2(a).

10. 86.AM.531. Solidus, slightly worn, issued in Nicomedia A.D. 364–367. Obv. same legend and type as before. Rev. same legend and type as before. In exergue SMNI. *RIC*, vol. 9, p. 250, no. 2(a).

11. 83.AM.224.4a. Solidus in good condition, issued in Nicomedia A.D. 364–367. Obv. same legend and type as before. Rev. same legend and type as before. In exergue SMNM. *RIC*, vol. 9, p. 250, no. 2(a).

12. 83.AM.224.9. Solidus in excellent condition, issued in Nicomedia A.D. 364–367. Obv. same legend as before. Bust of emperor with rosette diadem. Rev. same legend and type as before. In exergue SMNS. *RIC*, vol. 9, p. 250, no. 2(b).

*Valens* (A.D. 364–378)

13. 83.AM.224.5a. Solidus in good condition, issued in Antioch A.D. 364–367. Obv. DN VALENS AUG. Bust of emperor with beaded diadem, cuirass, and paludamentum to the right. Rev. RESTITUTOR REI PUBLICAE. Standing emperor with vexillum and crowning Victory. In exergue ANT. *RIC*, vol. 9, p. 272, no. 2(d).

14. 83.AM.224.13. Solidus, worn, issued in Antioch A.D. 364–367. Obv. same legend and type as before. Rev. same legend and type as before. *RIC,* vol. 9, p. 272, no. 2(d).

15. 83.AM.224.5b. Solidus in good condition, issued in Antioch A.D. 364–367. Obv. same legend and type as before. Rev. same legend and type as before. In exergue ANTH. *RIC,* vol. 9, p. 272, no. 2(d).

16. 83.AM.224.1b (figs. 24n, o). Setting on the right of the central ornament: Solidus in perfect condition. Issued in Constantinople A.D. 364–367. Obv. DN VALENS PF AUG. Bust of emperor with rosette diadem, cuirass, and paludamentum to the right. Rev. RESTITUTOR REI PUBLI-CAE. Standing emperor with vexillum and crowning Victory. In exergue CONS between star and wreath. *RIC,* vol. 9, p. 210, no. 3(d).

17. 83.AM.224.11. Solidus in good condition, issued in Nicomedia A.D. 367–375. Obv. DN VALENS PF AUG. Bust of emperor wearing beaded diadem and imperial mantle and holding mappa and short scepter to the left. Rev. VOTA PU-BLICA. Two emperors in consular regalia, nimbate, enthroned facing, each holding mappa and short scepter. In exergue S N E separated by kneeling captives. *RIC,* vol. 9, p. 254, no. 16(b).

18. 83.AM.224.8. Solidus in good condition, issued in Nicomedia A.D. 364–367. Obv. same legend as before. Bust of emperor with beaded diadem, cuirass, and paludamentum to the right. Rev. RESTITUTOR REIPUBLICAE. Standing emperor with vexillum and crowning Victory. In exergue SMNE. *RIC,* vol. 9, p. 250, no. 2(d).

19. 83.AM.224.3. Setting beside hook. Slightly worn solidus, issued in Nicomedia A.D. 364–367. Obv. same legend and type as before. Rev. same legend and type as before. In exergue SMNI. *RIC,* vol. 9, p. 251, no. 2(d).

20. 83.AM.224.7. Solidus in very good condition, issued in Nicomedia A.D. 364–367. Obv. same legend and type as before. Rev. same legend and type as before. In exergue SMNM. *RIC,* vol. 9, p. 250, no. 2(d).

21. 83.AM.224.15. Solidus in good condition, issued in Nicomedia A.D. 364–367. Obv. same legend and type as before. Rev. same legend and type as before. In exergue SMNM. *RIC,* vol. 9, p. 250, no. 2(d).

22. 83.AM.224.12. Solidus in good condition, issued in Thessalonike A.D. 364–367. Obv. DN VALEN–S PF AUG. Bust of emperor with beaded diadem, cuirass, and paludamentum to the right. Rev. VICTORIA AUGG. Two emperors enthroned facing, holding a facing Victory on globe. In exergue SMTES. *RIC,* vol. 9, p. 174, no. 4(b).

*Theodosius I* (A.D. 379–395)

23. 83.AM.224.6b (figs. 25l, m, right). Solidus in good condition, issued in Aquileia in A.D. 383–388. Obv. DN THEODO–SIUS PF AUG. Bust of emperor with beaded diadem, cuirass, and paludamentum to the right. Rev. VICTOR–IA AUGG. Two emperors enthroned facing, together holding globe. Between them facing half figure of Victory and palm branch. In exergue COM, in field A–Q. *RIC,* vol. 9, p. 103, no. 40(b).

It is tempting to speculate about the accumulation of the coins used for the belt, although it is hardly possible to decide whether they were deliberately selected pieces or whether the goldsmith chose them at random. Coins used as a decorative device were popular from the third century A.D. onward.[116] They were mainly mounted as pendants, but also inserted in bracelets or finger rings. The coins used here are solidi with a weight each of about 4.54 g. For everyday purposes gold was, according to numismatic evidence, too valuable. However, it played a very important role in buying off the hostility of nations and tribes that pressed on the frontiers of the Roman Empire,[117] as donations, distributed regularly to the army, and as casual tokens of imperial favor and generosity, offered to high government officials.

There is one solidus with the name of Constans (no. 1) and two issued by Julianus (nos. 2, 3). The majority, however, is represented by Valentinianus with nine coins (nos. 4–12) and Valens with ten pieces (nos. 13–22). The single solidus by Theodosius represents a terminus post quem in the penultimate decade of the fourth century A.D. (no. 23). Constans (A.D. 337–350) was the youngest of the three sons of Constantine the Great. Julian, a nephew of Constantine the Great, best known for his attempted revival of paganism, became emperor in A.D. 360. Flavius Valentinianus, a senior army officer, was proclaimed emperor in A.D. 364 and took over government of the West. After spending most of his reign defending the northern frontier, he died in A.D. 375. His younger

brother, Flavius Valens, was appointed co-emperor in 364 and ruled the Eastern provinces of the empire for fourteen years from his capital of Constantinople. His death, on August 9, 378, occurred in one of the greatest military catastrophes ever suffered by Roman armies, the battle of Adrianople, in which the Goths annihilated a powerful imperial army under the command of the emperor himself. Flavius Theodosius was elevated to the vacant Eastern throne in A.D. 379, about five months after the death of Valens. He was one of the most competent emperors of the Late Roman period and the last ruler to exercise effective authority over the entire empire. His early death in A.D. 395 marks a turning point in Late Roman history. A solidus with his name is of particular interest in this context, for he was married to Aelia Flacilla, the empress whose portrait is presumably represented on the circular pendant.

Of the mints, Antioch is represented with seven coins, Constantinople with two, Sirmium with one, Thessalonike with one, Nicomedia with eleven, and Aquileia with one. This suggests an accumulation of the coins in the eastern part of the Roman Empire and, within certain limits, also a provenance of the belt from an eastern workshop. Of the two coins of the emperor Julianus, one (no. 2), a particularly fine piece in pristine condition, is on one side of the central ornament. Its opposite is a solidus of Valens (no. 16), an equally fine piece. Did the owner of the belt have a special reason for putting these two pieces in such prominent places? It has been pointed out that none of the objects in the hoard reveals any influence of Christianity. If the belt was made soon after A.D. 383–388— and considering the composition of the coins, there is no reason why this should not be so—the owner probably would not only have been well aware of Emperor Julianus's support of paganism, but must have chosen his coin deliberately during a period when paganism was suppressed through harsh legislation and repressive actions. With all due precaution, this seems to be an argument in favor of pagan ownership.

The problem is, however, even more intricate. The majority of the coins was accumulated in the sixties of the fourth century. With one exception, the solidus number 17, dated to A.D. 367–375, none of the coins of Valentinianus I and Valens is later than A.D. 364–367. Then there is a gap of nearly twenty years, followed by the single solidus of Theodosius, issued A.D. 385–388. Can this piece be a later addition, used to replace an earlier coin? A competent goldsmith would have been able to do this without leaving

any obvious traces. In any case, without going into speculation, we can assume a date for the coin belt in the last three decades of the fourth century A.D.

Coin belts are not exactly common in Late Roman and Early Byzantine jewelry, and of all pieces or fragments preserved, this belt seems to be the earliest as well as the most magnificent one.[118] A fragment in the Walters Art Gallery consists of a gold medallion of Constantius II (A.D. 337–361) mounted in an openwork frame with three tassels, a mounted aureus of Faustina I, and part of a quintuple link strap, joined by hinges.[119] A framed medallion in the de Clercq collection, fitted with three pendant chains and hinges, probably was the central ornament of a similar coin belt.[120] Its generally accepted sixth-century date might be a bit too late. The magnificent coin girdle from the Lambousa treasure, composed of consular medallions and solidi ranging from Theodosius II to Maurice Tiberius, originated in a Byzantine workshop of the late sixth or very early seventh century.[121] The single coins and medallions are mounted in plain frames, which are, not unlike the empress pendant from the Getty hoard, surrounded by a beaded border. Closely affiliated to the coin belts though forming a particular group are Early Byzantine marriage belts, one in Dumbarton Oaks,[122] another in the de Clercq collection.[123] Comparable in concept, they are, however, made of molded plaques and not of coins.

The Roman *cingulum* or belt is an important part of the official attire of the emperor as well as of the simple soldier.[124] In the fourth century A.D. wearing precious bejeweled belts seems to have been an imperial privilege.[125] On silver medallions of Constans issued in A.D. 338 he and his brothers Constantine II and Constantius are represented in their official court dress, wearing belts that seem to consist of circular elements, sometimes apparently in square settings.[126] These may be coin belts, constructed like the one in the Getty hoard. There is, however, one considerable difference between the belts on representations of Late Roman emperors and our piece. Depictions of belts worn by men show that they are fastened with buckles, and none has a decorative circular central ornament. In fact, the central ornament seems to be restricted to belts worn by women. On the famous diptych in Monza dated to A.D. 400, Serena, daughter of the emperor Honorius and wife of the consul and *magister militium* Stilicho, is wearing a bejeweled girdle, the large centerpiece and separate, inlaid elements of which are similar to our belt.[127] Apparently this belt was also fastened at the back, the centerpiece having a

solely ornamental function. Presumably Serena, like her husband and son, is represented in official attire, the belt being part of a court dress. Similarly splendid belts are shown on mosaics in the church of Santa Maria Maggiore in Rome, dated to the first half of the fifth century A.D., and these, too, were probably inspired by representations of formal clothes.[128]

### CONCLUSION

All objects discussed here have suggested comparisons with Roman material of the third and fourth centuries A.D. Some, such as the two pendants, already had a history when they were buried; others seem to have been fairly new. The cameo pendant, originally a third-century brooch, appears to be the oldest object, the openwork bracelet with hunting scenes the latest one. The coins used for the belt offer evidence for a terminus post quem of A.D. 385–388, which is supported by the date of the imperial portrait on the circular medallion. However, it has to be taken into consideration that the pendant has been reset and "embellished" with encrustation. The question of when this was done remains open. A somewhat later concealment of the hoard cannot be excluded. Parallels for the necklaces are found in late fourth- to early fifth-century contexts. The closest analogy for the openwork bracelet with hunting scenes is a bracelet from the so-called Desana hoard. All this implies an early fifth-century date for the burial of the hoard.

The odd mixture of earlier and later types is certainly not coincidental. It reflects the assembling of wealth over a longer period, of bringing together precious objects in the course of time, possibly even of looting. In this respect, the Getty hoard recalls to a certain degree the Desana group, the hoard from Reggio Emilia, the finds from Apahida,[129] or the treasure from Malaia Pereschepina. At the same time, the hoard shares an overall similarity with the Late Roman treasures from Ténès, Thetford, and Carthage, though none of them provides any straightforward parallels for any of the objects. It would, however, be pointless to seek exact correlation between the different hoards as each appears to be unique. In fact, the total difference between the jewelry in all hoards mentioned above strikingly illustrates the diversity in the decorative arts of Late Antiquity.

Contemporary scholarship tends to attribute most of the Late Antique and Early Byzantine jewelry to workshops in Constantinople or Rome. However, the contrasts are so great that they can be explained

only by the activity of a number of independent workshops in different parts of the empire. Furthermore, in the East and northeast there were artists who combined classical and barbaric traditions, whereas in Western Europe Germanic craftsmen imitated Late Roman as well as Early Byzantine pieces. These various semibarbaric styles, exemplified by one of the Getty bracelets, and their relations to the big centers are not yet clearly defined.

Unfortunately the provenance of the Getty hoard remains unknown. However, the fact that all coins but one have been issued in eastern mints cannot be ignored. In addition, the coins are not the only indication of an eastern provenance. The lavish attitude toward colored inlays, the cloisonné technique, and the particular way of securing pearls, all point to an Eastern origin. The polychrome style, marked by the encrusting of gold with precious and semiprecious stones or colored glass, had its roots in the East.[130] It is not without significance that the jewelry in the Ténès hoard, which probably originated in a Western workshop, is entirely restricted to goldwork.

With this framework in mind, one may turn to the historical background, which has to be taken into account in any attempt to date the hoard.[131] The interment of wealth is usually directly related to violent events, and in the eastern part of the Roman Empire, particularly in the Balkans, there was no shortage of these during the last decades of the fourth and the early fifth centuries. Menacing barbarian invasions; infiltrations and relentless migrations; a constant conflict with the Persians, who threatened the eastern border; differences between the Eastern and the Western empires; the uprising of the usurpers Magnus Maximus, A.D. 383–388, and Eugenius, A.D. 392–394; interior crises; quarrels between different Christian groups; and harsh repression of paganism all created a continuous situation of unease and insecurity.

The far-reaching political, social, and religious changes that overtook the Roman world in the fourth and fifth centuries A.D. make it one of the most exciting periods in ancient history. The repercussions of this period persisted to the end of the ancient world and led toward the making of the modern world. Continuity of styles from one period to the next can best be seen in crafts, the products of which reached a wider circle than monumental art. In jewelry, the Byzantine goldsmith was able to draw, at first or second hand, on types and motifs that were already familiar in the Late Roman period. The survival of traditions combined with the development of new

ideas so characteristic of the Late Antique period is well reflected by the Getty hoard.

Not surprisingly, given the splendor of Late Roman jewelry, it is the aesthetic aspect of the hoard that first attracts attention; however, far more important is its archaeological value.

Frankfurt am Main

## NOTES

Abbreviations:

| | |
|---|---|
| *Age of Spirituality* | K. Weitzman, ed., *Age of Spirituality: Late Antique and Early Christian Art, Third to Seventh Century*, exh. cat., The Metropolitan Museum of Art, New York, November 1977–February 1978 (New York, 1979). |
| *Germanen, Hunnen und Awaren* | W. Menghin, ed., *Germanen, Hunnen und Awaren: Schätze der Völkerwanderungszeit*, exh. cat., Germanisches Nationalmuseum, Nürnberg, and Museum für Vor- und Frühgeschichte der Stadt Frankfurt am Main, December 1987–May 1988 (Nürnberg, 1987). |
| Harhoiu, *Pietroasa* | R. Harhoiu, *The Treasure from Pietroasa, Romania. BAR*, suppl. ser. 24 (Oxford, 1977). |
| Lepage, "Bracelets" | C. Lepage, "Les Bracelets de luxe romains et byzantins du IIe au VIe siècle: Etude de la forme et de la structure," *CahArch* 21 (1971), pp. 1–25. |
| *RIC* | H. Mattingly, C. H. V. Sutherland, and R. A. G. Carson, eds., *The Roman Imperial Coinage*, vol. 8 (London, 1967), vol. 9 (London, 1968). |
| Ross, *DO* | M. C. Ross, *Jewelry, Enamels, and Art of the Migration Period*, Catalogue of the Byzantine and Early Mediaeval Antiquities in the Dumbarton Oaks Collection, vol. 2 (Washington, D.C., 1965). |
| *Wealth of the Roman World* | J. C. P. Kent and K. S. Painter, *Wealth of the Roman World: A.D. 300–700*, exh. cat., The British Museum, London, 1977 (London, 1977). |

1. *GettyMusJ* 12 (1984), Acquisitions 1983, p. 257, no. 142. I wish to acknowledge my gratitude to Marion True, who was the first to draw my attention to this hoard; to Arthur Houghton, who encouraged its publication; and to Marit Jentoft-Nilsen, who generously furnished information. For valuable advice and stimulating suggestions I am very much indebted to Herbert A. Cahn. Helmut Schubert helped to clarify numismatic questions. In all questions concerning goldsmithing methods I could rely on D. J. Content. Ph. Grierson has called my attention to coin belts. Jeffrey Spier sent me an impression of the portrait engraved on one of the finger rings. Denise Clarke kindly read the manuscript. To all of them I wish to express my gratitude.

2. O. M. Dalton, *Catalogue of Early Christian Antiquities and Objects from the Christian East in the Department of British and Mediaeval Antiquities and Ethnography of the British Museum* (London, 1901), pp. 38–39, nos. 242–248; *Jewellery through 7000 Years*, exh. cat., London, The British Museum, 1976 (London, 1976), p. 125, no. 186. For the silver plate from this hoard, cf. *Wealth of the Roman World*, pp. 50–52.

3. J. Heurgon, *Le Trésor de Ténès* (Paris, 1958).

4. C. Johns and T. Potter, *The Thetford Treasure* (London, 1983).

5. J. Ogden, *Jewellery of the Ancient World* (London, 1982), pp. 48–49.

6. N. Degrassi, "Trivolzio (Pavia): Rinvenimento di un tesoretto," *NSc* 7. ser. 2 (1941), pp. 303–331; A. Peroni, *Oreficerie di Pavia* (Spoleto, 1967), nos. 62–64, pls. 12–13.

7. M. Degani, *Il tesoro romano barbarico di Reggio Emilia* (Florence, 1959), p. 38, pl. 18.

8. B. Filow, "Le trésor romain de Nicolaévo," *BIABulg* 4 (1914), p. 33, fig. 8; cf. W. Rudolph and E. Rudolph, *Ancient Jewelry from the Collection of Burton Y. Berry*, Indiana University Art Museum (Bloomington, 1973), pp. 132–133, no. III.

9. Vienna, Kunsthistorisches Museum, Antikensammlung, VII 732. A. Bernhard-Walcher, in: *Severin zwischen Römerzeit und Völkerwanderung*, Ausstellung des Landes Oberösterreich, exh. cat., Stadtmuseum Enns, April 1982–October 1982 (Linz, 1982), pp. 496–497, no. 5/62, pl. 37; *Germanen, Hunnen und Awaren*, p. 340, no. 29, pl. 43.

10. Ross, *DO*, pls. XII.6B, XVIII.11; Dalton (above, note 2), p. 46, no. 282; cf. *Age of Spirituality*, p. 312, no. 286.

11. M. Tatic-Duric, "Joyaux en or de Visnjica," *Zbornik Radova Narodnog Muzeja* (Recueil du Musée National Beograd) 4 (1964), pp. 185–195, pls. I–X.

12. Cf. the so-called pectoral from Cluj-Someseni, K. Horedt and D. Protase, "Ein völkerwanderungszeitlicher Schatzfund aus Cluj-Someseni," *Germania* 48 (1970), pp. 85–98, pl. 21, fig. 3; S. Burda, *Tezaure de aur din Romania* (Bucharest, 1979), pl. 94, no. 54.

13. Ross, *DO*, pp. 48–50, no. 50; Dalton (above, note 2), pp. 32–33, no. 207; see also F. H. Marshall, *Catalogue of the Finger Rings, Greek, Etruscan and Roman, in the Departments of Antiquities, British Museum* (London, 1907), no. 208.

14. For the crowning victories, cf. the reverse of the mounted gold medallion of Constantius II in Baltimore, A. Garside, ed., *Jewelry, Ancient to Modern*, Baltimore, The Walters Art Gallery, 1979, pp. 119–120, no. 330; the emperor pendant in Dumbarton Oaks, Ross, *DO*, pl. 92.179A; and the gold medallion in the de Clercq collection, E. Coche de la Ferté, *Antique Jewellery from the Second to the Eighth Century* (Bern, 1962), pl. 13.

15. R. Delbrueck, *Spätantike Kaiserportraits* (Berlin, 1933), pl. 23; cf. the solidus issued in A.D. 383 in Constantinople, *Wealth of the Roman World*, p. 172, no. 502.

16. Similar traits can be found on a "Flacilla type" marble head in Hamburg, Delbrueck (above, note 15), pl. 99. Very different from the coin portraits is the so-called Aelia Flacilla statuette in the Bibliothèque Nationale, *Age of Spirituality*, pp. 26–27, no. 20; Delbrueck (above, note 15), pls. 163–165; for the identification of female portraits of the fourth century A.D. in general, see also A. F. de Aviles, "La cabeza femenil, constantiniana, de Palencia," *ArchEspArq* 20 (1947), pp. 83–95, esp. p. 91, fig. 4.

17. W. Hagen, "Kaiserzeitliche Gagatarbeiten aus dem rheinischen Germanien," *BonnJbb* 141 (1937), pp. 128–129, pl. 30.E 20–21.

18. Heurgon (above, note 3), pp. 63–73, pl. 1.33–34.

19. O. Neverov, *Antique Cameos in the Hermitage Collection* (Leningrad, 1971), pp. 48, 95, fig. 107.

20. E. Coche de la Ferté, *Le Camée de Rothschild: Un chef d'oeuvre du IVe siècle après J.C.* (Paris, 1957).

21. *Jewelry, Ancient to Modern* (above, note 14), no. 421. For a detailed study, see Ph. Verdier, "Notes sur trois bijoux d'or byzantins de Walters Art Gallery," *CahArch* 11 (1960), pp. 121–129.

22. Ross, *DO*, p. 117, no. 166A.

23. A. R. Noll, *Vom Altertum zum Mittelalter: Führer durch das Kunsthistorische Museum* (Vienna, 1974), p. 72, fig. 51; *Germanen, Hunnen und Awaren*, p. 318, pl. 44.

24. *Germanen, Hunnen und Awaren*, pp. 342–344, pl. 46; for related material, see Harhoiu, *Pietroasa*, pp. 25–28, fig. 13.

25. For this type of cloisonné technique, cf. B. Arrhenius, *Merowingian Garnet Jewellery* (Stockholm, 1985), pp. 77–95.

26. For keeled garnets, cf. Arrhenius (above, note 25), pp. 43–44.

27. D. Buckton, "The Beauty of Holiness: *Opus interrasile* from a Late Antique Workshop," *Jewellery Studies* 1 (1983/1984), pp. 15–19.

28. I am grateful to D. J. Content for sharing his vast knowledge and experience in all questions concerning the technical process of *opus interrasile.*

29. A detailed study by the author on *opus interrasile*-decorated jewelry will be published by the Römisch-Germanisches Zentralmuseum, Mainz.

30. W.-R. Megow, *Kameen von Augustus bis Alexander Severus* (Berlin, 1987), pp. 200–201, no. A81.

31. Megow (above, note 30), pp. 239–240, no. A143, pl. 48.11.

32. A. Dimitrova, "Camées à portrait de femmes de la première moitié du III s. de n.è.," *Archaeologija* (Sofia) 11.2 (1969), pp. 43–50; A. Dimitrova-Milcheva, "Die Gemmen und Kameen vom unteren Donaulimes in Bulgarien: Studien zu den Militärgrenzen Roms," *BonnJbb*, Beiheft 38 (1977), pp. 284–287; A. Dimitrova-Milcheva, *Antique Engraved Gems and Cameos in the National Archaeological Museum in Sofia* (Sofia, 1981), nos. 295–301; Megow (above, note 30), pls. 46–51.

33. K. Wessel, "Römische Frauenfrisuren," *AA* 61.2 (1946/1947), pp. 67–68, fig. 3.

34. A. Krug, "Antike Gemmen im Römisch-Germanischen Museum Köln," *BerRGK* 61 (1980), p. 187, no. 72, pl. 76; Megow (above, note 30), p. 309, no. E7, pl. 50.8.

35. Paris, Hôtel Drouot, *Catalogue des objets antiques et du moyenâge: Collection de M. Guilhou* (A. Sambon) (March 14–15, 1905), no. 168; Paris, Hôtel Drouot, *Collection d'orfèvrerie antique* (June 13, 1934), no. 53, pl. III.

36. W. Oberleitner, *Geschnittene Steine: Die Prunkkameen der Wiener Antikensammlung* (Vienna, 1985), p. 66, fig. 51.

37. Hagen (above, note 17), pl. 31.

38. G. Becatti, *Oreficerie antiche* (Rome, 1955), pl. 148, no. 525.

39. A. Comarmond, *Description de l'écrin d'une dame romaine trouvé à Lyon en 1841* (Paris and Lyons, 1844), pl. 2.

40. *Germanen, Hunnen und Awaren*, p. 193, pl. 14.

41. Cf. above, note 23.

42. A. Javakhishvili and G. Abramishvili, *Jewellery and Metalwork in the Museums of Georgia* (Leningrad, 1986), figs. 51d, 56. Cf. also an earring, said to come from Egypt, with emerald pendants and similar circlets: M. Ruxer and J. Kubczak, "Bijouterie antique de l'ancienne collection Czartoryski," *ArcheologiaWar* 25 (1974), pp. 73–74, no. 28, fig. 21; *Germanen, Hunnen und Awaren*, pl. 21; Z. Vinski, "Arheoloski spomenici velike seobe naroda u Srijemu," *Situla* 2 (1957), p. 30, pl. 20.68.

43. E. Coche de la Ferté, "Bijoux de Chio, de Crète, de Salonique," in P. Amandry, ed., *Collection H. Stathatos: Les objets byzantins et postbyzantins* (Strasbourg, 1957), pp. 13ff., pl. 1. M.

44. W. A. v. Jenny and W. F. Volbach, *Germanischer Schmuck* (Berlin, 1933), pl. 26.

45. Cf. H. Mötefindt, "Zur Geschichte der Löttechnik in vor- und frühgeschichtlicher Zeit: 5. Verwendung der Löttechnik bei der Herstellung von Schrauben," *BonnJbb* 123 (1916), pp. 151–162. See also B. Arrhenius, "Die Schraube als Statussymbol," *Frankfurter Beiträge zur Mittelalter Archäologie*, vol. 2 (1990), pp. 13–16.

46. J. Hampel, *Die Altertümer des frühen Mittelalters in Ungarn* (Braunschweig, 1905), vol. 1, pp. 416, 805; vol. 2, pp. 2–3; vol. 3, pl. 2.2.

47. J. Werner, *Der Grabfund von Malaia Pereschepina und Kuvrat, Kagan der Bulgaren* (Munich, 1984), pl. 25.

48. Mötefindt (above, note 45), pp. 151–162; E. Keller, *Die spätrömischen Grabfunde in Südbayern* (Munich, 1971), p. 52.

49. *Age of Spirituality*, p. 307, no. 280.

50. T. Hackens and R. Winkes, eds., *Gold Jewelry* (Louvain, 1983), pp. 133ff., no. 36; L. Berge and K. Alexander, "Ancient Gold Work and Jewelry from Chicago Collections," *AncW* 11.1–2 (1985), p. 11, no. 24.

51. Lepage, "Bracelets," pp. 5–12; *Jewelry, Ancient to Modern* (above, note 14), p. 151, no. 423; B. Deppert-Lippitz, "Die Bedeutung der palmyrenischen Grabreliefs für die Kenntnis römischen Schmucks," *Linzer Archäologische Forschungen* 16 (1987), pp. 190–191, fig. 13.

52. H. Hoffmann, *Ten Centuries that Shaped the West*, exh. cat., Institute for the Arts, Rice University, and other institutions, 1970, pp. 471–472.

53. M. E. Marien, *L'Empreinte de Rome* (Brussels, 1980), p. 338, fig. 246.

54. Filow (above, note 8), pl. 4.4.; I. Wenedikow and I. Marasow, *Gold der Thraker*, exh. cat., Römisch-Germanisches Museum, Cologne, and other institutions, October 1979–June 1980 (Mainz, 1979), nos. 438–456.

55. A. Héron de Villefosse, *Trésor de Monaco, MAntFr* 4th ser., 10 (1879), p. 224.

56. Javakhishvili and Abramishvili (above, note 42), fig. 77.

57. R. Bianchi Bandinelli, *Rom: Das Ende der Antike, Universum der Kunst* (Munich, 1971), fig. 243.

58. A. Greifenhagen, *Schmuckarbeiten in Edelmetall, Staatliche Museen Preußischer Kulturbesitz, Antikenabteilung*, vol. 1, *Fundgruppen* (Berlin, 1970), pls. 55.7, 56; G. Eisen, *Bulletin of the City Art Museum* 10 (1925), pp. 53ff. Deppert-Lippitz (above, note 51), p. 192, fig. 14.

59. M. C. Ross, "Jewels of Byzantium," *Arts in Virginia* 9.1 (1968), fig. 16.

60. P. La Baume, *Römisches Kunstgewerbe* (Braunschweig, 1964), p. 293, pl. 14; H. Hellenkemper, ed., *Trésors romains—trésors barbares*, exh. cat., Passage 44 du Crédit Communal de Belgique, Brussels, March–May 1979, p. 103, no. 20.

61. Cf. N. Dürr and P. Bastien, "Trésor de Solidi," *Swiss Numismatic Review* 63 (1984), pp. 205–219; Buckton (above, note 27), pp. 15ff., fig. 6; *LA* 5 (1968), pp. 206–207; N. Duval, "Un grand médaillon monétaire du IVe siècle," *RLouvre* 23 (1973), pp. 367–374; *Age of Spirituality*, p. 304, no. 276; D. Buckton, "Byzantine Coin-Set Pendant, A.D. 324–388," *National Art-Collections Fund Review*, 1985, p. 93.

62. Lepage, "Bracelets," pp. 17–20; *Age of Spirituality*, pp. 316–317, no. 292, p. 321, no. 297, pp. 322ff., nos. 299–300; K. R. Brown, "The Mosaics of San Vitale: Evidence for the Attribution of Some Early Byzantine Jewelry to Court Workshops," *Gesta* 18.1 (1979), pp. 57–62; idem, "A Note on the Morgan Bracelets in the Metropolitan Museum of Art," *Byzantine Studies* 9.1 (1982), pp. 48–57.

63. P. Bastien and C. Metzger, *Le trésor de Beaurains* (Arras, 1977), p. 170, B 12; R. Higgins, *Greek and Roman Jewellery* (London, 1980), pl. 64F; Ogden (above, note 5), p. 83, color pl. 16.

64. P. La Baume, "Das Achatgefäß von Köln," *KölnJb* 12 (1971), p. 85, fig. 4.4; *Trésors romains* (above, note 60), p. 99, no. 18; cf. also the finger rings from a third-century hoard from Cyprus, R. A. Lunsingh Scheurleer, *Antieke Sier, Allard Pierson Museum, Amsterdam* (Amsterdam, 1987), pp. 74–75, no. 4, and a diamond ring of unknown provenance, Ogden (above, note 5), p. 155, fig. 29.

65. For the polychrome style characteristics for this Oriental and barbarian jewelry, cf. Harhoiu, *Pietroasa*, pp. 19–22.

66. *Age of Spirituality,* p. 611; *Wealth of the Roman World,* p. 140; Werner (above, note 47), pp. 18–19, pl. 23.

67. Ibid., pp. 38–43.

68. J. M. C. Toynbee and J. B. Ward-Perkins, "Peopled Scrolls: A Hellenistic Motiv in Imperial Art," *BSR* 18 (1950), pp. 1–43, pls. 1–26.

69. M. C. Ross, *Catalogue of the Byzantine and Medieval Antiquities in the Dumbarton Oaks Collection: Metalwork* (Washington, D.C., 1962), no. 58; *Age of Spirituality,* nos. 76–77.

70. Dalton (above, note 2), no. 252; E. Kitzinger, *Early Medieval Art,* 2nd ed. (London, 1955), p. 26; W. Volbach and M. Hirmer, *Early Christian Art* (London, 1961), pl. 119; Chr. Belting-Ihm, "Spätrömische Buckelarmringe mit Reliefdekor," *JRGZM* 10 (1963), p. 104, pl. 16.1; *Wealth of the Roman World,* p. 27, no. 15; *Age of Spirituality,* p. 597, fig. 87; F. Baratte, "La plaque de ceinture du Coudray," *MonPiot* 61 (1977), pp. 54–55, fig. 11.; Brown, "Morgan Bracelets" (above, note 62), p. 57, fig. 6; Buckton (above, note 27), pp. 15–19, figs. 1, 2. Attention should be called to the fact that the filigreelike effect of this plaque recalls the lock of the Lipsanothek from Brescia, cf. R. Delbrueck, *Probleme der Lipsanothek von Brescia* (Bonn, 1952), p. 5, pl. 8. For the hunting motif rendered in niello on a gold plaque in Boston, cf. C. C. Vermeule, *Museum of Fine Arts Boston, Annual Report 1971–1972,* p. 42; C. C. Vermeule, *Romans and Barbarians,* exh. cat., Museum of Fine Arts, Boston, 1977, p. 75, no. 107.

71. Dalton (above, note 2), pp. 39–40, pl. 4.252–255; *Wealth of the Roman World,* p. 27, no. 15; M. Sommer, "Die Gürtel und Gürtelbeschläge des 4. und 5. Jahrhunderts im römischen Reich," *Bonner Hefte zur Vorgeschichte* 22 (1984), pp. 76–78, pl. 54.9–11.

72. V. Viale, "Recenti trovamenti archeologici a Vercelli e nel Vercellese: Il tesoro di Desana," *Bollettino storico bibliografico subalpino* 44 (1942), p. 7, figs. 19–20; Becatti (above, note 38), no. 545; V. Bierbrauer, *Die ostgotischen Grab- und Schatzfunde in Italien* (Spoleto, 1975), p. 269, pl. 17.2.

73. F. H. Marshall, *Catalogue of the Jewellery, Greek, Etruscan, and Roman, in the Departments of Antiquities, the British Museum* (London, 1911), no. 2817; Lepage, "Bracelets," p. 15, fig. 24; Heurgon (above, note 3), pl. 26.4; *Wealth of the Roman World,* p. 58, no. 11.

74. Brown 1979 (above, note 62), pp. 48–57.

75. Lepage, "Bracelets," p. 15, no. 70; Heurgon (above, note 3), p. 48, pl. 26.2.

76. Lepage, "Bracelets," p. 15 n. 71; Heurgon (above, note 3), p. 48; H. Schlunk, *Kunst der Spätantike im Mittelmeerraum,* exh. cat., Staatliche Museen zu Berlin, 1939, no. 41, pl. 7; R. Zahn, "Zur Sammlung F. L. v. Gans," *Amtliche Berichte aus den königlichen Kunstsammlungen* 38 (1916), cols. 26–27, figs. 9–11.

77. For a recent though not comprehensive study on Late Roman and Early Byzantine finger rings, cf. G. Vikan, "Early Christian and Byzantine Rings in the Zucker Family Collection," *JWalt* 45 (1987), pp. 32–43.

78. Several finger rings from the two Italian groups repeat the chased ornament in the form of heavily veined leaves found on the Thetford rings, Johns and Potter (above, note 4), p. 80, fig. 7, p. 82, fig. 4; Bierbrauer (above, note 72), pl. 12.8; Degani (above, note 7), pl. 21.

79. Johns and Potter (above, note 4), p. 91, no. 16.

80. M. Henig, *A Corpus of Roman Engraved Gemstones from British Sites,* 2nd ed., *BAR,* British Series 8 (Oxford, 1978), p. 257, no. 581.

81. G. Platz-Horster, *Die antiken Gemmen im Rheinischen Landesmuseum Bonn* (Bonn, 1984), pp. 75–83.

82. C. Parkhurst, *Melvin Gutman Collection of Ancient and Medieval Gold. Allen Memorial Art Museum,* Oberlin, Ohio, *Bulletin* 18 (1961), p. 205, no. 126.

83. Cf. a ring found in Rome, now in the Musée du Louvre, E. Fontenay, *Les Bijoux anciens et modernes* (Paris, 1887), p. 38.

84. Johns and Potter (above, note 4), pp. 86–87, no. 10, pp. 88–91, nos. 12–13, 15.

85. F. Henkel, *Die römischen Fingerringe des Rheinlandes und der benachbarten Gebiete* (Berlin, 1913), no. 272.

86. Platz-Horster (above, note 81), p. 4, no. 41. Cf. A. Krug, "Römische Fundgemmen 3," *Germania* 56 (1978), p. 493, pl. 52.18.

87. Ross, *DO,* pp. 10–12, no. 6F, pl. 14; see also pp. 135–139, no. 179Q, pl. 99. Cf. Rudolph and Rudolph (above, note 8), pp. 132–133, no. 111c.

88. Cf. above, note 24; see also Hampel (above, note 46), vol. 1, p. 434, fig. 1252.

89. Cf. *Age of Spirituality,* p. 328, no. 307.

90. Cf. above, note 12.

91. C. J. Brunner, *Sassanian Stamp Seals in the Metropolitan Museum of Art* (New York, 1978), no. 21; A. Y. Borisov and V. G. Lukonin, *Sasanidskie gemmy sobraniya gosudarstvennogo ermitazha* (Catalogue of the Sassanian Gems in the Hermitage Museum) (Leningrad, 1962), nos. 7, 9, 10, 12, 14; Ph. Gignoux and R. Gyselen, *Sceaux sasanides de diverses collections privées* (Louvain, 1982), no. 20.9; Ph. Gignoux, *Catalogue des sceaux, camées et bulles sasanides de la Bibliothèque Nationale et du Musée du Louvre* (Paris, 1978), no. 3.18; P. Zazoff, *Die antiken Gemmen* (Munich, 1983), pl. 120.6–8; R. Göbl, *Der Sassanidische Siegelkanon* (Braunschweig, 1973), pls. 5, 7a; A. D. H. Bivar, *Catalogue of the Western Asiatic Seals in the British Museum: Stamp Seals,* vol. 2, *The Sassanian Dynasty* (London, 1969), pl. 1.1–4.

92. G. Zahlhaas, *Fingerringe und Gemmen: Sammlung Dr. E. Pressma,* exh. cat., Munich, Prähistorische Staatssammlung, 1985, p. 53, no. 76; Basel, Münzen und Medaillen, *Sonderliste S* (1980), no. 83.

93. Henkel (above, note 85), no. 99.

94. Ibid., no. 93; *Trier: Kaiserresidenz und Bischofssitz,* exh. cat., Trier, Rheinisches Landesmuseum, May–November 1984 (Mainz, 1984), p. 115, no. 33b. Cf. also the bronze ring, Henkel (above, note 85), no. 1064.

95. Ross, *DO,* pp. 48–51, no. 50, with bibl.; M. Deloche, *Etude historique et archéologique sur les anneaux sigillaires* (Paris, 1900), p. 67; Vikan (above, note 77), pp. 33–34; E. Schlicht, "Ein goldener Ehering des 4. Jahrhunderts von Hummeldorf, Kr. Lingen," *Germania* 43 (1965), pp. 381–382.

96. Henig (above, note 80), no. 799.

97. Ibid., no. 800.

98. Ibid., no. 801; *Wealth of the Roman World,* p. 62, nos. 141–143.

99. Harhoiu, *Pietroasa,* pp. 19–22. A similar technique can be observed on goldwork with garnet encrustation from fifth-century A.D. finds, K. Horedt and D. Protase, "Das zweite Fürstengrab von Apahida," *Germania* 50 (1972), p. 191 n. 13; Harhoiu, *Pietroasa,* figs. 10.3, 11.1, 4. M. Schulze, in: *Gallien in der Spätantike,* exh. cat., Mainz, Römisch-Germanisches Zentralmuseum, October 1980–January 1981 (Mainz, 1980),

no. 297; *Germanen, Hunnen und Awaren,* pp. 183–184, no. 55, pl. 13.

100. For the cloisonné technique, cf. Arrhenius (above, note 25), pp. 79–80.

101. *Age of Spirituality,* pp. 261–262, no. 244.

102. K. S. Painter, *The Water Newton Early Christian Silver* (London, 1977), p. 12, nos. 5, 20.

103. Ross, *DO,* no. 166F; *Age of Spirituality,* p. 309, no. 283; J. Spier, "A Byzantine Pendant in the J. Paul Getty Museum," *Getty-MusJ* 15 (1987), p. 6, figs. 1b, c; p. 7, figs. 2a, b; p. 9, fig. 4b; p. 14, fig. 12.

104. Ross, *DO,* p. 117, no. 166A.

105. Cf. necklace with a pendant in the shape of a mounted solidus of Constantius II (A.D. 337–361) in Paris, Bibliothèque Nationale 154a.

106. *Jewelry, Ancient to Modern* (above, note 14), p. 142, no. 405; *Age of Spirituality,* pp. 314–315, no. 289.

107. Deppert-Lippitz (above, note 51), p. 188, fig. 12.

108. W. F. Volbach, *Elfenbeinarbeiten der Spätantike und des frühen Mittelalters* (Mainz, 1952), pl. 10, no. 38.

109. Ibid., p. 22, no. 78; *Age of Spirituality,* pp. 149–150, no. 127.

110. *AA,* 1904, p. 214; Marshall (above, note 73), nos. 2824, 2866–2877; *Jewellery Through 7000 Years* (above, note 2), no. 158.

111. Greifenhagen (above, note 58), pl. 51.2; Lepage, "Bracelets," pp. 16–17, fig. 27.

112. Cf. above, note 12.

113. A. M. Apakidze, *Mtskheta I: Findings of the Archaeological Investigation: The Artifacts Found at Armaziskhevi During the Excavations of 1937–1946* (Tbilisi, 1958), pls. 100.12, 13, 103.1, 12; Javakhishvili and Abramishvili (above, note 42), pl. 54.

114. The author would like to thank Ifigenia Diogissiadu, an intern in the Department of Antiquities at the Getty Museum, for her work in sketching these graffiti. For similar graffiti on Late Antique ornaments, see R. A. Lunsingh Scheurleer, *Antieke Sier,* Allard Pierson Museum (Amsterdam, 1987), p. 74, no. 50.1; C. Metzger, "Collier, diadèmes ou ceintures? Elements de bijoux cousus de l'Antiquité Tardive," *RLouvre* (February 1980), pp. 1–5.

115. For a recent study on the coinage of the second half of the fourth century A.D., cf. Dürr and Bastien (above, note 61), pp. 205–240.

116. Cf. M. Mowat, "De quelques objets antiques incrustés de monnaies," *MAntFr* 50 (1889), pp. 321–336; R. Gadant, "Note sur un pendentif romain en or trouvé à Autun et sur des bijoux analogues de l'époque romaine," *Mémoires de la Société éduenne* 58 (1910), pp. 355–377; C. C. Vermeule, "Numismatics in Antiquity," *Swiss Numismatic Review* 54 (1975), pp. 5–32.

117. J. Iluk, "The Export of Gold from the Roman Empire to Barbarian Countries from the 4th to the 6th Centuries," *Münstersche Beiträge zur Handelsgeschichte* 4.1 (1985), pp. 79–102.

118. Ph. Grierson, "The Kyrenia Girdle of Byzantine Medallions and Solidi," *NC* 6th ser. 15 (1955), pp. 55–70.

119. Vermeule (above, note 116), p. 28, no. 53; *Jewelry, Ancient to Modern* (above, note 14), p. 119, no. 330.

120. Coche de la Ferté (above, note 14), pl. 13.

121. A. Stylianou and J. Stylianou, *The Treasures of Lambousa* (Vasilia, Cyprus, 1969), pp. 49–53, 64, no. 16; Ph. Grierson, "The Date of the Dumbarton Oaks Epiphany Medallion," *DOP* 15 (1961), pp. 221–224; *Age of Spirituality,* pp. 71–72, no. 61.

122. E. H. Kantorowicz, "On the Golden Marriage Belt and the Marriage Rings of the Dumbarton Oaks Collection," *DOP* 14 (1960), pp. 1–16, fig. 1; Ross, *DO,* pp. 37–39; *Age of Spirituality,* pp. 283–284, no. 262.

123. Coche de la Ferté (above, note 14), pl. 11.

124. A. Alföldi, "Insignien und Tracht der römischen Kaiser," *RM* 50 (1935), p. 64.

125. Delbrueck (above, note 15), p. XIX.

126. Alföldi (above, note 124), p. 61, fig. 7; J. M. C. Toynbee, "Roman Medallions," *Nusmismatic Studies* 5 (1944), p. 199; A. Grabar, *The Beginnings of Christian Art* (London, 1967), p. 193, fig. 208; *Age of Spirituality,* p. 74, no. 63; P. Strauss, "Die Münzen der spätrömischen Kaiserzeit," *HelvArch* 11 (1980), p. 72. I am indebted to Ph. Grierson for drawing my attention to these medallions.

127. Volbach (above, note 108), pl. 19, no. 63.

128. A. Grabar, *Die Kunst im Zeitalter Justinians* (Munich, 1967), figs. 161–162; H. Karpp, *Die frühchristlichen und mittelalterlichen Mosaiken in Santa Maria zu Rom* (Baden-Baden, 1966).

129. Horedt and Protase (above, note 99), pp. 174–220.

130. Cf. Harhoiu, *Pietroasa,* pp. 19–22, 29–35.

131. For all historical and economical questions of this period, see A. H. M. Jones, *The Later Roman Empire* (Oxford, 1964); Harhoiu, *Pietroasa,* pp. 31–35.